Brooks Brothers

200 YEARS OF
AMERICAN STYLE

Edited by **KATE BETTS**

RIZZOLI
NEW YORK

New York · Paris · London · Milan

TABLE OF CONTENTS

FOLIO *C522* **New York,** *Dec' 18th 1885*

Mr J. L. Truslow *219 Pearl St.*

Bought of Brooks Brothers,

CLOTHING,

Gentlemen's Furnishing Goods,

ESTABLISHED 1818.

John E. Brooks.
Francis Wagner. M. S. Euen.
Jarvis Weed. Francis G. Lloyd.

TERMS NET CASH. BROADWAY Cor. TWENTY SECOND ST.

1885					
July 1	Suit $33. Suit $28.		F C	$61 00	
Sept 16	Suit $32. Overcoat $27.		"	59 00	
" 29	Suit $75. Pants $14.		"	89 00	
					$209 00

Please receipt + return

REC'D PAYMENT
$209 00
FEB 19 1886
BROOKS BROTHERS.

A Brooks Brothers billhead from
December 18, 1885, when the store
was located at Broadway and
22nd Street.

"We're not good because we're old,
we are old because we're good."

—CLAUDIO DEL VECCHIO,
Chairman & CEO, Brooks Brothers

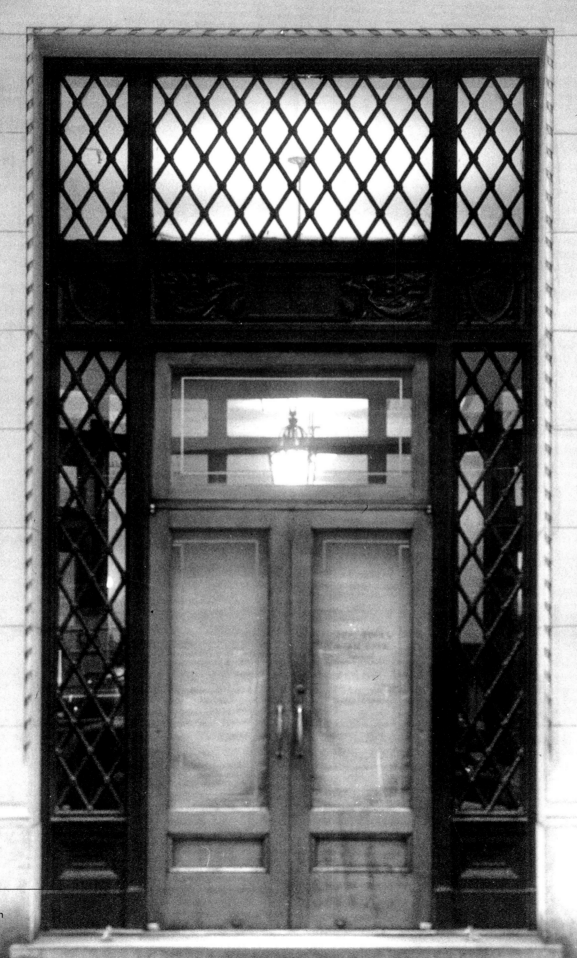

Brooks Brothers Madison
Avenue flagship.

A FAMILY AFFAIR

At any one time, the five members of my nuclear family each owned the same blue and white striped oxford cloth button-down shirt. Why the blue? I could just as easily have said the pink and white or the solid yellow oxford cloth shirts. We had them all. They were crisp and somehow always made their wearers look smart—smart in the book sense and smart in the stylish sense. They were not particularly soft to the touch, but they were 100 percent cotton and held their shape.

Of course, these shirts came from Brooks Brothers, from the men's, the women's, and the boys' departments. How we came to be supplied with these items I didn't know. We always wore them. Did they grow on trees? Were they delivered while we slept? Why did we have them, and why did most people we knew have them too?

The obvious answer is that someone in the know went to 346 Madison Avenue and purchased them. The more elusive answer is that we had a uniform and we were happy to obey its rules.

I grew up in a simpler time in the 1960s and '70s. Unlike the freedom-loving, drugtaking, black-light-rock-festival era we've all read about, my world was about coloring within the lines, and emulating our elders in preparation for a good outcome. We thought *inside* the box, because we lived in the box. It was a lovely box, mind you.

One of my happy memories was the first day of my coed high school after nine years of attending an all-girls' school. The reason should be obvious. The boys dressed in corduroys, oxford cloth button-down shirts from Brooks Brothers, and tweed sport coats. They looked like boys I wanted to know.

Did we speak of these sartorial choices we made? It was not necessary. We could spend our time instead discussing *Siddhartha*, utopian communities, or differential equations (whatever those were). The clothing we all shared was a kind of code. It wasn't meant to keep people out; it was meant to remind all of us that we were connected.

Later, when I started paying attention, I realized that my father must have bought his shirts at Brooks Brothers after a day at the office, and that I got hand-me-downs that my mother had purchased there for my brothers. In college, I began my practice of shopping for myself in the boys' department. As a mother, I continued to rely on Brooks Brothers. As an author, I have worn Brooks Brothers women's wear on many book tours.

But enough about me. This is about the oldest haberdashery in the United States, one that weaves Abraham Lincoln, anyone named Roosevelt, John F. Kennedy, Cary Grant, prep schools, the Ivy League, country clubs, and Don Draper in its DNA. Besides being classicists, the Brothers have been innovators, as you will read in this book.

What makes Brooks Brothers special is that they provide a kind of polish to those of us who don't want to overthink. They are America's great exporters of *sprezzatura*; we want to look good, but we don't want to look like we tried too hard. Brooks Brothers does the thinking, the making, and the fitting for us. On behalf of my family and myself, thank you.

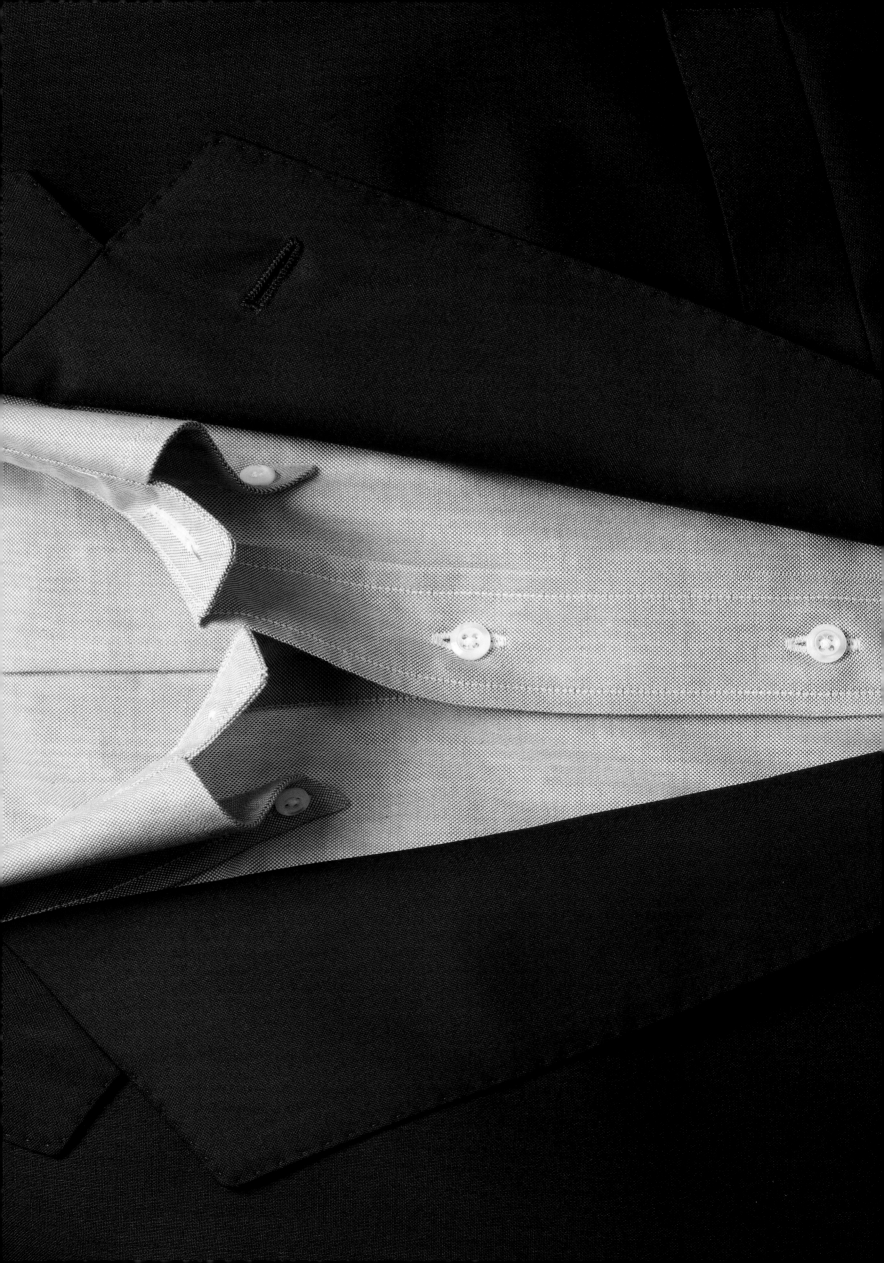

CHAPTER ONE

THE CORNER STORE

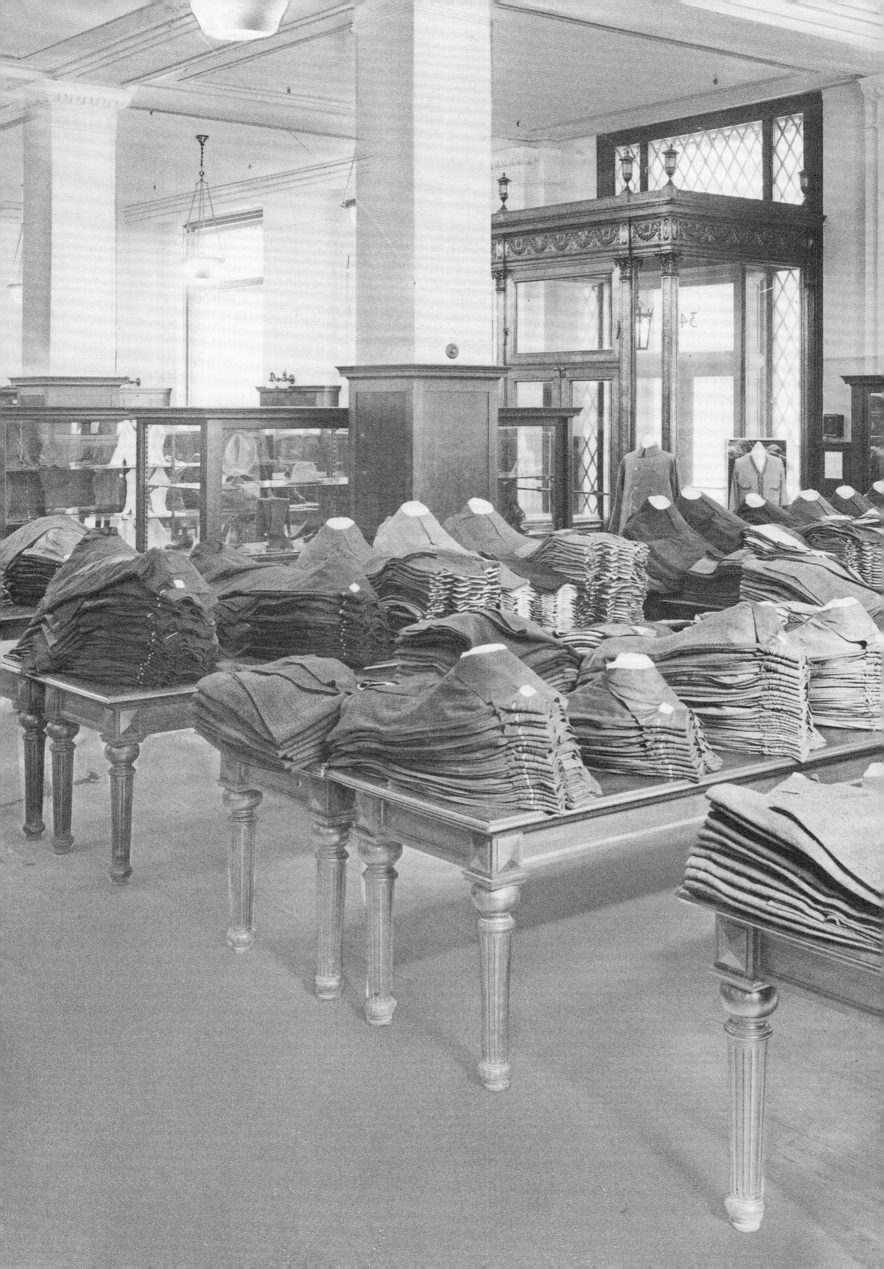

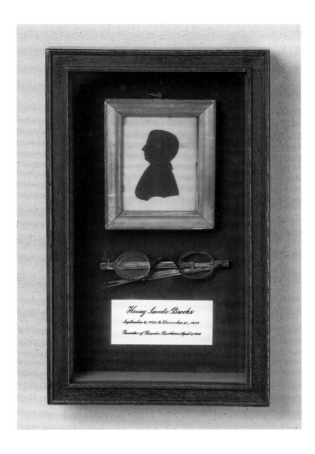

It's strange that there's no picture—not even a period drawing—of Henry Sands Brooks, the visionary merchant who began his career as a grocer and, at the age of forty-six, had the prescient idea to open a men's clothing store in the heart of what was then a fashionable residential neighborhood on the outskirts of Manhattan's mercantile district. Instead, the only visual image that remains of this influential innovator is a stark and mysterious silhouette of his profile. Instead of the man himself, picture, if you will, Brooks's New York City in the spring of 1818: the corner of Catherine and Cherry Streets was the apex of the city's social elite, teeming with lawyers, seafaring merchants, and ship owners who, when they bought their pantaloons and waistcoats from Brooks, were rewarded with a swig of Medford rum from a bottle kept under the counter.

When Henry Sands Brooks bid $15,250 at auction for the building and grounds at Catherine and Cherry Streets, New York City was still a small town with only 125,000 residents, encompassing the swath of three-story wooden and brick houses that stretched north to Thirty-First Street and west to Broadway. The crooked, narrow streets of lower Manhattan were dirty and dark, illuminated only by oil lamps. The city council fretted over the number of swine running in the streets. Congress had standardized the American flag just days before, with thirteen stripes. And James Monroe had been sworn in as President a year earlier. The Brooklyn Bridge had yet to be built; there was no subway and no "Great White Way." Institutions like the *New York Times* and R. H. Macy & Co. would not come along for another thirty years.

The majority of church-going New Yorkers were Episcopalian and wealthy residents dressed in full-skirted coats with gilt buttons and wide lapels. They wore long white waistcoats, buckskin breeches, and floppy neckerchiefs tied in a bow. Needless to say, this was not the look Brooks Brothers customers of F. Scott Fitzgerald's generation a century later would affectionately call "being Brooksy"—that uniquely and authentically American mix of tradition, ingenuity, and style.

Henry Sands Brooks, a dandy at heart, had a hunch about men's clothing and furnishings and what he could do with his taste for dressing "appropriately." He was fond of traveling to London—where Beau Brummel was busy rewriting the rules of English tailoring with straight, narrow trousers and riding boots. Brooks would visit the tailors of Savile Row and bring back trunks filled with colorful waistcoats and silk cravats and lavish them on his friends.

This habit became a business, and Brooks became a legendary purveyor of American style to generations of men, women, and children.

OPPOSITE Up until the mid-1960s, Brooks Brothers suits were displayed in stacks on tables, folded partially inside out to reveal the fine craftsmanship of the garments.

ABOVE The silhouette and spectacles of Brooks Brothers founder Henry Sands Brooks.

He laid the groundwork for ready-made fashion, a revolutionary idea that may seem obvious now, but was radically disruptive to early-nineteenth-century sartorial traditions of custom-made clothing. Although the concept of buying off the rack would not take hold until after Brooks passed away in 1833, his entrepreneurial—and egalitarian—flair inspired a style and sensibility that would endure for centuries.

Henry's brother, David, became a partner briefly and they named the company H. & D. H. Brooks. When Henry died in 1833, he left his five sons in charge of the Catherine Street shop (his eldest son, Henry Jr., died shortly after Henry Sands Brooks) and they changed the name to Brooks Brothers in 1850. But even with their father gone, they kept in step with social advances, staying ahead of the fashion curve by innovating with new ways to display and sell clothing. In 1849, as adventurers and merchants were setting out for distant ports in Sacramento or Singapore, the Brooks brothers understood that they wouldn't have time to order custom-made clothes. So they placed advertisements in the *Morning Courier* and the *New York Enquirer*, announcing their stock of "ready-made clothing suitable for the California trade." It was the beginning of what we now call ready-to-wear. Before that time all clothing had been made by hand. In manufacturing their own products and supplying their customers with ready-made clothing of the highest quality, Brooks Brothers changed the way Americans dressed. To this day, with state-of-the-art manufacturing facilities, Brooks Brothers is proud to continue to be "makers and merchants" and to proudly label their clothing "Made in America."

Henry Sands Brooks was by no means a snob; in fact, his clothing and ideas were said to have been created "not for the rich, but for the successful" and years after his death, when his five sons would take over the company, deliveries from the store would be equally distributed to the Bronx as they were to Park Avenue. That said, the Brooks Brothers store would follow the path north of ever-affluent New York City society as it migrated uptown, first moving to Broadway and Grand Street in 1858, where it opened an elegant "warehouse" with frescoes and Tiffany lamps and served Generals Grant, Sherman, and Sheridan and made uniforms for the Union troops under a contract with the governor of New York. Ten years later the store moved to Broadway and Bond, and further north still in 1884 to Broadway and Twenty-Second Street, just south of then fashionable Madison Square. Finally, in 1915, Brooks Brothers opened in a ten-story building at Madison Avenue and Forty-Fourth Street, where it remains an essential resource for everything, from oxford cloth to etiquette. Eventually Brooks Brothers would also become the first American clothing company to export their product globally.

In a world where style is now driven by speed and flamboyance, Brooks Brothers remains a beacon of good taste. Two hundred years later, Henry Sands Brooks's original mission, "To make and deal only in merchandise of the best quality, to sell it at a fair profit only, and to deal only with people who seek and are capable of appreciating such merchandise," remains the guiding principle of the brand. Although new styles are introduced and innovation continues apace, with the help of contemporary designers like Zac Posen and Thom Browne, the classic Brooks hallmarks rarely change (and when they do, all hell breaks loose with customers writing angry letters, as they did when the Washington, D.C. retailer Julius Garfinckel & Co. bought the store in 1946 and tried to do away with the button behind the collar and the extra-long shirttails on the oxford cloth button-down shirt).

Brooks the man could not have imagined his lasting legacy—the patronage of so many impressive individuals, from Presidents Abraham Lincoln to Barack Obama and Fred Astaire to Madonna, not to mention the literary icons, fictitious and real, identified and characterized by their Brooks Brothers look. He couldn't have imagined that his store on the corner of Catherine and Cherry Streets would eventually grow into a global brand with boutiques in over 250 locations around the world, including Tokyo, where Japanese businessmen opened their own outpost in 1979, affectionately calling it "Burukksu Burazazu."

It's as hard to recapture the New York City of Henry Sands Brooks's era as it would have been for him to envision our contemporary culture of iPhone-toting, image-obsessed consumers. With the dawn of the silver screen, the influence of television, video, and now Instagram, we have come to expect an instant snapshot of this man, this legend. But maybe that's unnecessary because the image and sensibility Brooks created was much bigger than one man.

OPPOSITE Henry Sands Brooks's sons (from top left), Daniel H. Brooks, John Brooks, Edward Sands Brooks, and Elisha Brooks, inherited the store in 1833. In 1850, they changed the company name to Brooks Brothers.

FOLLOWING PAGES An 1864 engraving of the original H. & D. H. Brooks & Co. store at 116 Cherry Street.

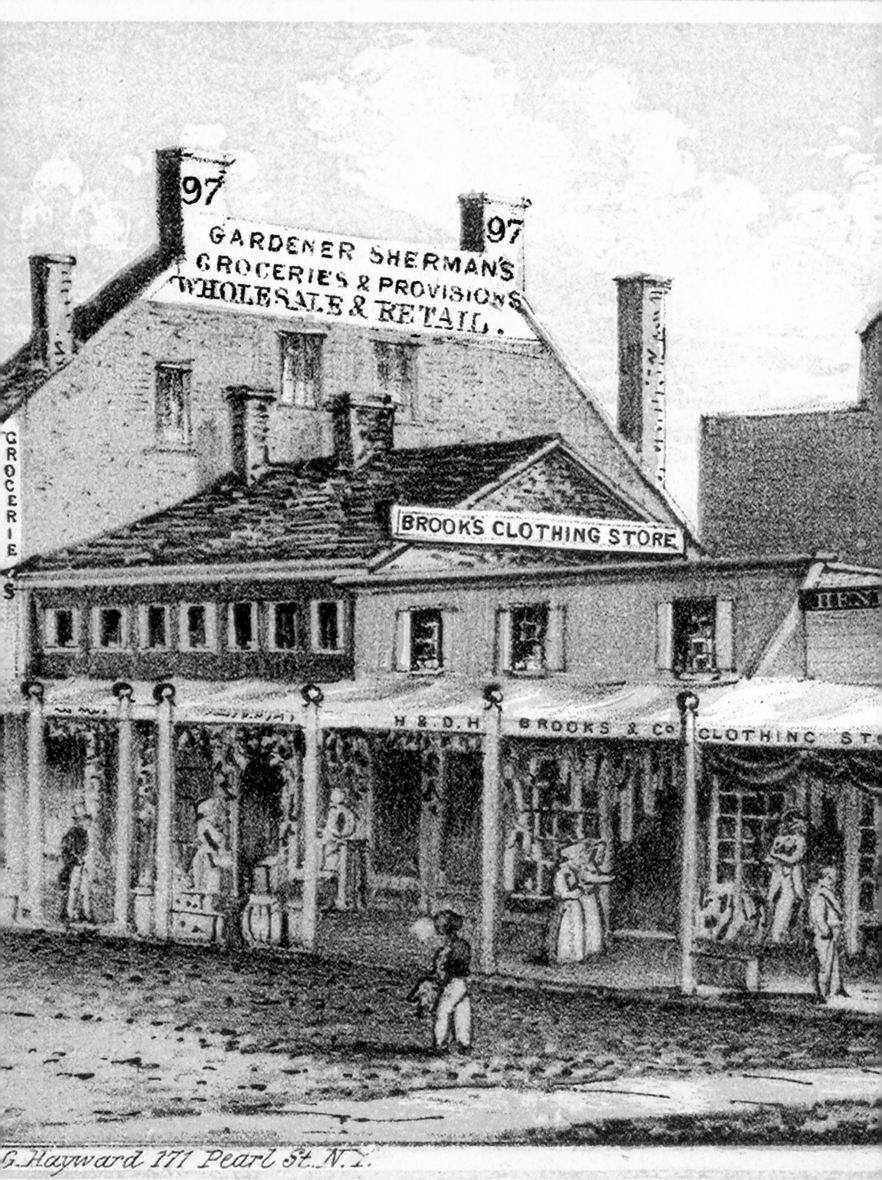

97
97

GARDENER SHERMAN'S
GROCERIES & PROVISIONS
WHOLESALE & RETAIL.

GROCERIES

BROOKS CLOTHING STORE

H & D.H BROOKS & C.o CLOTHING STO

G. Hayward 171 Pearl St. N.Y.

BROOKS CLOTHING STOR

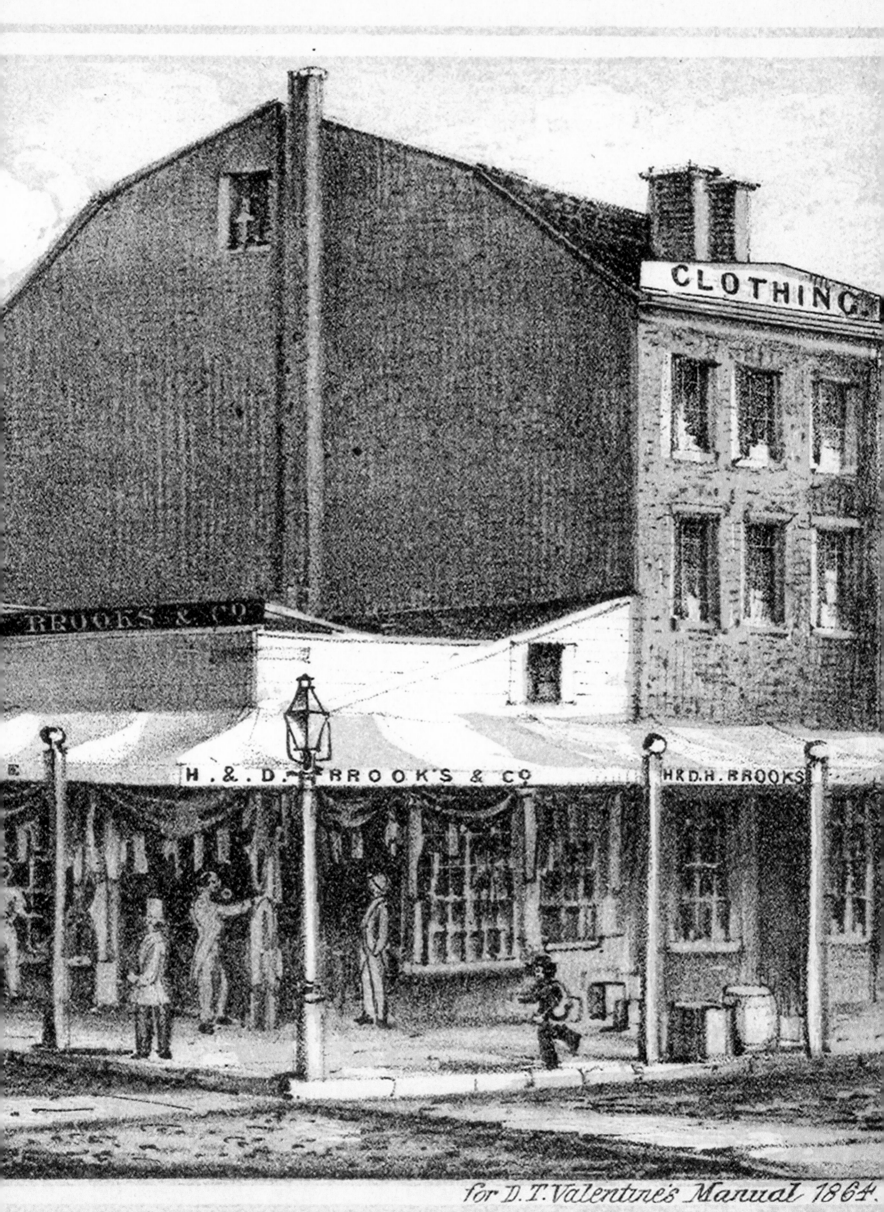

CLOTHING.

ROOKS & CO

H. & D. BROOKS & CO HRD.H.BROOKS

for D.T.Valentine's Manual 1864.

CATHARINE ST. N.Y. 1845.

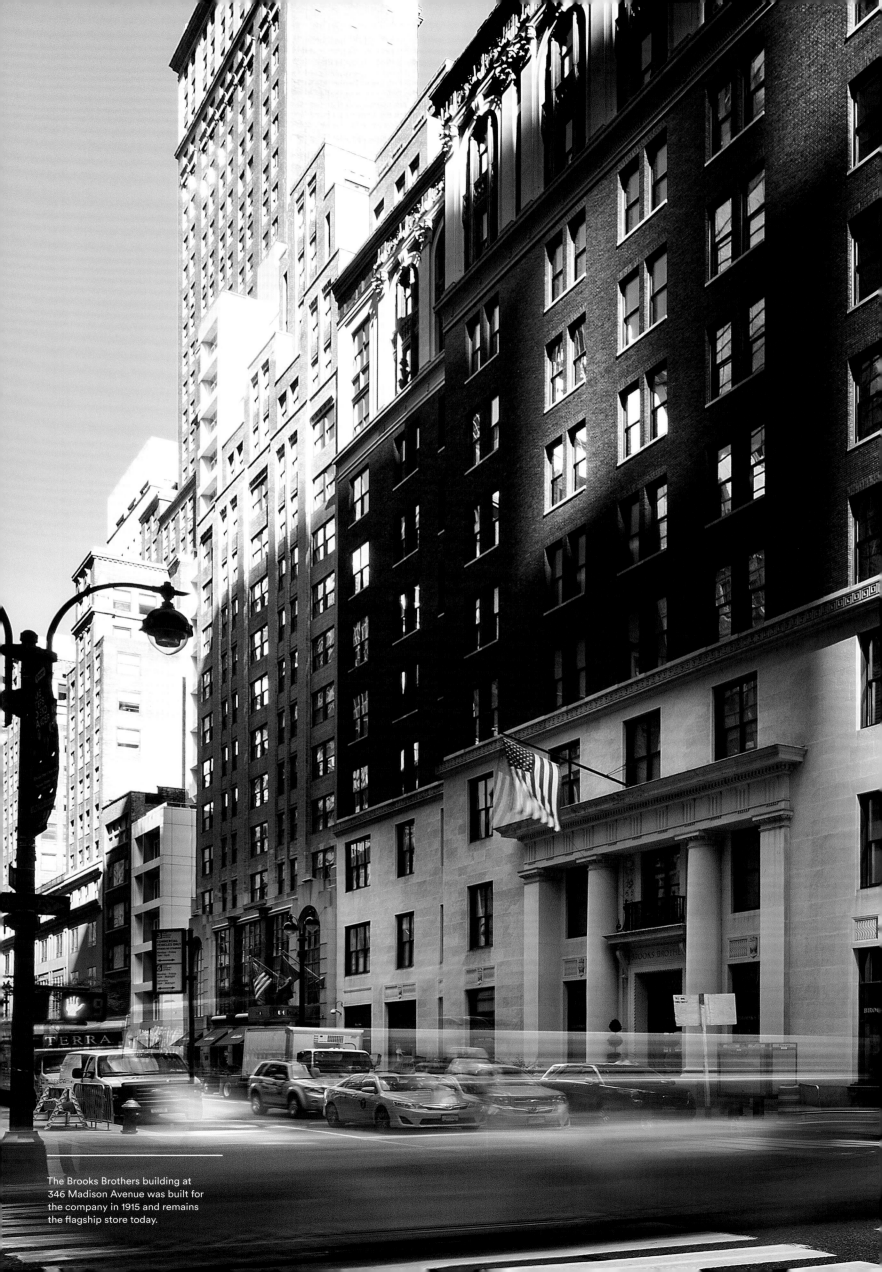

The Brooks Brothers building at 346 Madison Avenue was built for the company in 1915 and remains the flagship store today.

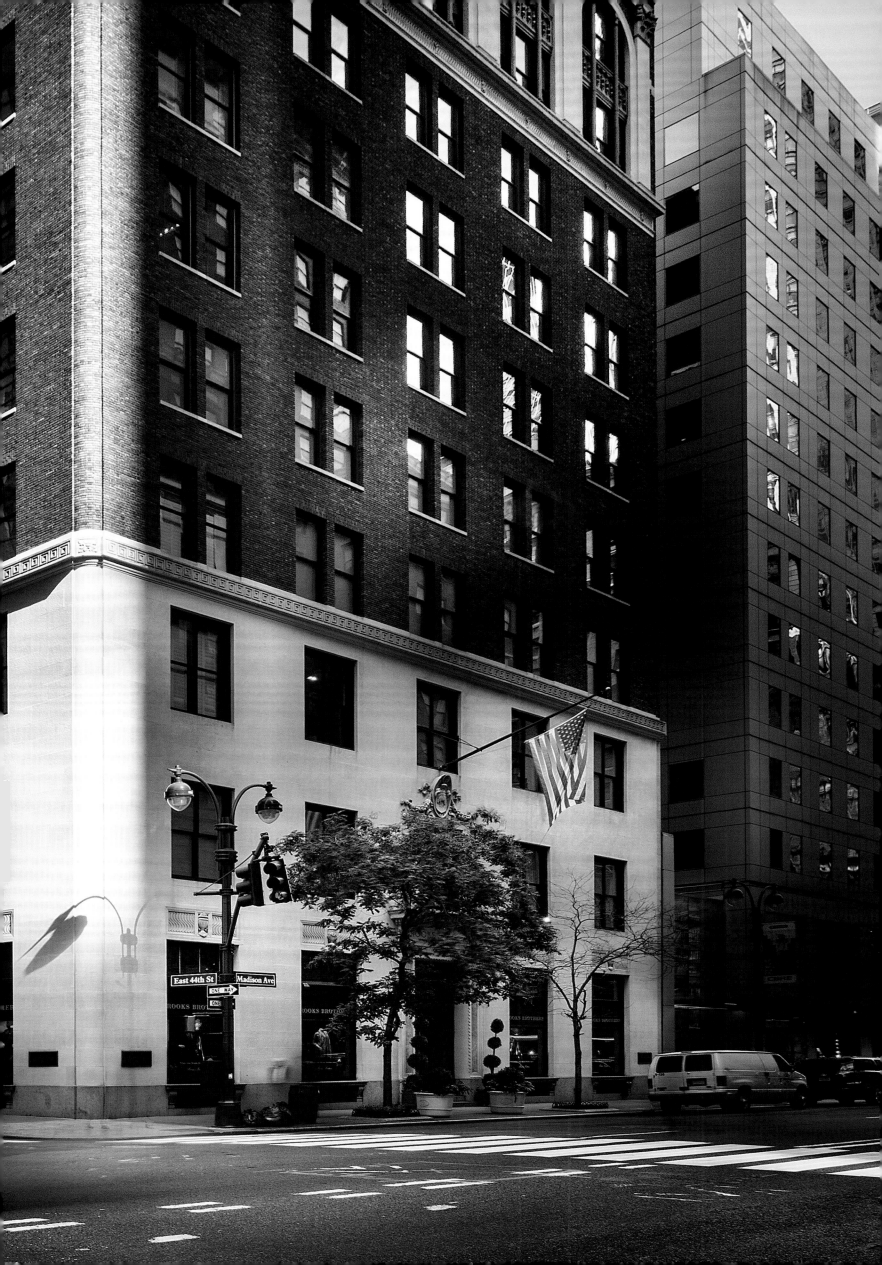

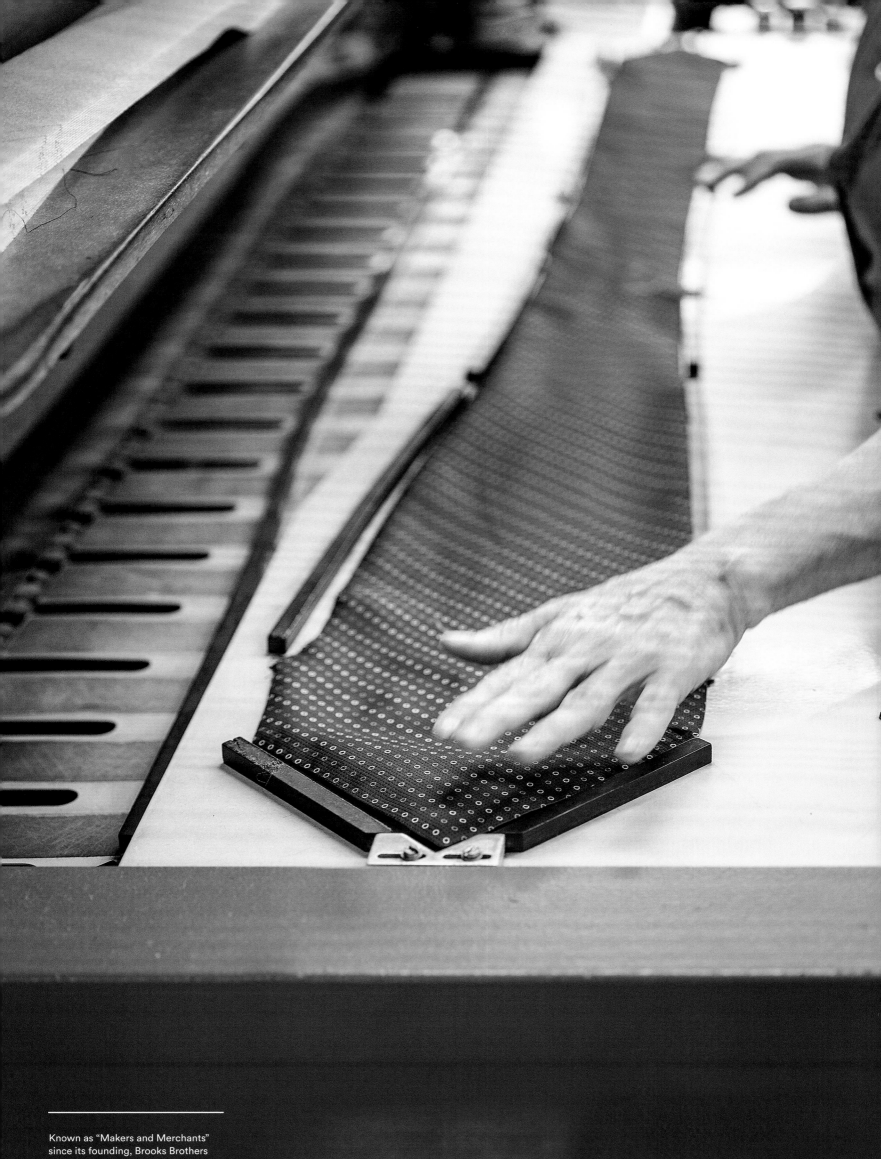

Known as "Makers and Merchants" since its founding, Brooks Brothers has distinguished itself through the excellent workmanship of every garment. Here, a woven jacquard tie being blocked out by hand in the company's factory in NYC.

"Today's Brooks Brothers remains classic yet thoroughly modern, reflecting all the shifts in fashion of the past 20 years—from casual dressing and e-commerce, to global retail expansion. Under Del Vecchio's stewardship, Brooks Brothers has defied its competitors by incorporating novelties and innovations, most notably its best-selling non-iron dress shirts, as well as designer collaborations with Thom Browne and Zac Posen and the hip Black Fleece label and Red Fleece boutique concepts. All have elevated the Brooks Brothers trademark to attract a new generation of consumers who love classic American styling, quality and value. Brooks Brothers has been fortified for the long run."

—TERI AGINS, *Wall Street Journal* reporter and author of
Hijacking the Runway and *The End of Fashion*

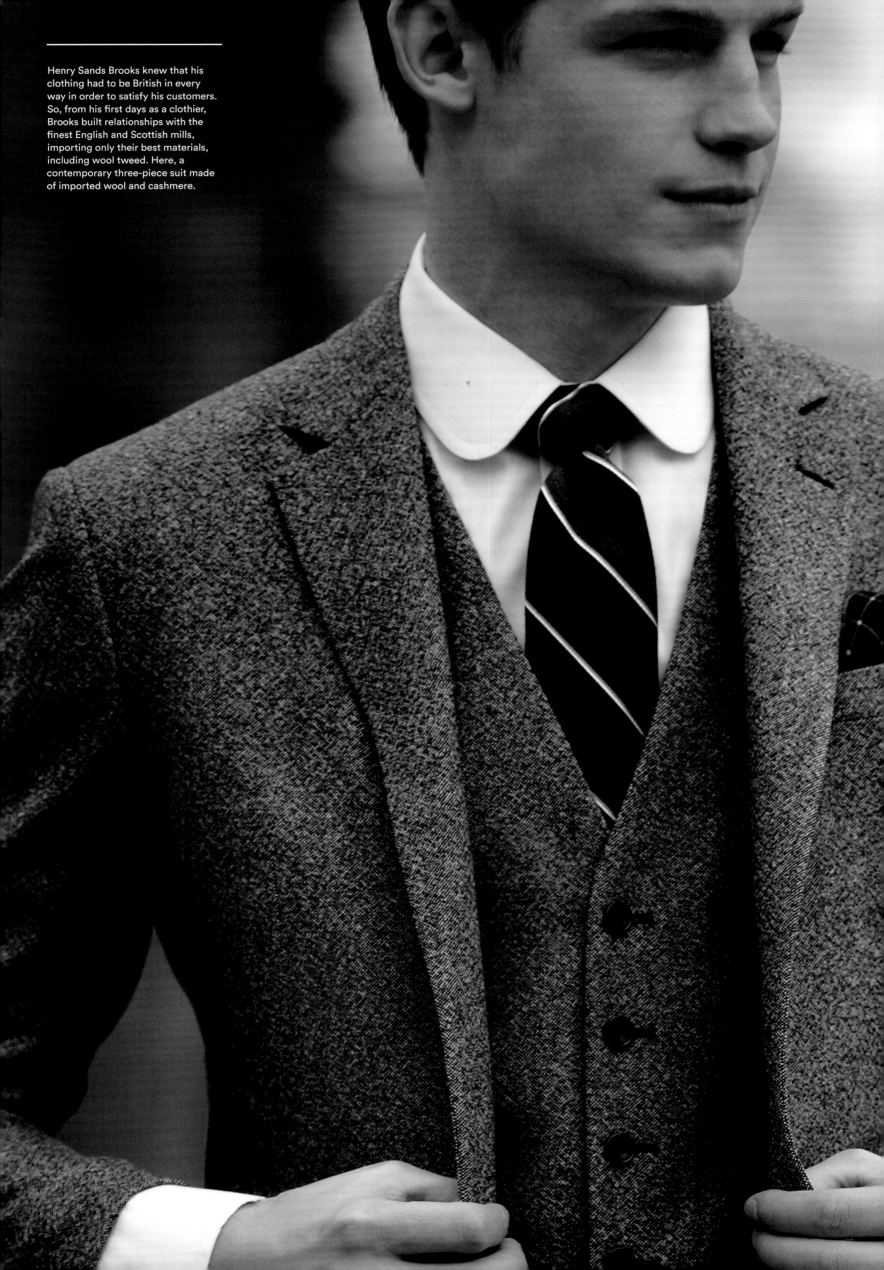

Henry Sands Brooks knew that his clothing had to be British in every way in order to satisfy his customers. So, from his first days as a clothier, Brooks built relationships with the finest English and Scottish mills, importing only their best materials, including wool tweed. Here, a contemporary three-piece suit made of imported wool and cashmere.

"I've always loved Brooks Brothers.
They are the authentic American
Ivy League preppy brand—
aspirational, inspirational, and
accessible! I still love the Madison
Avenue store to this day!"

—TOMMY HILFIGER, designer

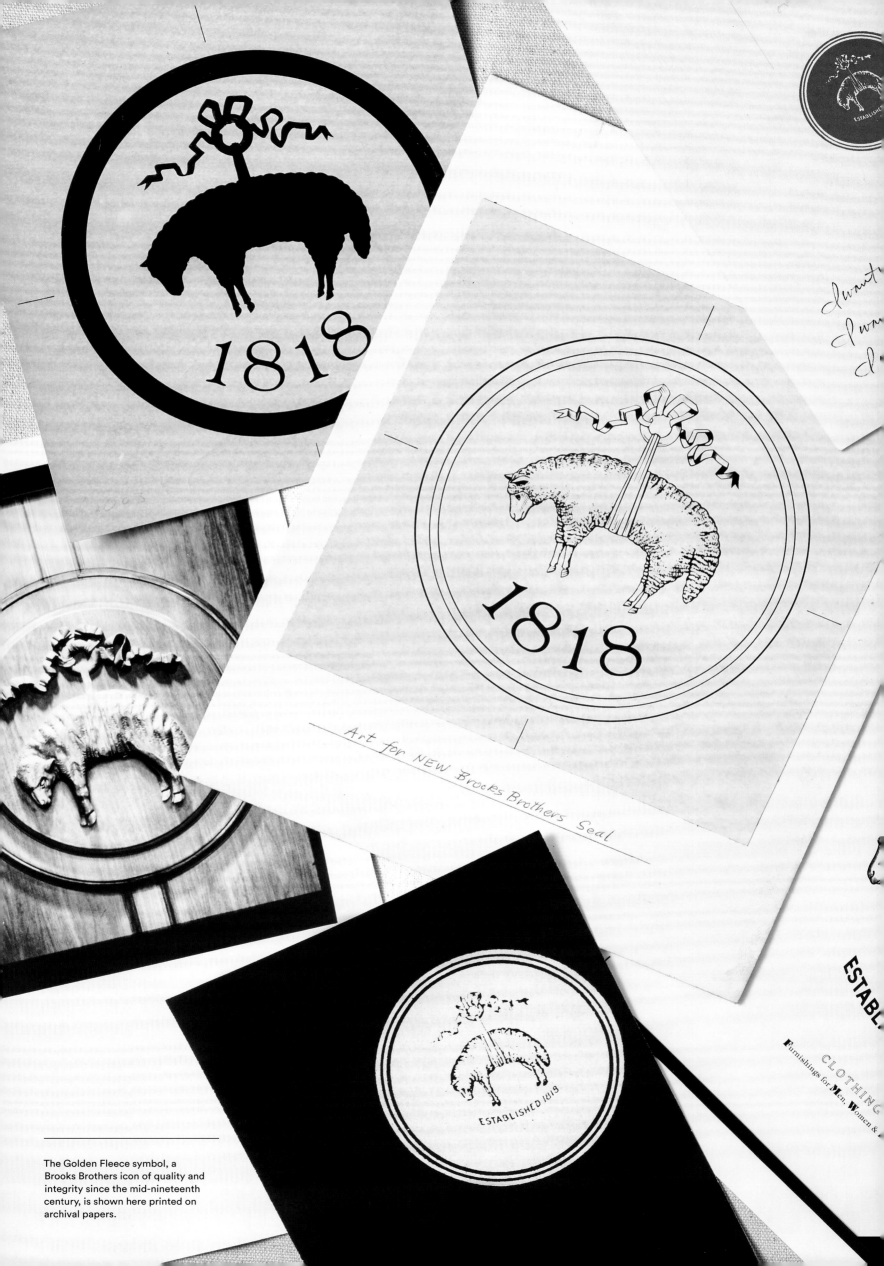

1818

1818

Art for NEW Brooks Brothers Seal

ESTABLISHED 1818

The Golden Fleece symbol, a Brooks Brothers icon of quality and integrity since the mid-nineteenth century, is shown here printed on archival papers.

THE GOLDEN FLEECE

Back in 1430 when Philip the Good, Duke of Burgundy, and The Netherlands ruled over a medieval knighthood called the Golden Fleece, the insignia of the lamb suspended by a ribbon stood for humility and for the unparalleled success of the Burgundian wool trade. The Knights of the Golden Fleece were also known as some of the best-dressed men of Europe, dashing in their red and purple embroidered velvet robes. In adopting the Golden Fleece icon in the mid-nineteenth century, Brooks Brothers was likely alluding to both the quality of the wool trade, but also to Europe's rich sartorial tradition, a tradition that had inspired Henry Sands Brooks. The icon still symbolizes Brooks Brothers' high quality as well as the company's rich merchant and manufacturing heritage. And, two hundred years later, Brooks Brothers Chairman and CEO Claudio Del Vecchio continues to nurture the company's heritage of quality, craftsmanship, and innovation to deliver on the historical promise of the Golden Fleece. "We have the ability to adapt because we make the product ourselves," Del Vecchio says. "We are still here because we are innovators and disrupters." Indeed, the Golden Fleece has not only served as a mark of quality, it has also inspired innovations that Del Vecchio has introduced since buying the brand in 2001: the Black Fleece label introduced in 2007 with designer Thom Browne; the Red Fleece brand introduced in 2014 for a new generation of Brooks Brothers customers; and the Golden Fleece collection, showcasing an ongoing commitment to craftsmanship and innovation—all carrying the globally recognized insignia.

In the Brooks Brothers tradition of quality and craftsmanship, the company's Southwick factory in Haverhill, Massachusetts, is the epicenter of American tailoring. State-of-the-art machinery and skilled workmanship come together to create traditional tailoring with the finest fabrics, including Brooks Brothers' premium Golden Fleece suiting.

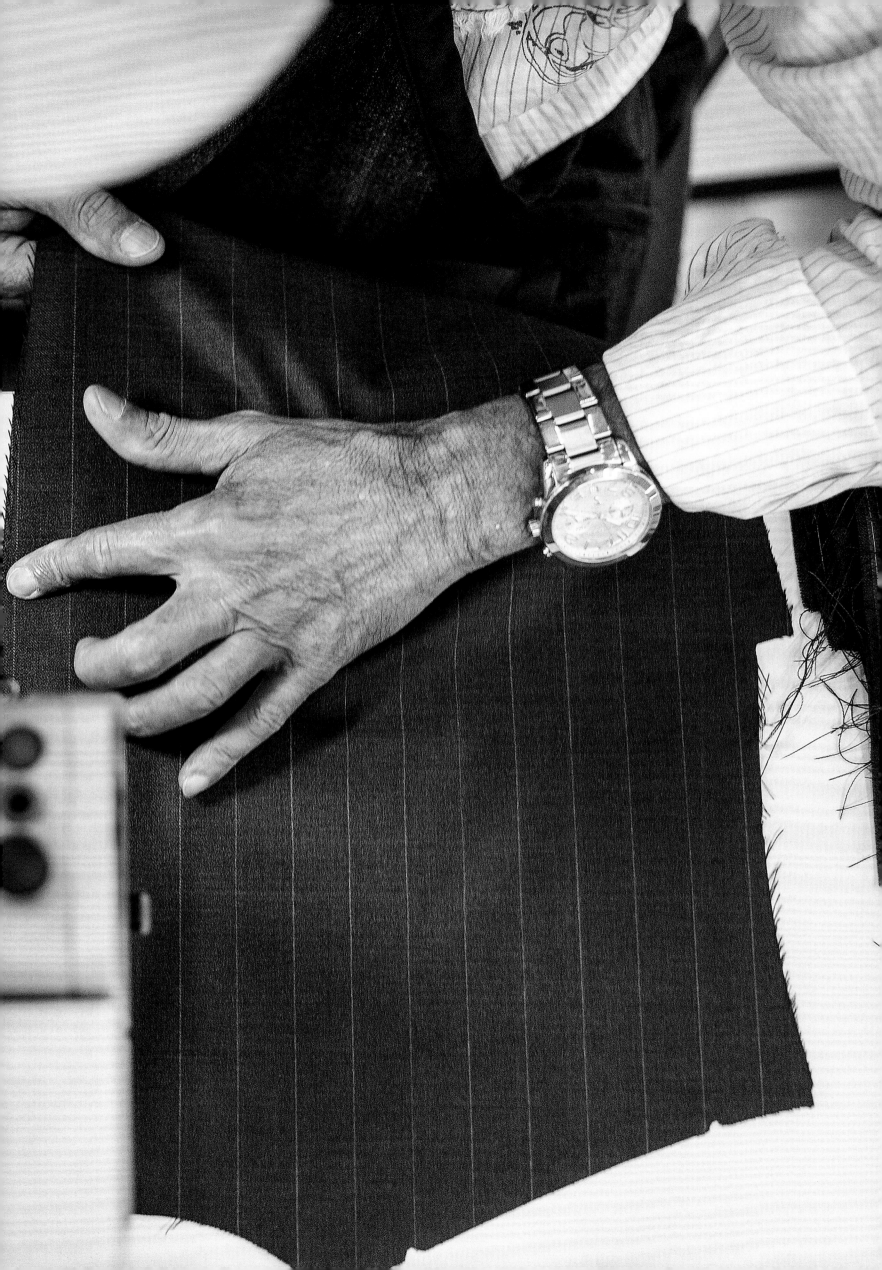

CHAPTER TWO

THE DISRUPTER

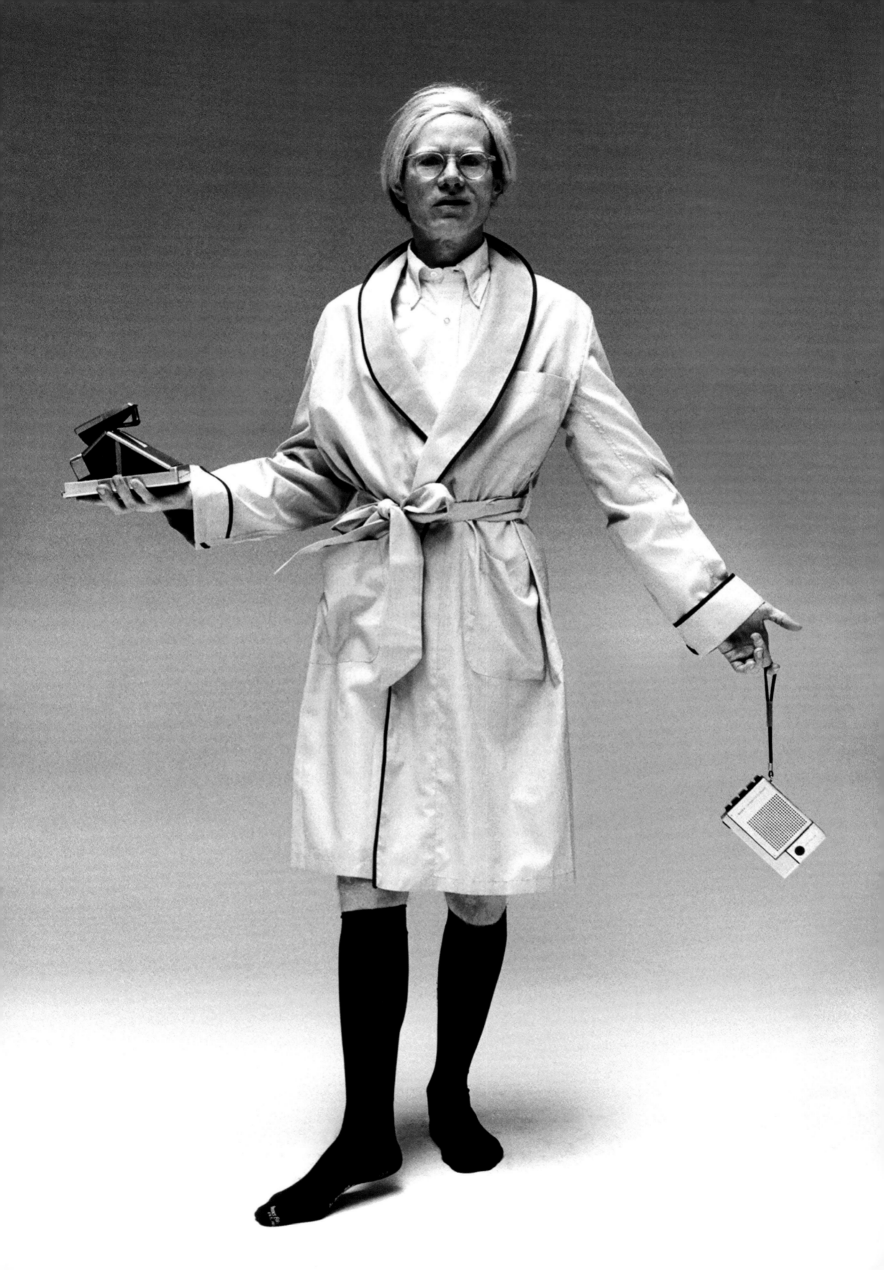

he crowd was going crazy when Madonna stepped onstage at London's O2 Arena in July 2009 for her *Sticky and Sweet* tour. Her sheer black satin bodysuit was nothing out of the ordinary for one of fashion's biggest risk-takers. But behind the Material Girl, a phalanx of back-up dancers shimmied and strutted to the tinny pop beat of "Candy Shop." They were dressed in matching Brooks Brothers tuxedo shirts, a surprising costume choice given that the brand is more often associated with the classic look of an F. Scott Fitzgerald character or a mid-century Madison Avenue executive.

Brooks Brothers may be the country's oldest men's apparel store, but it hasn't always been known for the quiet conservatism that began to define it in the middle of the twentieth century. More than just the impressive roster of disrupters who have worn its clothing—from Kermit the Frog to Lady Gaga to Abraham Lincoln and Andy Warhol—Brooks Brothers has always been at the forefront of change in menswear, making the rules and then breaking them, revolutionizing the way men dress, how clothing is merchandised, and how certain wardrobe basics are worn. In fact, for years Brooks Brothers executives didn't dare display new models in their store windows for fear of competitors copying them.

Right from the get-go, Henry Sands Brooks and his sons introduced a groundbreaking approach to the early-nineteenth-century world of custom-tailored menswear when they began selling ready-made wares, forever changing the way Americans would purchase clothing. It was a democratic idea: create and manufacture quality clothing anyone could buy. Brooks Brothers was unique, too, in it's "Own Make" designation, which meant that all of its merchandise was manufactured in company-owned factories, eliminating the middleman and making their merchandise more accessible.

Today we may think of Brooks Brothers as the original classic American brand, or the original "preppy" brand, but from 1818 to 1946 they were at the height of fashion—pushing the envelope with their daring choices of colors and styles. By the turn of the century, under the leadership of John Brooks, the grandson of the founder, Brooks Brothers had already launched a litany of sartorial firsts. They were the first store to sell ready-made suits off the rack, the first to introduce the foulard tie in 1890, and the first to bring Harris tweed to the United States from Scotland in 1900. From the United Kingdom, they were the first to import Shetland sweaters, the polo coat, and coconut straw hats. As early as 1920, they imported Madras fabric from India.

One of Brooks Brothers' most enduring disruptions to menswear was the soft-collared button-down polo shirt, introduced at the end of the nineteenth century and groundbreaking because it was comfortable and washable, unlike the detachable linen collars and cuffs that were sized and stiff. John E. Brooks, grandson of the founder and a fashion revolutionary in his own right, had spotted the style on a polo player in England in 1896. Players tacked down their collars so they wouldn't flap up in the wind. Brooks brought several of the shirts back to New York and replaced the stitched-down collars with tiny buttons. At the time, Brooks claimed his objective was to get the "perfect bit of collar roll that distinguishes the ultimate refine-

OPPOSITE The soft collar button-down oxford shirt no. 10 was as revolutionary when it was introduced at the end of the nineteenth century as Pop artist Andy Warhol's Campbell's Soup Cans were in the 1960s. Warhol wore Brooks Brothers' white button-down oxford shirts almost exclusively. Here, his whole ensemble is Brooks Brothers— from bathrobe to knee socks.

ment in oxford." The columnist Heywood Broun announced the soft collar as a revolutionary move, an act of rebellion akin to women bobbing their hair. Brooks Brothers introduced the shirt in white, but by the 1920s, thanks to the influence of the Duke of Windsor, pastel colors became fashionable with light blue, yellow, and pink (Fred Astaire's favorite) being most popular.

In 1896, Brooks Brothers introduced another famous signature: the four-button Number 1 sack suit, a single-breasted jacket with unpadded, natural shoulders, modest lapels, and a straight hang. It was another daring departure from the more structured British models and would become the uniform for "appropriately" dressed men—from Ivy League campuses to Wall Street to the White House. In 1918, Brooks Brothers reintroduced the same suit with three buttons. And eventually, inspired by the way kids on Ivy League campuses were pressing back the lapels of their jackets to make them more stylish, they created a two-button sack suit, but kept the first buttonhole and button as if the lapel had just been pressed back. A 1938 article in *The New Yorker* called the "uncompromising sloppiness" of the suit "a whole philosophy of dress."

Many advances in American tailoring came from Brooks Brothers and many of them came from the fabrics and items the store's executives were sourcing around the world. The brand was the first to bring linen crash, shantung silk, and cotton cord to the United States. In the 1920s they popularized seersucker, calling it "Palm Beach" cloth. They introduced items like the Norfolk jacket, the Tattersall vest, and the deerstalker cap. They exclusively imported Lock & Co. hats and Peal & Co. shoes from England. And they reversed the stripes of the English club tie, making the rep tie their own.

When, in the early 1950s, consumers began to demand more convenience in maintaining their clothing, Brooks Brothers partnered with Dupont and introduced the quick-drying "Brooksweave" shirt. In the signature soft-sell language of their advertising, Brooks Brothers executives suggested these practical shirts "might be of interest." A year later they created "Brookscloth"—a Dacron and Egyptian cotton-blend shirt that promised to "look neater longer."

Some innovations came about with complete serendipity. In 1952 John C. Wood, the blunt, starchy president who had been known for making Brooks Brothers "even Brooksier," saw a friend wearing a pair of hose his wife had knit for him by hand. Woods asked to borrow them and brought them back to the Brooks Brothers factory to have them remade. The result was called the Kirkudbright panel argyle sock. They sold out in a day. Later, "Brooksease" suits were developed after Wood discovered the natural stretch in the wool upholstery fabric on the seat of a Swedish car.

The Brooks Brothers "Fun" shirts were a creation of the 1970s, when scraps of broadcloth found on the factory floors were used to teach workers how to make the Brooks Brothers polo shirt. Ash Wall, the vice president at the time, tried one on and wore it back to the office. Demand was so high they decided to sell them.

Everything about the stores was new and different, too. In 1884, the Broadway and Twenty-Second Street store featured tables piled high with inside-out jackets folded neatly and stacked one on top of the other. The service was also innovative and legendary, with tenured salesmen dressing several generations of the same families. And no customer request was ever too esoteric at Brooks Brothers. During the epic blizzard of 1888, one customer came to the store: a man requesting a pair of white wool pants. His order was filled without missing a beat.

Brooks Brothers has always been one step ahead, innovating in response to their customers' demands. The company's traditions and taste level have been provoked and shaped by the same bankers and writers and artists and politicians who have shaped American history and culture—from Madonna to J. P. Morgan and from J. D. Salinger to JFK.

OPPOSITE Naomi Campbell poses for *Vogue* magazine in a Brooks Brothers Oxford cloth button-down.

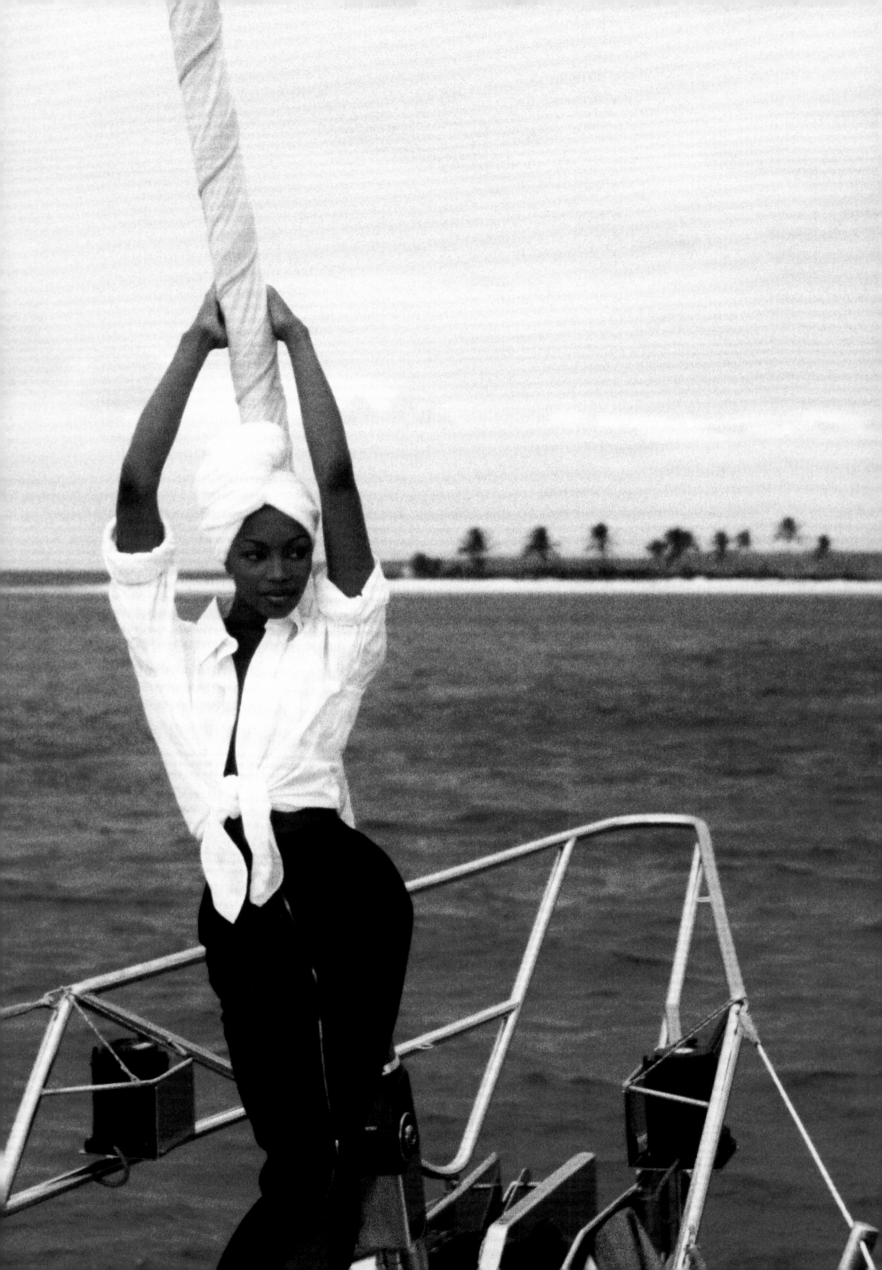

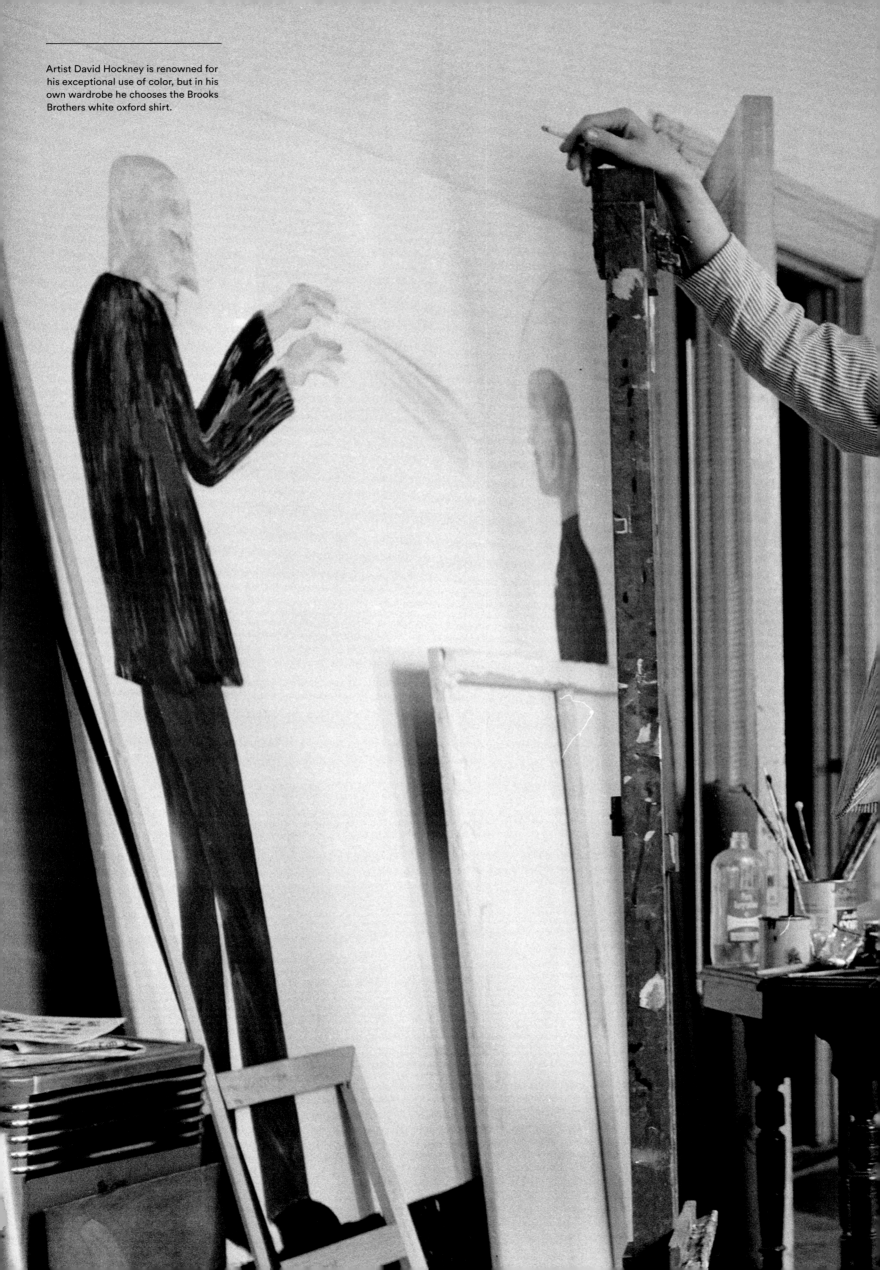

Artist David Hockney is renowned for his exceptional use of color, but in his own wardrobe he chooses the Brooks Brothers white oxford shirt.

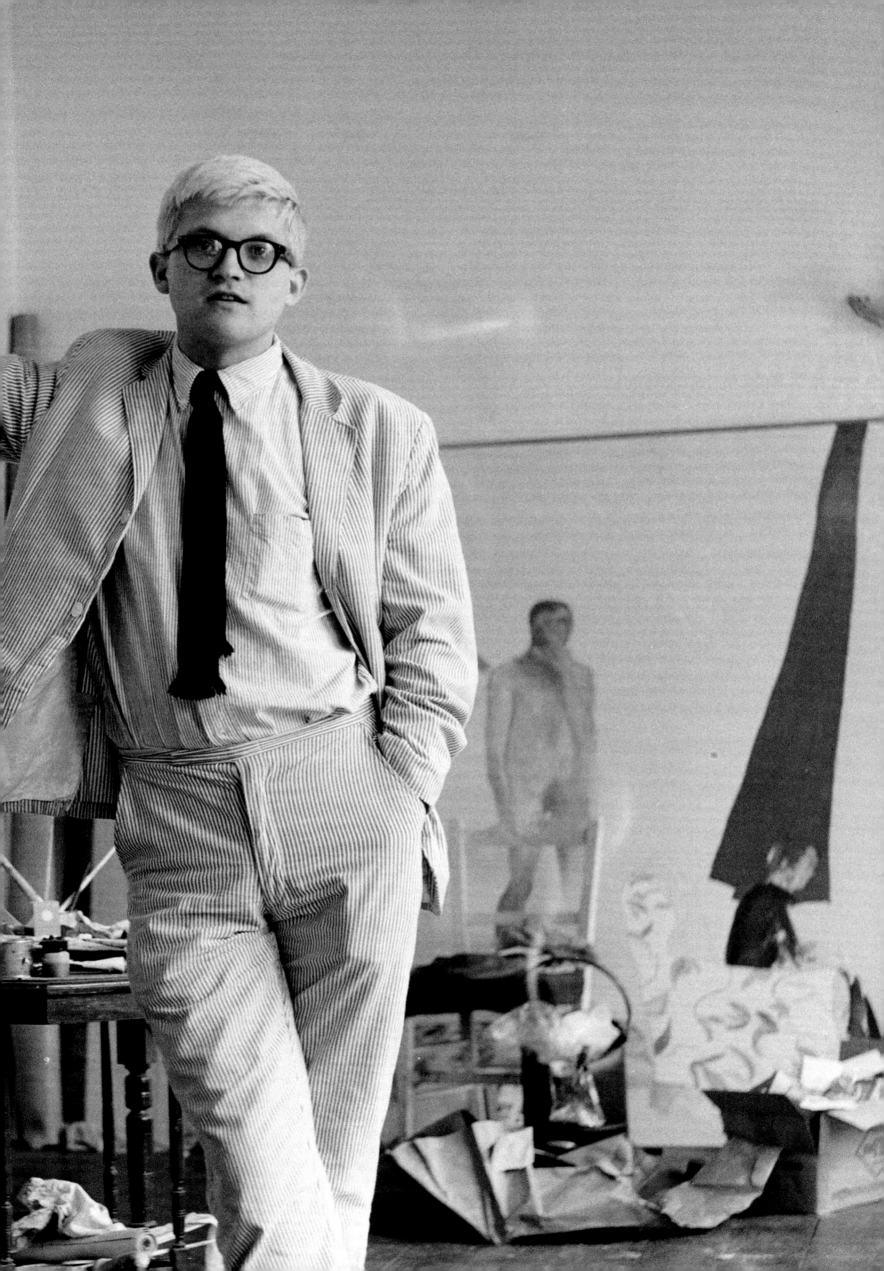

"She prefers a pair of tight red slacks and a pink Brooks shirt to anything in her closet."

—from THE SECRET TO AUDREY HEPBURN'S CHARM, *Contact*, July 1954

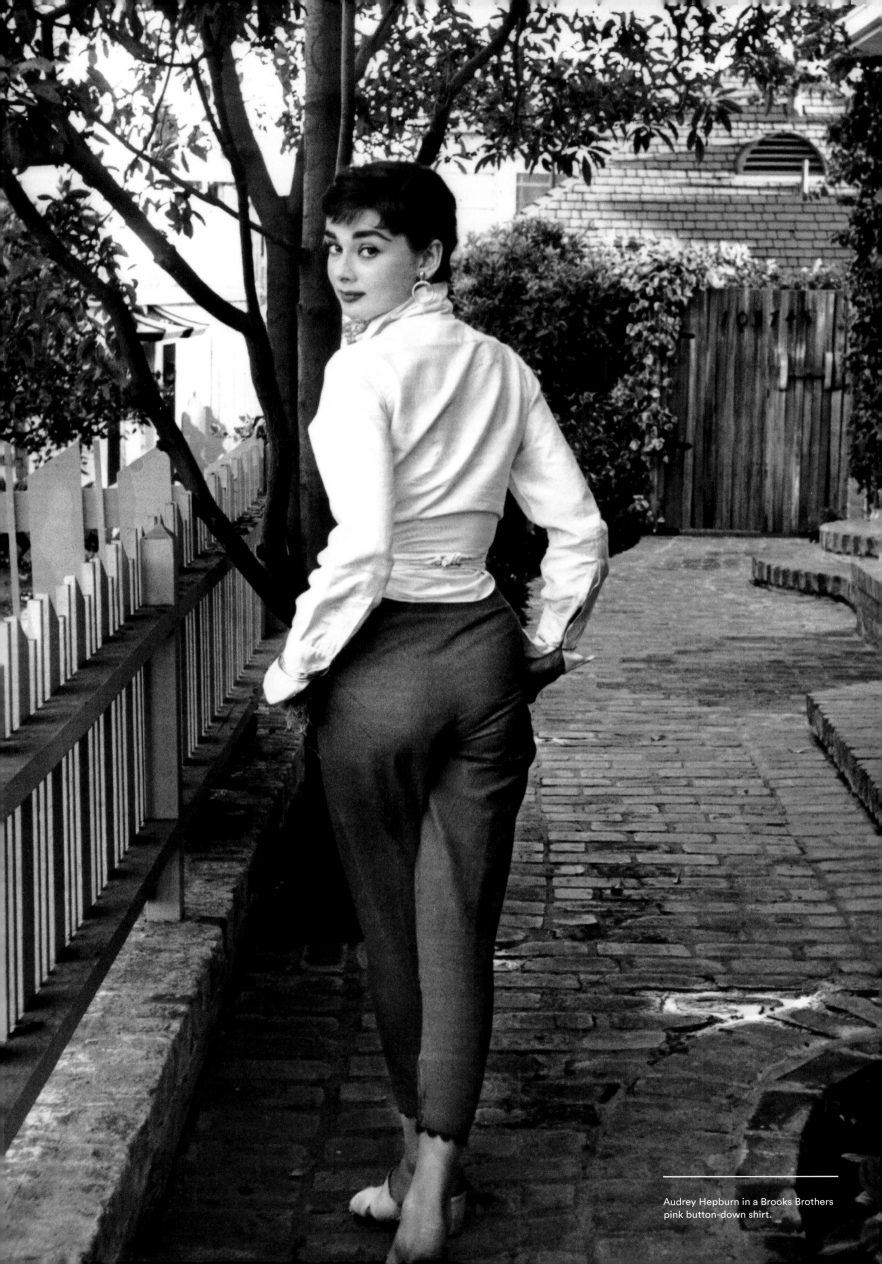

Audrey Hepburn in a Brooks Brothers pink button-down shirt.

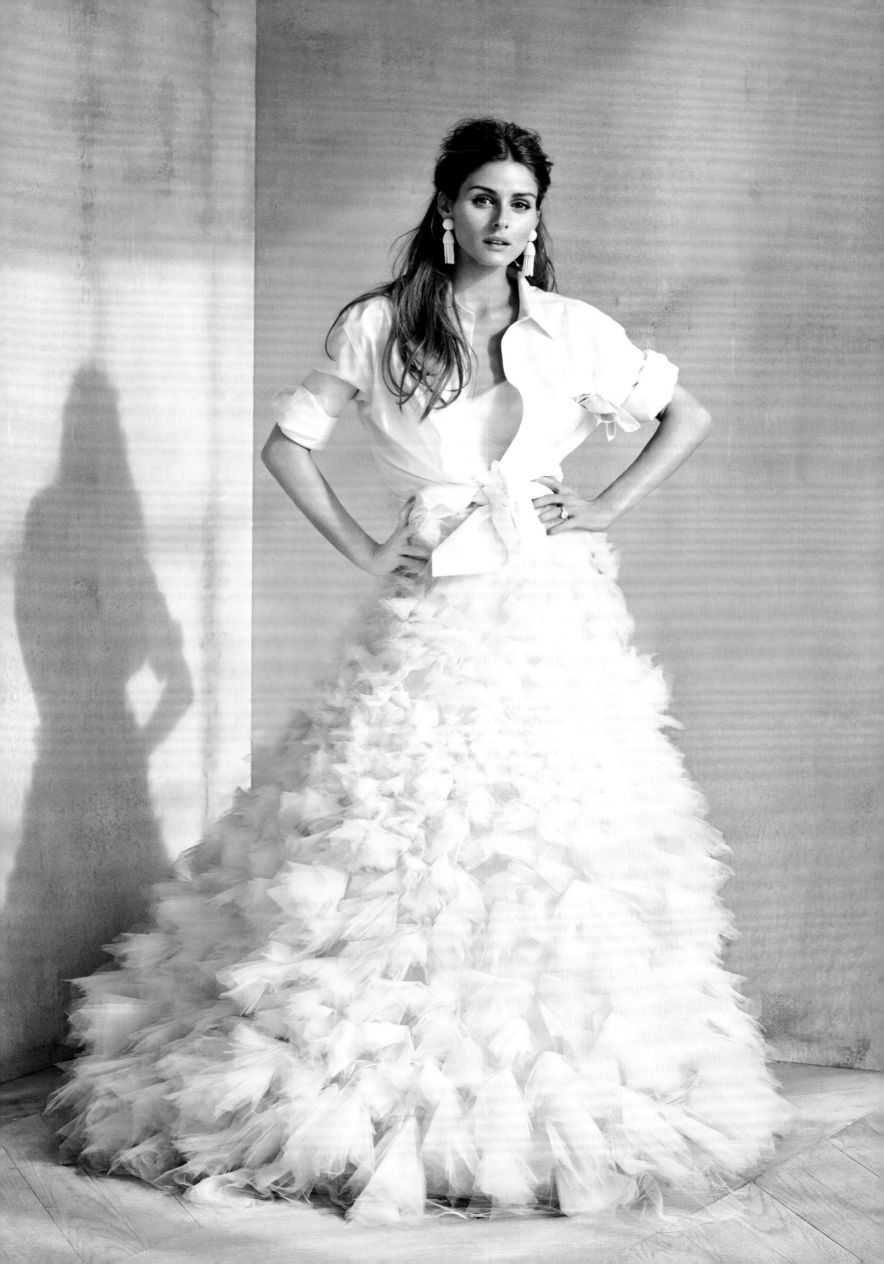

From Grace Kelly (this page) to Olivia Palermo (opposite), classic American style icons have favored Brooks Brothers' iconic white oxford button-down shirt. The cloth for the shirts was originally discovered by a Brooks Brothers representative in England in the late nineteenth century. Brooks worked with the mill to create a special weave which to this day remains a trade secret, unchanged from the original.

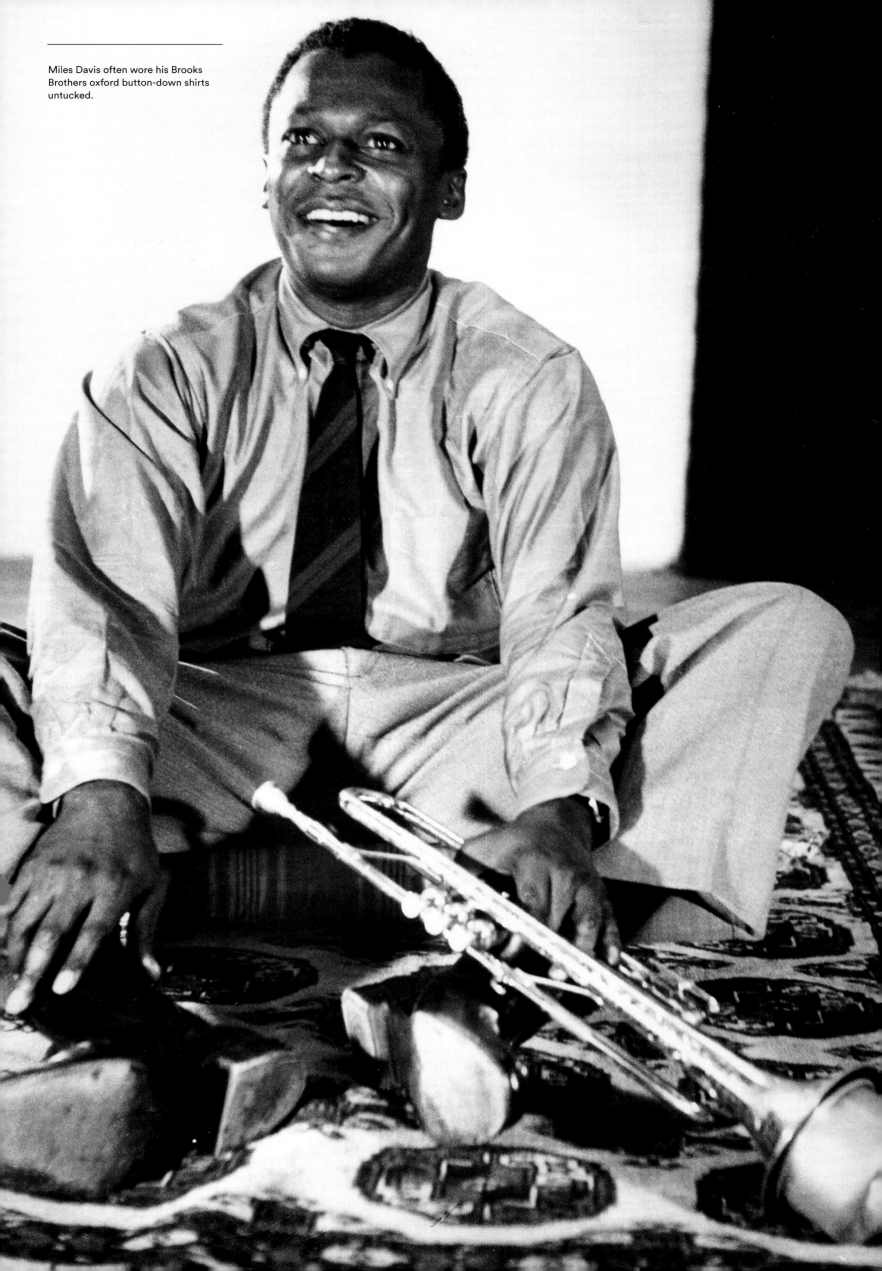

Miles Davis often wore his Brooks Brothers oxford button-down shirts untucked.

"I call it Postwar Fusion, the look adapted
by the hippest and most fashionable men of the
moment. Working and middle-class men
were coming into Ivy League colleges on the G.I.
Bill and they were mixing up the established codes,
wearing khakis with button-down shirts.
They became an influence, as did jazz musicians
playing venues at Ivy League campuses.
They were picking up on the look, too, and adding
their twist to it. They called it 'Jivey Ivy.'"

—PATRICIA MEARS, deputy director of the Museum at F.I.T.

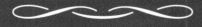

PICTURE POST

See pages 18 & 19

FRED ASTAIRE AND
RITA HAYWORTH
(See pages 18 & 19)

HULTON'S
NATIONAL
WEEKLY

In this issue:

A PLAN FOR
THE HIGHLANDS

4

MARCH 13, 1943

Vol. 18. No. 11

THIS PAGE Arthur Miller wore his uniform of Brooks Brothers oxford-cloth button-down shirts when he married Marilyn Monroe.

OPPOSITE Fred Astaire taking flight with Rita Hayworth. His signature look included a Brooks button-down, a foulard tie, and another foulard tie or scarf as a belt.

THIS PAGE Jimmy Kimmel covered in oxford cloth and kisses.

OPPOSITE Italian style icon Gianni Agnelli famously wore his watch over the cuff of his Brooks Brothers oxford-cloth button-down.

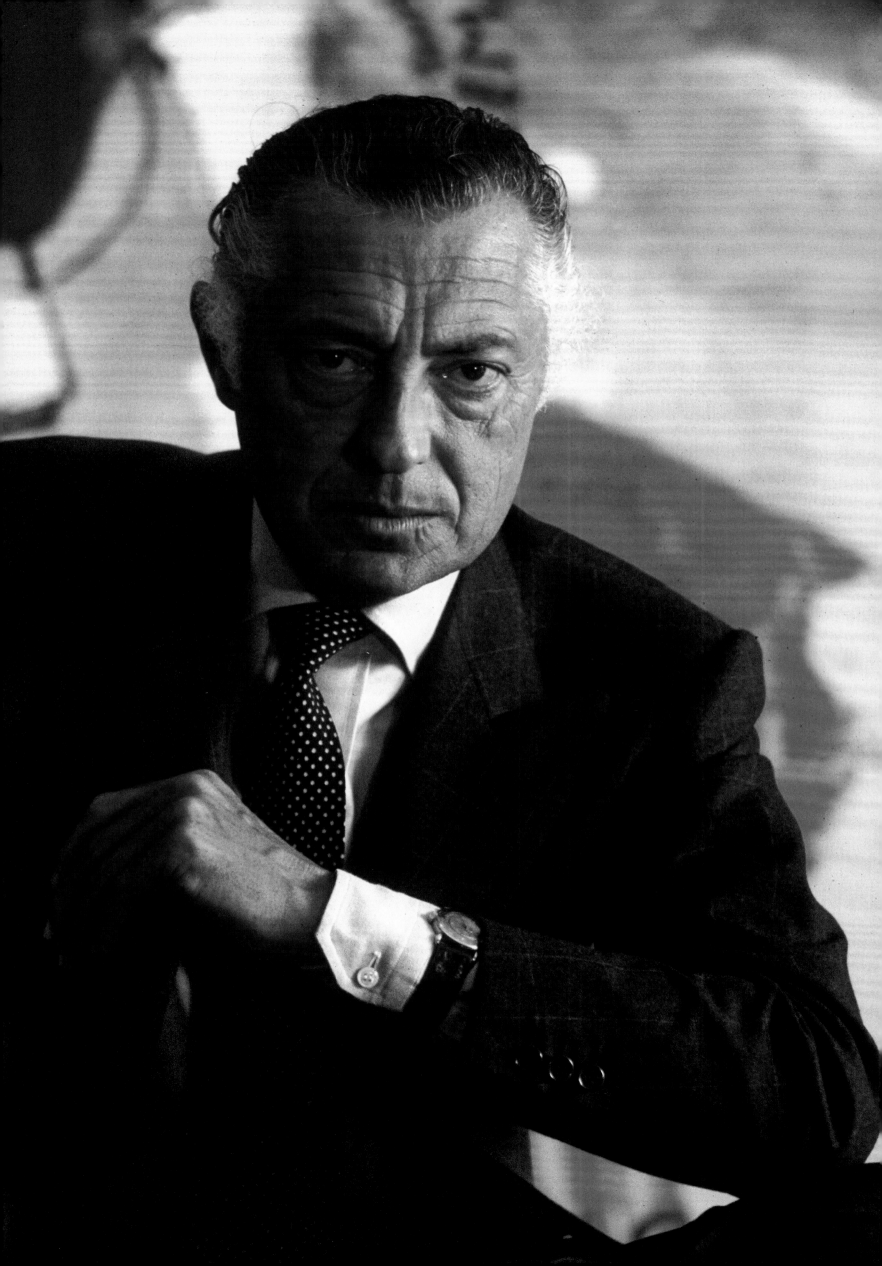

BROOKS BROTHERS have long been the leaders in setting the fashions for men's warm weather wear. This year our selections are better than ever, with many patterns and materials . . . all of them lightweight and porous and *comfortable* . . . and all made exclusively for us on our own patterns. Our comprehensive selections include single- and double-breasted suits and single-breasted odd jackets in a choice of colors.

ESTABLISHED 1818

Brooks Brothers
CLOTHING
Men's Furnishings, Hats & Shoes

346 MADISON AVE., COR. 44TH ST., NEW YORK 17, N. Y.
111 BROADWAY, NEW YORK 6, N. Y.
BOSTON • LOS ANGELES • SAN FRANCISCO

OPPOSITE Brooks Brothers madras and seersucker ties have always been a staple among the Ivy League crowd.

THIS PAGE Two Brooks Brothers circulars advertise the company's innovative fabrics, including "sensible" seersucker, which the company popularized in the 1920s.

Seersucker

**LINENS, CORDS AND RAYONS
IN A REALLY GREAT CHOICE
OF WARM-WEATHER SUITS**

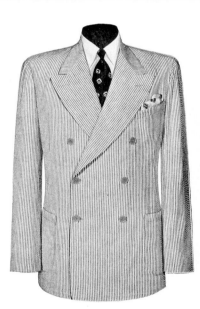

DOUBLE-BREASTED SUIT cut on BROOKS BROTHERS' pattern as illustrated—two pieces. Double-breasted jacket and trousers—may be had in Seersuckers, Cords, Linens, Rayons and other materials as presented in this circular. Mail orders should specify style number which will indicate both pattern and color. Complete measurements should be filled in on Measurement Blank Form printed in this circular. Seersucker Suits as illustrated are $19.50.

"You can say fashion is cyclical and things
come in and out of style, but great
American style you have to hand to Brooks
Brothers. They were doing all of this stuff
first. Their emporiums were filled with
lush Americana. It wasn't a price point issue,
they were offering a lifestyle based on basics
and those basics make up the vocabulary of
menswear as we know it. What would menswear
be without Brooks Brothers?
They held onto all those classics after World
War II—khakis with the high waist, links
cardigans, the military coat—they held
onto them and then created this whole unique
shopping experience based on service.
Brooks Brothers clothes and service will
never go out of style."

—JIM MOORE, creative director of *GQ*

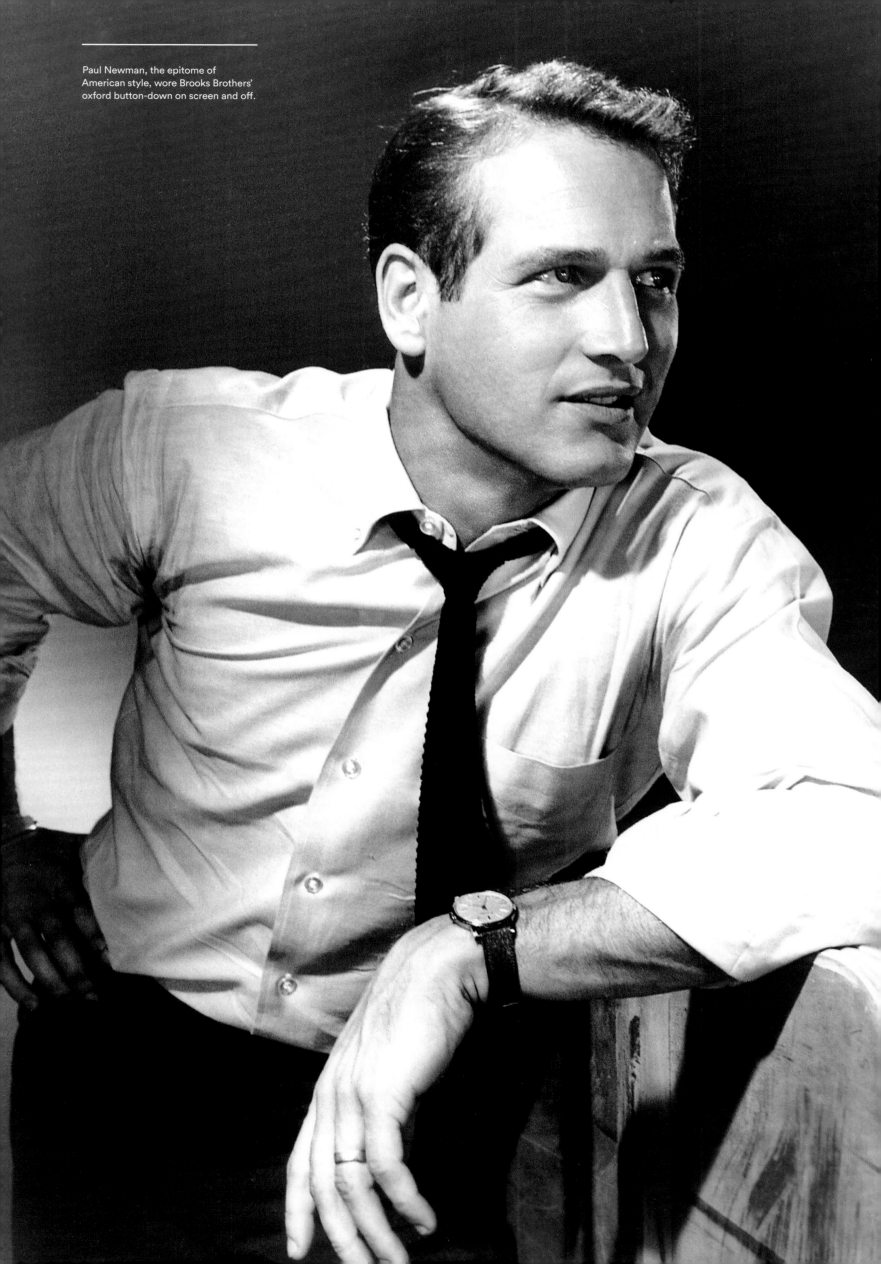

Paul Newman, the epitome of
American style, wore Brooks Brothers'
oxford button-down on screen and off.

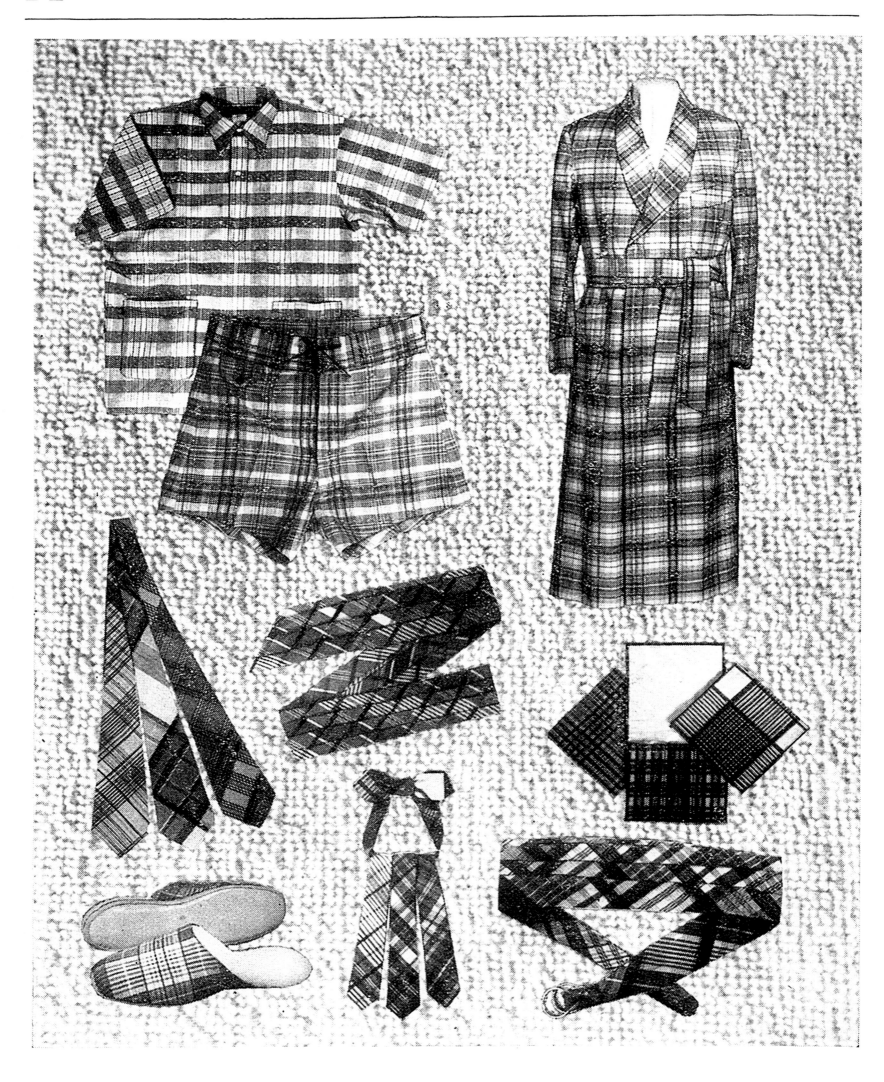

INDIA PRINTS
(Terry Cloth Background)

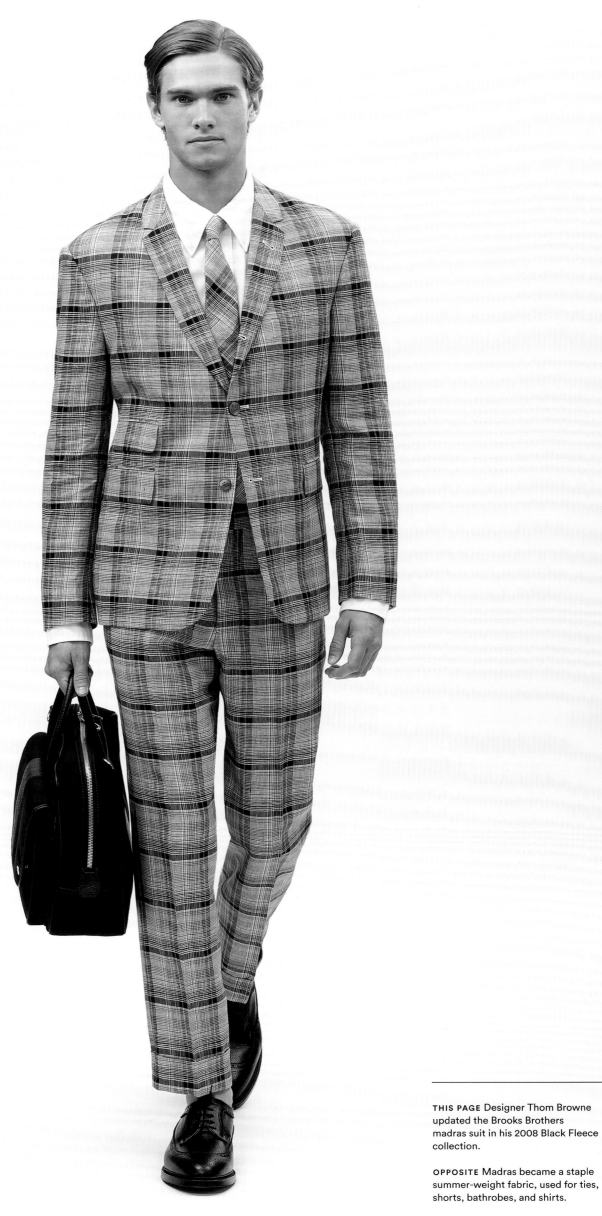

THIS PAGE Designer Thom Browne updated the Brooks Brothers madras suit in his 2008 Black Fleece collection.

OPPOSITE Madras became a staple summer-weight fabric, used for ties, shorts, bathrobes, and shirts.

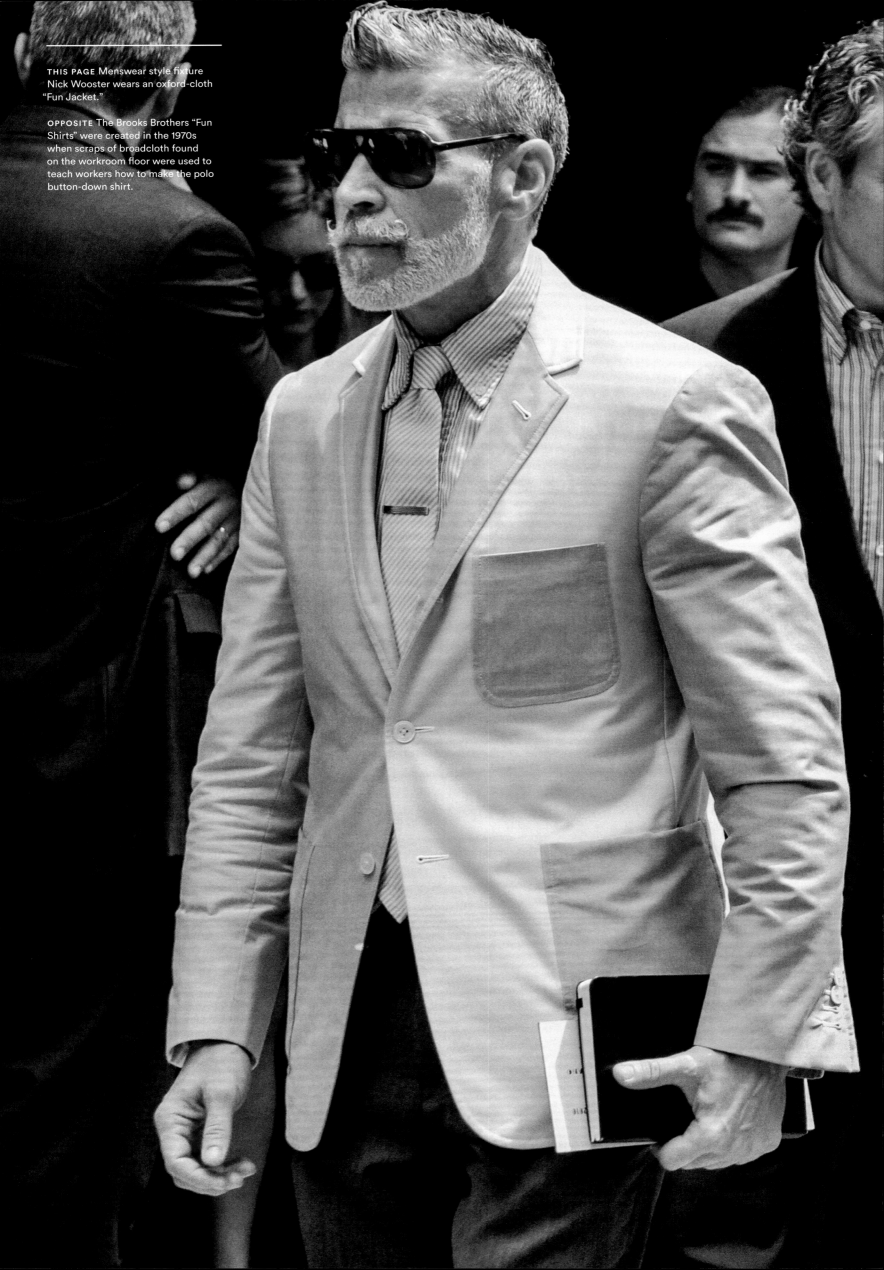

THIS PAGE Menswear style fixture Nick Wooster wears an oxford-cloth "Fun Jacket."

OPPOSITE The Brooks Brothers "Fun Shirts" were created in the 1970s when scraps of broadcloth found on the workroom floor were used to teach workers how to make the polo button-down shirt.

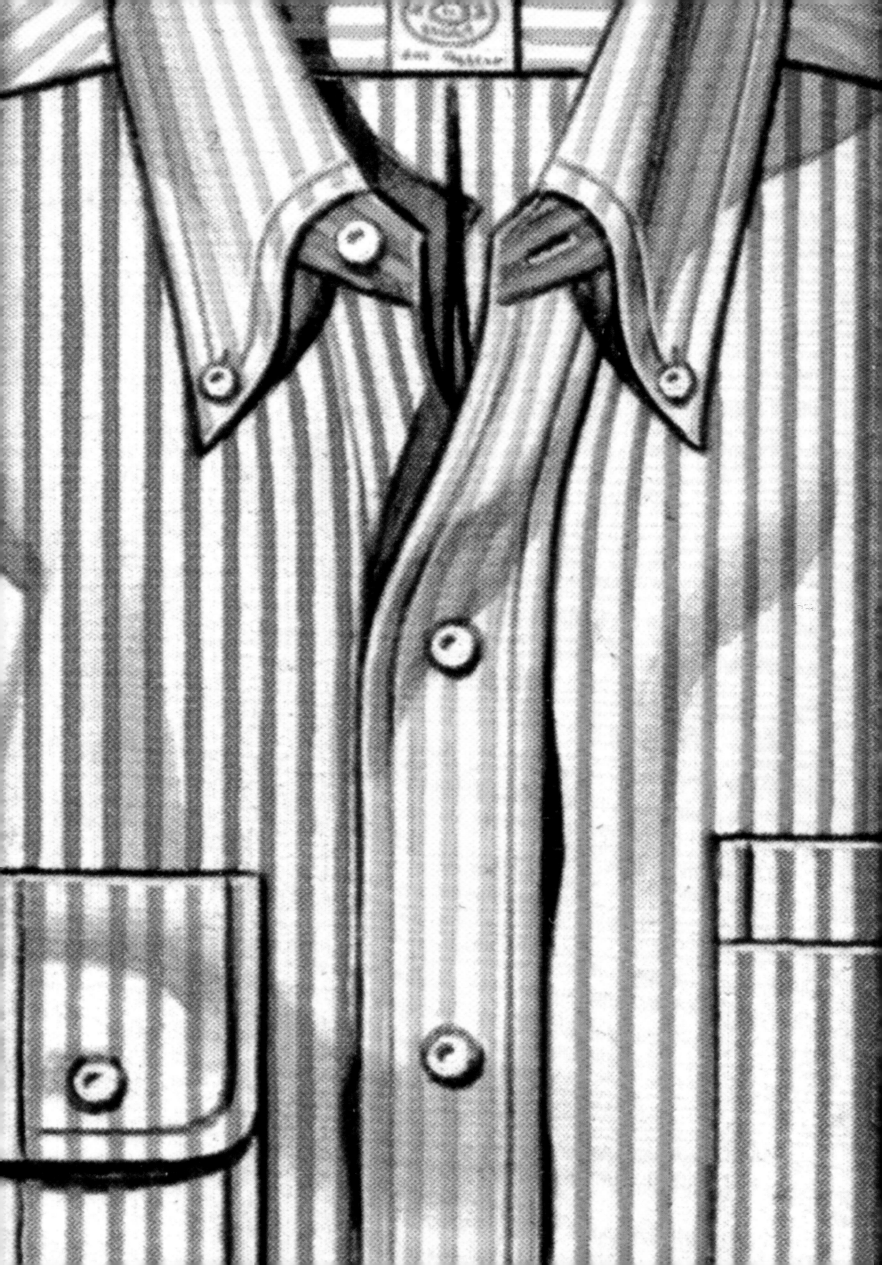

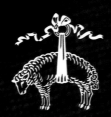

CHAPTER THREE

BEING PRESIDENTIAL

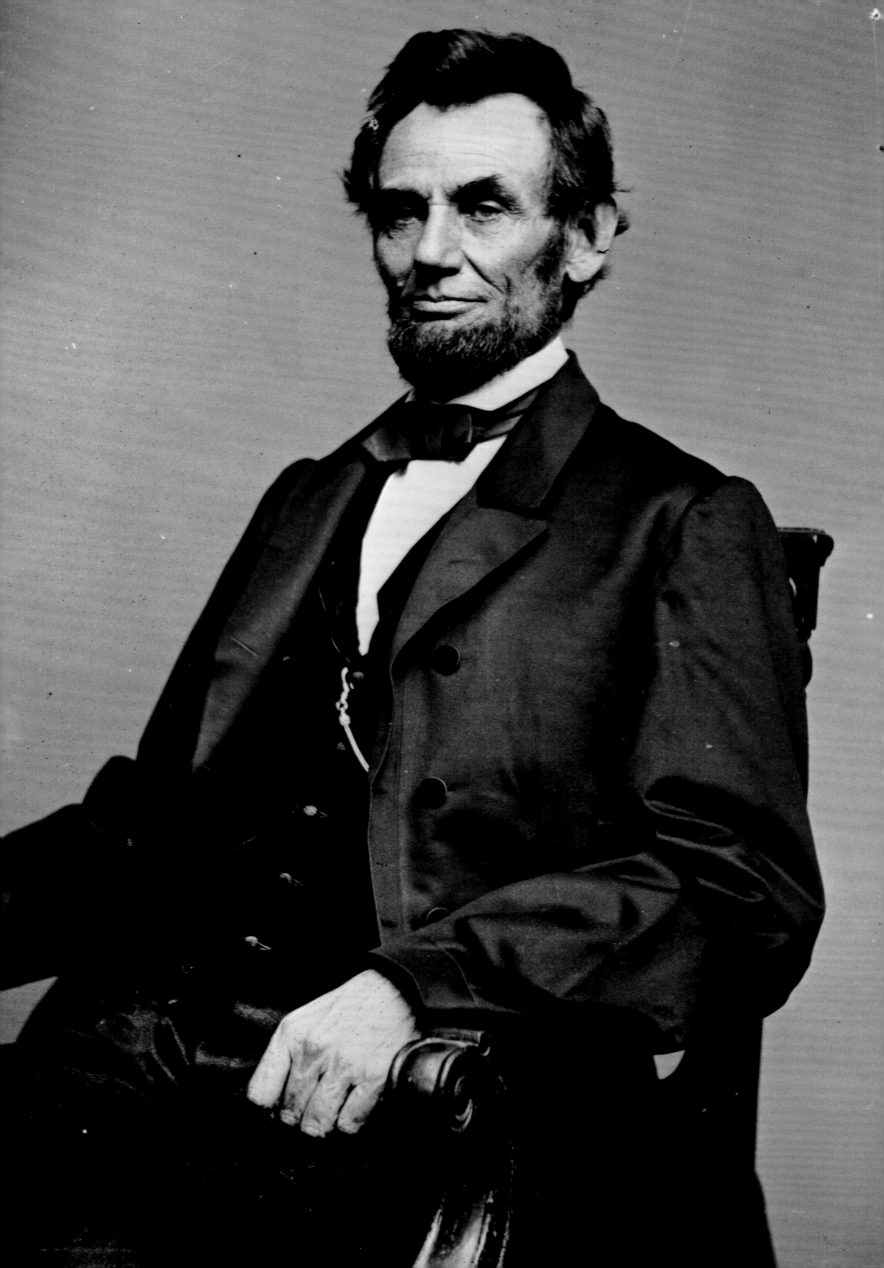

In the winter of 1865, President Abraham Lincoln was given a Brooks Brothers custom black broadcloth frock coat for his second inaugural swearing-in ceremony. A young seamstress named Agnes Breckenridge spent four ten-hour days embroidering the silk twill lining of the coat with an eagle holding in its beak two banners inscribed with the Daniel Webster quote, "One Country, One Destiny"—a prophecy for the future of the deeply divided country. At six feet four inches, Lincoln required a special mirror in order to fit his clothes correctly, and Brooks Brothers complied. But not every request was met and Mary Todd Lincoln complained bitterly, by letter, when the store didn't send a tailor to measure "His Excellency" at home.

Lincoln wore the Brooks Brothers black frock coat as he took the oath of office on the Capitol's east portico before a rain-soaked crowd. Five weeks later, Lincoln was wearing the same coat inside Ford's Theatre when John Wilkes Booth fatally shot him. Lincoln's funeral cortege wound its way through New York City and passed in front of the Brooks Brothers store at Broadway and Grand Street. The entire staff saluted the president; he had been a very good customer. Some say that after Lincoln's death, Brooks Brothers even went so far as to stop making black suits, only reintroducing them in the the early 2000s.

Lincoln was not the first nor the last American president to wear Brooks Brothers. Brooks Brothers has clothed forty sitting United States presidents, including Ulysses S. Grant, Woodrow Wilson, Theodore Roosevelt, Franklin D. Roosevelt, and Barack Obama, who wore the Westbury coat and a red Brooks Brothers scarf to his first inauguration. Dwight Eisenhower, Richard Nixon, and Gerald Ford were also sworn in wearing Brooks Brothers. In 1960 the *New York Times* described John F. Kennedy as a "model of Brooks Brothers perfection" on the Senate floor. As president, Kennedy had the habit of buttoning two buttons on his suit, despite the fact that it was considered gauche. His streamlined look of a white oxford shirt, lean suit, and narrow tie would come to define a generation of men who wanted to look both Ivy League-worthy and presidential.

The connection between Brooks Brothers and the Office of the President dates back to 1818, when Brooks Brothers began creating military uniforms for the veterans of the War of 1812. Presidents who served in the military typically wore Brooks Brothers, beginning with Chester A. Arthur, who, as Quartermaster of the Army, ordered three hundred overcoats for his Union regiment in 1861. During the Civil War, the Broadway and Grand Street store became the supplier to the Union Army, boasting that they could manufacture an overcoat in half the time it took to make them by hand. Officers wore Brooks Brothers dress uniforms as early as the Mexican-American War in 1847 and Civil War Generals Grant, Sheridan, Hooker, and Sherman outfitted them at the Grand Street store.

Teddy Roosevelt so admired Brooks Brothers' tailoring that he had the store make uniforms for the 1st U.S. Volunteer Cavalry Regiment—otherwise known as the Rough Riders, so named for the rough-and-tumble look of their cowboy-style Brooks Brothers uniforms. For his second inauguration, New York's Brilliant Squadron A escorted him to the Capitol in

OPPOSITE President Abraham Lincoln wore a Brooks Brothers custom black frock coat to his second inaugural swearing-in ceremony in 1865.

uniforms they'd bought from Brooks. His first inauguration came as something of a surprise. Nobody thought President William McKinley would die after he was shot, including Roosevelt, who was on a family camping trip in the Adirondacks when he received the news. Roosevelt rushed by train to Buffalo, but had no appropriate clothing, so he borrowed a Brooks Brothers jacket for his swearing-in ceremony.

Franklin D. Roosevelt wore a Brooks Brothers cape when he met Winston Churchill and Joseph Stalin at Yalta in the waning days of World War II and for many years, the company made their famous "Hoover" collars for President Herbert Hoover, who also had Union suits custom made of D. & J. Anderson broadcloth. More recently, Bill Clinton has worn a Brooks Brothers suede jacket, a gift from his wife.

Two weeks after Lincoln's death, Mary Todd Lincoln gave the black broadcloth coat and other personal relics to Alphonse Donn, her husband's favorite footman. "Retain them always, in memory of the best and noblest man who ever lived," she wrote in a note bequeathing them to Donn, who kept the coat in his family for several decades, storing it in a military trunk. His granddaughter finally sold Lincoln's coat to the Parks Department in 1968 so that it could be displayed at the Ford's Theatre Museum. In 1990, when the Lincoln Museum underwent restoration, Brooks Brothers refurbished the fragile coat and made two copies, one for the museum and one for their archives.

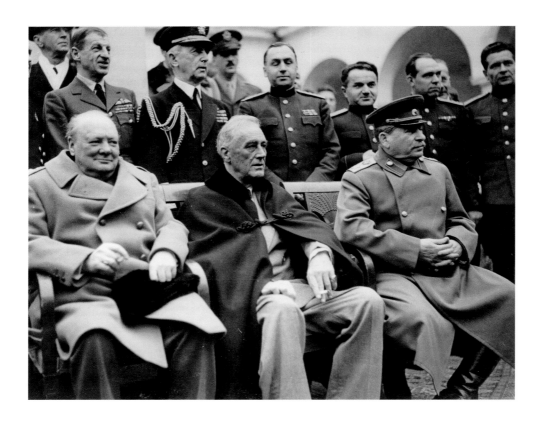

THIS PAGE Franklin Delano Roosevelt wore a Brooks Brothers cape to meet Winston Churchill and Joseph Stalin at Yalta at the end of World War II.

OPPOSITE: A detail of a navy blue Brooks Brothers cape made in 1912.

"Some of the nation's greatest Presidents took
their oath of office while dressed in a Brooks Brothers
suit or coat, or both, from Ulysses S. Grant to
Woodrow Wilson to Theodore Roosevelt.
Grant and Roosevelt had already been relying on
the store's style before leading the nation.
Grant had Brooks Brothers design his Union Army
officer uniforms. Before even setting foot on
a naval vessel, once Roosevelt had resigned as
Assistant Navy Secretary and been commissioned
as a lieutenant colonel in the cavalry, he dashed first
to Brooks Brothers to have a heroic dress uniform
designed for him, then went to a studio to be
photographed in it. The most legendary President
literally made Brooks Brothers part of history.
Lincoln wore a special coat made for him at the store
to his 1865 inaugural. The lining of his coat was
embroidered with an eagle design and the inscription,
'One Country, One Destiny.' One month later,
he was wearing the coat when he was assassinated
at Ford's Theatre."

—CARL SFERRAZZA ANTHONY,
Author and National First Ladies' Library Historian

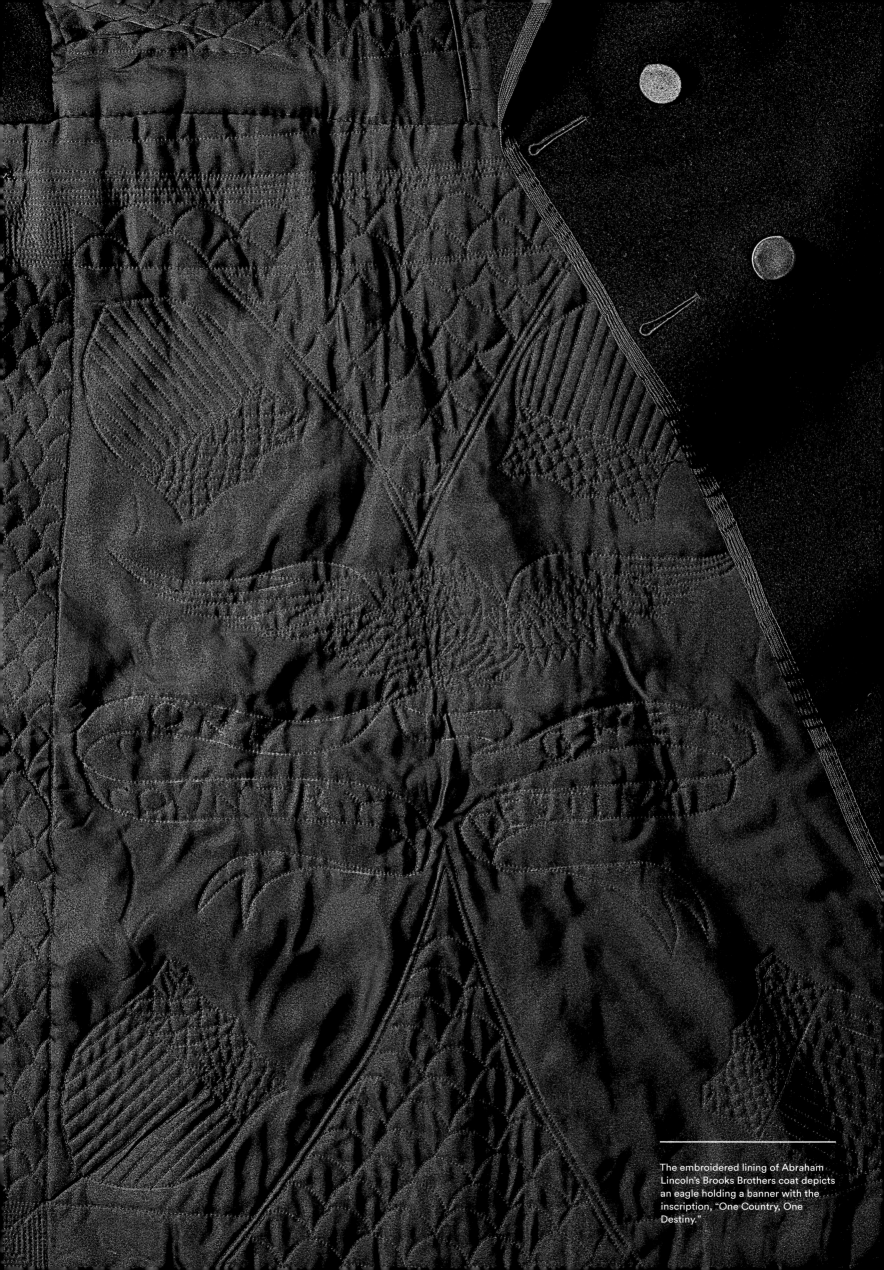

The embroidered lining of Abraham Lincoln's Brooks Brothers coat depicts an eagle holding a banner with the inscription, "One Country, One Destiny."

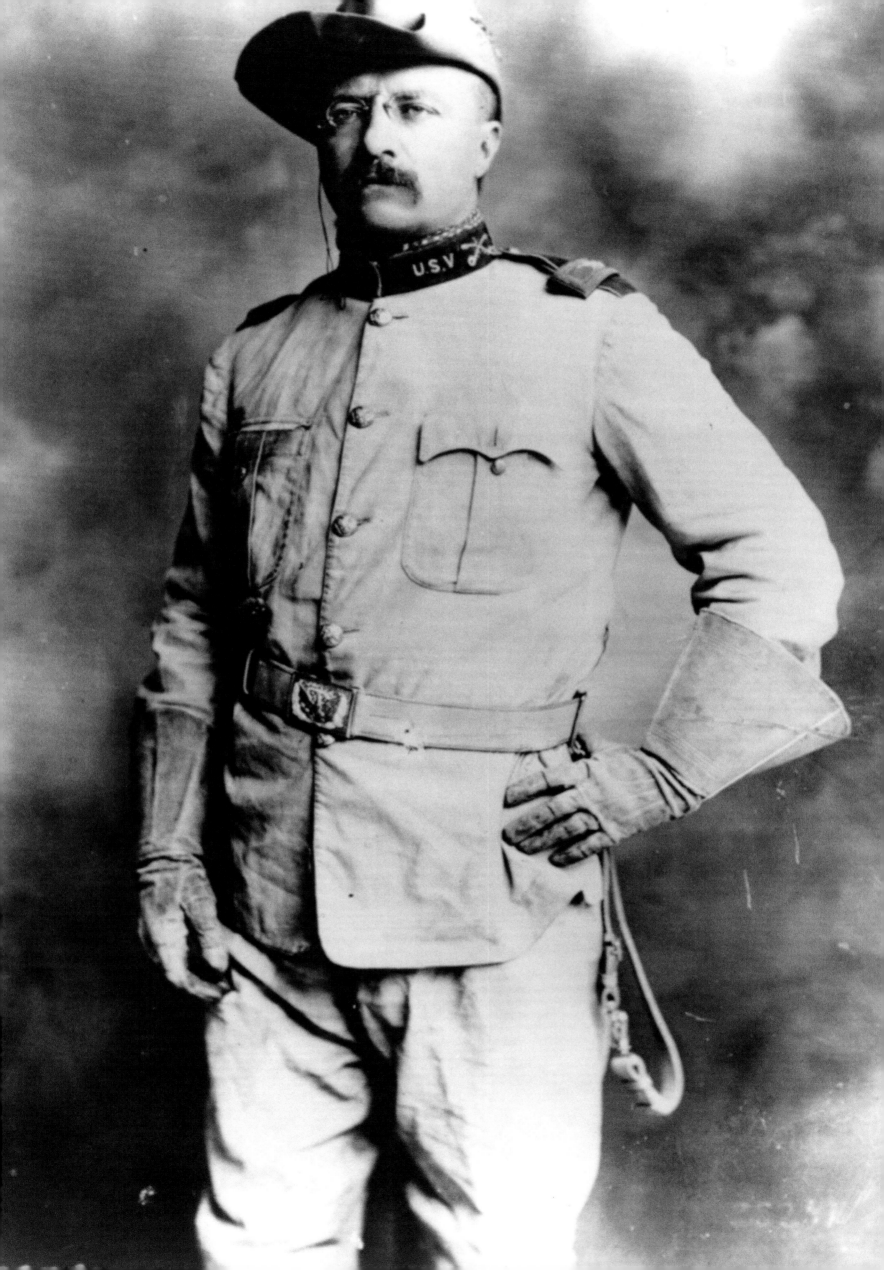

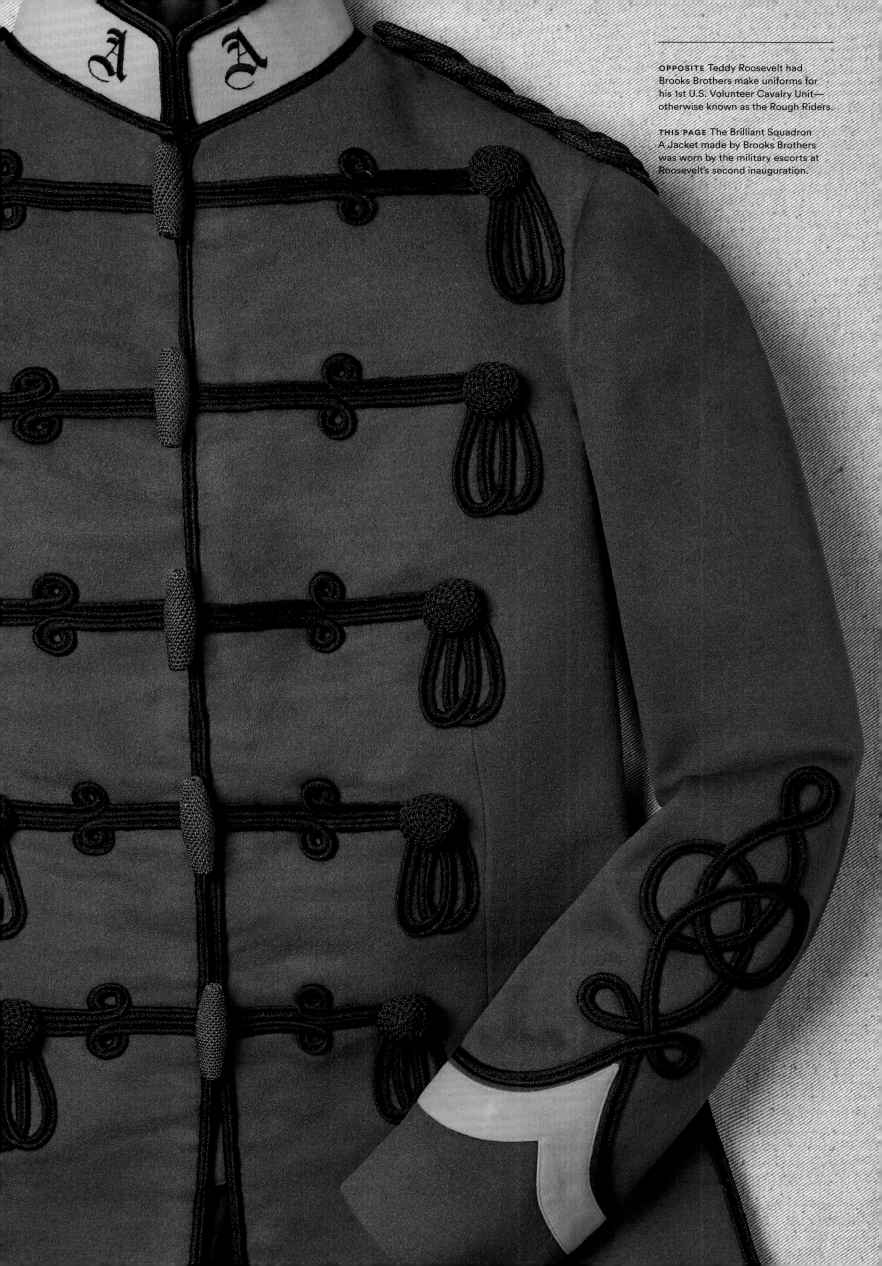

OPPOSITE Teddy Roosevelt had Brooks Brothers make uniforms for his 1st U.S. Volunteer Cavalry Unit—otherwise known as the Rough Riders.

THIS PAGE The Brilliant Squadron A Jacket made by Brooks Brothers was worn by the military escorts at Roosevelt's second inauguration.

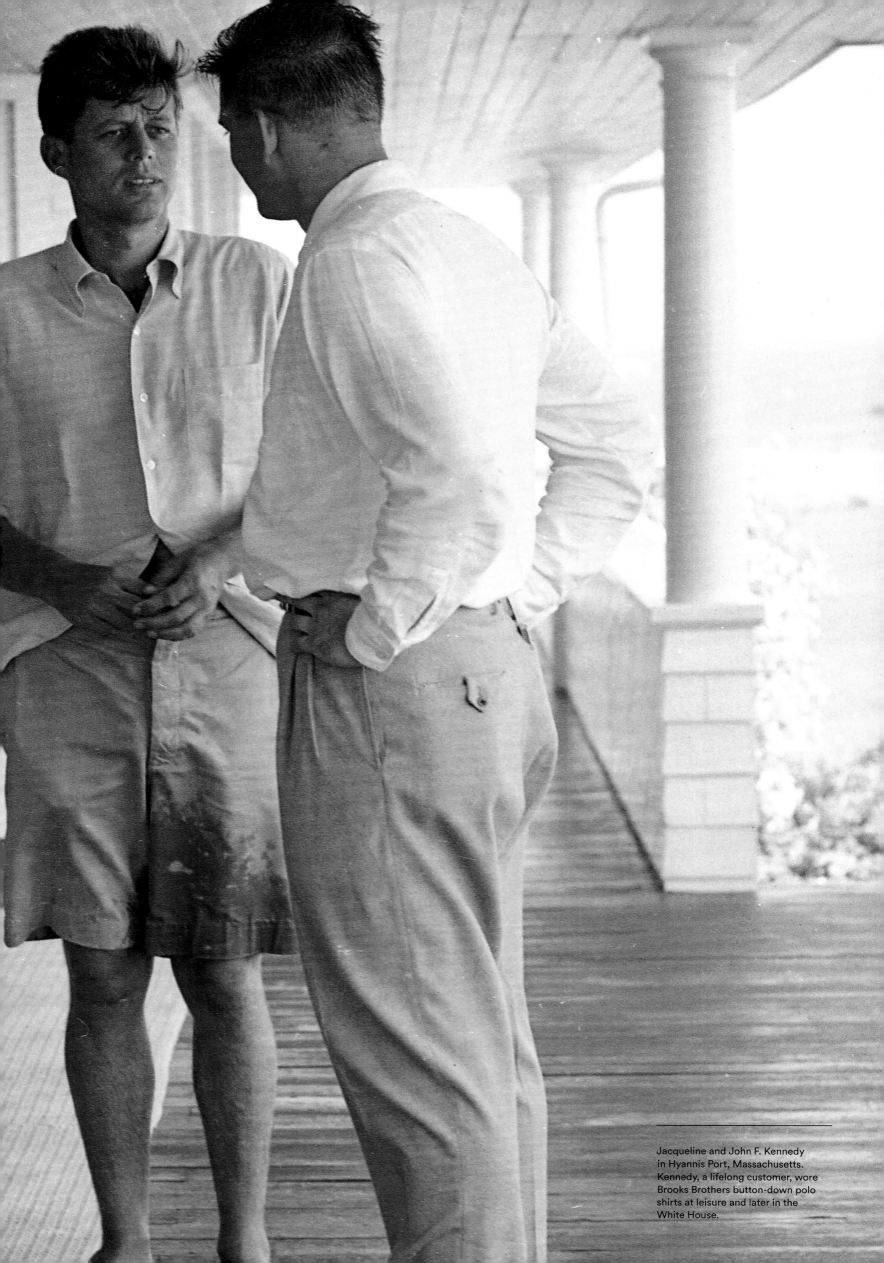

Jacqueline and John F. Kennedy in Hyannis Port, Massachusetts. Kennedy, a lifelong customer, wore Brooks Brothers button-down polo shirts at leisure and later in the White House.

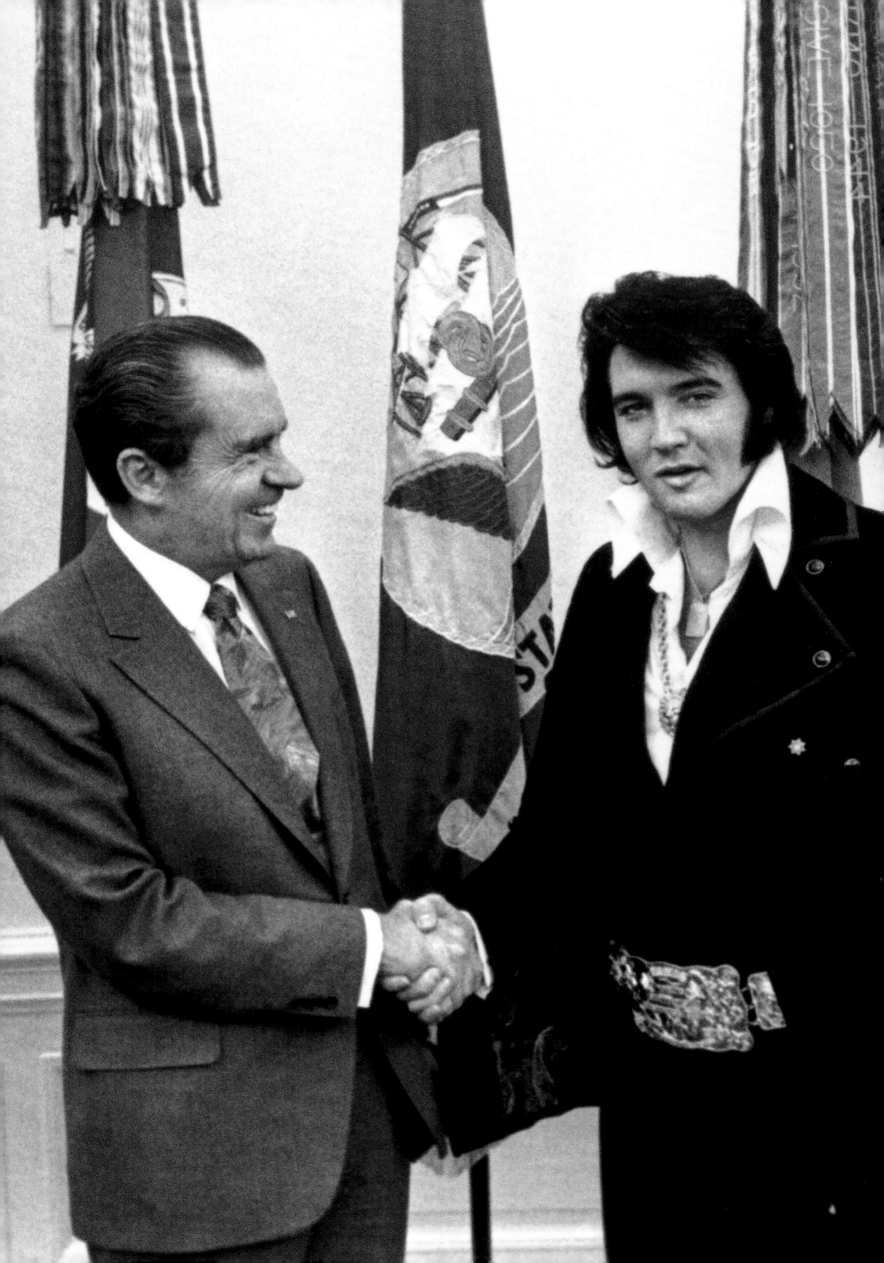

HOW CAN YOU BE PRESIDENT OF THE UNITED STATES IF YOU DON'T WEAR A BROOKS BROTHERS SUIT?

Practically every president since
Abraham Lincoln has worn clothes from
Brooks Brothers. A coincidence?
We think not. Because, truly, one cannot help
but look presidential in our classic suit.
Surprisingly priced from $350 to $875.

The Surprise of Brooks Brothers

46 NEWBURY STREET, BOSTON, MA 02116
THE MALL, CHESTNUT HILL, MA 02167
wbury Street open Sundays 12 P.M. to 5 P.M.
rooks Brothers card, American Express, MasterCard or Vi.

★ WE HAVE DRESSED ★

40 out of 45

★ PRESIDENTS ★

James Madison
James Monroe
John Quincy Adams
Andrew Jackson
Martin Van Buren
William Henry Harrison
John Tyler
James K. Polk
Zachary Taylor
Millard Fillmore
Franklin Pierce
James Buchanan
Abraham Lincoln
Andrew Johnson
Ulysses S. Grant
Rutherford B. Hayes
James Garfield
Chester A. Arthur
Grover Cleveland*
Benjamin Harrison
William McKinley
Theodore Roosevelt
William Howard Taft
Woodrow Wilson
Warren G. Harding
Calvin Coolidge
Herbert Hoover
Franklin D. Roosevelt
Harry S. Truman
Dwight D. Eisenhower
John F. Kennedy
Lyndon B. Johnson
Richard M. Nixon
Gerald R. Ford
George H. W. Bush
William J. Clinton
George W. Bush
Barack Obama
Donald J. Trump

Turning Gentlemen into Presidents since 1818.

*A Brooks Man during both of his presidencies.

THIS PAGE A Brooks Brothers advertisement takes a tally of Presidential customers.

OPPOSITE On the first State visit to Japan in 1974, President Gerald Ford and Emperor Hirohito—two world leaders from different continents— greet each other wearing identical Brooks Brothers morning suits.

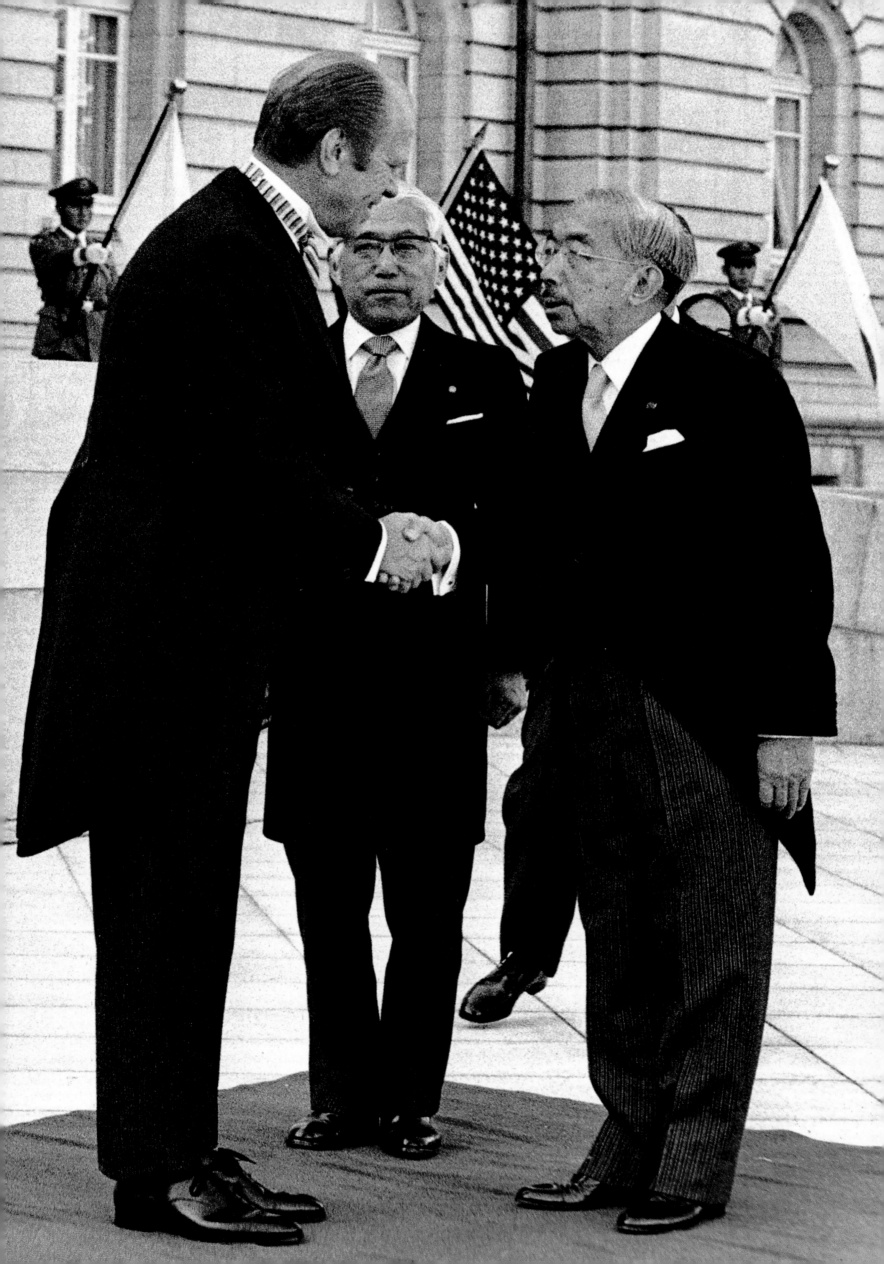

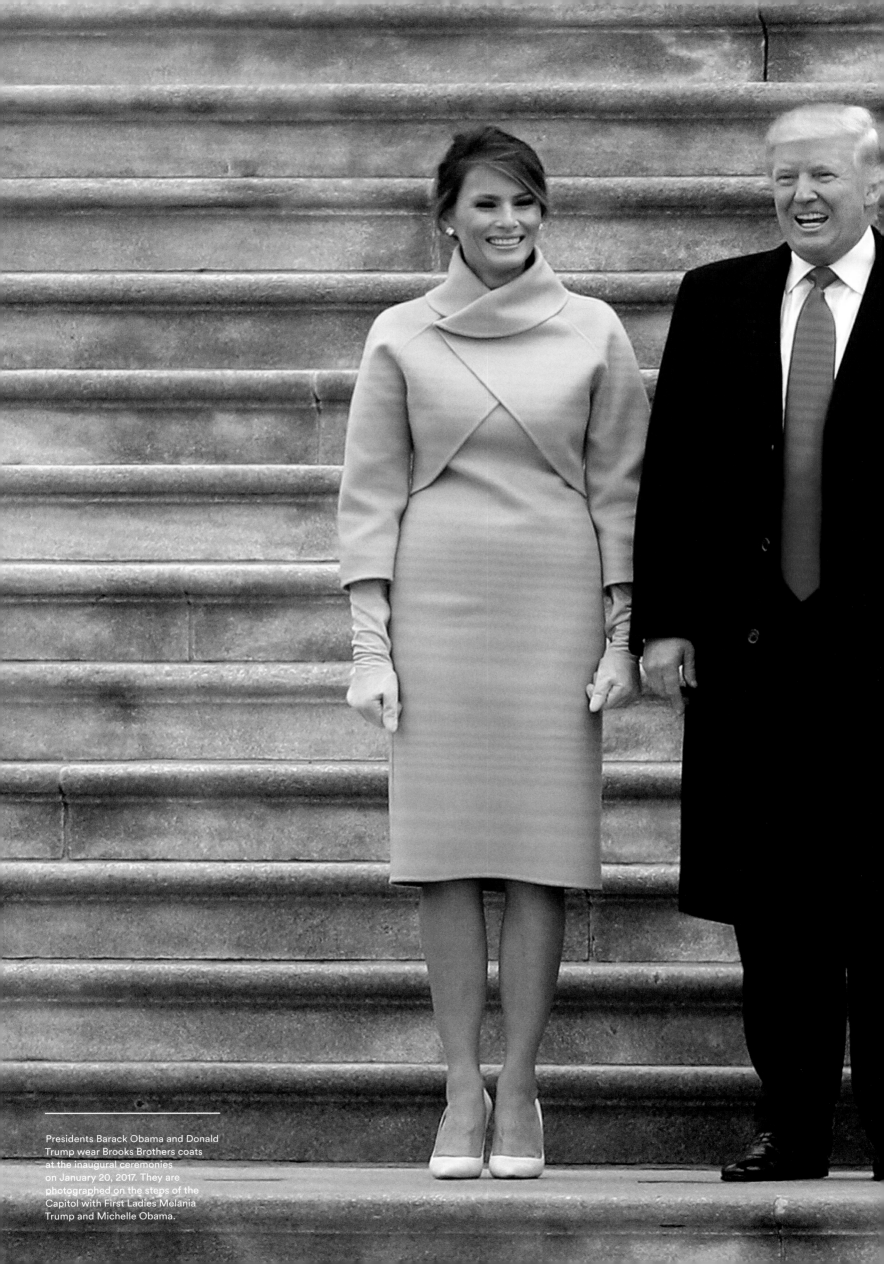

Presidents Barack Obama and Donald Trump wear Brooks Brothers coats at the inaugural ceremonies on January 20, 2017. They are photographed on the steps of the Capitol with First Ladies Melania Trump and Michelle Obama.

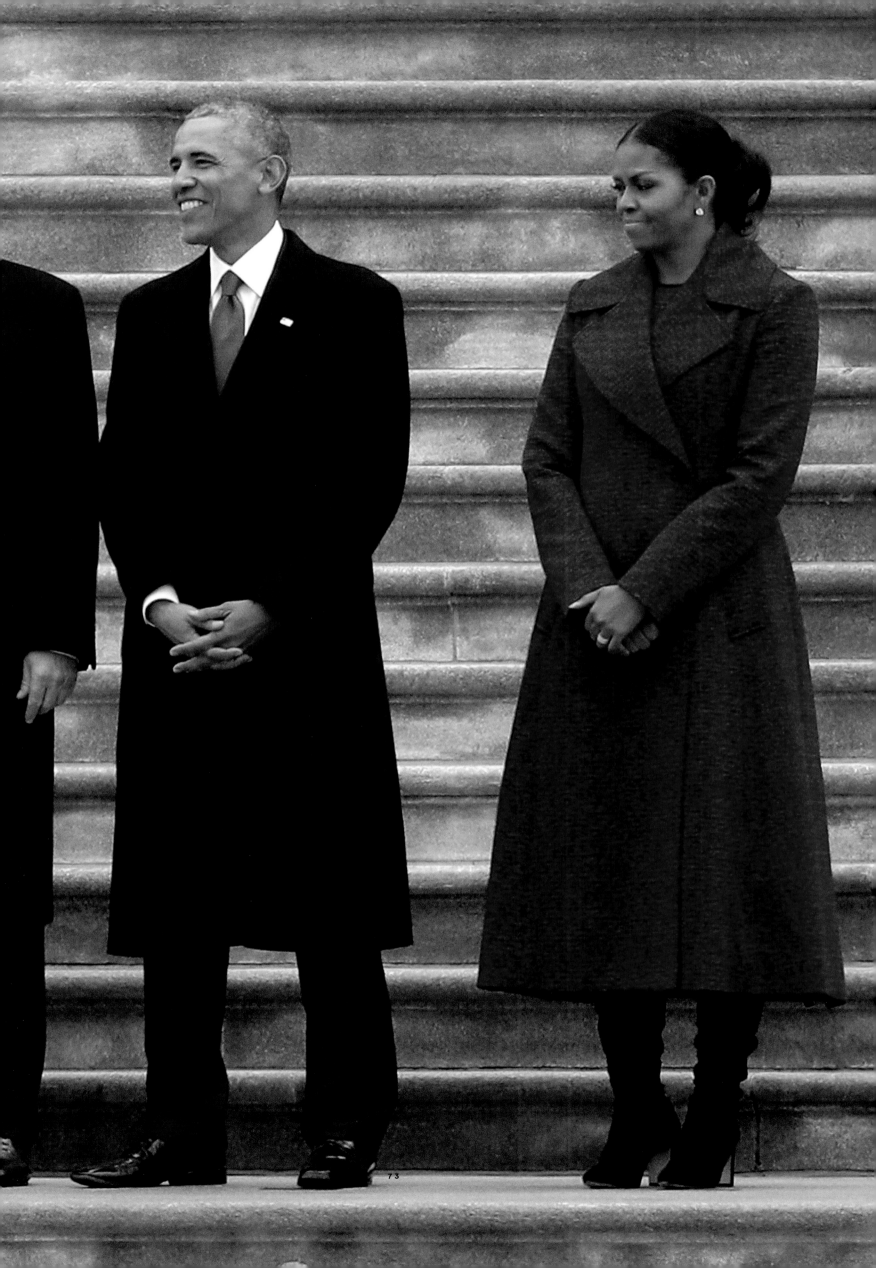

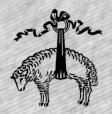

THE
JAZZ AGE

There's a scene in Baz Luhrmann's incandescent movie *The Great Gatsby* where Jay Gatsby and Tom Buchanan get into a fight. They've been drinking all night in a suite at the Plaza Hotel and things between the two men unravel when Tom tries to discredit Gatsby by scoffing at his clothes. "Mr. Gatsby," he says, "I'd like to know exactly who are you anyway? Can't you see who this guy is, Daisy? His house, his parties, his fancy clothes."

Gatsby, the flashy fashion plate, wears a slick pink linen suit while his nemesis Tom, in blue shirtsleeves and a vest, is the picture of upper-class leisure. The story's narrator, Nick Carraway, watches from the wings, all buttoned up in a brown tweed suit—a nod to his grounded Midwestern roots. More than F. Scott Fitzgerald's crisp prose, the character's clothes tell the story of the enormous social shift happening in 1920s America.

It's the summer of 1922. New York City is the center of a world reeling from the hard-won victories of World War I and caught between the thrilling ambition of modernism and a wistful nostalgia for the way things were. The end of the war has inspired newness and change—innovation in design, music, social mores, fashion, and culture are all happening at once. Society is leaping forward into what we now know as the beginning of the American Century. Women have the right to vote; innovation in transportation makes travel accessible; and the first radio station spreads news faster.

Fitzgerald—a longtime Brooks Brothers customer—was obsessed with the idea of clothing as a class signifier. So it made sense that the costume and production designer of the movie, Catherine Martin, would enlist Brooks Brothers to recreate the look that defined a decade of opulence, freedom, and, ultimately, the fluid social mobility that was Fitzgerald's obsession. Martin, who spent hours researching material from the Brooks Brothers archives, dressed Gatsby and his entourage to reflect this shifting social tension, leaving some characters in the nostalgic tradition of tailored English menswear while outfitting others with a sleek, modern American look.

In the 1920s, this new look was Brooks Brothers' focus, too, as company executives made a concerted effort to move beyond their British sartorial heritage and to define an American style. In one of the company's *Little Books*, published in 1921 and entitled *Liveries*, Brooks acknowledges that livery uniforms in America didn't have to adhere to European standards anymore (at the time, Brooks Brothers had a whole livery department). "In this country we are at liberty to take just what attitude we please in the matter."

OPPOSITE Actor Tobey Maguire plays Nick Carraway in Baz Luhrmann's film adaptation of F. Scott Fitzgerald's *The Great Gatsby*. For Carraways' costume, designer Catherine Martin called on Brooks Brothers to recreate the period specific three-piece suit.

Another pronounced rejection of English sartorial traditions had come in 1920 with the introduction of the striped rep tie, which was adapted from the British regimental patterns of the early 1900s. The original versions featured stripes from left to right—or, as the saying went, "from heart to sword." Instead of producing an exact copy, Brooks Brothers inverted the direction of the stripes from right to left so as not to be confused with the English version. The colorful ties were immediately adopted by Ivy League undergrads looking for ways to demonstrate their allegiance to a club, a team, or a school.

Some fashion trends were grossly exaggerated in the heady 1920s, like Oxford bags, or the strangely elongated zoot suit. Jazz music brought a loosening of fashion codes and a taste for something flashier—brightly colored socks, patterned ties. But Brooks Brothers stood firm with its natural American look. As Winthrop Holley Brooks famously said: "We are not in the fashion business, we're in the clothing business."

That business focused on servicing the newest members of the leisure class—customers who felt equally at ease on playing fields as they did in boardrooms. For weekend and travel wear, Brooks Brothers introduced "odd" items—richly textured and patterned jackets and trousers with less formal design. They introduced their famous Norfolk jacket as a casual alternative to the suit. They imported madras, an informal cotton fabric, from India. And, later in the decade, they began experimenting with lighter weight fabrics like seersucker.

While Brooks Brothers had maintained a modest seasonal outpost in Newport, Rhode Island, since the turn of the century, in 1924 they took the uncharacteristic step to expand permanently beyond Manhattan, opening in Palm Beach. The product offering expanded, too. Catalogs and circulars featured clothing for lawn tennis and tennis oxfords, buckskin shoes, and canvas tennis shoes. They sold bar accessories and English garden baskets, straw boater hats, Panama hats, beach robes, corduroy shooting jackets, Shetland sweaters, and dressing gowns.

Adventurers and innovators alike flocked to Brooks Brothers—and not just for casual clothing. In 1927, after completing his solo transatlantic flight in Paris, Charles Lindbergh found he didn't have the cargo space to pack a proper suit and so he borrowed a Brooks Brothers suit from the American ambassador to France.

"Brookspeak" not only became the shorthand for the brand in the 1920s—meaning that one was appropriately attired—but authors like Fitzgerald also described Brooks Brothers clothing so often in their writing that the Brooks sensibility became its own kind of 1920s literary symbol. In *This Side of Paradise*, Fitzgerald describes one character struggling mightily with the social stigmas and clubby atmosphere of the day when he says, "I want to go where people aren't barred because of the color of their neckties and the roll of their coats."

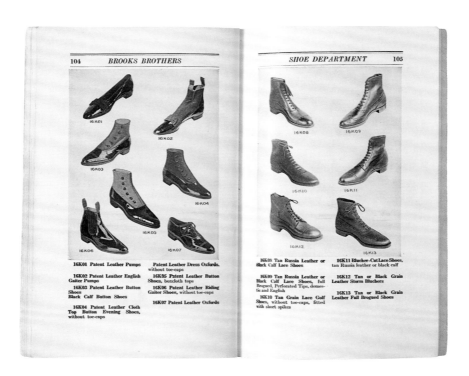

THIS PAGE A Brooks Brothers catalog from the 1920s depicts the wide variety of pumps, oxfords, and bullion riding shoes sold in the store.

OPPOSITE A 1920s illustration of a Brooks Brothers tailcoat.

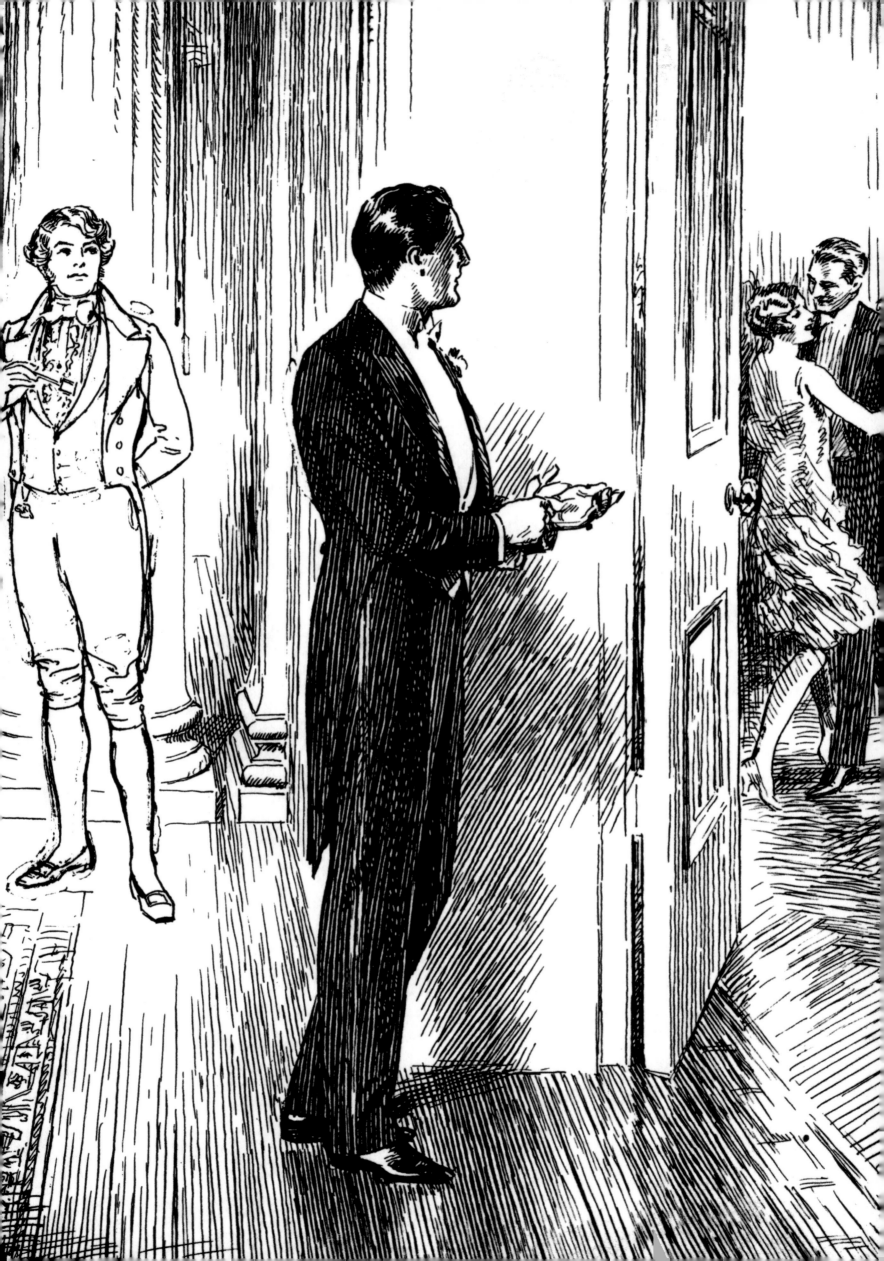

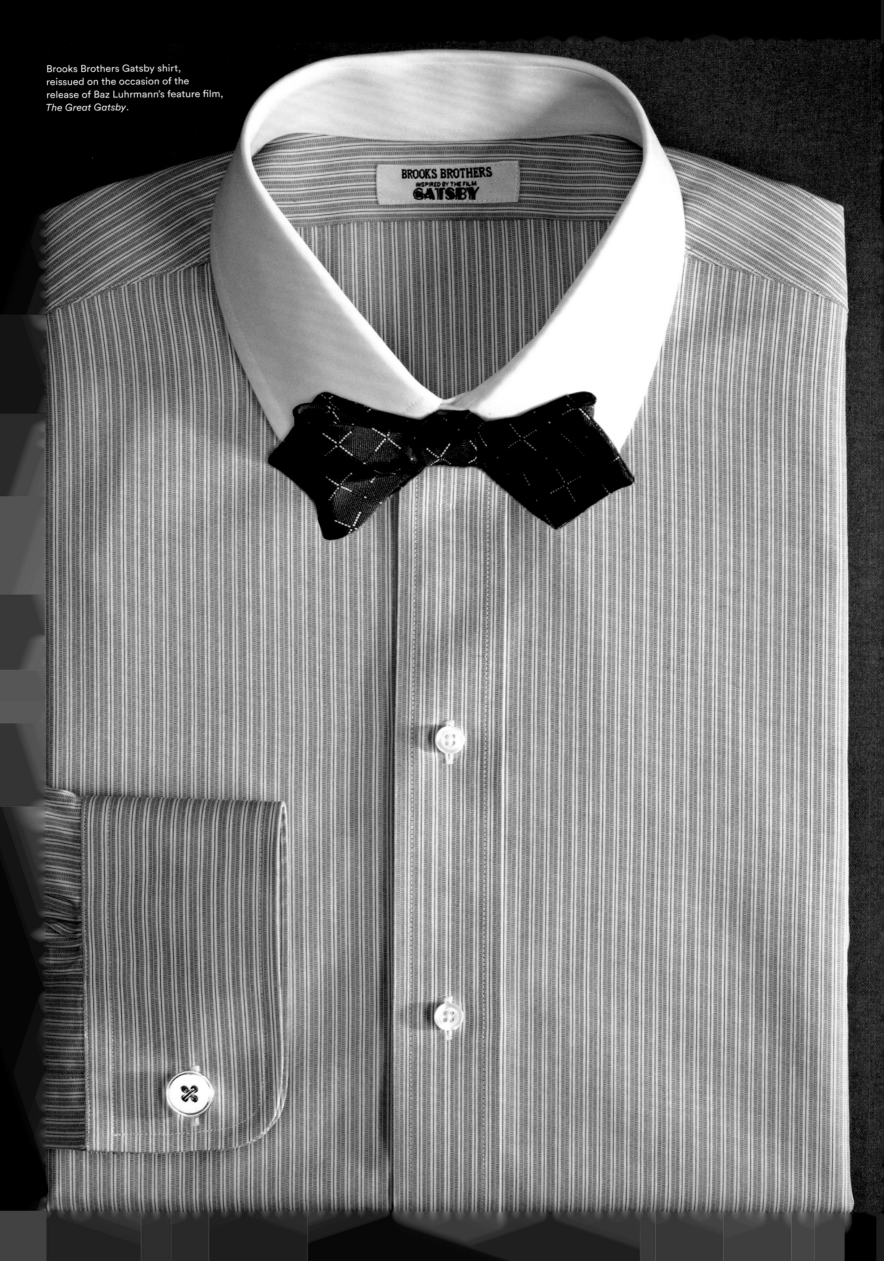

Brooks Brothers Gatsby shirt, reissued on the occasion of the release of Baz Luhrmann's feature film, *The Great Gatsby*.

INSIDE GATSBY'S WARDROBE

A Conversation With

CATHERINE MARTIN

When we were preparing the costumes for *The Great Gatsby*, it was important to associate ourselves with the original outfitter of the times, and Brooks Brothers was the preferred purveyor of clothes for F. Scott Fitzgerald. There are a number of his letters where he was ordering or selecting clothes to be made by Brooks Brothers. Fitzgerald had an obsessive connection with his university days and the idea that it was a secret, elite club. He suffered from the misfortunes of his family and he desperately wanted to be associated with the educated elite. And that was certainly something that Brooks Brothers represented. They were the quintessential preppy gentleman's outfitter.

We used a lot of color in Gatsby's wardrobe because it was a fashion statement in the 1920s. The more we researched, the more we found references to colors in menswear. There's a scene in the book where, very famously, Gatsby wears a pink suit. It's the denouement of the story, the confrontation scene where the main characters are drinking whiskey in the Plaza suite. Tom Buchanan tries to discredit Gatsby by saying, "He wears a pink suit for God's sake!" It's difficult to find many historical references to pink suits at that time, but we found an earlier J. C. Leyendecker illustration of a guy in a pink and cream linen suit. And Brooks Brothers' most popular shirts at the time were pale pink and pale blue (this was before Hallmark made the distinction between pink for girls and blue for boys). In the Brooks Brothers archives we found many references to pink seersucker. For example, one very rich client had noticed that his housekeeper was wearing seersucker to keep cool in the summers, so he ordered a pink suit in 1925. That sealed the deal for us. Remember, it was the 1920s and Brooks Brothers was making a lot of livery uniforms. Some very rich clients were having livery uniforms made to match the interior upholstery of their cars, or the interiors of their dining rooms. Also, Brooks Brothers was famous for their beautiful shirt displays in the stores—often with many colors. In the shirt scene where Gatsby shows his wardrobe to the impressionable Daisy we used a lot of color.

Fitzgerald was very interested in how clothes define you and your class in America. This concept became more interesting in the early twentieth century with the rise of sportswear. Tom Buchanan is an example of someone from that period becoming so rich that they can subscribe to their own code; they no longer have to follow European traditions. Tom plays by his own rules, like when he comes in straight off the polo field to dinner without changing into formal clothing—a link to the creation of an American elite style.

The style of Nick Carraway's clothes is more strongly related to the late nineteenth century and fashions prior to World War I. He is also Midwestern, so he wears sensible tweeds in brown and green earth tones, cardigans, and conservative, tight tailoring. His look is about being grounded, while Gatsby is the flamboyant dandy. He wears more modern colors that are associated with the twentieth century, like white and tropical sporting colors associated with tennis and sailing. He's at the forefront of fashion.

CATHERINE MARTIN is an award-winning costume, production, and set designer and producer.

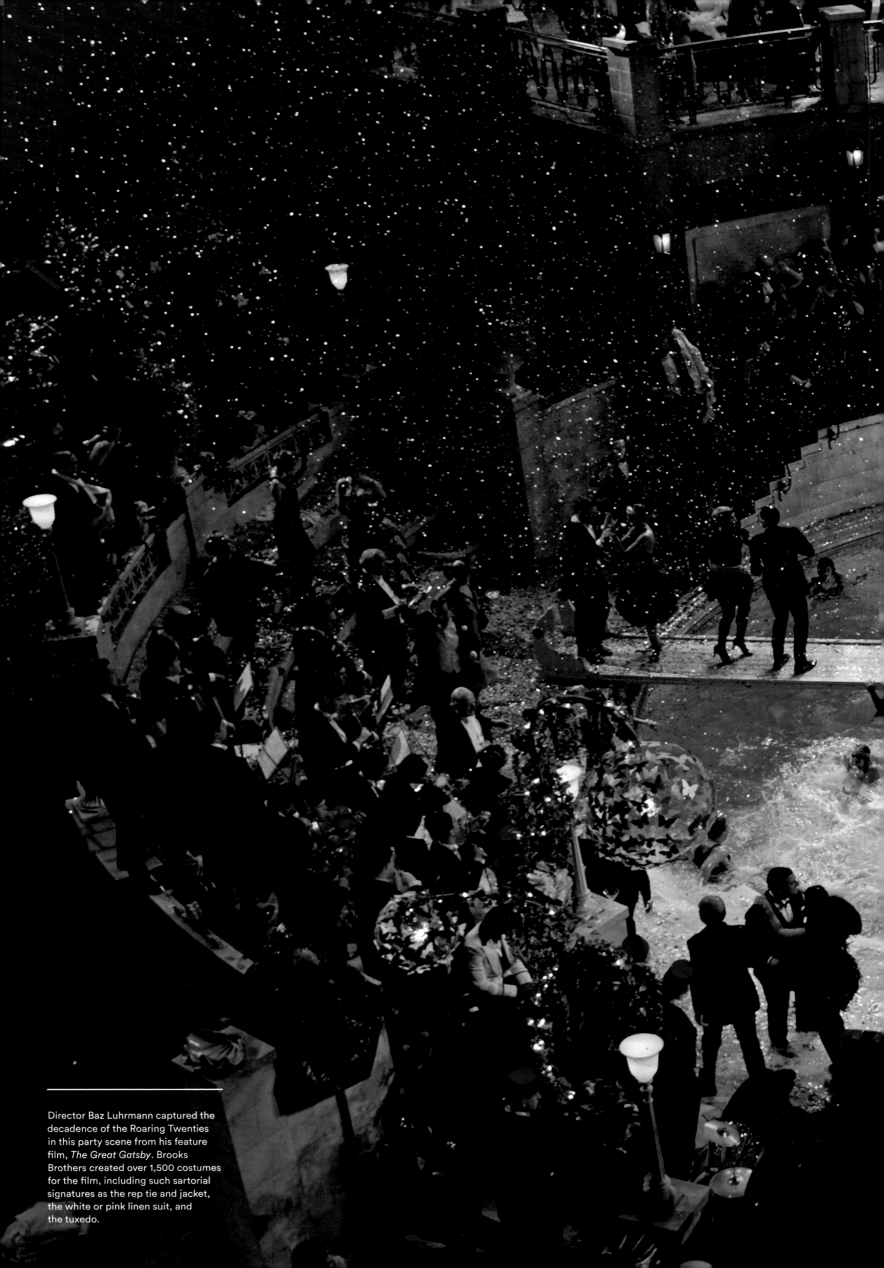

Director Baz Luhrmann captured the decadence of the Roaring Twenties in this party scene from his feature film, *The Great Gatsby*. Brooks Brothers created over 1,500 costumes for the film, including such sartorial signatures as the rep tie and jacket, the white or pink linen suit, and the tuxedo.

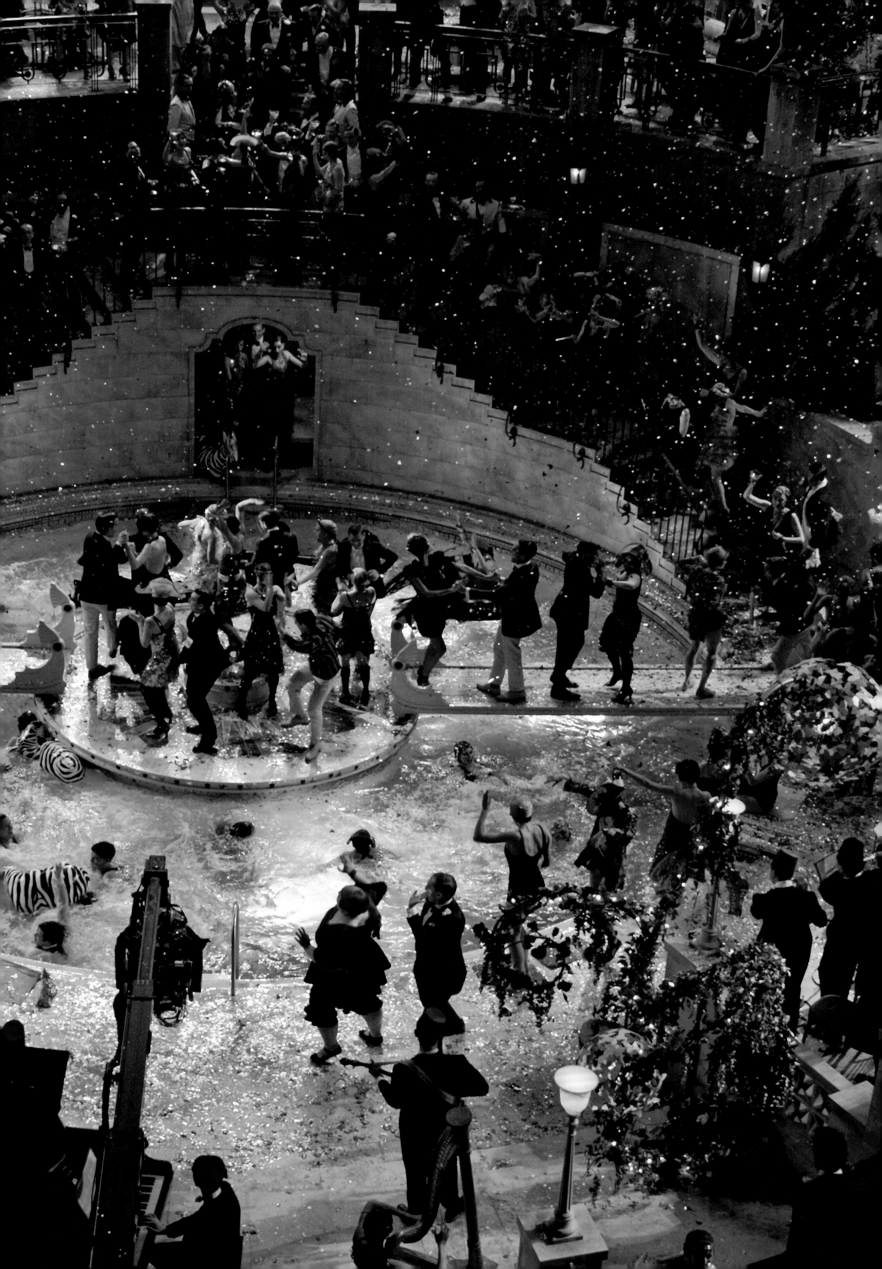

"At Princeton, Scott outfitted
himself at Brooks Brothers.
He was impeccably, aristocratically
Ivy League. When he answered
the call to the colors in 1917, he
stopped again at Brooks Brothers
to fill out his footlocker."

—ELEANOR LANAHAN,
granddaughter of F. Scott Fitzgerald, in *The New York Times*, September 1996

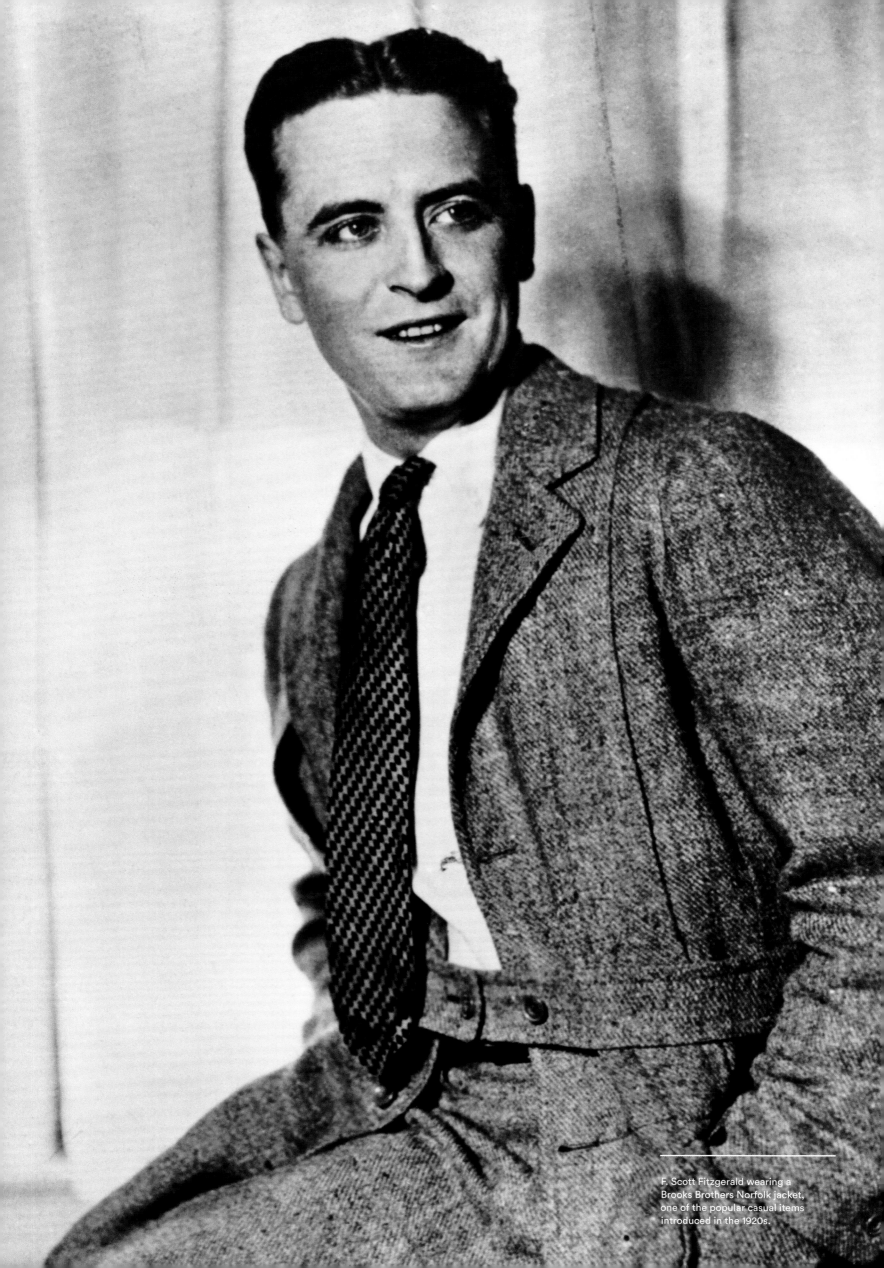

F. Scott Fitzgerald wearing a
Brooks Brothers Norfolk jacket,
one of the popular casual items
introduced in the 1920s.

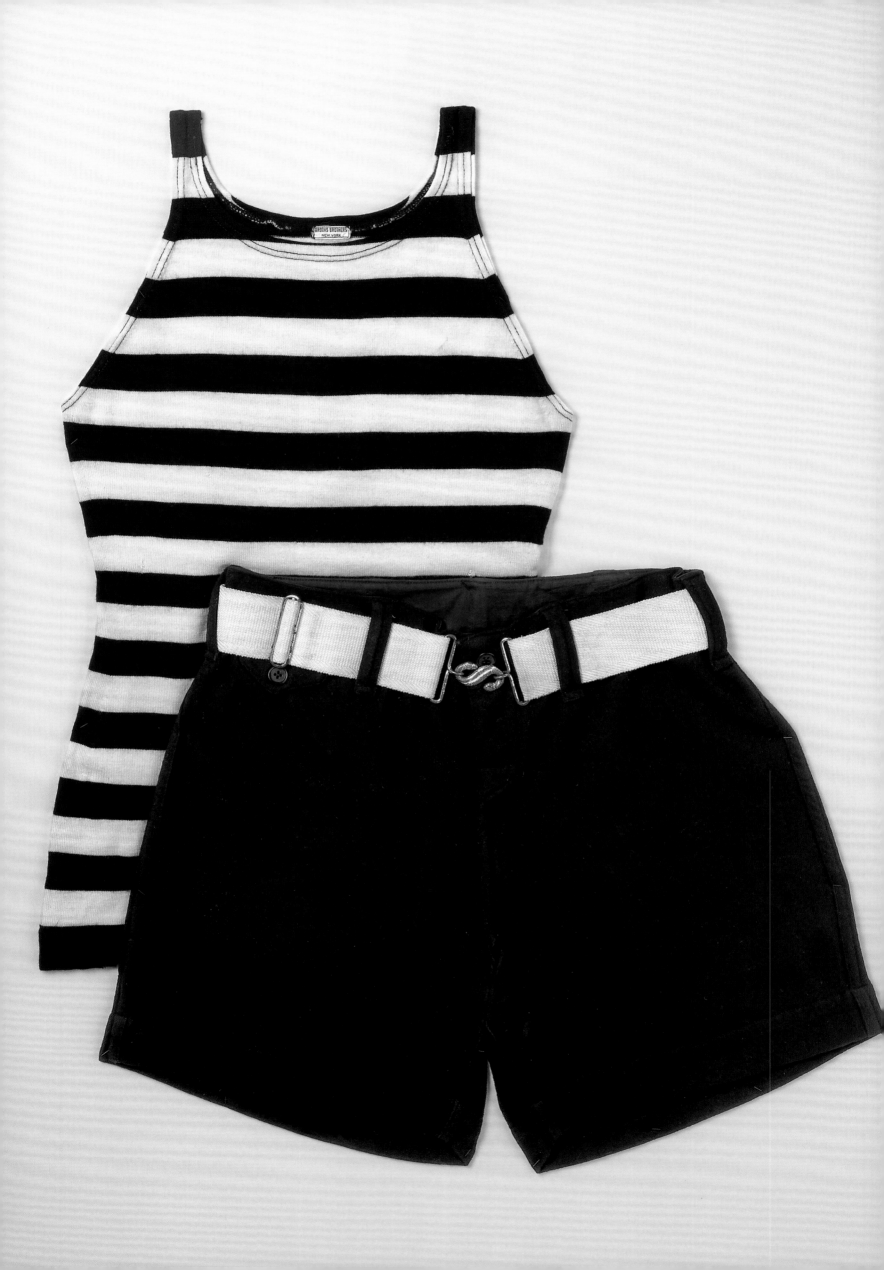

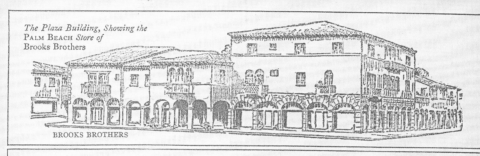

The Plaza Building, Showing the PALM BEACH *Store of* Brooks Brothers

BROOKS BROTHERS

Messrs. BROOKS BROTHERS *announce the Opening of a Store* in the Plaza Building, County Road, PALM BEACH, where they will have for sale a representative stock of their Clothing especially suitable for wear at Southern Resorts, as well as Furnishings, Hats, Shoes, Leather Goods, Liveries, Travellers' and Smokers' Accessories.

TELEPHONE PALM BEACH 1618

View from the Patio of the Plaza Building BROOKS BROTHERS

OPPOSITE Fashionable swimwear from the 1920s, when Brooks Brothers catered to the rising popularity of leisure activities.

THIS PAGE An advertisement for the 1924 opening of Brooks Brothers' seasonal Palm Beach store, the company's second venture outside of New York City.

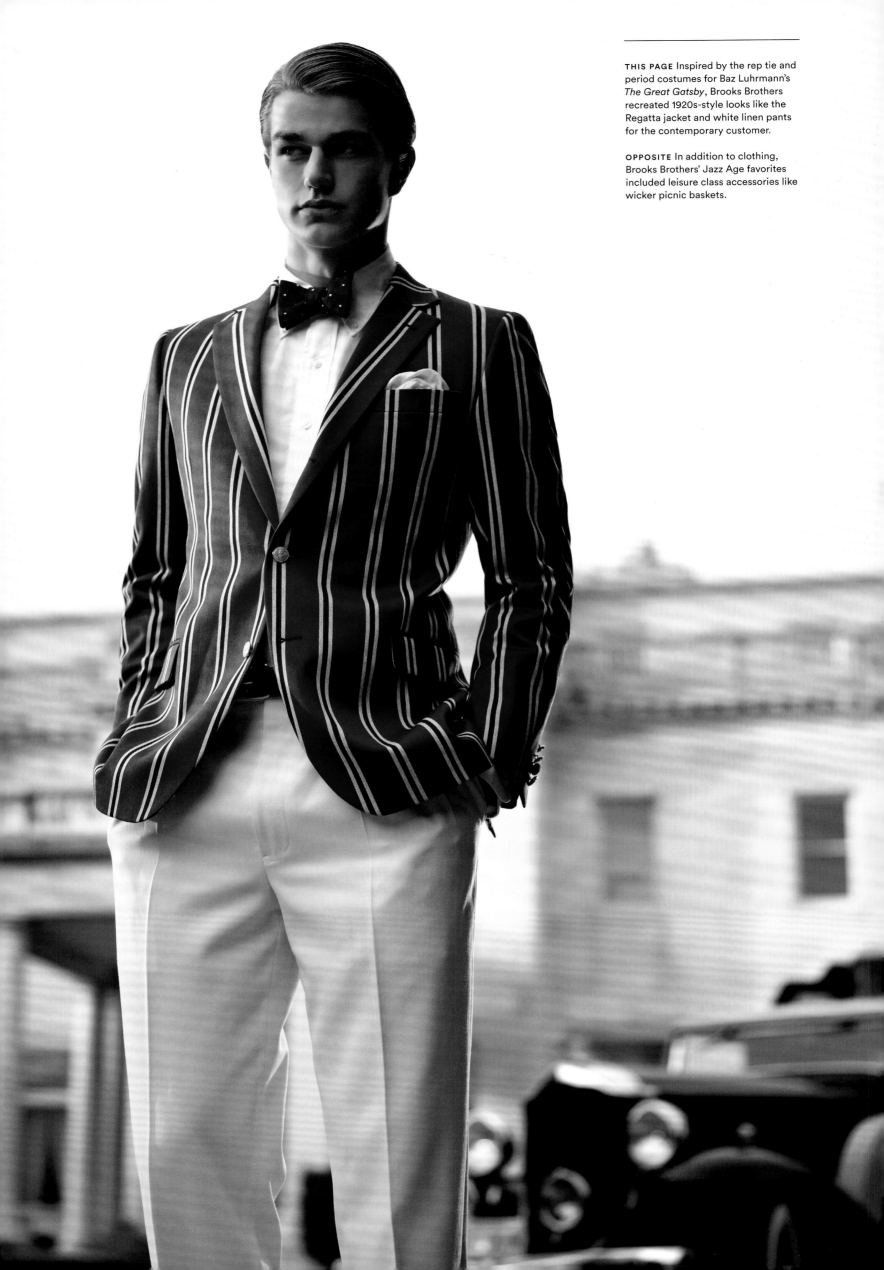

THIS PAGE Inspired by the rep tie and period costumes for Baz Luhrmann's *The Great Gatsby*, Brooks Brothers recreated 1920s-style looks like the Regatta jacket and white linen pants for the contemporary customer.

OPPOSITE In addition to clothing, Brooks Brothers' Jazz Age favorites included leisure class accessories like wicker picnic baskets.

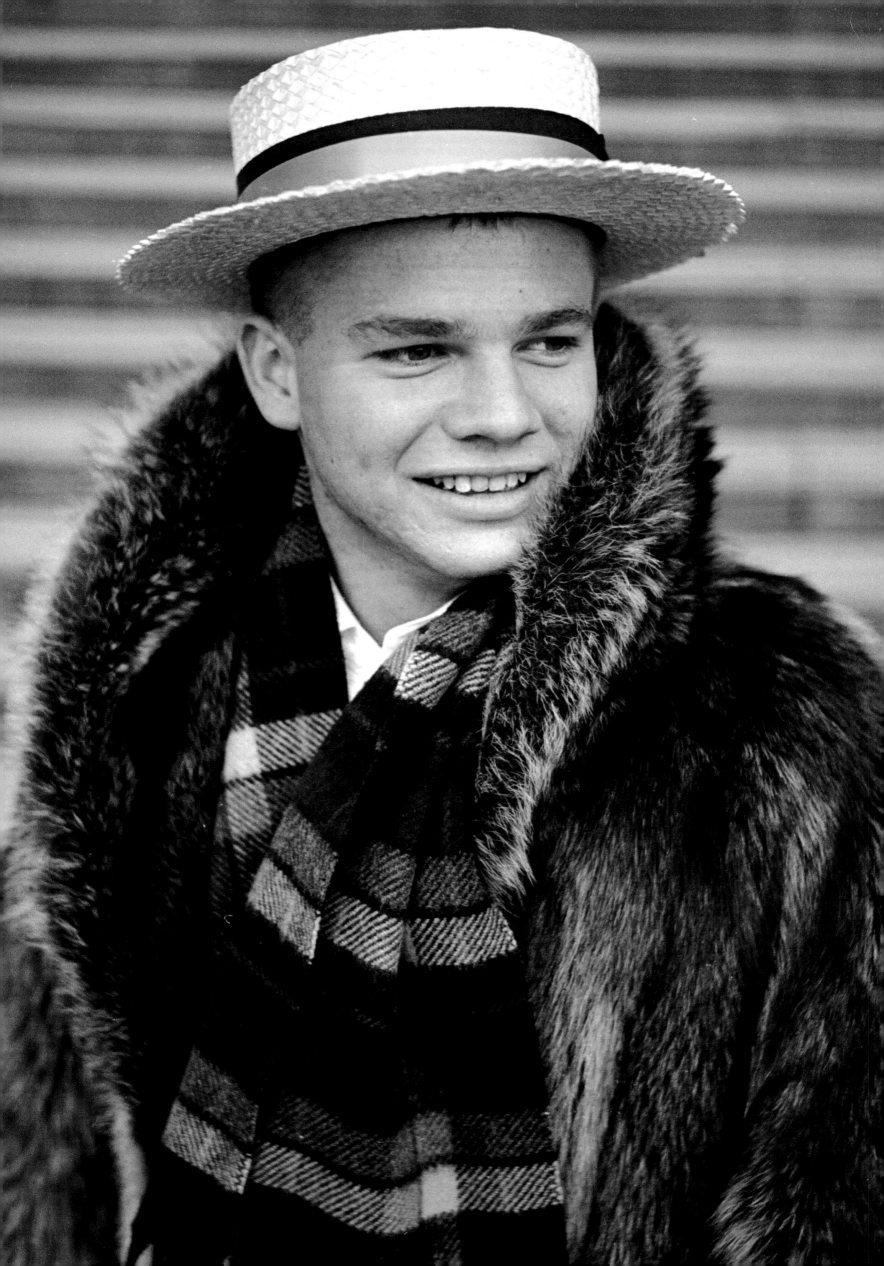

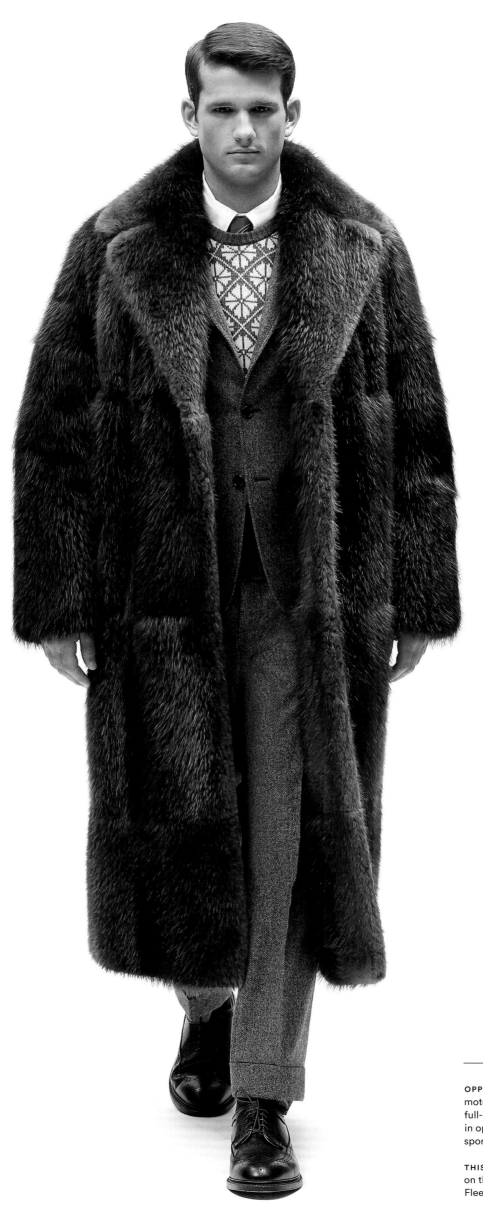

OPPOSITE The 1920s interest in motoring created a demand for full-length raccoon coats, to be worn in open cars in cool weather and at sporting events.

THIS PAGE A contemporary take on the raccoon coat from the Black Fleece Fall 2009 collection.

SPORTING LIFE

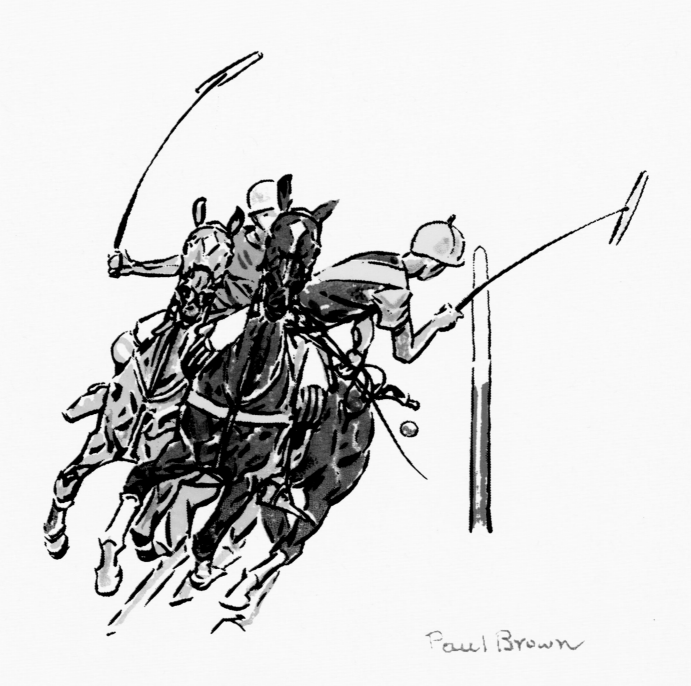

Paul Brown

n the early 1900s, under the leadership of Francis Lloyd, Brooks Brothers began publishing a series of *Little Books*, instructive guides on how to pack luggage, play polo, fox hunt, ski, or improve a golf handicap. These books gave newly affluent customers access to the rules and codes of the East Coast establishment. It was a wonderfully democratic gesture that became a signature of the company—and a guide to generations of men schooled in the Brooks philosophy of dress. Many of the books served as introductions to the "American Dream sports" enjoyed by the leisure classes—polo, tennis, golf, and hunting—in resort destinations like Palm Beach, Newport, and East Hampton. As such, they marked Brooks Brothers' official association with sporting life.

America at the turn of the century was flush with innovations in the fields of transportation, manufacturing, communication, and electronics—and Brooks Brothers kept pace, responding to each new development with their own designs and products. When cars first rolled off assembly lines in the early 1900s, motoring became a popular sport and Brooks Brothers opened a dedicated department selling driving gloves and motor robes. Every sport, no matter how esoteric, seemed to be represented. In the shoe department alone Brooks sold hunting boots, cricketing kits, ski boots, tennis oxfords, and beagling gators. In the early 1920s, the Duke of Windsor began to radically change the rules of menswear, encouraging people to play sports in their shirtsleeves. Suddenly, everything he wore became a fad—or, better, a source of inspiration for innovation. The Duke was the first to wear Fair Isle sweaters while golfing at Saint Andrew's. Later, he popularized plus fours for golf and argyle stockings. Shetland sweaters also became fashionable attire both on and off the links and Brooks Brothers took note, importing only the finest wool from Scotland.

Sporting interests at Brooks Brothers accelerated with the leadership of Winthrop Holley Brooks, the great-grandson of Henry Sands Brooks and the heir apparent to the company. Of course, Brooks Brothers had always looked to gentleman's sports, such as polo, tennis, and golf, for innovative ideas, but Winthrop Holley Brooks was inspired by another kind of sporting lifestyle.

Two decades before taking the reigns at the family company in 1935, Brooks had traveled west to Wyoming with his friend Larry Larom to help purchase and run a rustic dude ranch on the upper south fork of the Shoshone River, about forty-five miles from Cody. Their idea was to set up a

OPPOSITE In 1932 Brooks Brothers president Winthrop Holley Brooks hired the sporting illustrator Paul Brown to sketch equestrian images for the company's catalogs and ads. The polo pony was Brown's frequent subject. "We sometimes suggest corrections on the human beings in his preliminary sketches," Brooks told *The New Yorker*, "But he won't take comments on his horses, and he's right. His horses and dogs are superb."

vacation destination where members of their social circles back East could come to soak up the magnificent scenery. Like Larom, Brooks was dazzled by the vast landscapes and the rustic, simple pleasures of Western life. After his first visit, Brooks gave Larom $10,000 to secure a bank loan and purchase the 175-acre ranch, which they called Valley Ranch.

For $90 a month guests would return every summer to fish, hunt grouse and ducks, and ride while their children set off on Yellowstone pack trips. Eventually Larom set up the Valley Ranch School for Boys and even inspired friends back East to invest in land on the upper south fork.

But by 1919 World War I had ended, rations were lifted, supplies were available again, and Brooks was called back to New York City to work at the family company. He maintained his financial interest in Valley Ranch until 1927 and returned every summer with his family. In 1933 Brooks gave Larom an office on the fourth floor of the Brooks Brothers building so that Valley Ranch could have an East Coast presence. Although he had given up his own rancher dream, Winthrop made sure Western wear was sold in the store, including cowboy boots and denim frontier riders made by Levi's. For a time, there was even a saddle for sale in the store and a series of ads that asked customers if they were "Going ranching?" When the rodeo came to town, Winthrop hosted raucous reunions with his Wyoming friends.

By 1930, Brooks Brothers had employed the sporting artist Paul Brown to sketch many of its advertisements and catalogs depicting horses, hunting life, and sportsmanship. Later, they would be the first to import the Lacoste machine-knit piqué polo shirt, introduced in 1926 by the French tennis champion René Lacoste.

Athletes in search of a more genteel look turned to Brooks Brothers. Professional boxer Gene Tunney bought his dressing gowns at Brooks while his nemesis, Jack Dempsey, regularly stocked up on Peal shoes. But the most faithful customers were professional golfers who inspired Brooks Brothers to debut the Country Club collection of performance golf shirts and authentic Sea Island cotton tennis whites in 2003.

In the last decade, designers like Thom Browne have drawn inspiration from the Essex fox hunting red coat for his first Black Fleece collection. And Brooks Brothers has reinvented its sporting life heritage by collaborating on products for events such as the Head of the Charles Regatta and the St. Jude Classic golf tournament.

OPPOSITE Players from the Milan soccer team F. C. International are outfitted in Brooks Brothers single-breasted three-button jackets, classic white button-down shirts, and rep ties featuring the team's logo.

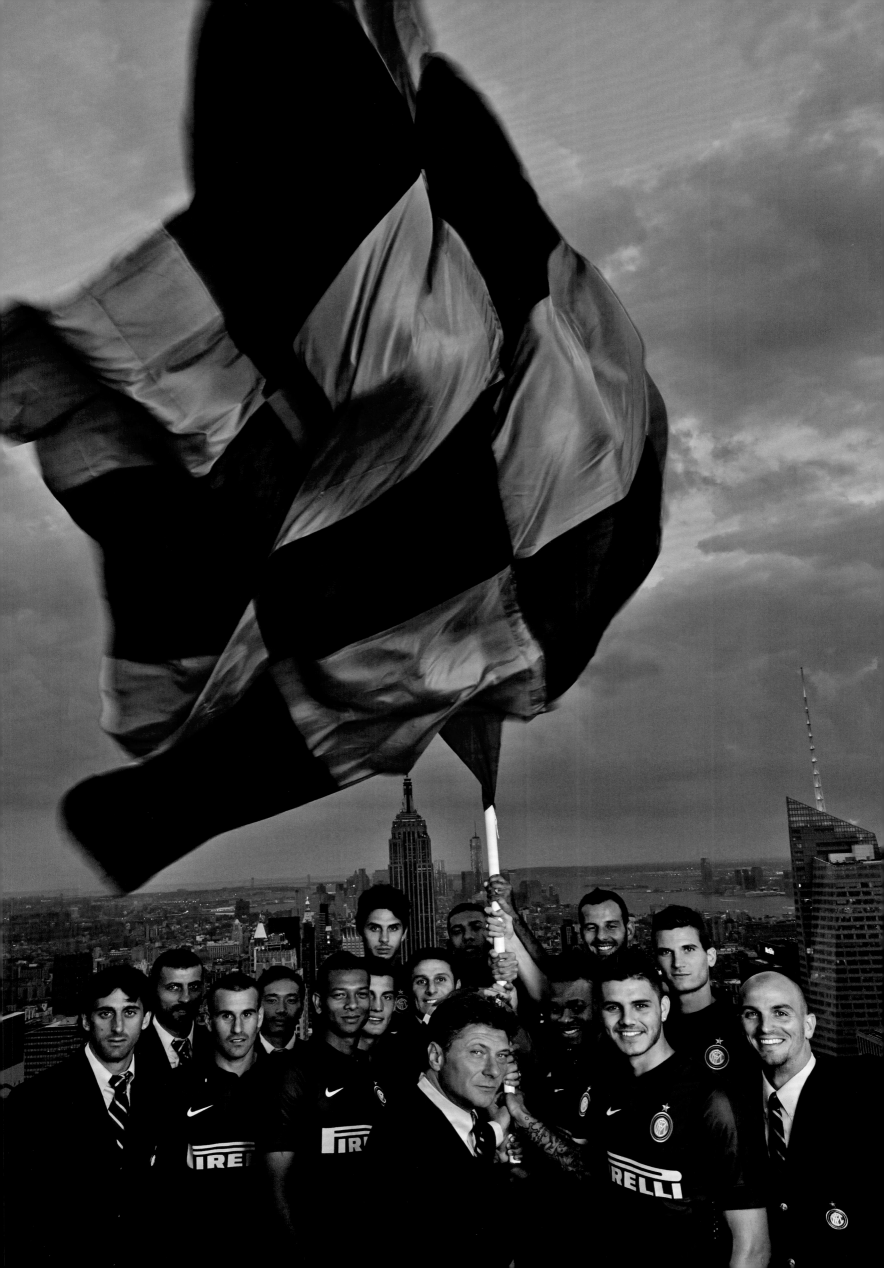

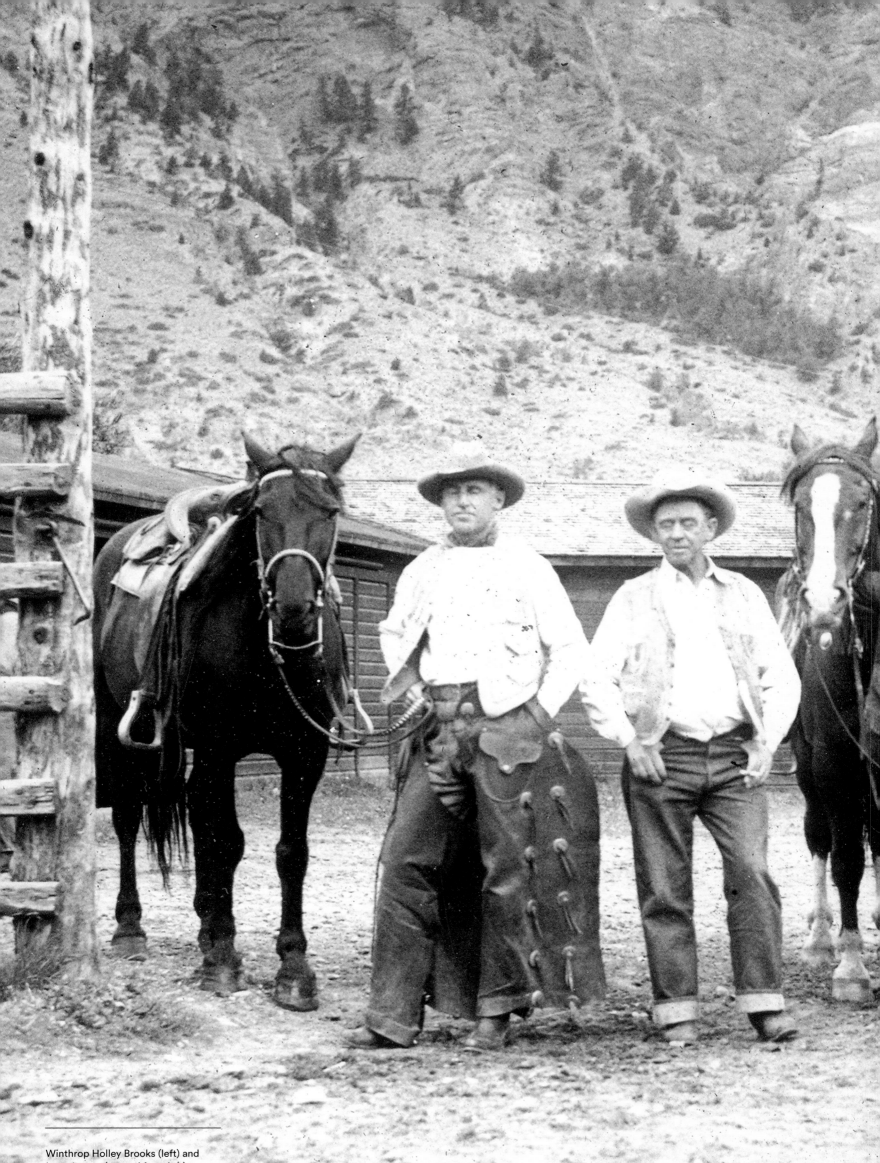

Winthrop Holley Brooks (left) and
Larry Larom (second from left)
at Valley Ranch, Wyoming, in 1930,
before Brooks returned East to
become president of his family's
company.

"He seeks to display his good taste
in dress by the perfect lines
of his garments and by the quality
of the material necessary to
preserve these rather than by any
thing exaggerated or obtrusive."

—from "THE DEVELOPMENT OF MALE APPAREL,"
a Brooks Brothers *Little Book* printed after World War I

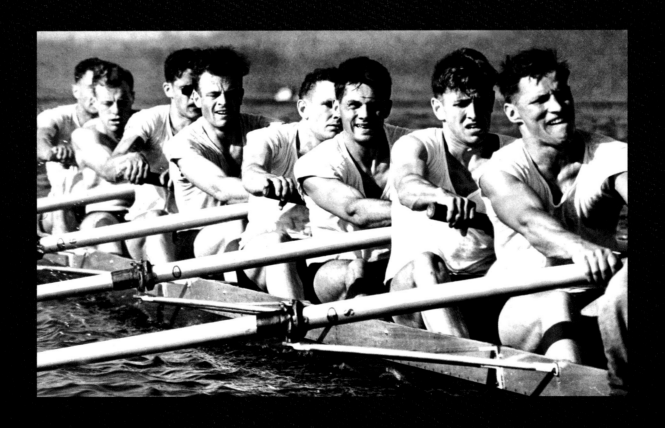

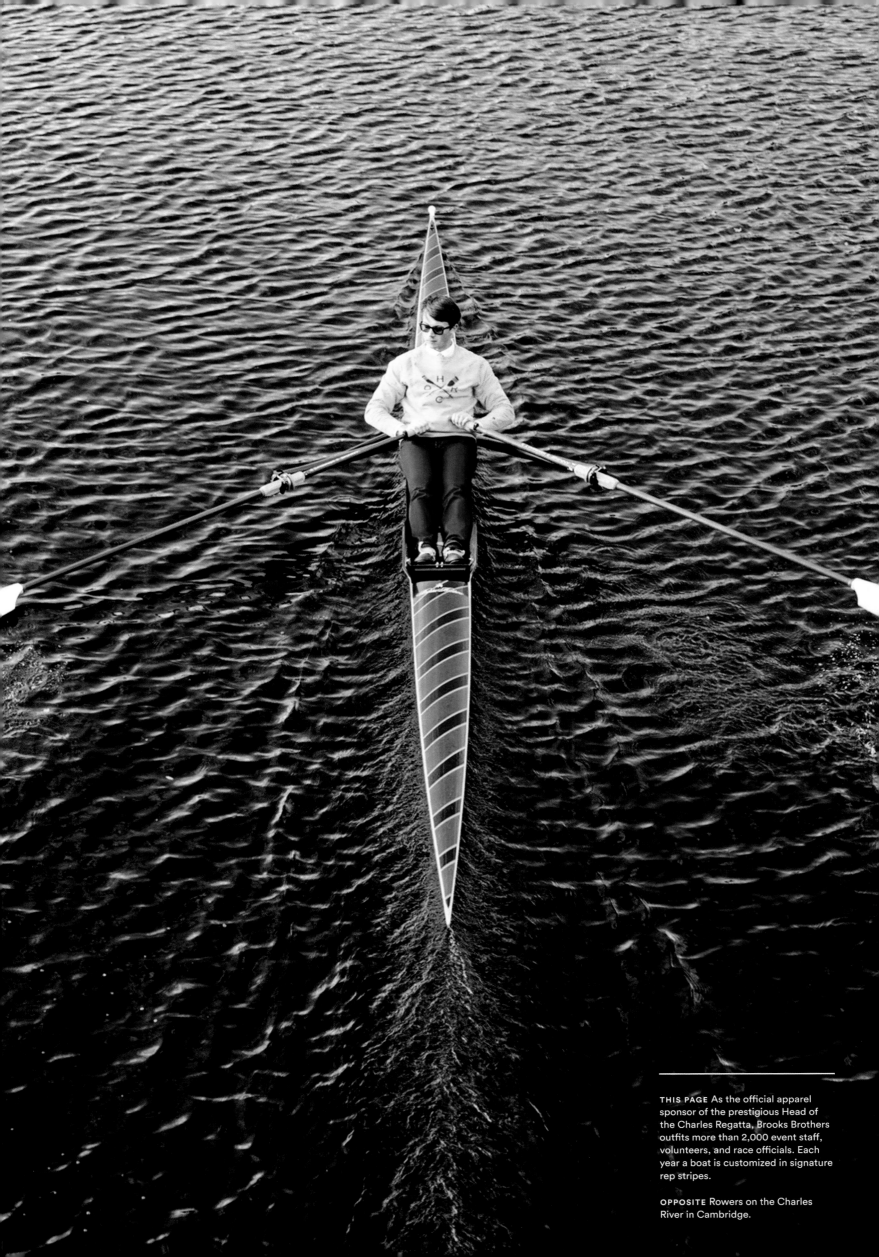

THIS PAGE As the official apparel sponsor of the prestigious Head of the Charles Regatta, Brooks Brothers outfits more than 2,000 event staff, volunteers, and race officials. Each year a boat is customized in signature rep stripes.

OPPOSITE Rowers on the Charles River in Cambridge.

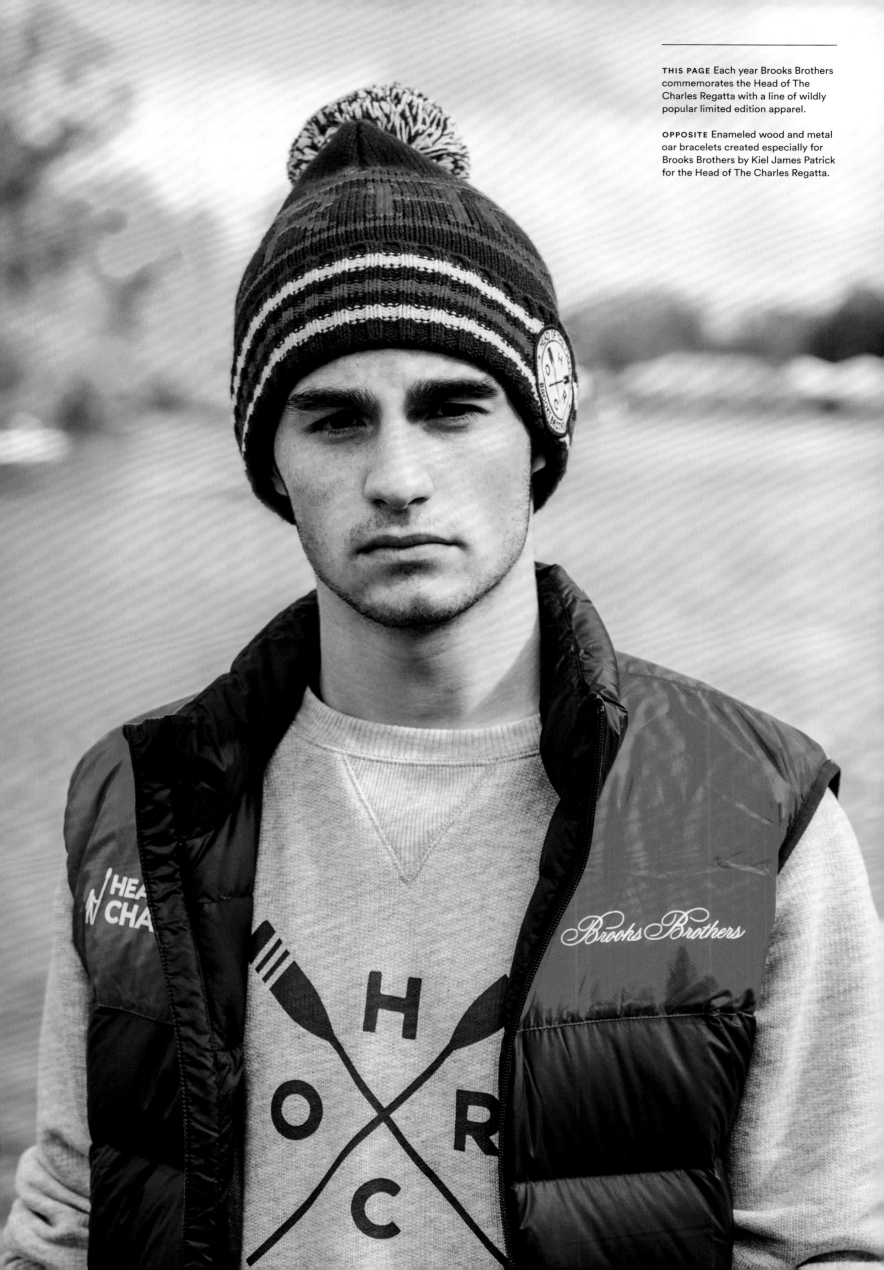

THIS PAGE Each year Brooks Brothers commemorates the Head of The Charles Regatta with a line of wildly popular limited edition apparel.

OPPOSITE Enameled wood and metal oar bracelets created especially for Brooks Brothers by Kiel James Patrick for the Head of The Charles Regatta.

THIS PAGE Brooks Brothers was the
first American retailer to import the
Lacoste knit polo shirt. Early versions
featured a co-branded label.

OPPOSITE A Paul Brown illustration
of lawn tennis matches. Brown
produced over one thousand
illustrations for Brooks Brothers.

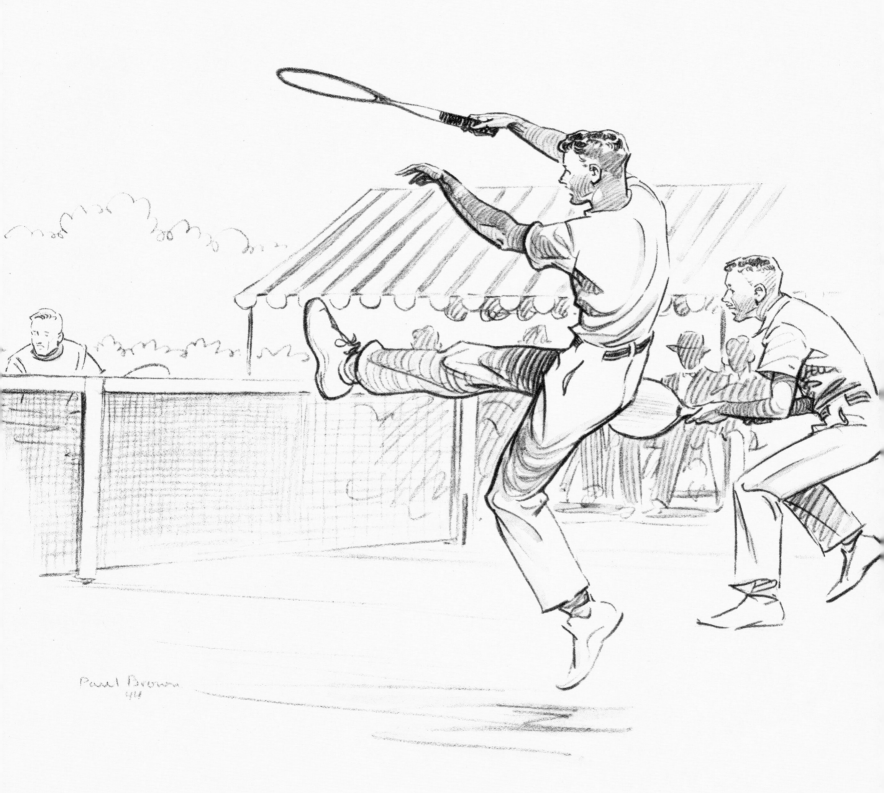

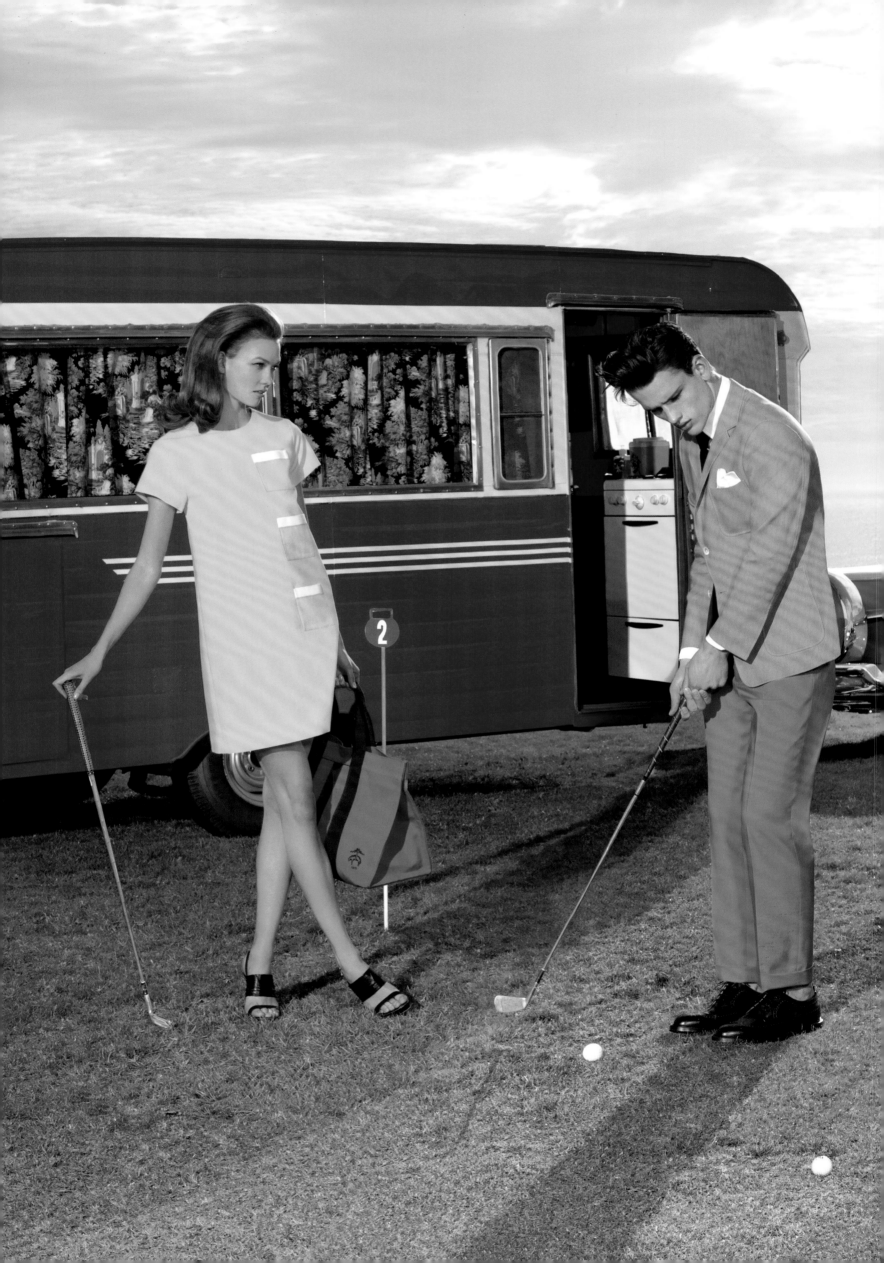

"I used to go to Brooks Brothers in the late 1970s when I was *Vogue*'s menswear editor and Brooks Brothers was right next door to the Condé Nast building. At that time men's fashion was really happening. Magazines like *GQ* and *Esquire* were shooting Armani and all that. But for many people a man was not appropriately dressed if he wasn't in something from Brooks. Everything had to be from Brooks—the pajamas, the underwear, the shoes. Brooks was the most American sign of good breeding.

I wasn't from that world, but I would go there to learn. I wanted to buy a Brooks Brothers suit so badly!

I remember Bruce Weber shoots in the late 1970s where we would use pajamas and bathrobes and the oxford cloth shirts—always Brooks shirts—we would put them on everyone. In menswear they always say you have to know the rules to break them. Of course we were mixing everything—coats and jackets over pajamas and bathrobes. To me Brooks was the standard of what everything should look like, and then we would pervert it. I still go to Brooks Brothers. I love the history of it and that there is a standard. It's the great American brand for men."

—**PAUL CAVACO**, fashion editor

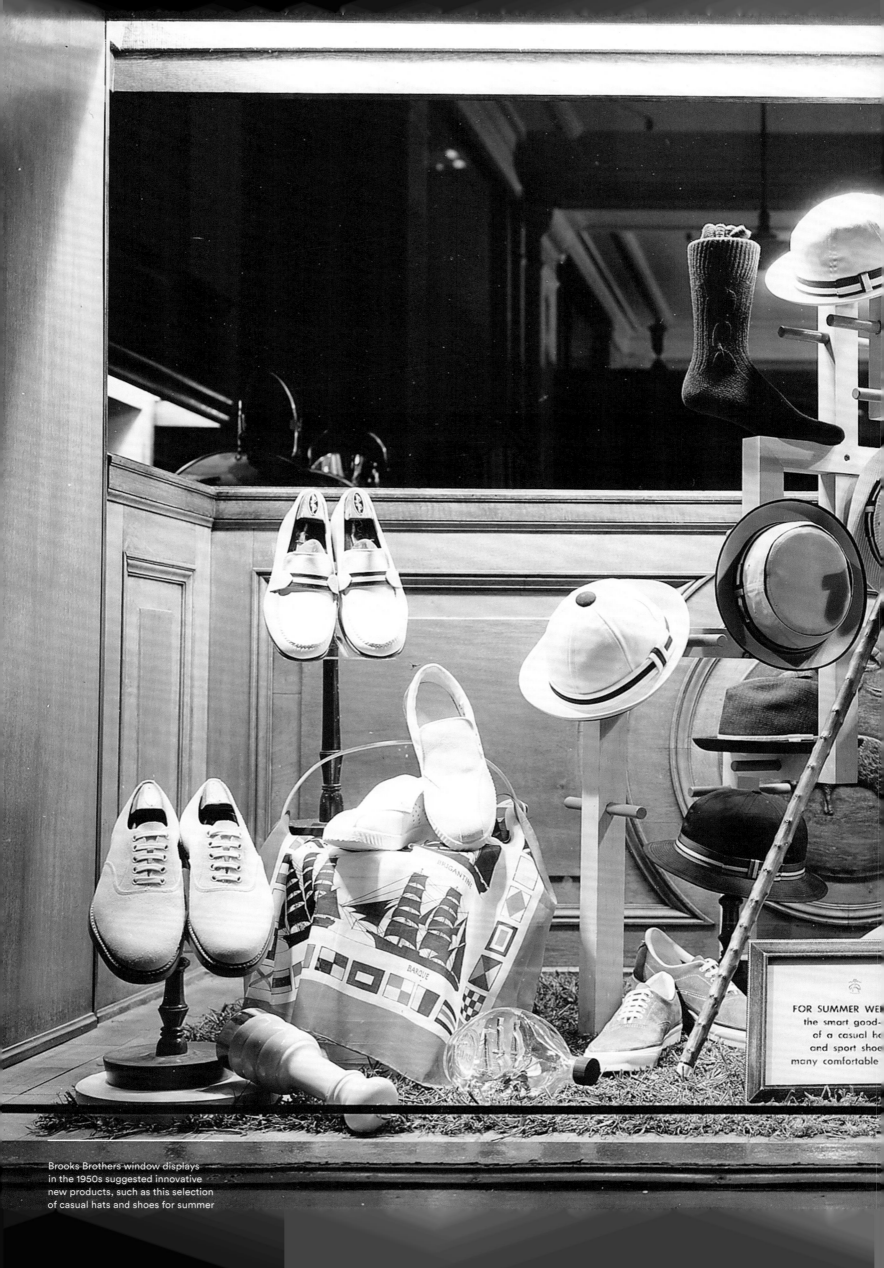

FOR SUMMER WE
the smart good-
of a casual h
and sport shoe
many comfortable

Brooks Brothers window displays
in the 1950s suggested innovative
new products, such as this selection
of casual hats and shoes for summer

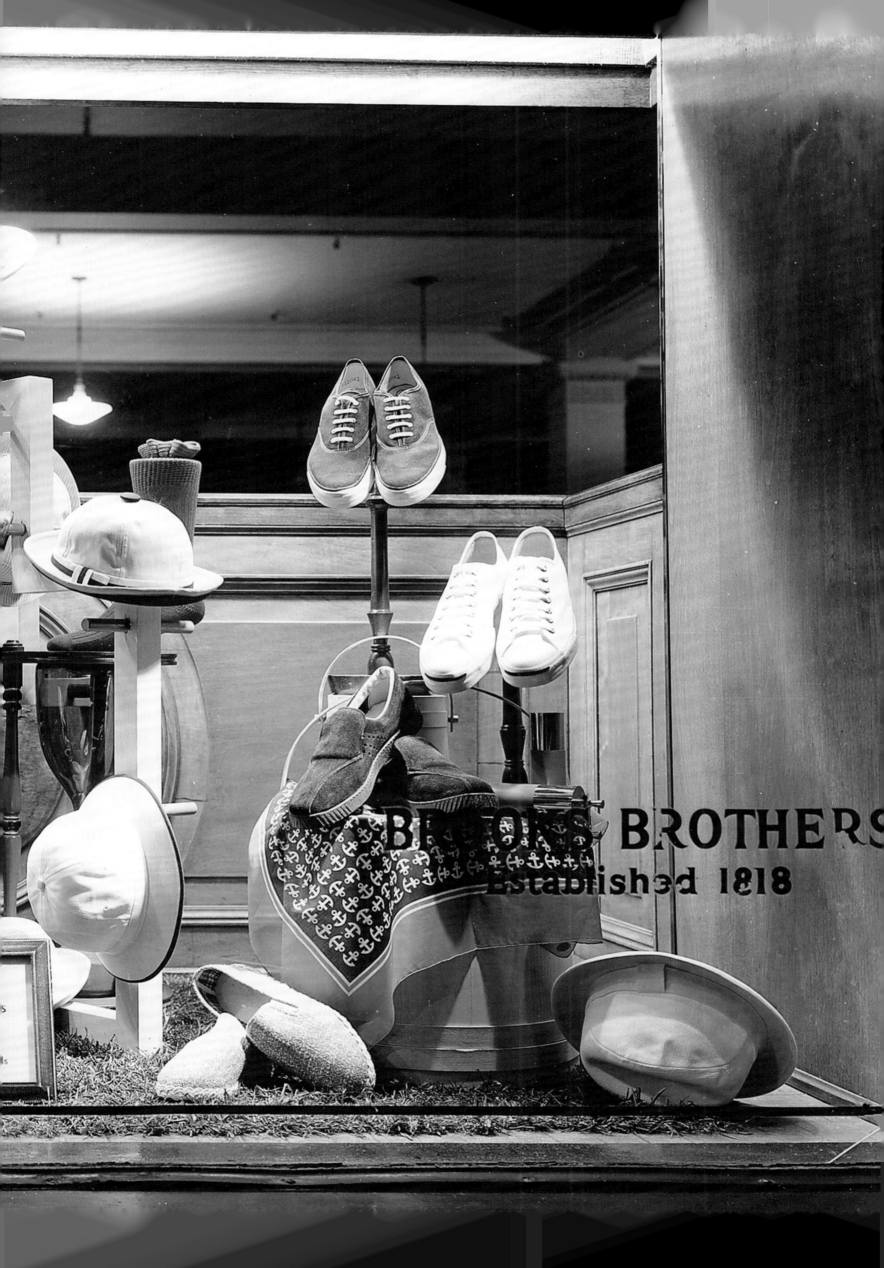

KS BROTHERS

CLOTHES
and the Hour

A

CO
18

Bro

The
LINKS
Book

A BOX OF MATCHES
BROOKS BROTHERS
CONTAINING
40 WAYS TO PLAY GOLF

Perip

The
Motor Book

Aero-

itudes

ARISONS
1923

BLISHED 1818

Brothers

Brooks Brothers
LIBRARY

The Replenishment of the
Wardrobe

Brooks Brothers *Little Books*, intro-
duced in 1900, schooled customers in
everything from customs regulations
for international travelers to links
course etiquette for the novice golfer.

POL

How the Fence-Breakers' League
Was "Stumped"

by David Gray

The
etic Hazard

B·B

Going to Europe

BROOKS BROTHERS
N.Y.

HUNTING
for the

an
M.F

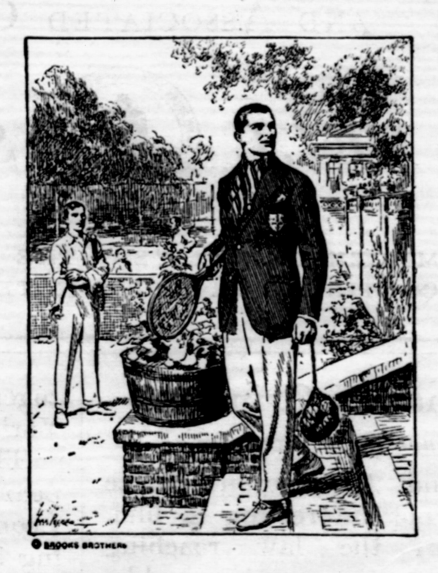

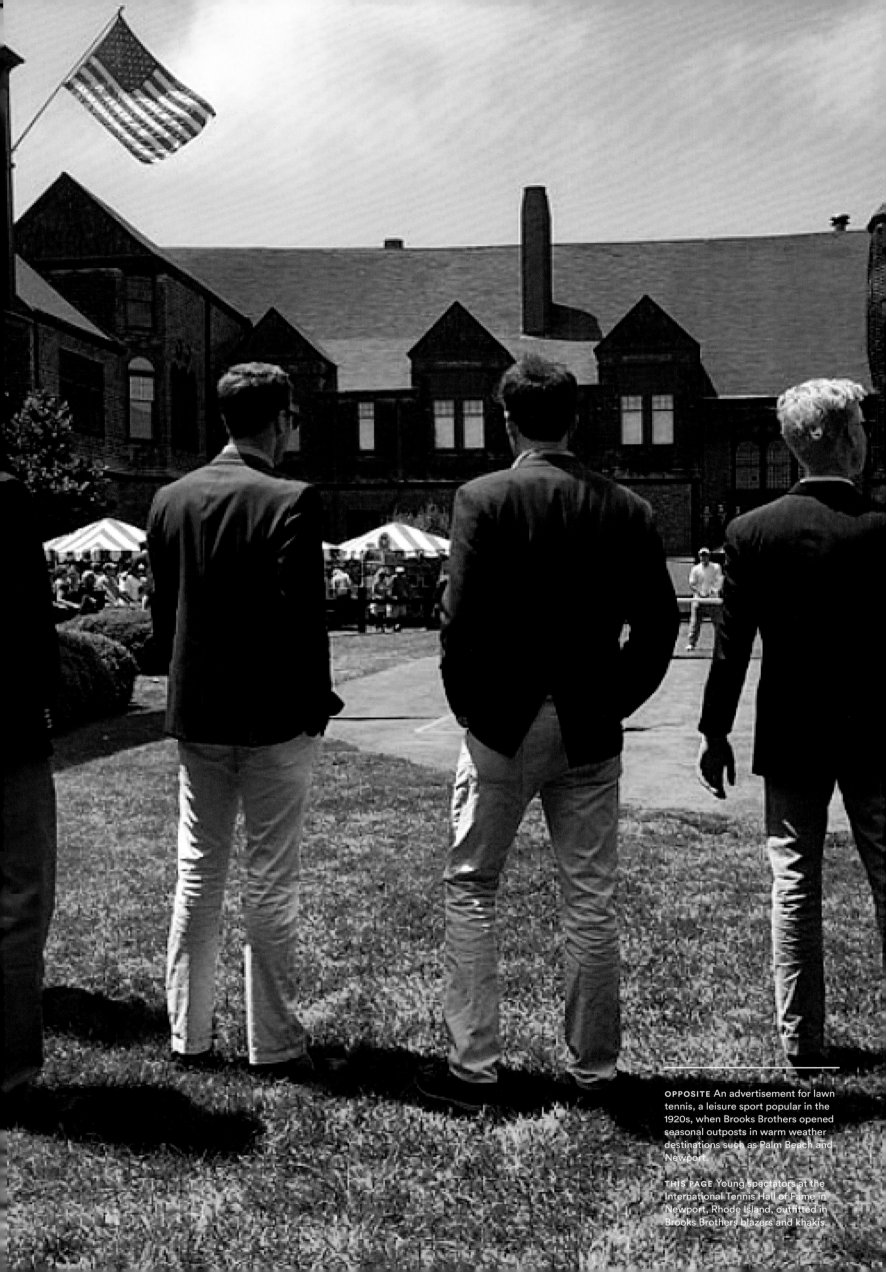

OPPOSITE An advertisement for lawn tennis, a leisure sport popular in the 1920s, when Brooks Brothers opened seasonal outposts in warm weather destinations such as Palm Beach and Newport.

THIS PAGE Young spectators at the International Tennis Hall of Fame in Newport, Rhode Island, outfitted in Brooks Brothers blazers and khakis.

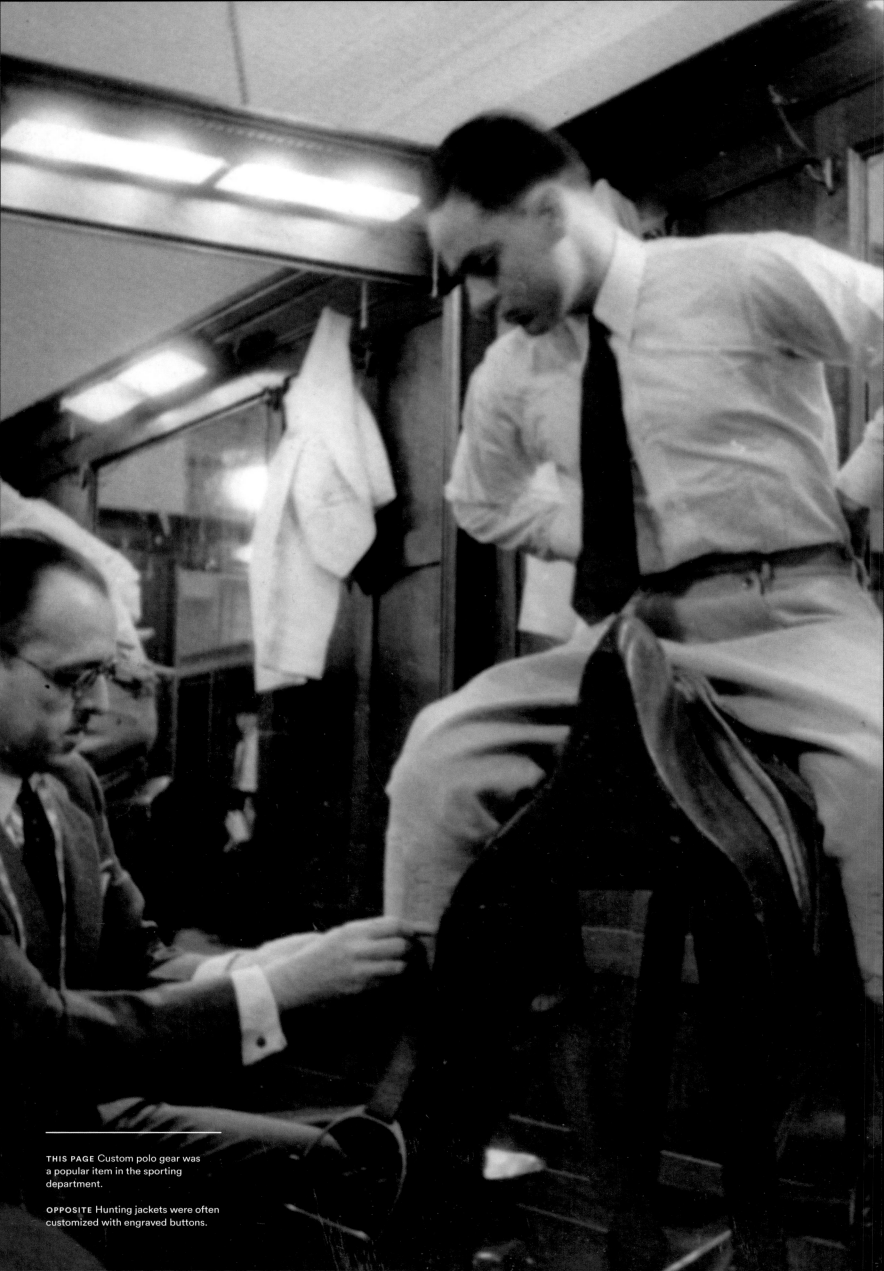

THIS PAGE Custom polo gear was
a popular item in the sporting
department.

OPPOSITE Hunting jackets were often
customized with engraved buttons.

IVY LEAGUE

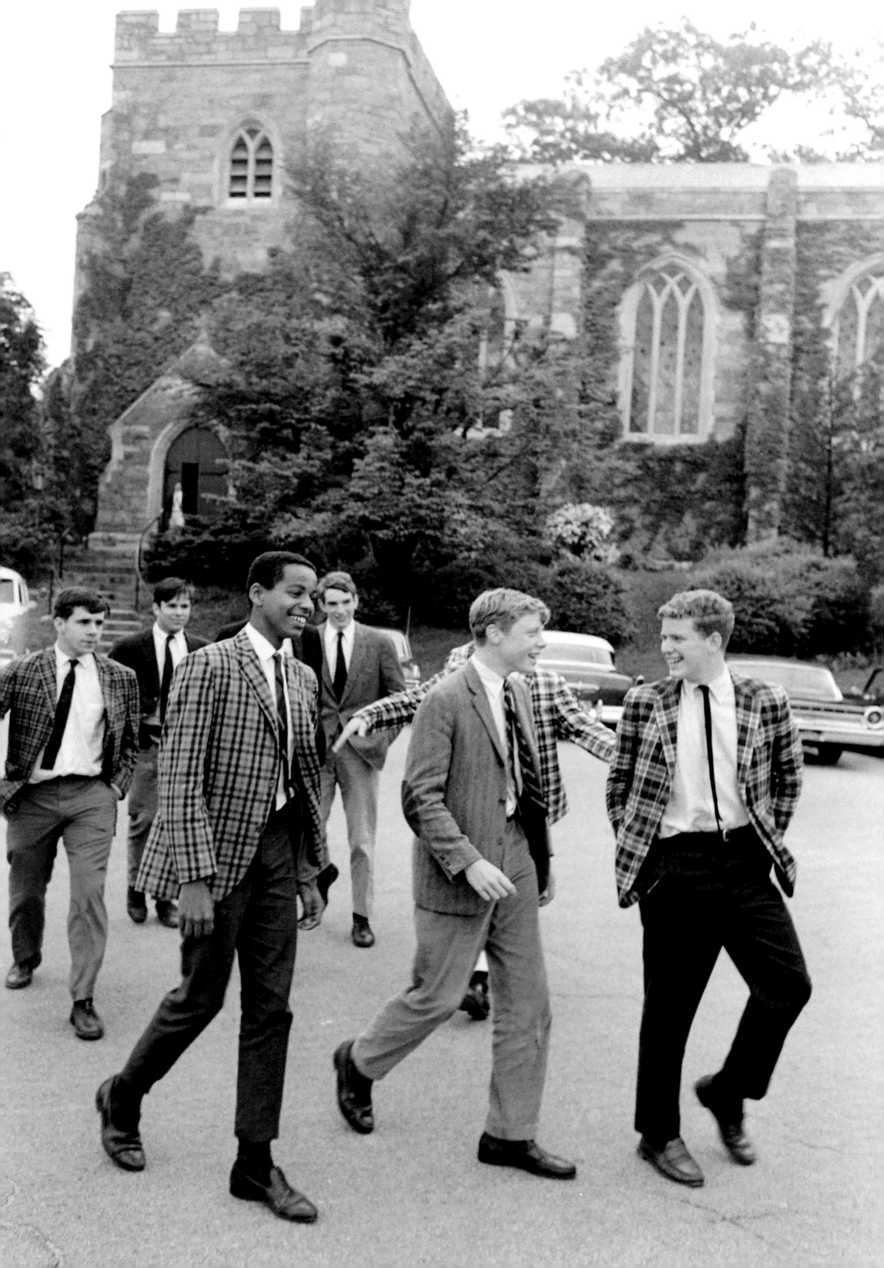

IVY LEAGUE

hey started young. The offspring of prominent East Coast families were brought to Brooks Brothers at age eight or nine to be fitted for their first holiday suit, pants, shirt, and tie. In the dressing room on the fourth floor, young boys would learn the dress codes that would serve them through college and into professional life. They would be dressed "appropriately" in a natural shouldered sack suit, or a Harris tweed or seersucker jacket, button-down oxford cloth shirt, khakis, argyle socks, and Alden loafers. This code became a kind of social blueprint for generations of Astors, Morgans, and Vanderbilts. For generations of upper-class educated men, and later, for a much broader socio-economic population, the message was clear: if you were dressed correctly, you could join the club.

When they went off to college at places like Princeton, Harvard, and Yale, they shared the code with their classmates, carrying this sensibility and sartorial proficiency from the dorm room to the playing field to the eating club. The idea was that once they knew the rules, they could break them, mixing sports clothing like tennis sweaters, golf knickers, and rugby shirts with their more formal daywear and articulating what would eventually come to be called Ivy League style.

The term "Ivy League" first appeared in the Christian Science Monitor in 1935 in reference to the formation of the sports league that dates back to 1876, when representatives from four universities met to decide on rules for the emerging game of college football. Sports culture influenced many aspects of Ivy League style, from the knickerbockers and tasseled loafers of golf to the crested blazers worn by rowers at the Henley Royal Regatta in England. It was after the first World War that this idea of sports-influenced clothes took root on Ivy League campuses, particularly Harvard, Yale, and Princeton. Illustrators like J. C. Leyendecker were capturing the tweedy look for magazine covers and F. Scott Fitzgerald was describing the Ivy League uniform in *This Side of Paradise*. When the character Tom D'Invilliers, a friend of the protagonist, complains about the conformity and superficiality of the Princeton look, Amory tells him it's too late, he has already "been stamped," he is already wearing the clubby uniform of his fellow coeds: a tweedy Norfolk jacket, a Brooks Brothers button-down shirt, a rep tie, maybe even a Shetland sweater.

In Fitzgerald's era, style was the path to social success. Conformity was cool. Nobody wanted to be out of sync with the crowd. And Brooks Brothers perpetuated the code, dispatching traveling salesmen—what they called Road Men—to every major American city and college and prep school campus to sell and replenish wardrobes with oxford cloth shirts, khakis, and navy blazers.

OPPOSITE Skinny rep ties, madras jackets, and white oxford button-down shirts were all the rage on prep school and Ivy League college campuses in the 1960s.

Later, in the 1950s, fashion sections of newspapers and magazines featured the "Ivy League Look"—a look essentially defined by Brooks Brothers. Students on these campuses would have three essential wardrobes—one each for formal, casual, and sports—and they began this idea of mixing and matching these pieces. Brooks Brothers picked up on their habits, selling what they called "odd trousers," which didn't match a jacket, or creating accessories like socks and ties with brightly colored new dyes that were just coming onto the market.

After World War II there was an influx of working- and middle-class students into the Ivy League, which had previously been a bastion of conservative, white, upper-class privilege. The result was a kind of fusion of the Ivy League look; jazz musicians were wearing it, and middle-class kids were aspiring to it. Even women picked up on it.

"The more you could buy from Brooks Brothers, the better," recalled Mira Lehr, a 1956 Vassar graduate. "I ran to Brooks Brothers to buy everything; the store had an attitude that made you feel you were part of this select group who were smart, privileged, and had great futures." Soon, women at the Seven Sisters schools had adopted their own Ivy look: madras Bermuda shorts, knee socks, loafers, and Brooks Brothers button-down oxford shirts. They were dressing to be part of an elite.

"Ivy style was really like the first street style," says Patricia Mears, deputy director of the Museum at FIT. "Menswear publications like *Apparel Arts* were sending photographers to these Ivy League campuses to document trends; they were looking to these elite schools for this new style."

It may have started as a social code, a sign of prestige, status, and wealth among affluent college students, but the Ivy League look has become essentially democratic, so widely copied and admired globally that the style has outgrown its original parameters and is now popular from Tokyo to Tennessee.

OPPOSITE A 1940 Brooks Brothers
catalog featured school uniforms.

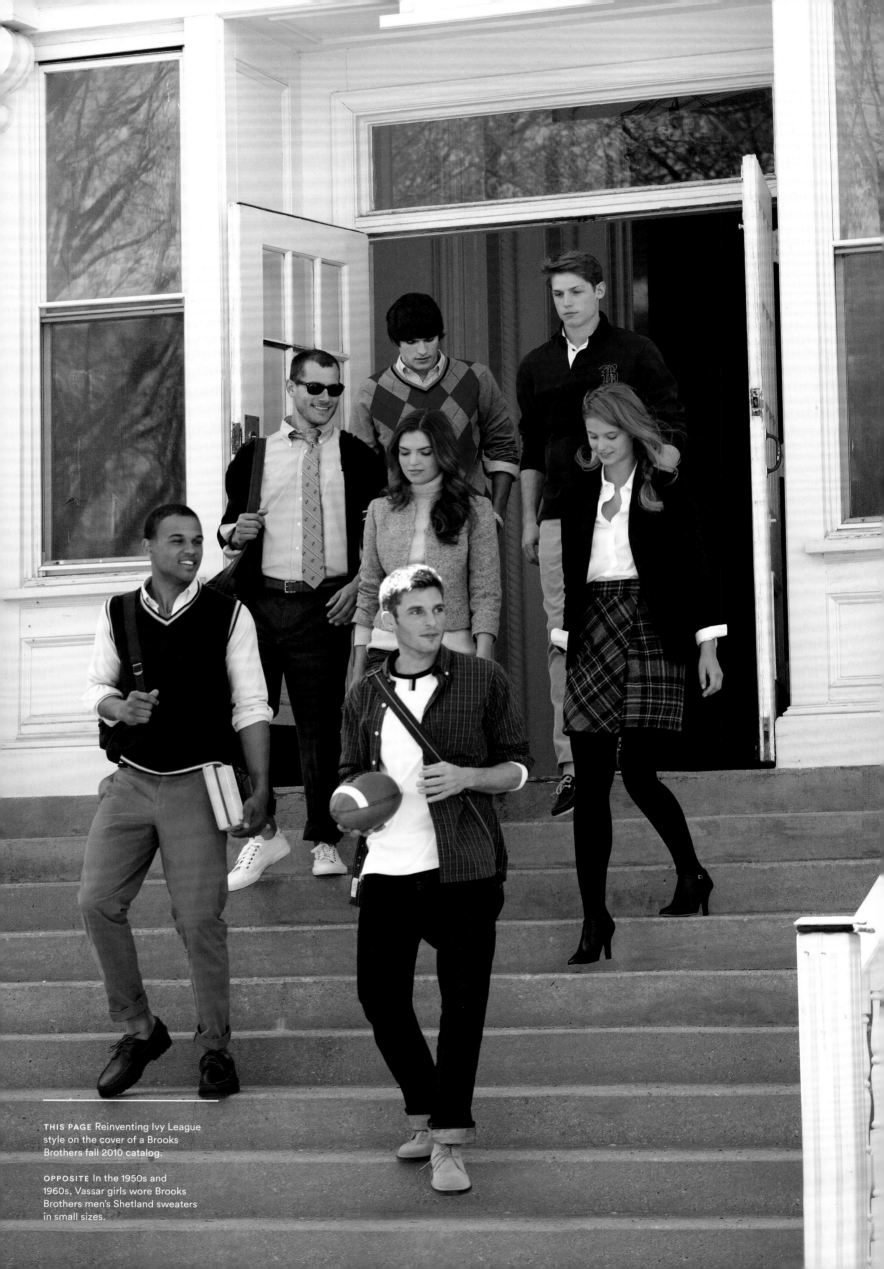

THIS PAGE Reinventing Ivy League style on the cover of a Brooks Brothers fall 2010 catalog.

OPPOSITE In the 1950s and 1960s, Vassar girls wore Brooks Brothers men's Shetland sweaters in small sizes.

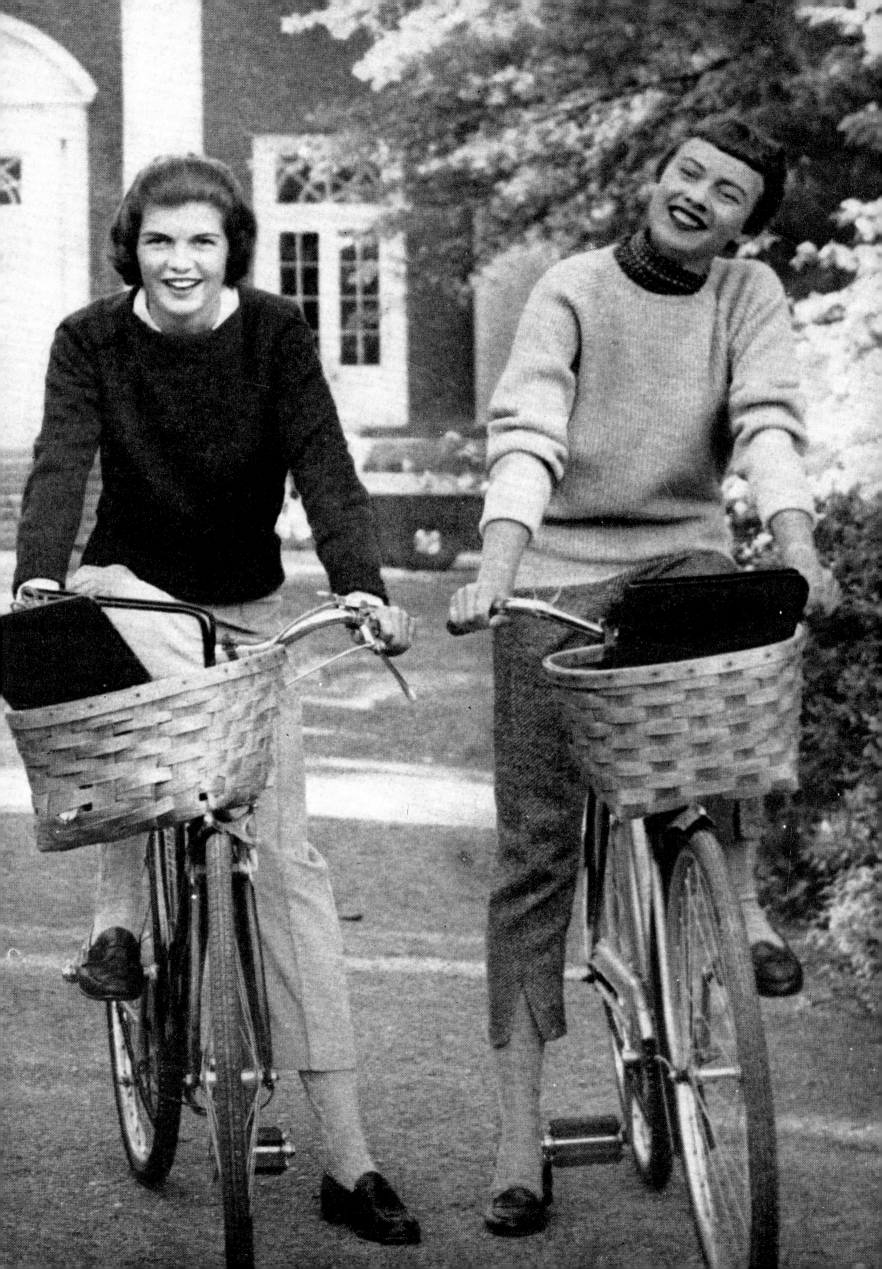

"I must have so many characters wearing Brooks Brothers! It's such a New York institution of male dress. It's almost like it stands for a certain kind of man— reliable, upstanding, decent."

—CANDACE BUSHNELL, best-selling author of *Sex and the City*

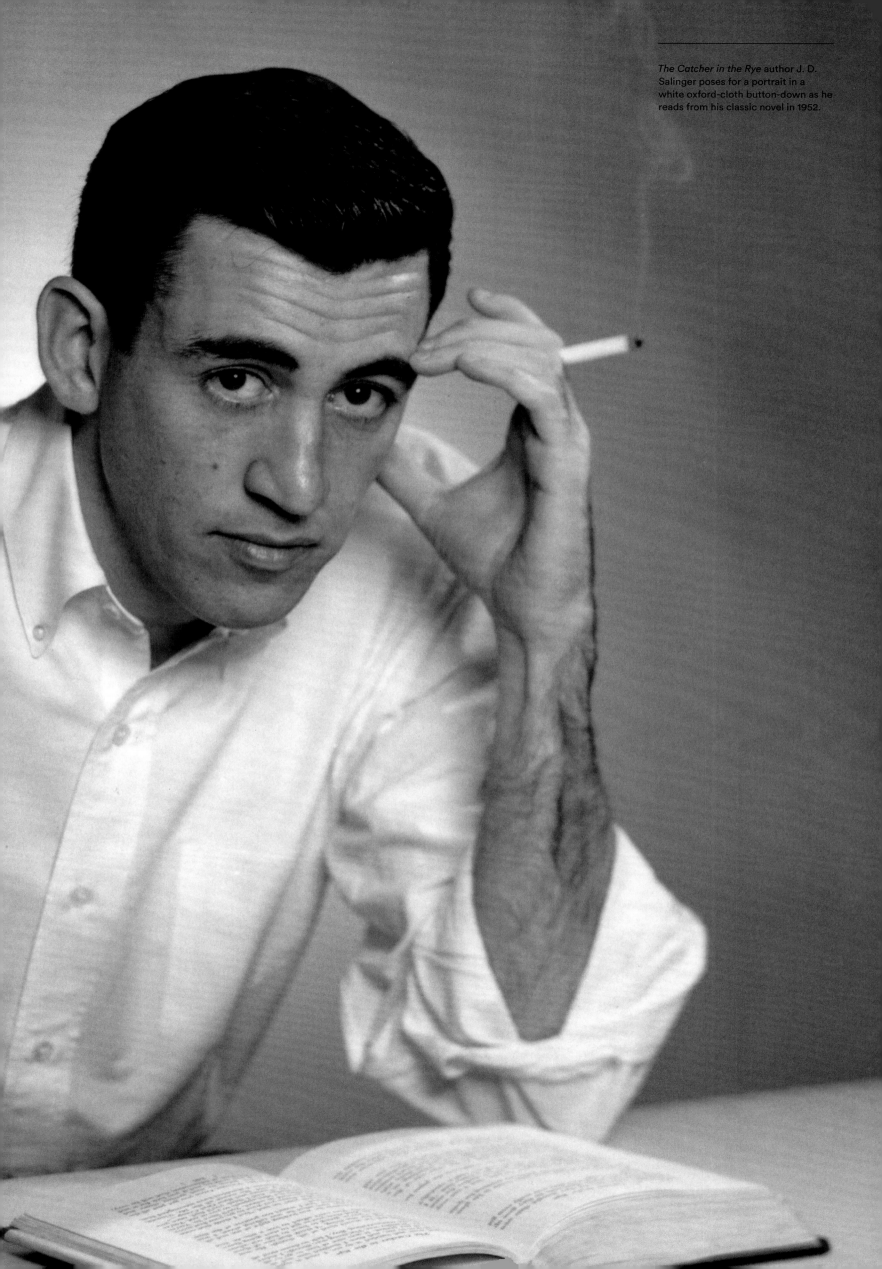

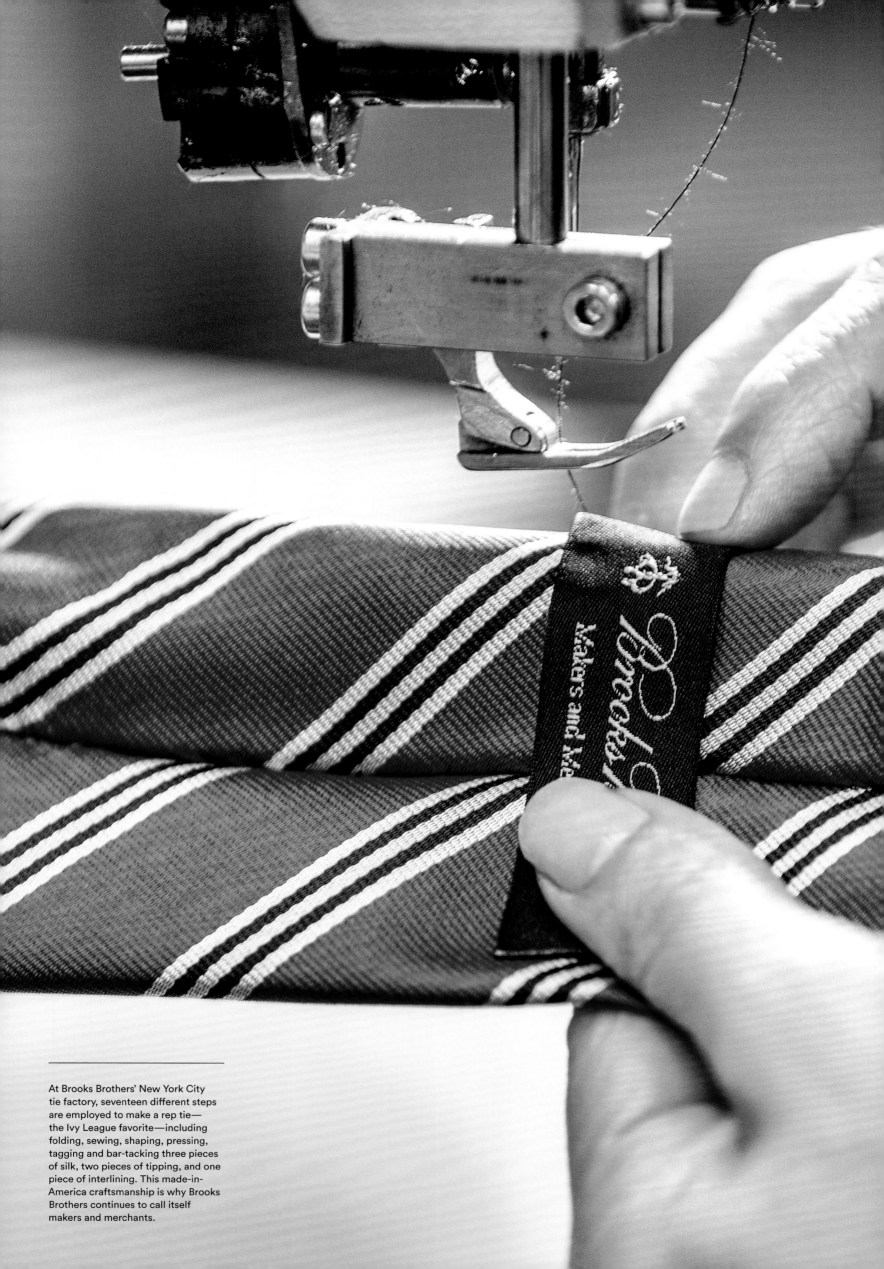

At Brooks Brothers' New York City tie factory, seventeen different steps are employed to make a rep tie—the Ivy League favorite—including folding, sewing, shaping, pressing, tagging and bar-tacking three pieces of silk, two pieces of tipping, and one piece of interlining. This made-in-America craftsmanship is why Brooks Brothers continues to call itself makers and merchants.

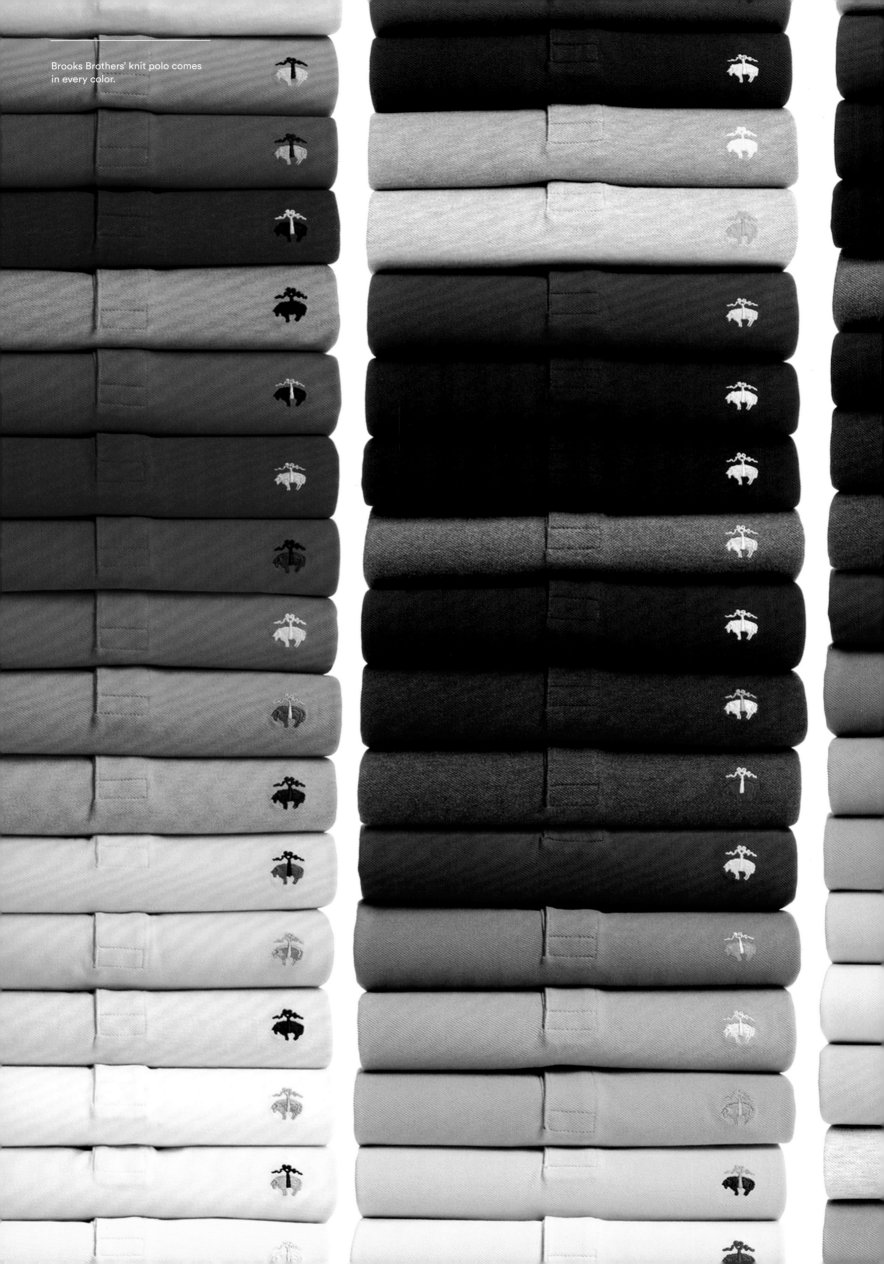

Brooks Brothers' knit polo comes
in every color.

A GOLDEN TALISMAN

by **JAY FIELDEN**

I once had a friend named Julian. This was thirty years ago, when I was sixteen and growing up in San Antonio. My family was Episcopalian but didn't attend church much; even so, I became an acolyte assigned to the early service, which made it even more likely I'd be going alone. I had to arrive around 8 a.m. so that I'd have time to slip into the crucifer's white vestments and light the candles, yet invariably I woke up late and made up for lost time by pushing my four-speed 1969 Volvo 144 until the needle of the heat gauge danced into the red.

I cringe a little when I picture myself then. Yellow-lighting it down the final stretch of a palm-lined drive with cars parked on either side, trying to outspeed the clock on my dashboard as it ticked toward the moment when the service would begin, I was in such a panic that I often didn't touch the brake pedal until the nose of the car had broken the plane of my favorite parking spot. Franny Glass's pilgrim and W. Somerset Maugham's *The Razor's Edge* had given me romantic ideas about the holy life, but I'm not sure how my hell-on-wheels Sunday morning dash fit into the picture.

Sprinting for the sacristy, I'd catch a blurred glimpse of the church, a beautiful old thing made of brick and sandstone, with a tall spire and a genteel garnish of ancient oaks. The core of the congregation was the well-heeled offspring of the city's prominent families, and the pageantry of dress had a cocktail-hour snap. From where I sat near the altar, I could take in how their wardrobe changed with the seasons

JAY FIELDEN is the editor in chief of *Esquire*.

while listening to some memorable sermons (one of which was delivered by an associate priest wearing a rubber skull extension that made him look like Dan Aykroyd doing a *Coneheads* sketch on *SNL*) and occasionally feeling the cold slap of mortality when I came across lines like these, from one of Isaac Watts's famous eighteenth-century hymns:

> Time, like an ever rolling stream
> Bears all its sons away;
> They fly, forgotten, as a dream
> Dies at the opening day.

Hanging out afterward with a band of kids scattered from other high schools and neighborhoods who shared this seventh-day bond, I was always making a new friend. One day the boyfriend of someone showed up, a cool guy, I could tell, because he was wearing a pair of Diadora Heritage tennis shoes with a blue blazer whose buttons were embossed with the Golden Fleece. Julian, as he introduced himself, looked like Sting in the middle of puberty: spiked blond hair with an Adam's apple. I was trying to signal my own allegiance to the New Wave section of the record store with a complex mix of moussed hair, white bucks, and a bolo tie. It was clear, without our having to say it, that we liked the same music—the ultimate test of compatibility at that age.

Soon enough we began hanging out. For some reason I always seemed to go to his place, a bungalow apartment full of creeping plants, European stereo equipment, and herbal aromas. Julian lived between there—with his mother, who pretty much stayed behind closed doors—and his grandparents' condo nearby. His father, a photographer perpetually traveling the globe, seemed not to have been around for years. On the walls hung many of his pictures, and it was through these and Julian's prized possession—the Rolleiflex around his neck that his dad had given him—that he conjured the flickering mirage of his family.

He and I competed, as friends do, over the things we envied about each other. I imagine it was genuinely hard for Julian to know I had a father at home; one reason he probably never came over was so he could pretend it wasn't true. And I think I wished for what Julian had: a little freedom from an authority figure who, when you're that age, can seem more enemy than friend. But we were just as receptive when it came to each other's delusions. Would Julian become the next Mats Wilander? I could see that. Was I going to be F. Scott Fitzgerald? He was pretty positive.

"I think I should probably go to Exeter," I said one day, as I watched him smoke a cigarette.

"That'd be good," he said. "It's not far from Andover. I could visit you."

Neither of us had even applied to boarding school, much less the top two in the world. But we didn't call each other's bluff. We were, like most people, encircled by dream-dousing circumstances, and what we needed was the company of someone who could appreciate a colorful piece of fiction.

There's a blank in my memory between that conversation and the next time I saw Julian, perhaps a few months later. I remember having the sense—it was probably the reason I hadn't seen him—that his grandparents had had to take him in. We first exchanged endearing insults, and then, with a forced smile, he told me it was finally coming true. "They're sending me to boarding school," he said, and then went on to tell me about the trip he'd been on to decide which one.

He dropped a few unforgettable details, including the fact that he'd spent a weekend in New York City. His grandmother had taken him there to shop at Brooks Brothers, where he stocked up on everything he'd need at school: khakis and gray flannels; button-downs and sweaters; a trench; and so on. He described the store on Madison Avenue, around the corner from Grand Central—the walls of shirts, the tables of ties. Having never been to Manhattan, I could only imagine it.

"I got you something, too," Julian said, handing me a shopping bag with a blue box. Inside was a white polo shirt, the Golden Fleece emblazoned in yellow thread on its left breast. It immediately became my favorite shirt, something that made me feel as if my friend was near even years after he had gone away.

A coffee cup from Brooks Brothers'
Red Fleece Café in Manhattan's
Flatiron district.

Dustin Hoffman wore Brooks Brothers
to portray a bewildered college
graduate in Mike Nichol's 1967 film
The Graduate.

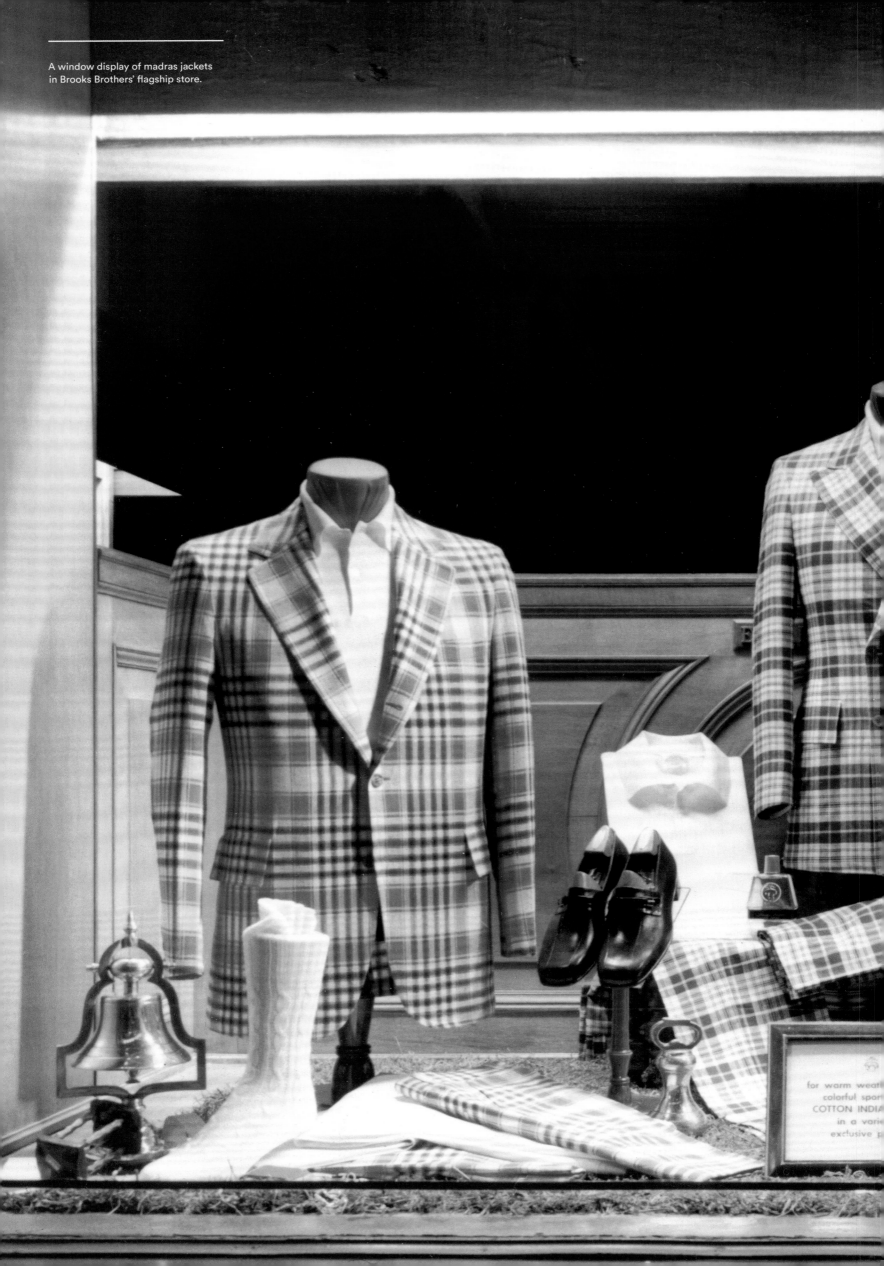

A window display of madras jackets in Brooks Brothers' flagship store.

for warm weath
colorful spor
COTTON INDIA
in a vari
exclusive p

BROOKS BROTHERS
Established 1818

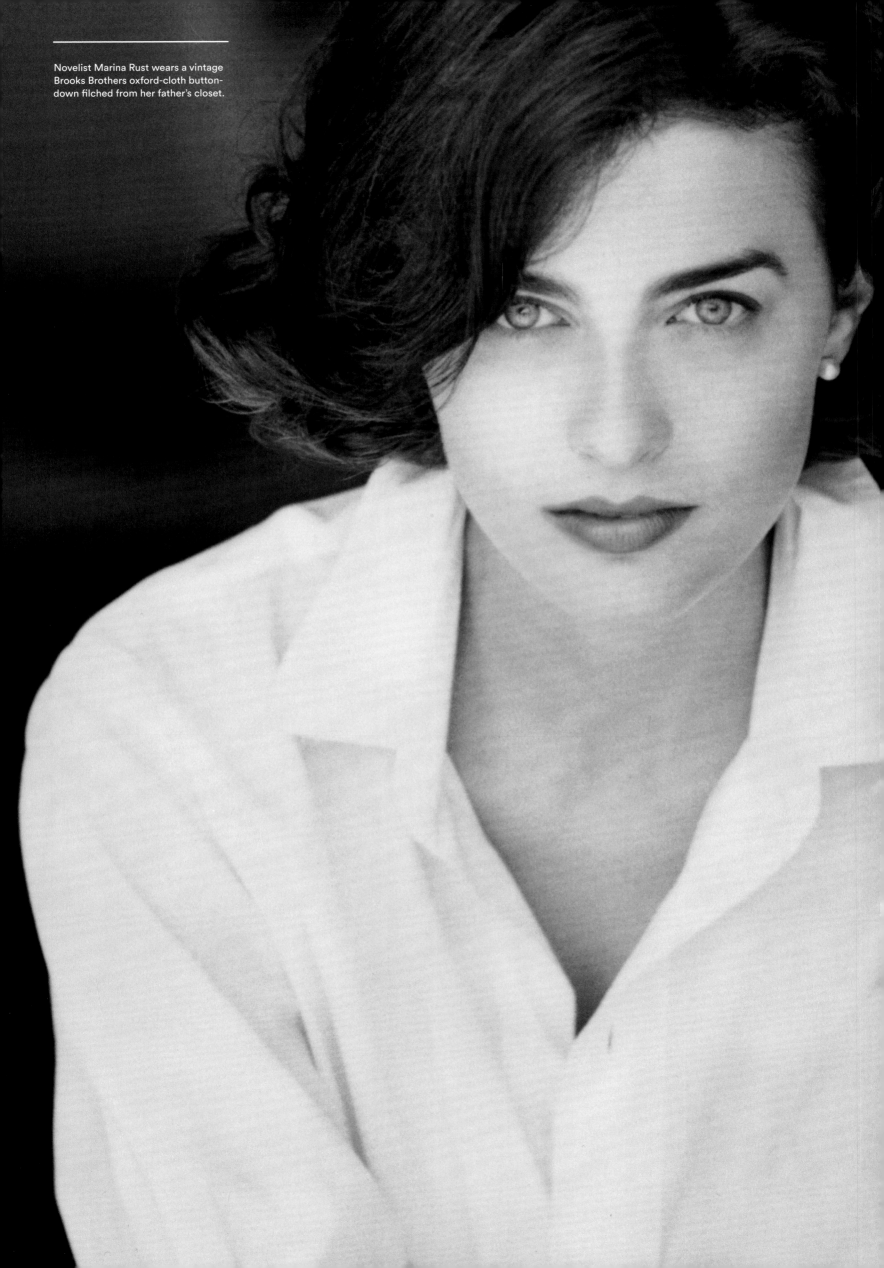

Novelist Marina Rust wears a vintage
Brooks Brothers oxford-cloth button-
down filched from her father's closet.

THE LADIES' DEPARTMENT

by MARINA RUST

I was raised in Washington and as a single Dad, my father would take me shopping at the downtown Brooks Brothers. He'd shop for his stuff, I'd shop for me. Freshman year of college, an assortment of long pleated skirts and crisp cotton blouses from Brooks got me through sorority rush. Coming home that summer, I decided every boat on its own bottom, and that I should get a job—preferably one with an employees discount. I marched to the Brooks Brothers at 19th and L and asked Dad's favorite salesperson, Carole, if they took summer hires. An interview was arranged, after which I was offered a job in the ladies department, where I put my discount to immediate use. I think I bought an ivory linen skirt suit and a floppy silk tie. Soon, we'd receive a shipment of seersucker golf skirts (these, in 1984, were what I thought of as date clothes).

It was a fun job, it felt much like a family. As I mentioned, they'd put me in the ladies department, which was not where I wanted to be. I wanted to be in men's ties. Thankfully, the store was basically all on one level, and while shirts, shorts and ties were in the grand front space, male customers would have to walk past the ladies department in order to get to suits. I ended up liking where I was placed—the idea that lawyers and lobbyists would take advice from me about what to wear to work seemed extraordinary, and I took great satisfaction in each suit with floppy tie I sold.

Carole had a beau in men's suits. She and other staff conspired and set me up with a young man who worked in shirts. I was slightly intimidated, as this guy was in his mid '20s and had modeled for the "Are You a Preppy?" poster. (He'd gone to UVA, I think.) I remember Carole and others waving good-bye as he and I left the store for lunch at a nearby cafe. I can't remember how lunch was and I don't remember his name or what I wore. Surely it was from stock.

Brooks Brothers and that location at 19th and L were intrinsic to Washington. It was social central, a meeting place. Today it would be like running into someone at Barneys. You ran into boys at Brooks Brothers. Think about it, you wouldn't run into boys at Neiman Marcus, would you?

MARINA RUST is an author and a contributing editor at *Vogue*.

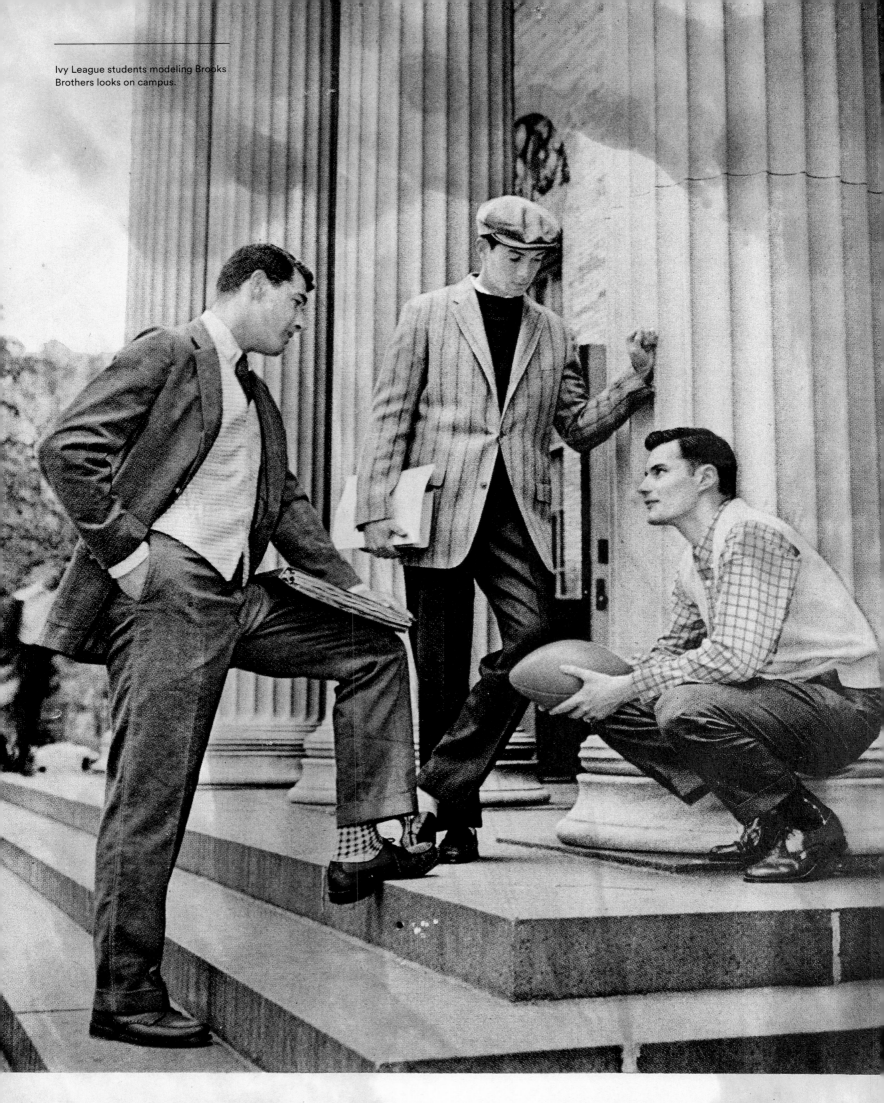

Ivy League students modeling Brooks Brothers looks on campus.

Bright clothes are as much of college as footballs, books and Greek pillars. The serious man at left has on a Brooks Bros. dacron/cotton corduroy suit ($58) with button-down shirt ($8.50). The vest is a Currick & Leiken tattersal ($15) with an Arrow tie ($1.50). In the middle, he's wear-ing a Chester Laurie Shetland jacket ($45); Arrow shirt and alpaca and wool sweater ($5 and $12 respectively); Majer slacks ($22.50) and a Knox corduroy cap ($4). The varsity man at right has on a Hathaway shirt ($9); Jantzen wool-and-vicara sweater ($10) and Majer slacks ($22.50).

A SENTIMENTAL EDUCATION

by KATE BETTS

On my phone I have a photo of my father, Hobart Betts, standing on the steps of the Colonial Club at Princeton. He must have been a sophomore or a junior, posing with a fellow club member at the start of what must have been spring house parties. He's wearing a crisp white three-button dinner jacket, a narrow dark tie, and high-waisted flannel pants—what was typical dinner attire at Princeton in the 1950s. To join the club, metaphorically speaking, you had to have a "complete" wardrobe of formal attire, jackets, and ties for class, and sports clothing for the playing fields.

In another photo of my father as a young Princeton grad he's sitting at the summit of the Matterhorn surrounded by four fellow climbers (one smoking, believe it or not). They're each bundled in layers of Shetland sweaters, Harris tweed jackets and knickers, and red-laced leather hiking boots, all outfitted at Brooks Brothers.

Like so many of Brooks Brothers' steady customers—or "see you" patrons as they were called—my dad was a creature of habit. Even in his late sixties he wore the same style Brooks Brothers gray flannels and white cotton V-neck undershirts and yellow or white oxford cloth button-downs when he attended lectures in McCosh Hall as a Princeton freshman.

As a kid, I remember looking through my dad's dresser drawers and marveling at the orderly rows of black wool socks, white cotton undershirts, and blue oxford cloth boxer shorts. A second drawer was filled with rows of pastel-colored oxford cloth shirts, still folded with drycleaner's pins tucked into the sleeves and resembling a box of rainbow sherbet. His suits hung side-by-side, alternating fabrics and colors (gray flannel, blue worsted wool), each with a natural shoulder and skinny lapels. The tie rack was a chorus line of dark collegiate colors and patterns—rep, foulard, rep, foulard. Dad was an architect; he appreciated order and structure.

On the few occasions that my father veered from his Brooks Brothers wardrobe, he would duck into André Oliver's Parisian-style haberdashery on Fifty-Seventh Street, across from his office, to buy cobalt blue or persimmon Shetland sweaters and magenta silk ties. In the 1970s and early 1980s menswear got a jolt of color when European designers began to infiltrate the American market (to my mind, Oliver's shop seemed a Technicolor, European version of Brooks Brothers). At Christmas time or when his birthday rolled around in the end of May, Dad would request homemade gifts or, perhaps something "odd" from Brooks—a black watch tartan robe or a pair of those strange elastic sock garters they used to sell.

When Barack Obama was elected in 2008, Dad ordered a dark blue suit from Hart, Schaffner, Marx. It was his way of marking that historic moment and pledging allegiance to our new president. Dad topped off that suit with an orange and black striped Princeton scarf.

Late in his life, when he was disabled and had trouble climbing the stairs to the Madison Avenue store, my father asked me to drive him to the Brooks Brothers outlet near his home on Long Island. As we entered through double-glass doors, Dad lingered by a table of $39.99 polo shirts. I wondered if he was disoriented, but then quickly realized he was simply looking for a familiar face, a "see you" salesperson.

After Dad passed away, I looked through his dresser drawers and found the same neat rows of socks and undershirts. His closet was filled with the same sequence of oxford cloth button-down shirts, but fewer suits. In retirement he had relied on a pair of Brooks Brothers brass buttoned blazers that hung next to each other and, to my astonishment, looked almost new.

KATE BETTS is the author of *My Paris Dream: An Education in Style, Slang, and Seduction in the Great City on the Seine.*

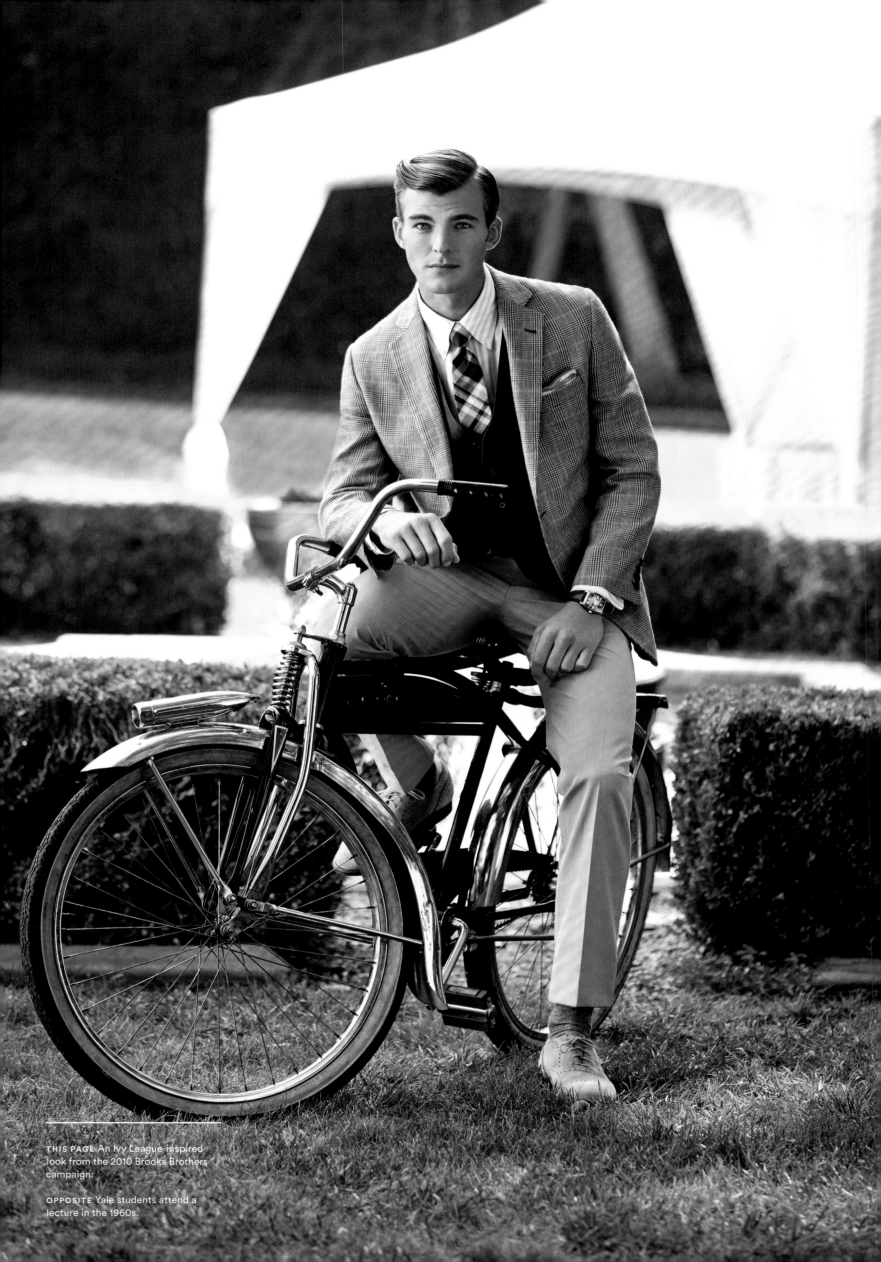

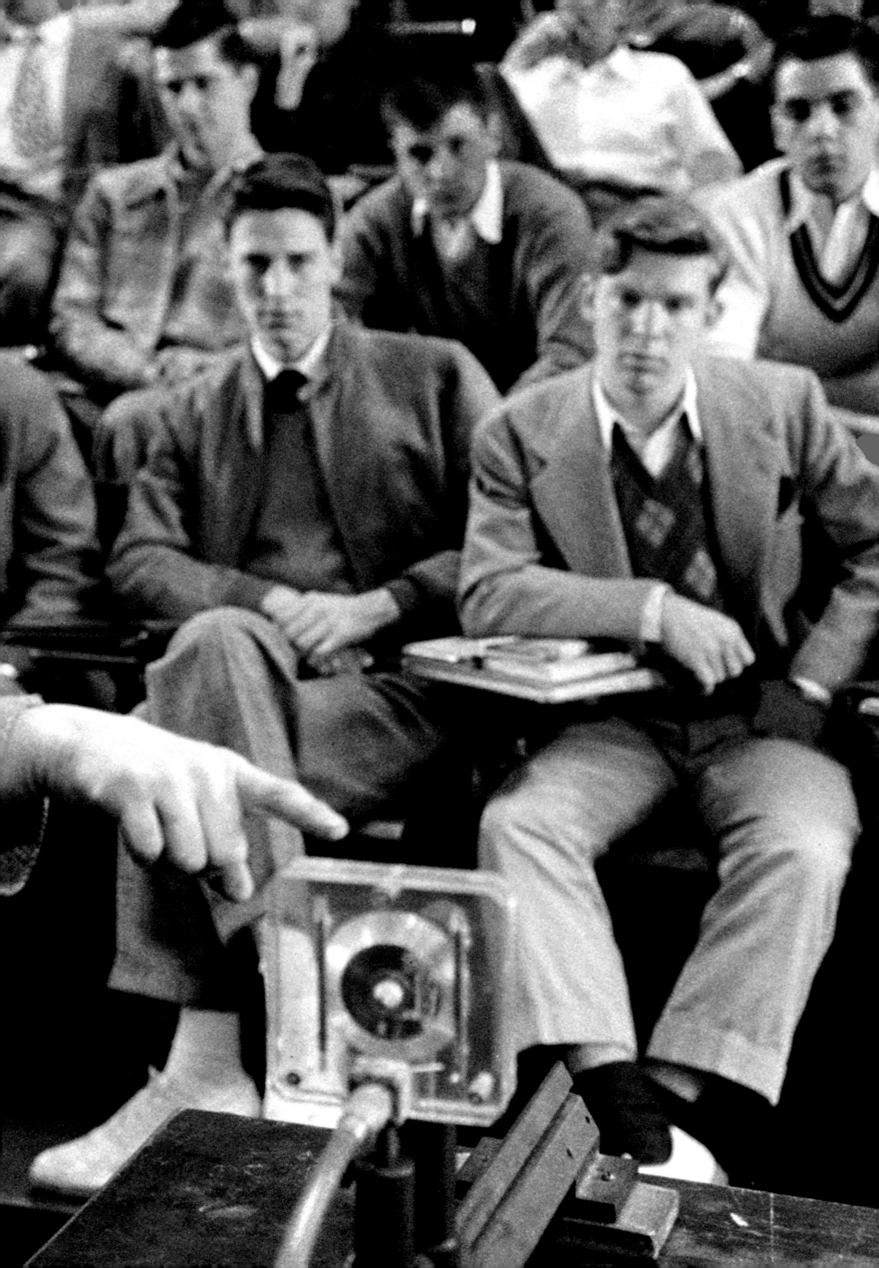

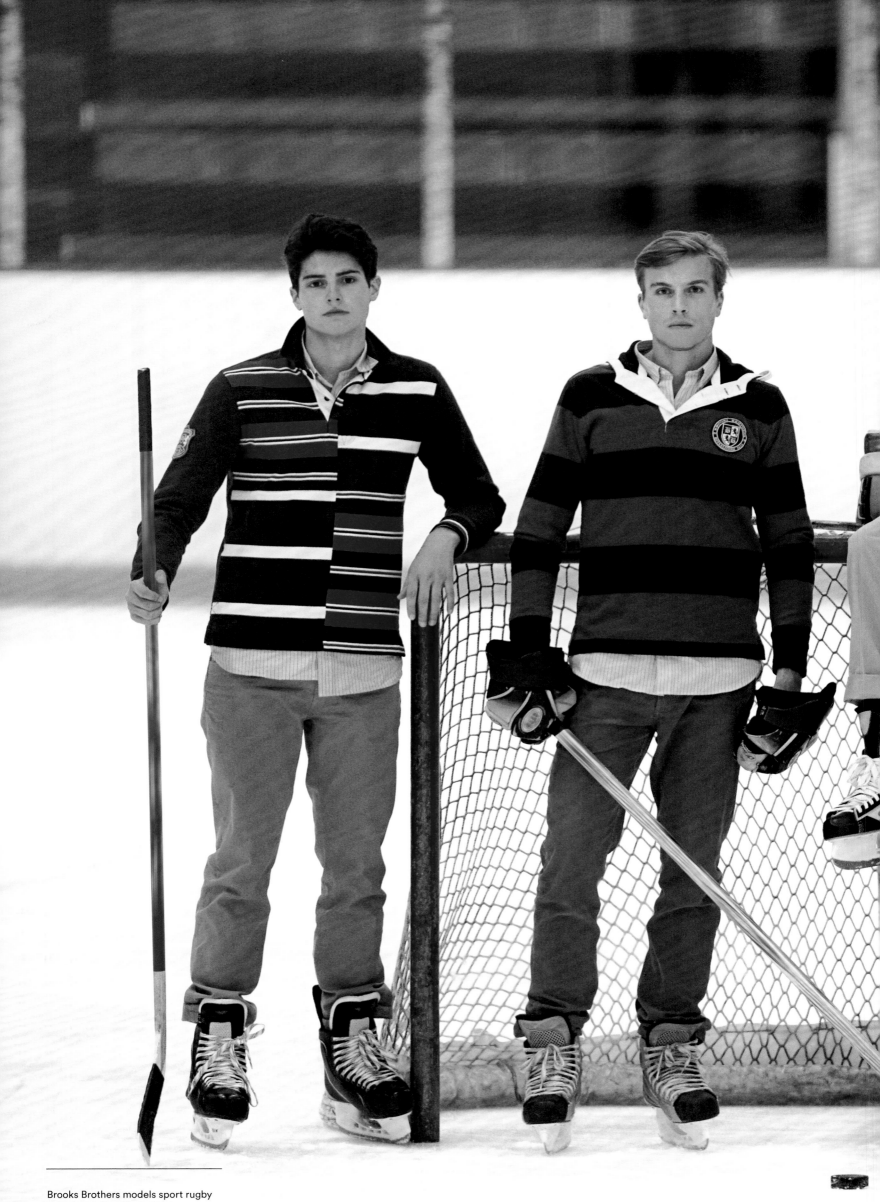

Brooks Brothers models sport rugby
shirts on the ice hockey rink.

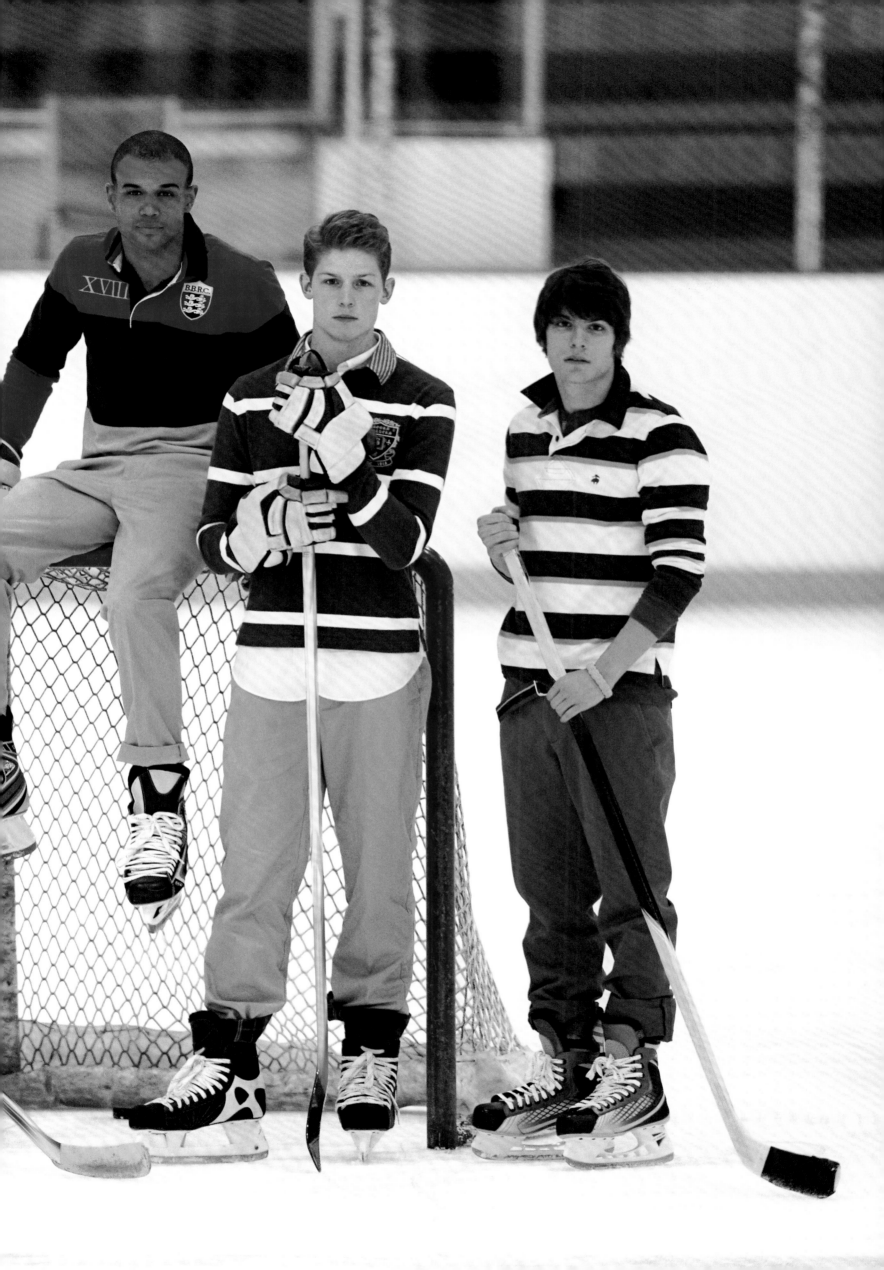

BORROWING FROM THE BOYS

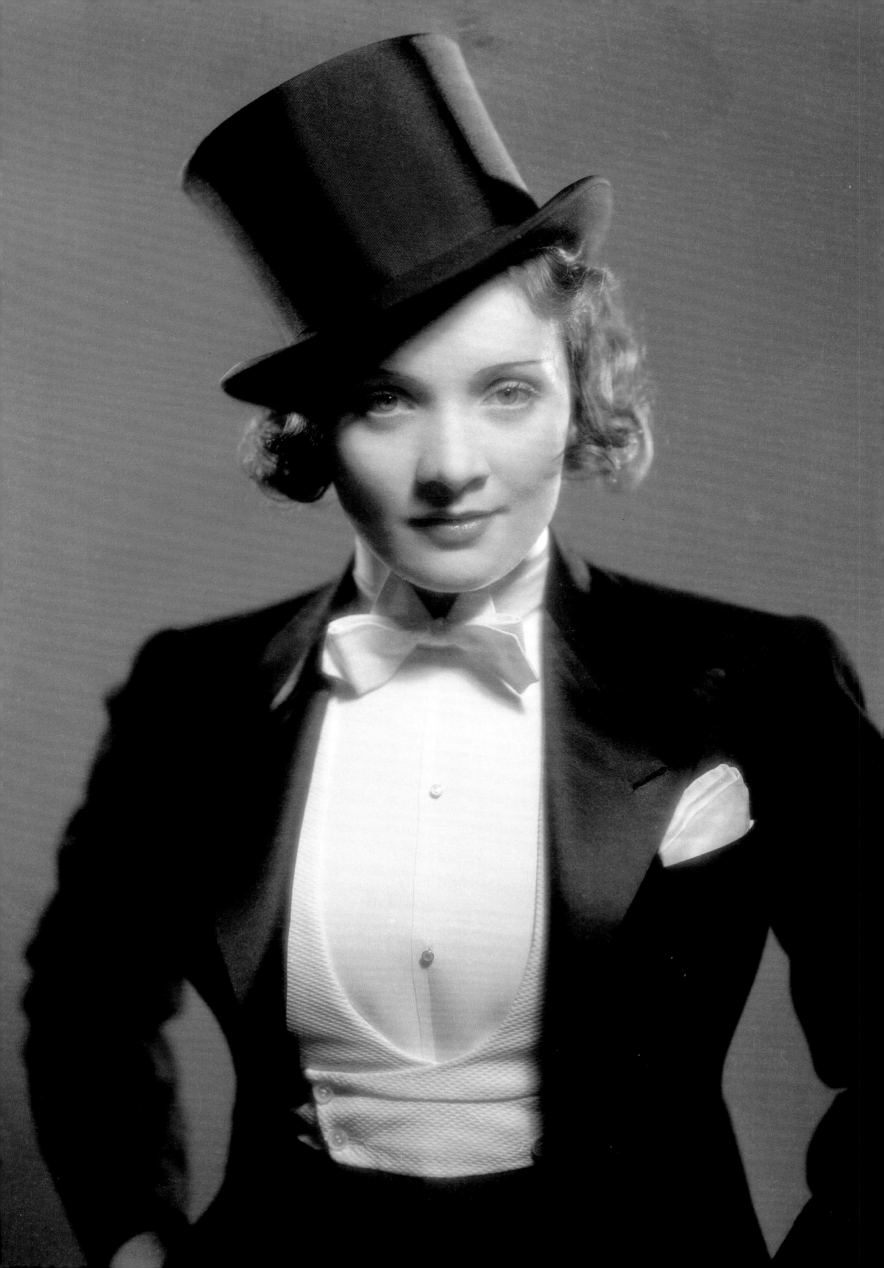

BORROWING FROM THE BOYS

I t's hard to pinpoint the exact date when "swipes"—the phenomenon of women buying men's clothing—became a fashionable trend. Many associate this idea of "borrowing from the boys" with the postwar period of the early 1950s, when young World War II veterans returned from service with their government-issue khakis and enrolled briefly at single-sex schools like Vassar in order to complete their G.I. Bill educations. Female colleagues noticed the "Vassar Vets" casual look and adopted it. Suddenly, girls were wearing khakis, jeans, and button-downs, too.

The truth is that women had already been raiding the men's department at Brooks Brothers for decades. When the polo coat was introduced in 1910, girls from Miss Porter's School began buying them in the boy's department and wearing them oversized, with buttons on the men's side. In the 1920s students at the Seven Sisters schools adopted the trend for "Daddy's fur coat," which meant that big, raggedy raccoon coats became a campus favorite. In the 1930s the same coeds filched men's sweaters, particularly the classic Shetland pullover. And by 1940, women at Smith, Vassar, and Wellesley were raiding men's shops for "mannish jackets in misses sizes," according to *Life* magazine. In 1944 the magazine published a photograph of two Wellesley students wearing baggy jeans and men's shirts, a look that became a uniform on women's college campuses and one that Simone de Beauvoir later described as "studied carelessness."

It wasn't until 1949, after recognizing that women were buying men's pink button-down shirts by the dozens, that Brooks Brothers begrudgingly agreed to fit the classic polo shirt to a woman's size.

"In the end, after months of soul-searching, we resolved to risk a restyled pink shirt for women, but never anything else for women," John C. Wood, then president of Brooks Brothers, told his customers. "We are definitely not in the women's clothing business. Thus far shall we go and no further."

OPPOSITE Marlene Dietrich famously donned a men's tuxedo for her role as a cabaret singer in Josef von Sternberg's 1930 movie *Morocco*. For her entire career, Dietrich was known for wearing Brooks Brothers suits and shirts.

The pink shirt appeared on the cover of *Vogue*'s college issue in August 1949 and the store was mobbed with women clamoring for their $8 polo. Brooks Brothers couldn't keep them in stock; an instant bestseller was born. Later that month the model Ann Hemenway appeared on the cover of *Life* magazine in a Brooks Brothers shirt she found in her laundry bag, put there by one of her brother's friends. Years later, Hemenway would recall that because of her *Life* magazine cover, she got a call from Frank Sinatra, who asked her out on a date. Sinatra showed up in a Brooks Brothers polo coat, which he immediately offered to Ann, unbuttoning the sleeves to roll them up so that she could wear it.

By 1951, Brooks Brothers' classic raglan-sleeve raincoat had been rescaled to women's measurements and the following spring slimmer Bermuda shorts hit the shelves. The store even added a customer service desk and fitting rooms for women in a dark and secluded part of the store in 1954. But despite Brooks Brothers' best efforts to appeal to the female customer with resized silhouettes, women kept crashing the boys club, buying everything from terry cloth and Indian madras shirts to flannel robes, knee socks, silk shorts, Bermuda shorts, and even boys' parkas for winter. Silk pocket squares were printed by Liberty as a concession to women's tastes (worn as headbands or scarves).

"You might say we have a sub-rosa arrangement with the ladies," a Brooks Brothers official told the *New York Times* in 1956, "We do a more or less under-the-counter business with them." He added that men's and boys' clothes appealed to women because of the quality and the tailoring and the fact that they last so long. That's certainly why Hollywood stars like Katharine Hepburn and Marlene Dietrich favored Brooks Brothers men's shirts and even slacks.

Although Brooks Brothers finally recognized the rise of the businesswoman and established a women's department in 1975, their female customers were still borrowing from the boys well into the late 1980s and early 1990s. *Vogue* editors working in the Condé Nast building next door to the 346 Madison Avenue store would run to the men's department to stock up on oxford cloth shirts, pajamas, and bathrobes. "On fashion shoots I always used Brooks Brothers classic white shirts, or I would bring along my father's striped versions," remembers Carlyne Cerf de Dudzeele, then a fashion editor at *Vogue*. When the waif look surfaced in the early 1990s, the same editors were running to the boy's department to buy shrunken blazers and shirts, a trend that has recently been revived among young Hollywood actresses like Michelle Williams and Reese Witherspoon, who wear their Brooks Brothers navy blue blazers over dresses on the red carpet.

During World War II rations and scarcity meant that many women had to forgo couture clothing and menswear was a necessity. But necessity no longer explains why women still borrow from the boys. Today it's fashion.

OPPOSITE Actor Yara Shahidi discovered her first Brooks Brothers shirt in her mother's closet. Here she models a look from the Red Fleece collection for the company's "My Brooks Brothers Story" 2015 ad campaign.

"I got my job at *Vanity Fair* because of Brooks
Brothers. I was working at *Vogue* at the time,
and one day I was in the elevator at 350 Madison,
the old Condé Nast offices. I had a shoot
that day and so I was on my way to the office
bright and early, it was probably about 5 am
and it was blazing hot so I had decided to wear
a pair of Brooks Brothers blue and white striped
pajamas—my version of a seersucker suit.
Back in those days we were all crazy for Brooks
Brothers! We would buy the pajamas and
the tuxedos in the boy's department. You know,
we wanted the Saint Laurent Smoking, but
all we could find were shrunken little Brooks
Brothers tuxedo jackets. Anyway, in the elevator
on the way to my office I ran into Graydon Carter.
He was on his way to meet with S.I. Newhouse.
I don't even know if he had yet gotten the job at
Vanity Fair, but he kept looking at me, doing a
double take. Finally, Graydon said 'wait a second,
didn't I just leave those at home?' I didn't really
know who he was, but I said 'I hope not!' Well,
he got the job and a week later I got a call to go
for an interview with him. I brought him a pair
of striped blue and white Brooks Brothers
pajamas, in his size."

—ELIZABETH SALTZMAN WALKER, stylist

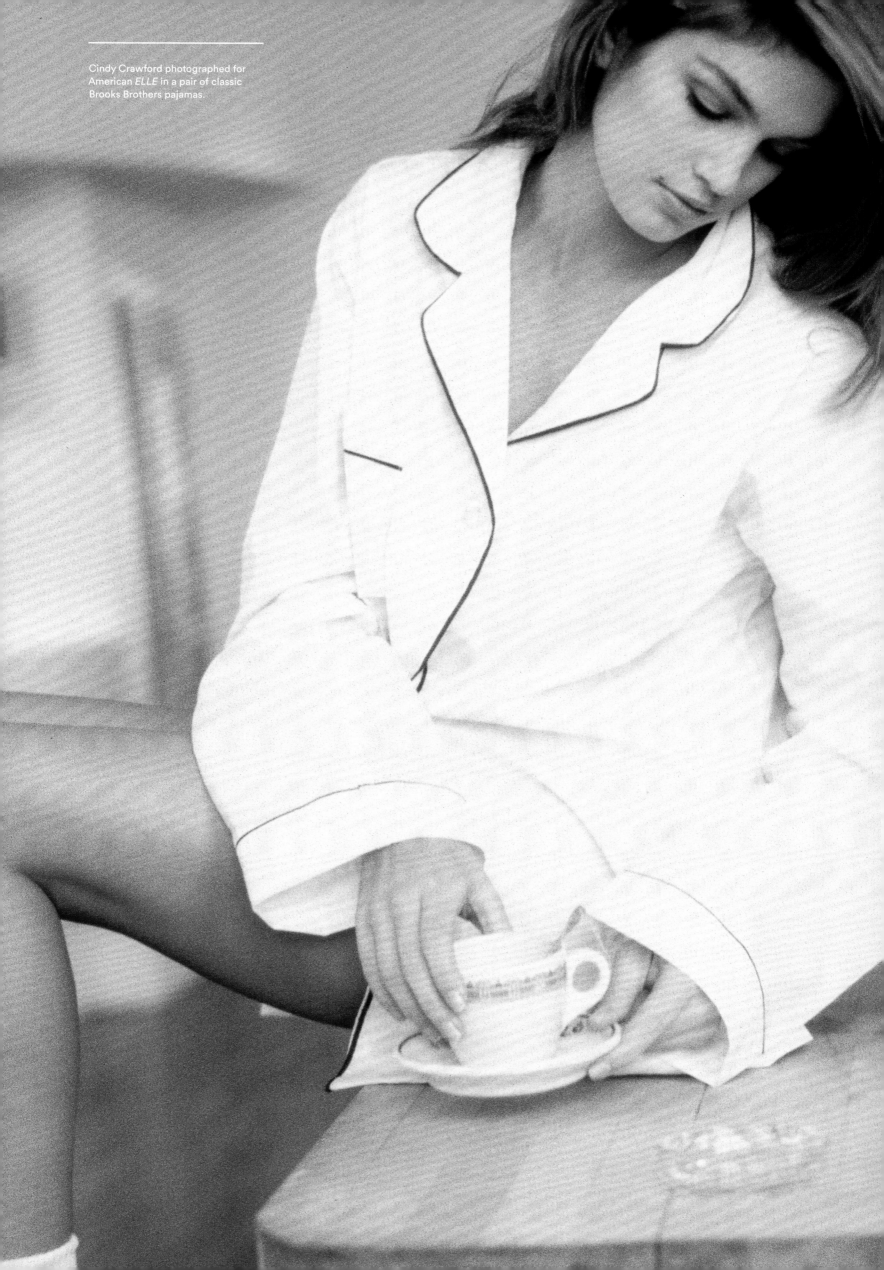

Cindy Crawford photographed for American *ELLE* in a pair of classic Brooks Brothers pajamas.

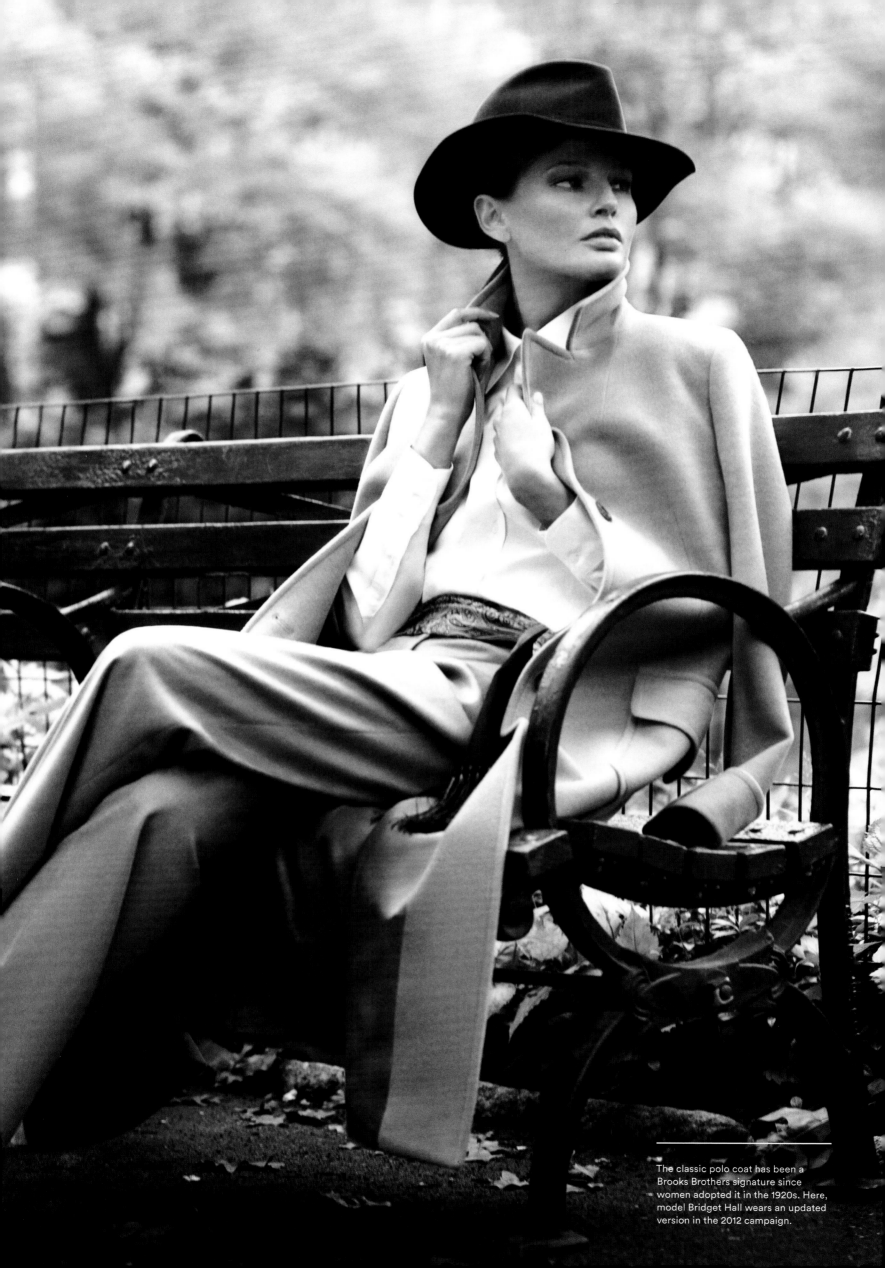

The classic polo coat has been a
Brooks Brothers signature since
women adopted it in the 1920s. Here,
model Bridget Hall wears an updated
version in the 2012 campaign.

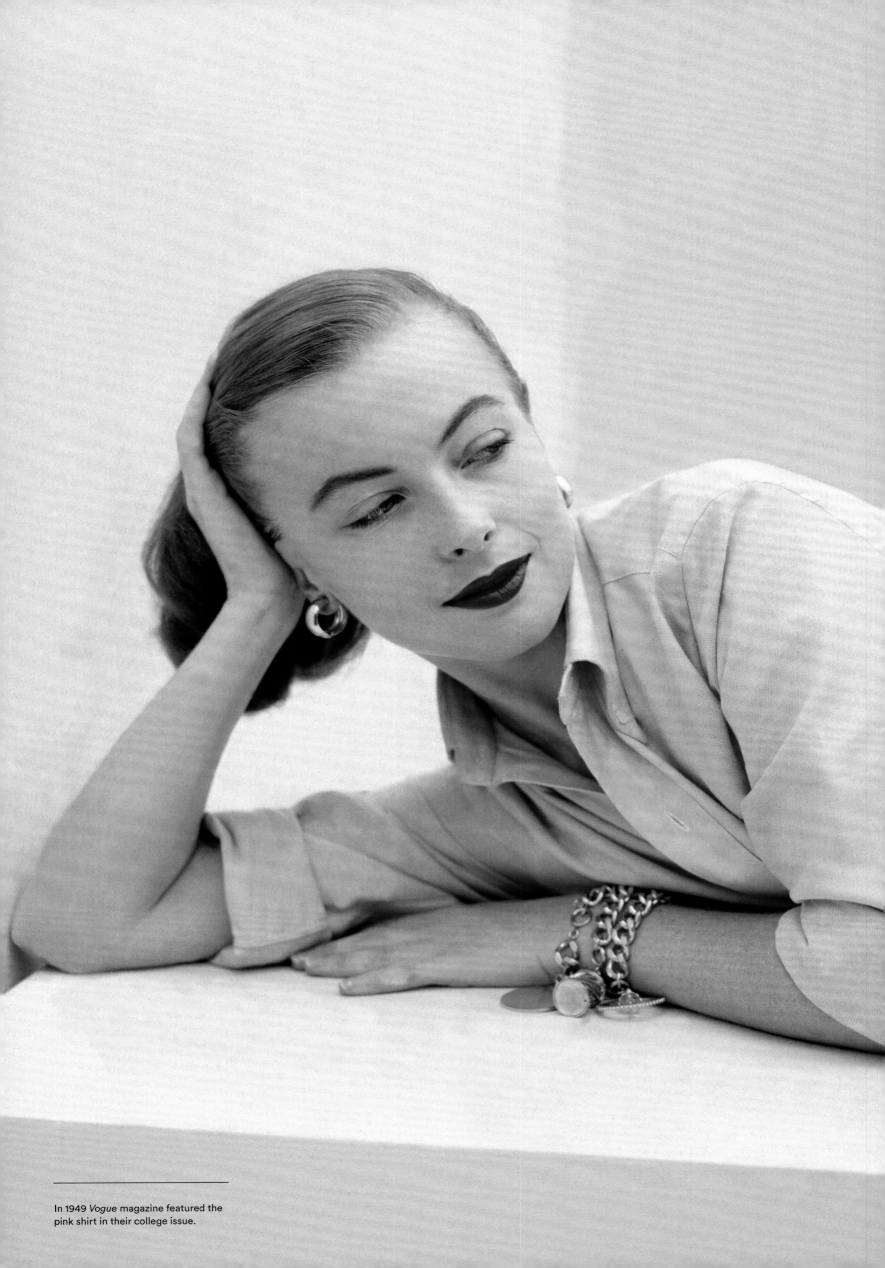

In 1949 *Vogue* magazine featured the
pink shirt in their college issue.

THINKING PINK

by KELLY STUART-JOHNSON

Women have been shopping at Brooks Brothers almost as long as there's been a Brooks. And, in many ways, the story of how the women's collection came to be is the story of how women convinced a store that had been called "the last stronghold of the American Male" to sell women's clothing. Depending on whom you ask, this war of attrition began in 1949, when we introduced the pink shirt, or in 1976, when we created a dedicated space in our Madison Avenue flagship to women's clothing. Neither date tells the whole story.

A few years ago we found a letter in the company's archives that had been tucked in a scrapbook from 1874, the year we opened our flagship at Broadway and Bond Streets in New York. The letter described a women's department. However, when the store moved to 346 Madison Avenue in 1915, many departments were enlarged due to the demands of an increasingly sporty American public . . . and one department was eliminated. As we moved uptown, the women's business moved out.

That's not to say that women stopped shopping at Brooks, and "borrowing from the boys" reached a fever pitch, becoming rampant—and necessary—during the Second World War.

But necessity doesn't explain why the girls at Miss Porter's took to wearing men's tailored fashions in the '20s, or why women continued to wear them after couture could again be had after the war.

One theory is that it's fashion. According to a 1950 issue of *Coronet*:

> Frequently, fashions created for men have been seized upon by women, disconcerting the store to no end. The ladies insist on buying men's silk shorts, robes, slacks, shirts, and even boys' parkas for winter wear. Katharine Hepburn is a frequent visitor in the slacks department, and Marlene Dietrich is partial to the dressing gowns. Billie Burke and Tallulah Bankhead drop by whenever they are in town.

KELLY STUART-JOHNSON is Brooks Brothers' Director of Learning and Brand Historian.

Another theory, posited by Brooks Brothers, was that women were looking for something they couldn't find from the manufacturers of the day: quality. The *New York Times* quoted a company official who put it this way:

> While certain types of men's or boys' clothes appeal to women is interesting; apparently, it's the quality and tailoring that goes into these clothes—also the fact that they last so well. Yes, by and large, it's their quality and stability.

Nowhere was this appeal more apparent than in the desire for the pink button-down shirt. Again, according to *Coronet*:

> For years Brooks had carried a line of pink shirts for men. Suddenly they struck female fancies and women started borrowing them from their brothers', fathers' and husbands' closets. Then the women who had no males to borrow from invaded Brooks. The store held out for a while but surrender was inevitable.

Our response was to open a small counter on the first floor of 346 Madison Avenue. By 1948, Brooks Brothers recognized that women had won and turned their attention toward making sure women represented the brand well. The September 17, 1949, issue of *The New Yorker* reported that, "The shirts hadn't been designed with the female configuration in mind and didn't look as well as they should." John C. Wood, Brooks Brothers' President at the time, looked to the fashion industry for some help: "I asked the people at *Vogue* if they would be interested in designing a pink shirt especially for women, and they were crazy about the idea. *Vogue* is entitled to all the credit for the design."

Thanks to our collaboration with *Vogue*, our pink shirt for women earned us a place in fashion history and has spawned more than a few imitators. Then, as now, we get by with a little help from our friends.

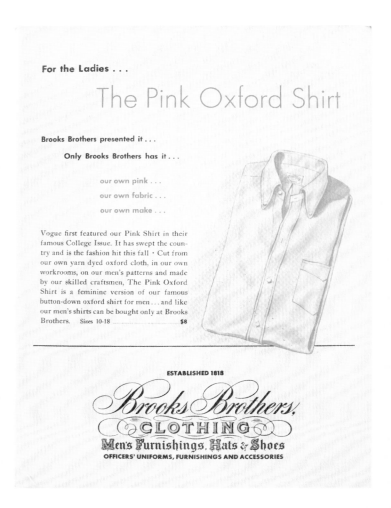

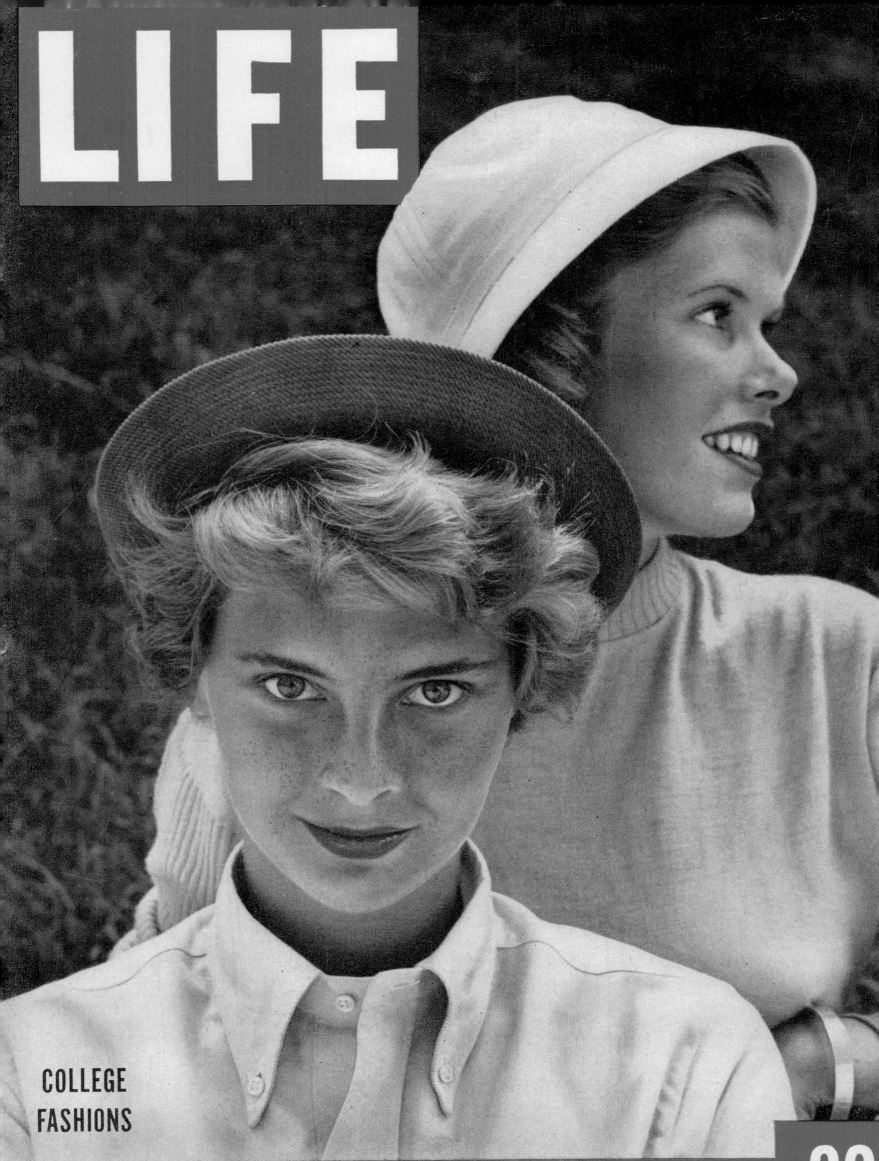

LIFE

COLLEGE
FASHIONS

AUGUST 29, 1949 20
YEARLY SUBSCRIPTION

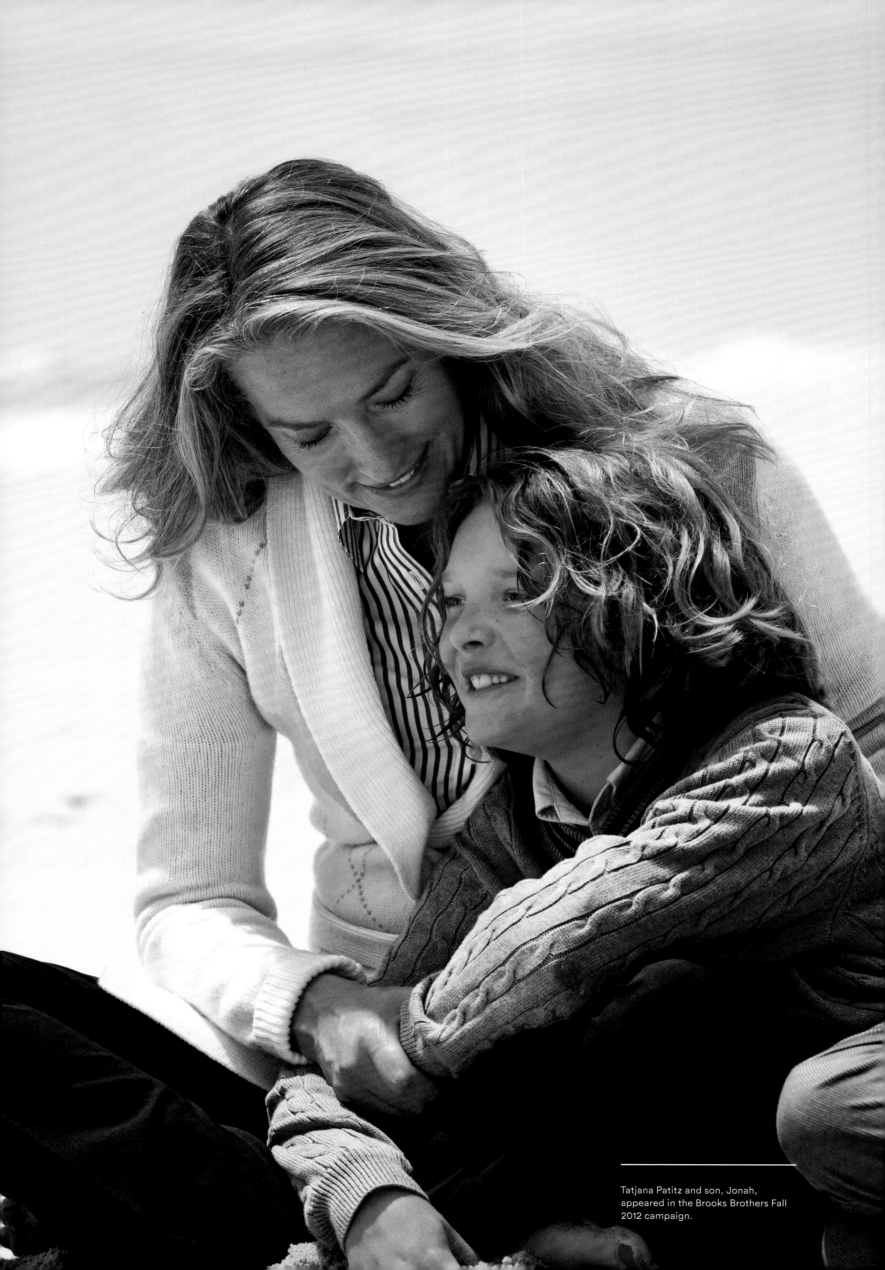

Tatjana Patitz and son, Jonah, appeared in the Brooks Brothers Fall 2012 campaign.

"For me Brooks Brothers is the classic striped shirt, absolutely. It is the only place to find this classic shirt. I still wear the ones that belonged to my father."

—CARLYNE CERF DE DUDZEELE, *fashion editor and photographer*

Katie Holmes wears a shrunken
Brooks Brothers tuxedo designed by
Zac Posen and it suits her just fine.

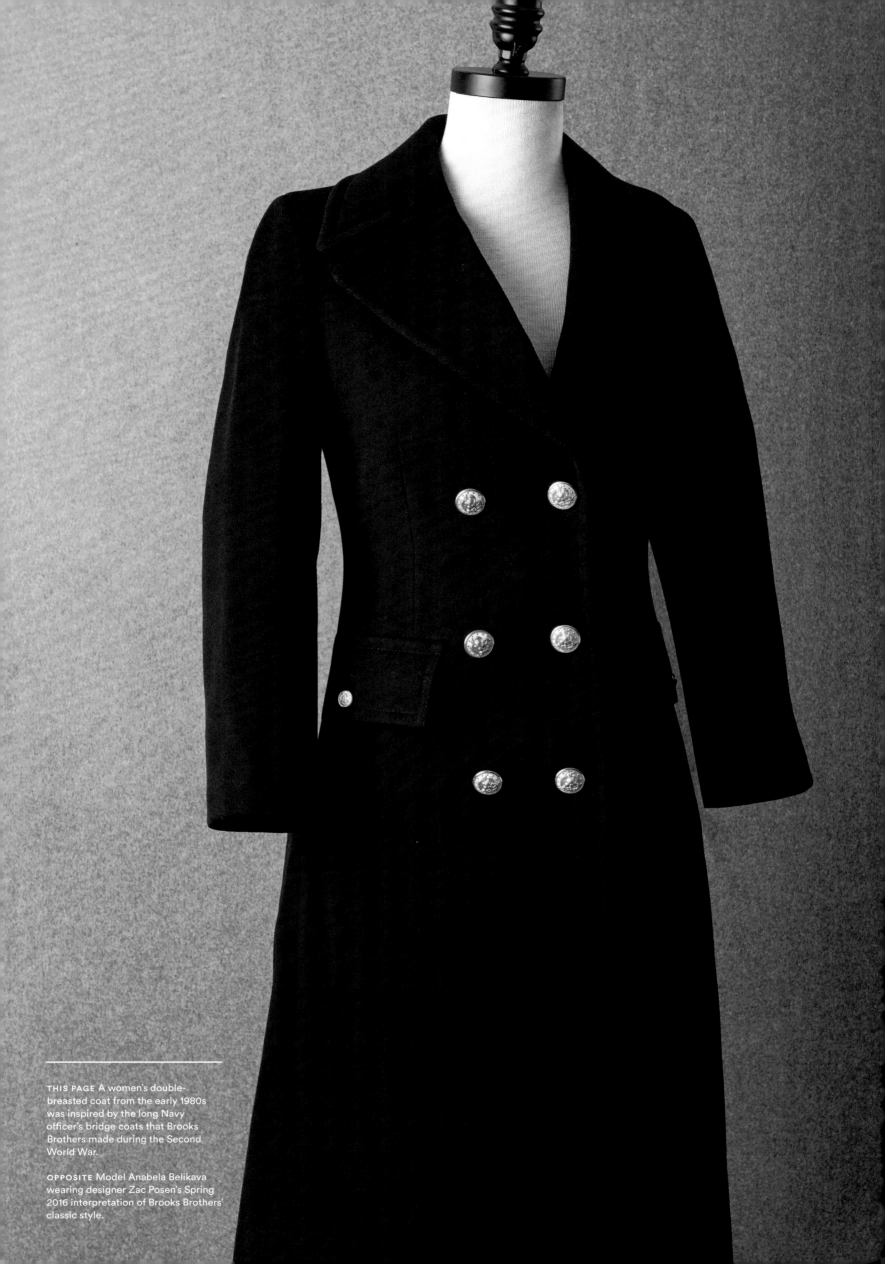

THIS PAGE A women's double-breasted coat from the early 1980s was inspired by the long Navy officer's bridge coats that Brooks Brothers made during the Second World War.

OPPOSITE Model Anabela Belikava wearing designer Zac Posen's Spring 2016 interpretation of Brooks Brothers' classic style.

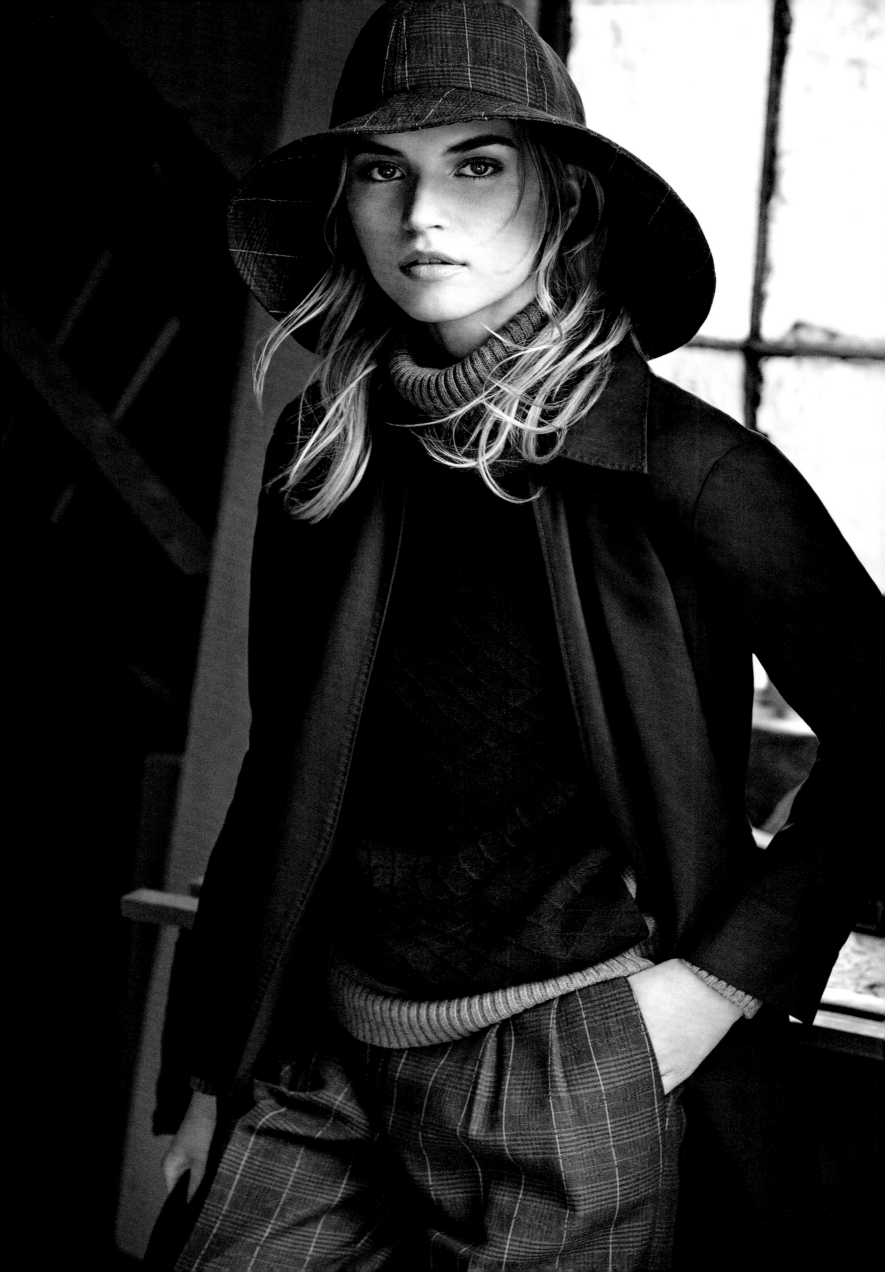

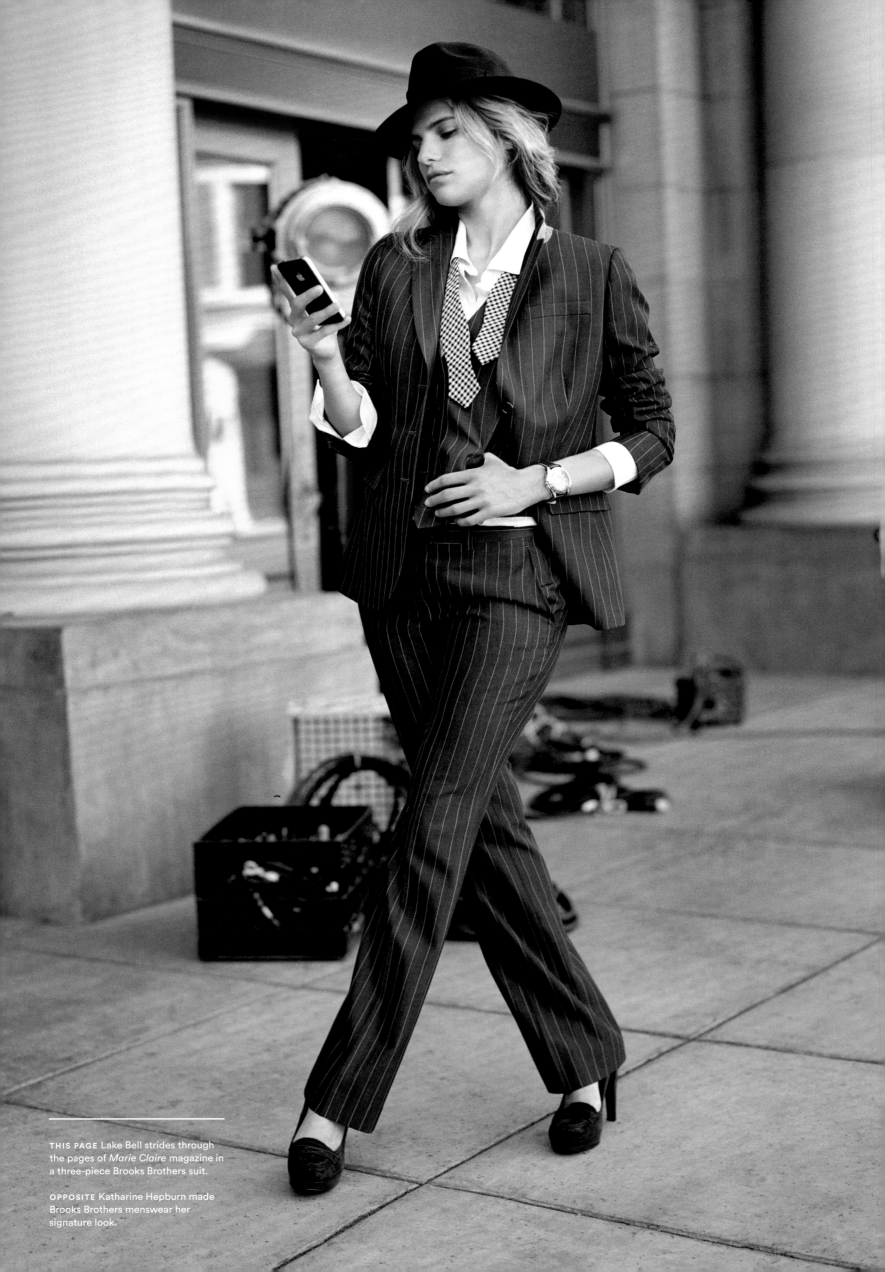

THIS PAGE Lake Bell strides through the pages of *Marie Claire* magazine in a three-piece Brooks Brothers suit.

OPPOSITE Katharine Hepburn made Brooks Brothers menswear her signature look.

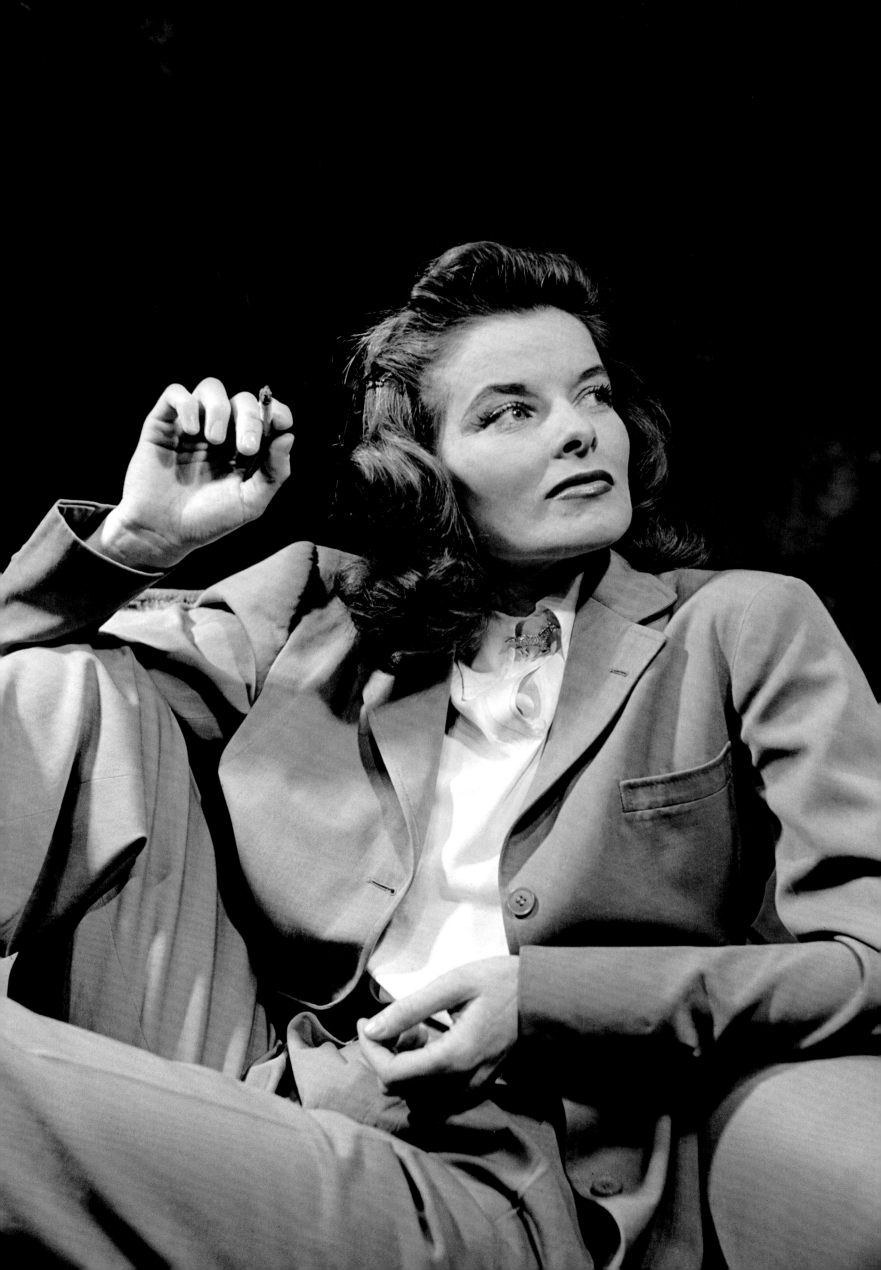

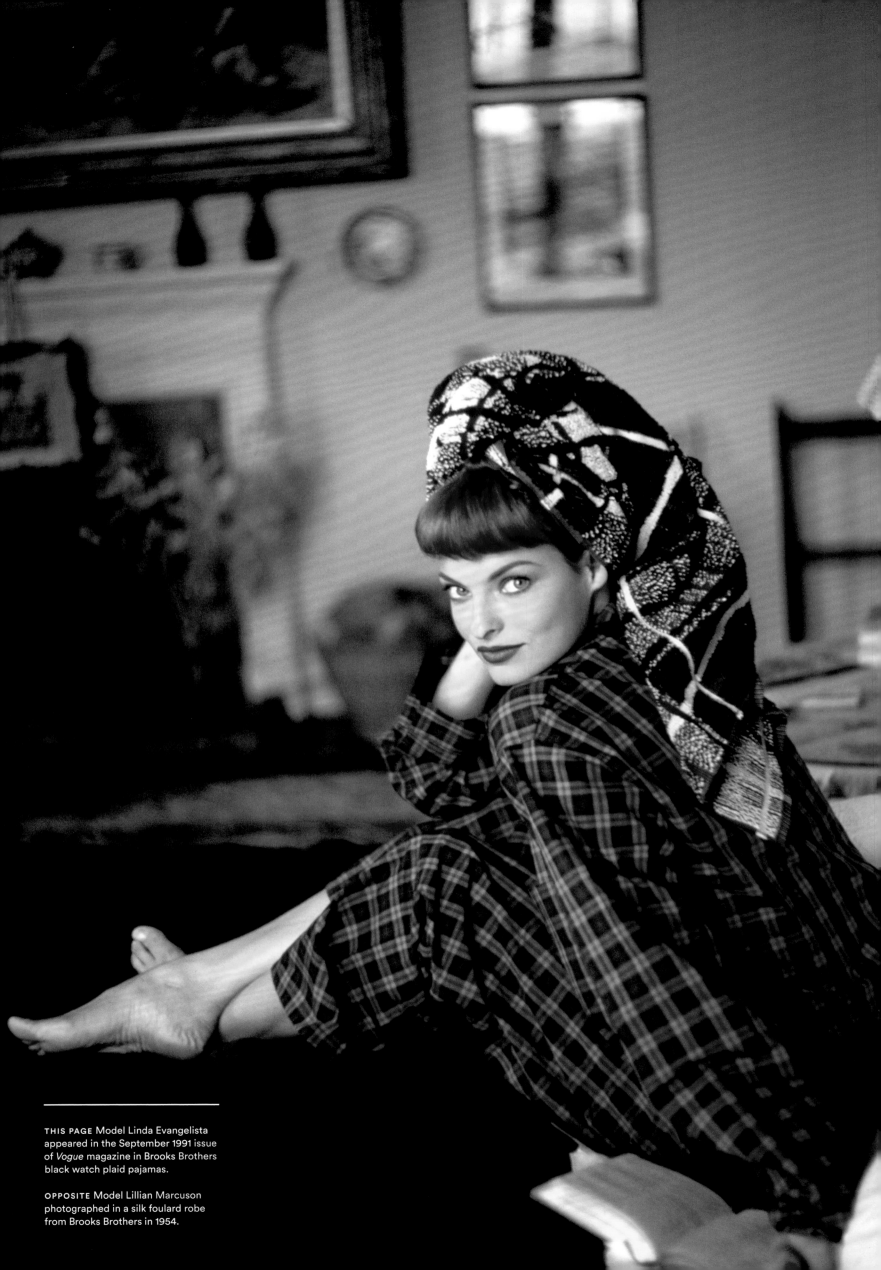

THIS PAGE Model Linda Evangelista appeared in the September 1991 issue of *Vogue* magazine in Brooks Brothers black watch plaid pajamas.

OPPOSITE Model Lillian Marcuson photographed in a silk foulard robe from Brooks Brothers in 1954.

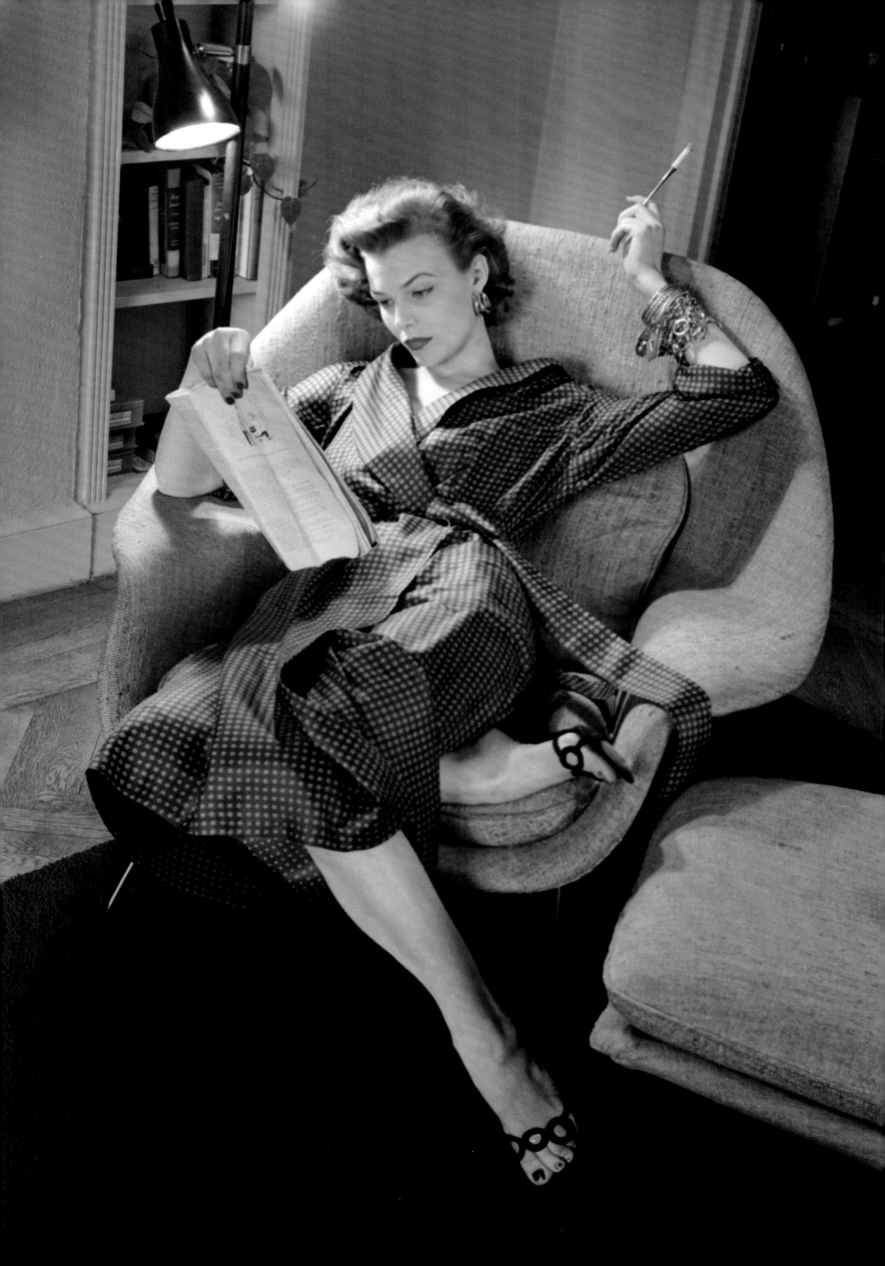

Nicole Richie in Brooks Brothers as skaters wreak havoc at a Los Angeles mansion in *Vanity Fair*.

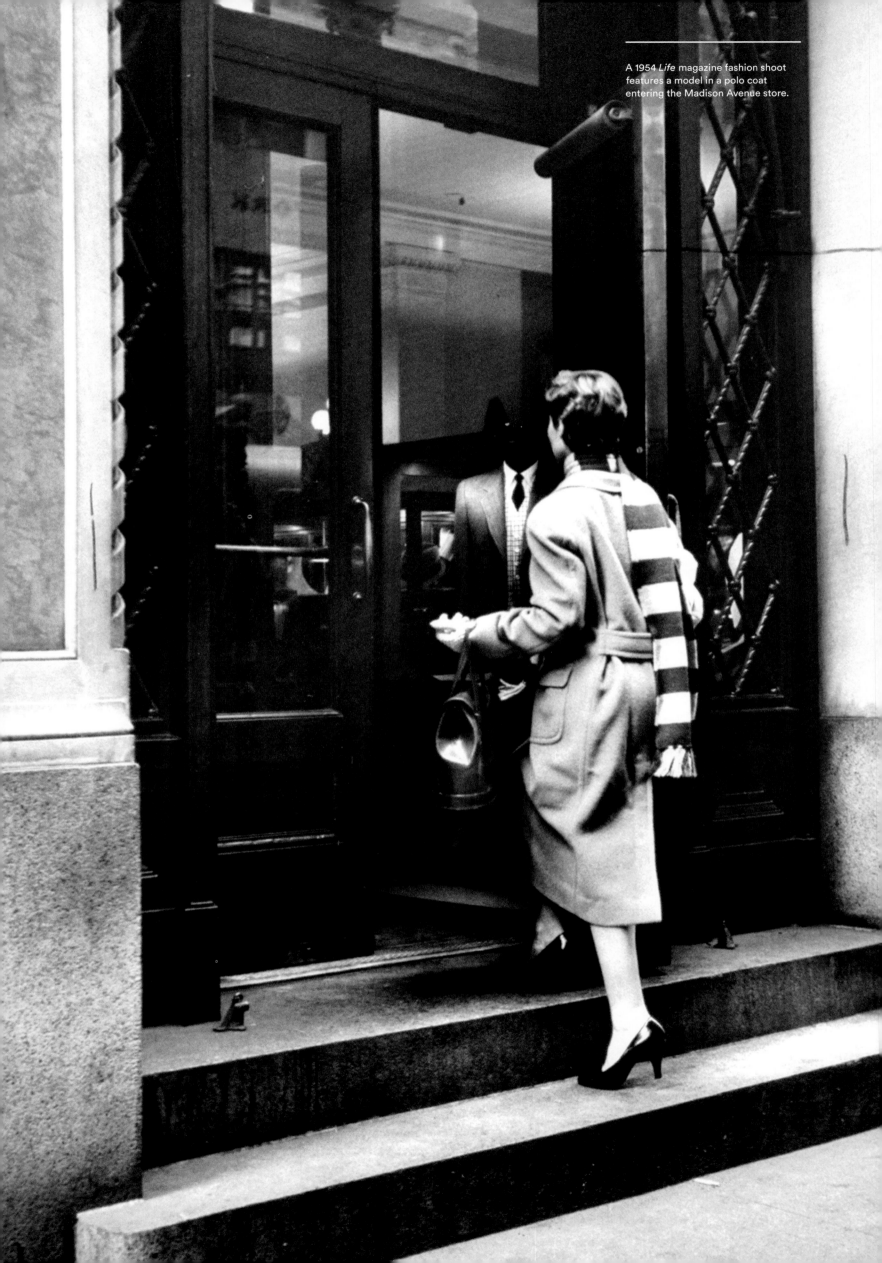

A 1954 *Life* magazine fashion shoot features a model in a polo coat entering the Madison Avenue store.

"All college girls
from Smith to Stanford,
are sisters under their
Brooks sweaters."

—*VOGUE* MAGAZINE, 1937
on the trend of college women shopping in men's stores

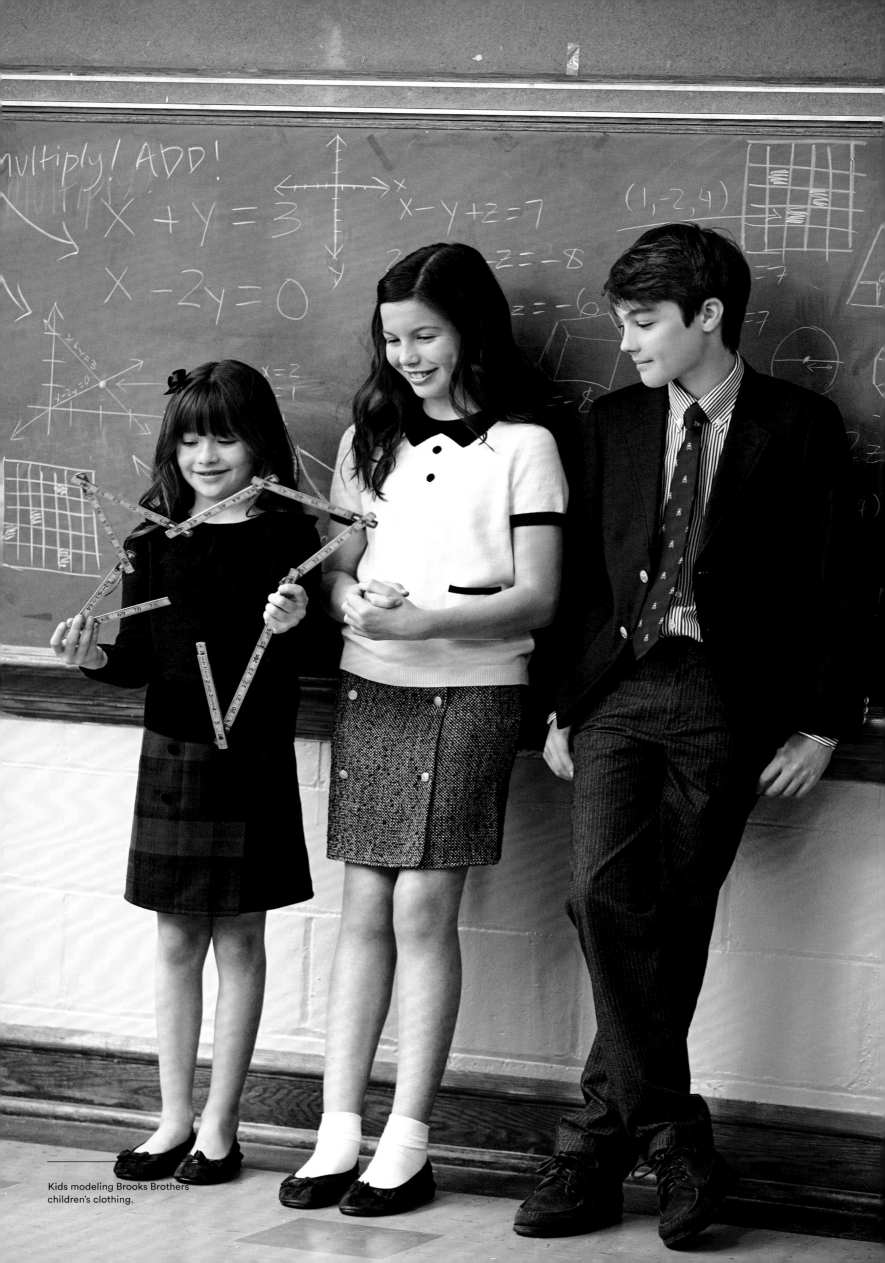

Kids modeling Brooks Brothers children's clothing.

NO KARG-DASHIANS HERE!

by **JILL KARGMAN**

I'm all for new and evolving fashion, infused with the latest runway trends and modern twists, but not for children. While I try to push my sartorial comfort zone and maintain a youthful edge as I age, one thing I insist on keeping strictly classic is the clothing in my kids' closets: smocked frocks, crisp blazers, traditional tartans. In a world of trashy rocker toddlers with shrunken motorcycle jackets, sneaker wedges, and the horrifying "jeggings" phenom, a Brooks Brothers velvet pinafore is a veritable lighthouse in very rough sartorial seas.

When my daughter was born, someone gave me a Misfits onesie from my favorite store, Trash and Vaudeville. I laughed, gave them a hug, and sent a thank-you note, but that onesie was only worn under pajamas and it never left the house. This may come as a surprise to viewers of *Odd Mom Out*, where I happily flaunt my tattoos and all-black ensembles, but my taste in kids' clothing is more Junior League than junior Goth.

Even though nothing else about me overlaps with preened staples and classic, patrician style, I've found that being "outside the box" begins with being inside it. My French mother always dressed me in Peter Pan blouses and pressed pleats. My daughters always wore grosgrain bows and ribbon-trimmed cardigans, and my son was properly turned out in blazers and khakis. It's not like I was trying to mold them into Dead Poets Society prepsters—I just wanted them to wear clothing that was innocent and simple rather than bedazzled black velour shorts with rhinestone letters spelling out "Daddy's Girl" (Oh, with the apostrophe as a star, natch!).

While some may think knee socks and Mary Jane's a sleepy symbol of yesteryear, I appreciate the link to pre-Instagram days before people posted their kids' latest fluorescent leather cross-body bags. Brooks Brothers navy over mauve metallic is so much more "of the moment" because it's a perennial that will never burn out. There's something comforting about the timelessness of a fall kilt or a shoulder-tied sundress—a visual bridge to my own '70s Central Park autumn holiday card snapshots, or beachside sunset smiles. I never tried to make my small kids look "cool"—style evolves, and with solid roots hopefully the tree won't grow into wayward territory.

My teenage daughter went through a "tween" phase of begging for the same knockoff Hervé Leger "bodycon" faux-bandage dresses some of her friends were wearing to dances at Doubles. I reflexively snapped back with my pronouncement, "the tighter the dress, the looser the behavior." Finally, after years of begging for the latest flash-in-the-pan "it" item, she's come around to my way of seeing things and now relies on chic staples. She even thanks me for the photographs in her baby book where Thanksgiving dinners, birthdays, anniversaries, and even a random field trip at school are all memorialized with a Madeleine-like sweetness. She looks not like a shrunken adult but like a child—at play or at the table, rising to the occasion with good manners and polite polish . . . at least for now.

JILL KARGMAN is an author, writer, and actress based in New York City.

CHAPTER EIGHT

MID-
CENTURY
MODERN

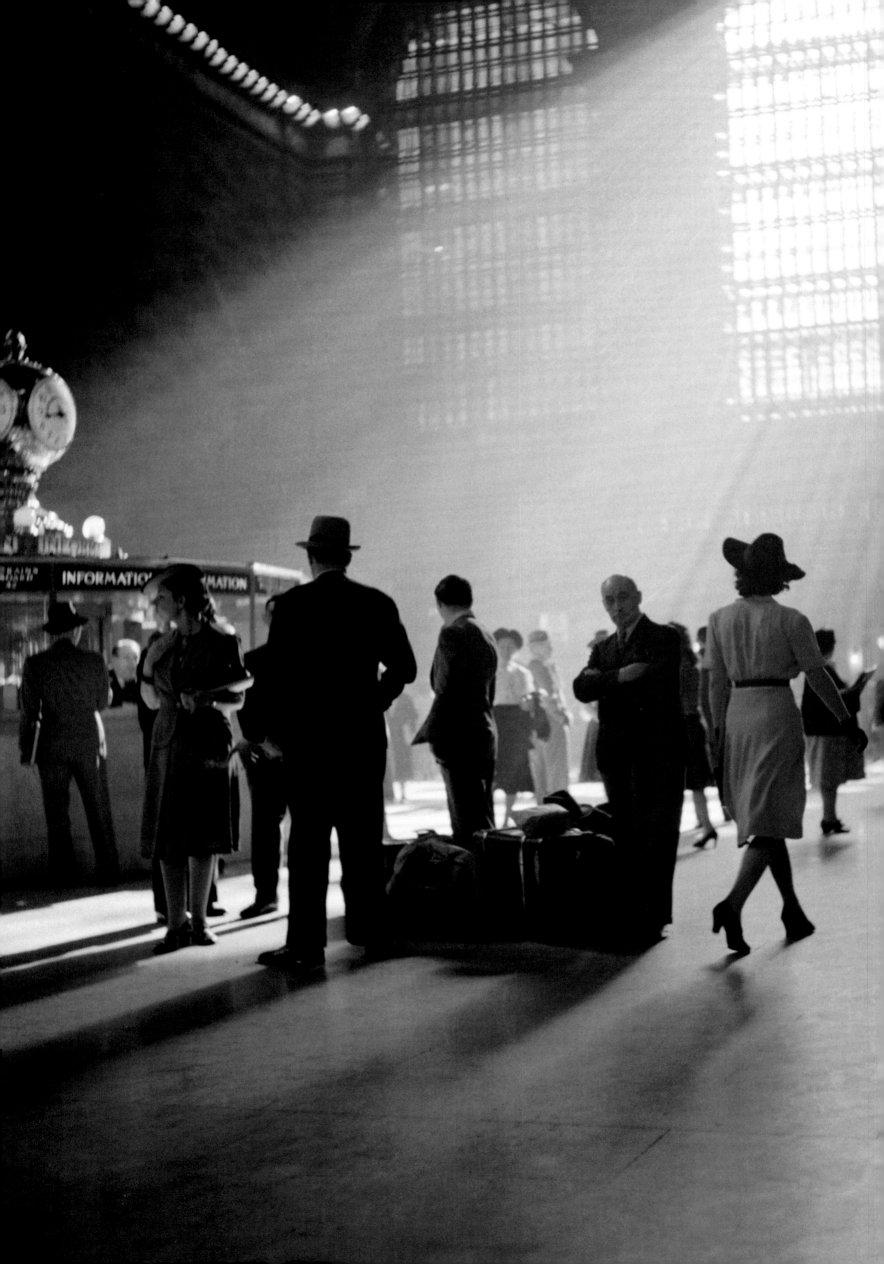

o image says mid-century Manhattan like one captured in Grand Central Station's main concourse during morning rush hour. Shafts of light stream through the cathedral windows as commuters rush from platform to sidewalk, brief cases in hand, felt hats perched firmly on their heads. The men are all seemingly dressed alike in the same two-button gray sack suit and white button-down shirt. They stride out onto Madison Avenue, carrying the country's confidence and ambition with them as they head to corporate offices tucked into skyscrapers in the heart of Midtown Manhattan, where Grand Central sits side-by-side with clubs like Delmonico's, the Yale Club, the Biltmore, and, of course, Brooks Brothers, its own kind of club.

These "Madison Avenue" men exude the confidence of postwar ambition and a booming economy. G.I.s returning from Europe more than a decade earlier had flowed effortlessly from Ivy League schools into corporate jobs, making their mark on New York City. Optimism soared like the skyscrapers cropping up around Midtown. More people had more money. The city was financially prosperous and new bridges, schools, and museums had been built. At the center of this social, economic, and cultural swirl were these young corporate strivers, and Brooks Brothers was their uniform. As Sloan Wilson wrote in the 1955 novel *The Man in the Gray Flannel Suit*, wearing Brooks Brothers signified a certain status. You had arrived. And Gregory Peck, dressed in a gray flannel suit, white shirt, and blue tie, as the star of the 1956 feature film by the same name, became the poster boy for that decade's ambitious corporate everyman.

Brooks Brothers was trusted because it was worn by the most trusted men, people like Walter Cronkite, who would appear every evening on television in a white button-down oxford cloth shirt and a gray sack suit. A famous 1962 photograph of Cronkite interviewing President John F. Kennedy shows both men wearing the exact same Brooks Brothers suit, shirt, and tie. The Brooks Brother look had become such a cliché that even *The New Yorker* cartoons of the era mocked it, one famously depicting a man dressed in a white shirt and rep tie seated on a desert island, refusing to disrobe as his wife fashions her dress into a distress signal.

Five decades later, writer Matthew Weiner would revive the cliché, turning the 1960s corporate everyman and his cronies into the AMC hit television show *Mad Men*. Don Draper, the ambitious striver, is appropriately dressed in the same classic Brooks Brothers sack suit with the same white shirt and navy blue rep tie, personifying the era's conflict between conformity and the illusion of conformity.

In reality, it was Brooks Brothers' newly appointed president, John C. Wood, who personified the Brooks look. A preppy advertising man who had been hired away from B. Altman by Garfinckel's when the Washington D.C.–based retailer purchased the company from the family in 1946, Wood made Brooks even "Brooksier." He wore gray flannel flat-weave suits with a white button-down shirt and the same navy blue silk tie everyday. He was a creature of habit and, more so, a creature of his time. He vowed never to change any of Brooks Brothers' sacred traditions and classic products, famously saying that he would "rather wear a zoot suit in Times Square."

OPPOSITE Early morning in New York City's Grand Central Station, circa 1941. Over the course of the following two decades, the neighborhood would become the center of Manhattan's bustling advertisement and men's retail businesses with Brooks Brothers' Madison Avenue flagship a few blocks away, as well as the Yale Club, The Knickerbocker, and the Biltmore Hotel.

Despite his conservative style, Wood innovated with classic Brooks Brothers products, collaborating with Dupont to incorporate their Dacron-and-cotton blended fiber into what would become "Brooksweave" wash-and-wear shirts and eventually suits. When President Kennedy brought a more athletic stylishness to the White House, Woods oversaw the introduction of the "Number 2" suit, a variation on the Number 1 model with "trimmer lines and a more tailored appearance than has been available." To attract younger customers, Wood created the "346" department selling the Brooks Brothers look at less expensive prices.

Wood also introduced a film about Brooks Brothers to educate the staff on the company's history, including the tradition of manufacturing their own distinctive designs in their own factories in order to maintain their high level of workmanship and detailing. As an advertising man, Wood believed in driving Brooks Brothers' expansion with a message-driven campaign that drew on the company's classic values. One such advertisement spoke to the idea that Brooks Brothers was "not just a business, but a friend."

With stores opening in Chicago and, later, San Francisco and Los Angeles, Brooks Brothers was keeping step with the expansive optimism of the era.

" You and your damned Brooks Brothers shirt!"

OPPOSITE John Slattery wore Brooks Brothers in 2014 to portray the 1960s style of cynical advertising executive Roger Sterling in Matthew Weiner's AMC hit *Mad Men*.

THIS PAGE A *New Yorker* cartoon from October 18, 1952 featuring Brooks Brothers.

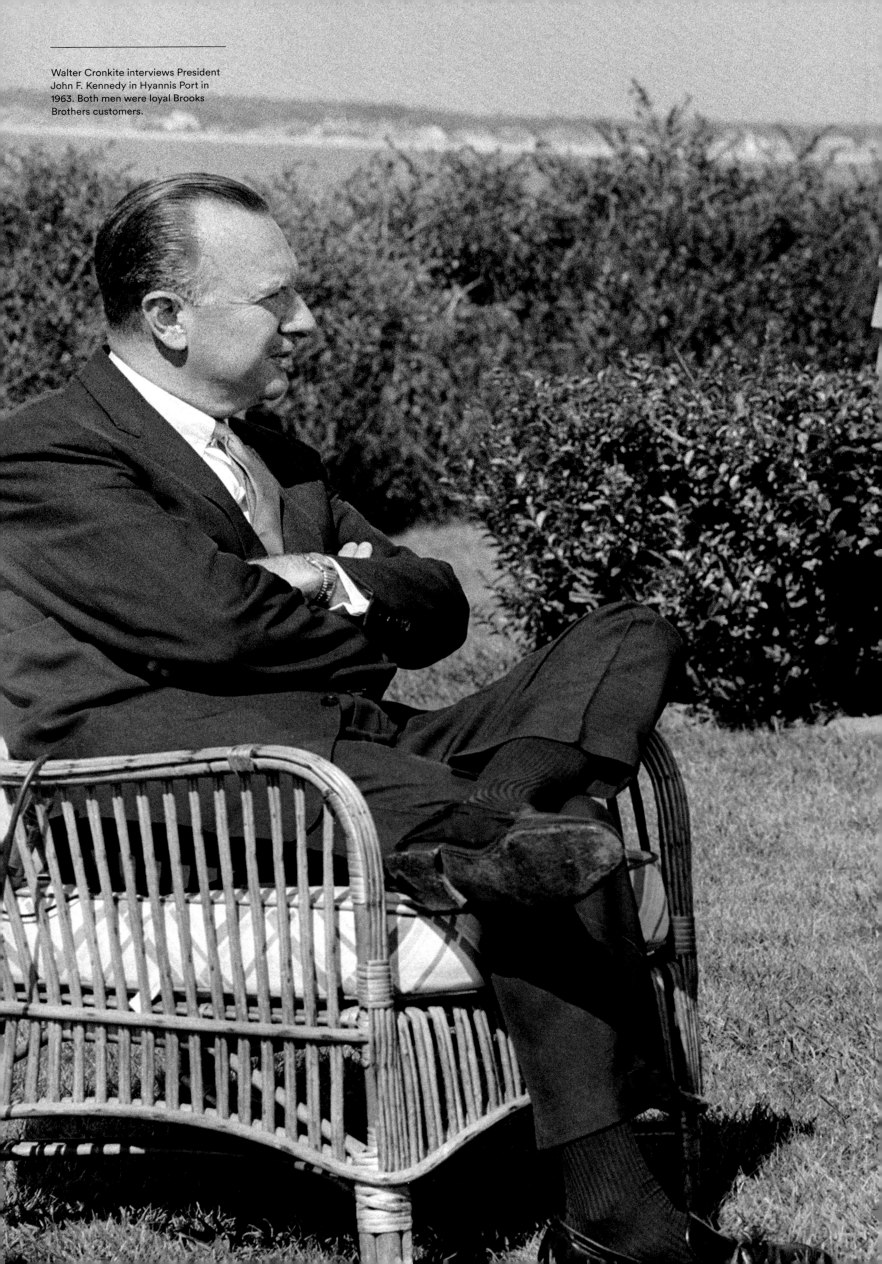

Walter Cronkite interviews President
John F. Kennedy in Hyannis Port in
1963. Both men were loyal Brooks
Brothers customers.

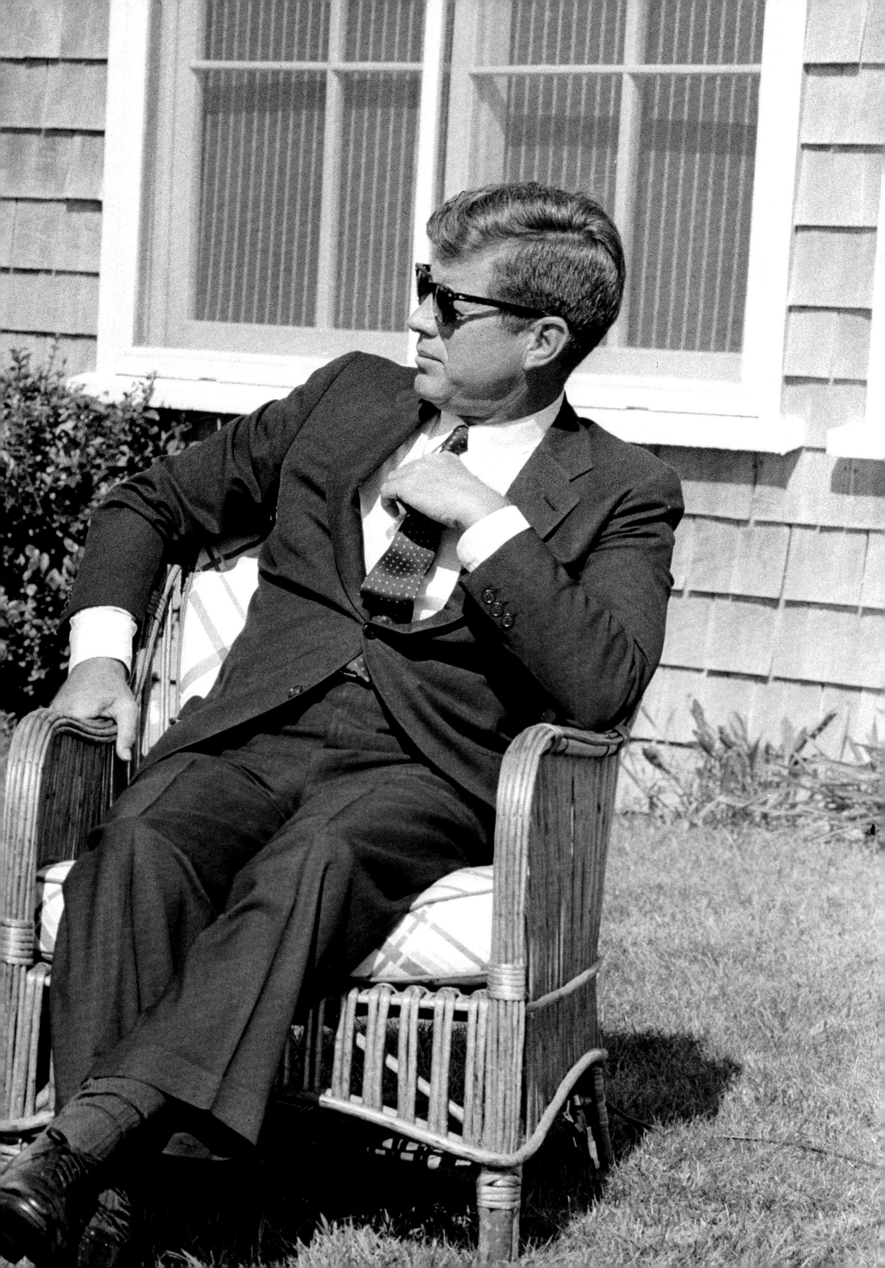

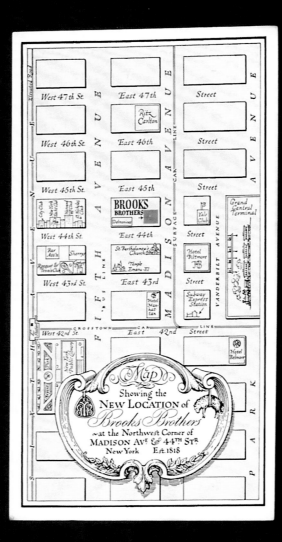

Casual evenings, the new idea: Opposite, the easy new shirting-weight jacket that's been developed for don't-dress evenings, to fill the gap between sports jackets (too casual) and business suits (too daytime). Jacket and Tattersall-striped trousers are of Lanella flannel—half cotton, half wool, Mitin mothproofed. Jacket, $38; trousers, $23. Worn with: a button-down-collar shirt, knit tie, patent leather pumps. All: Brooks Brothers.

VOGUE, APRIL 1, 1955

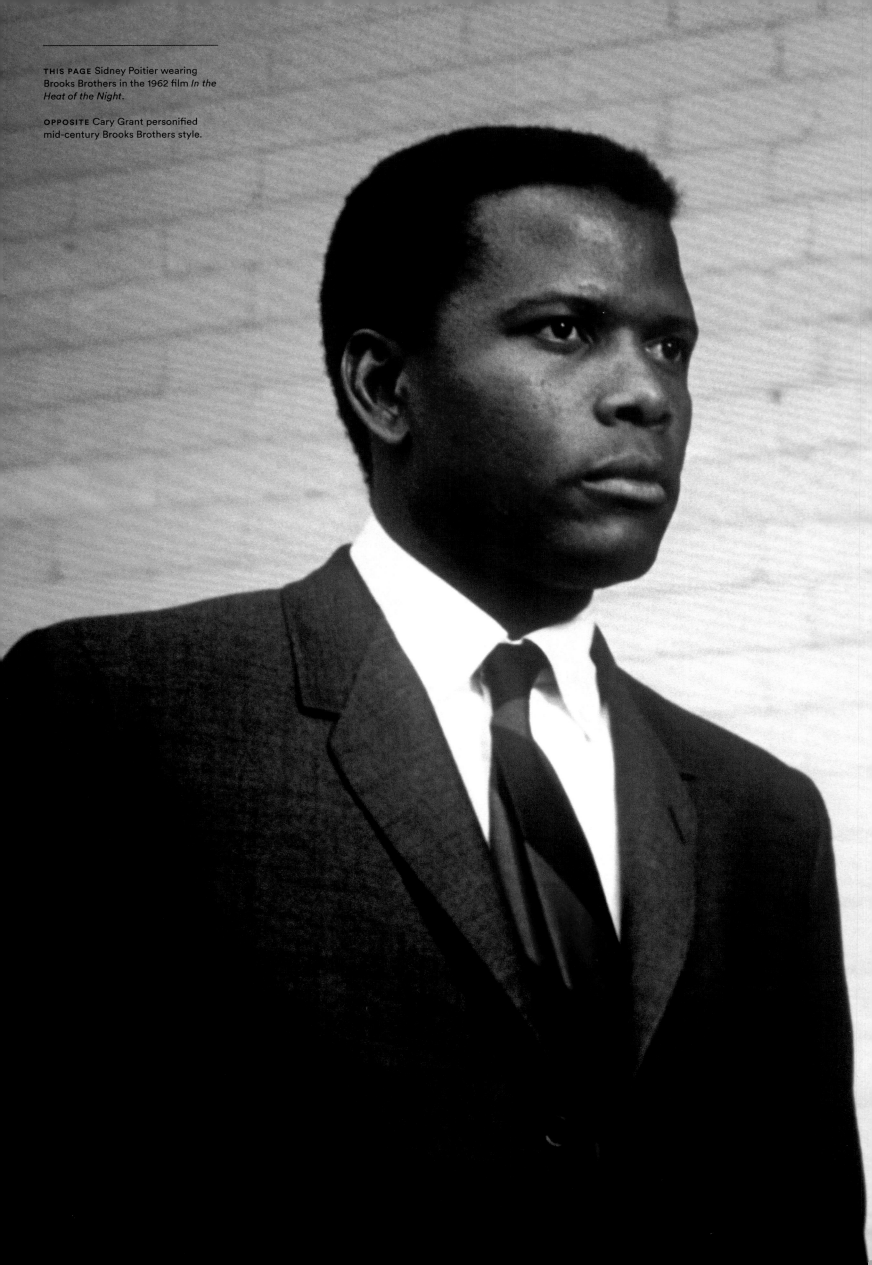

THIS PAGE Sidney Poitier wearing
Brooks Brothers in the 1962 film *In the
Heat of the Night*.

OPPOSITE Cary Grant personified
mid-century Brooks Brothers style.

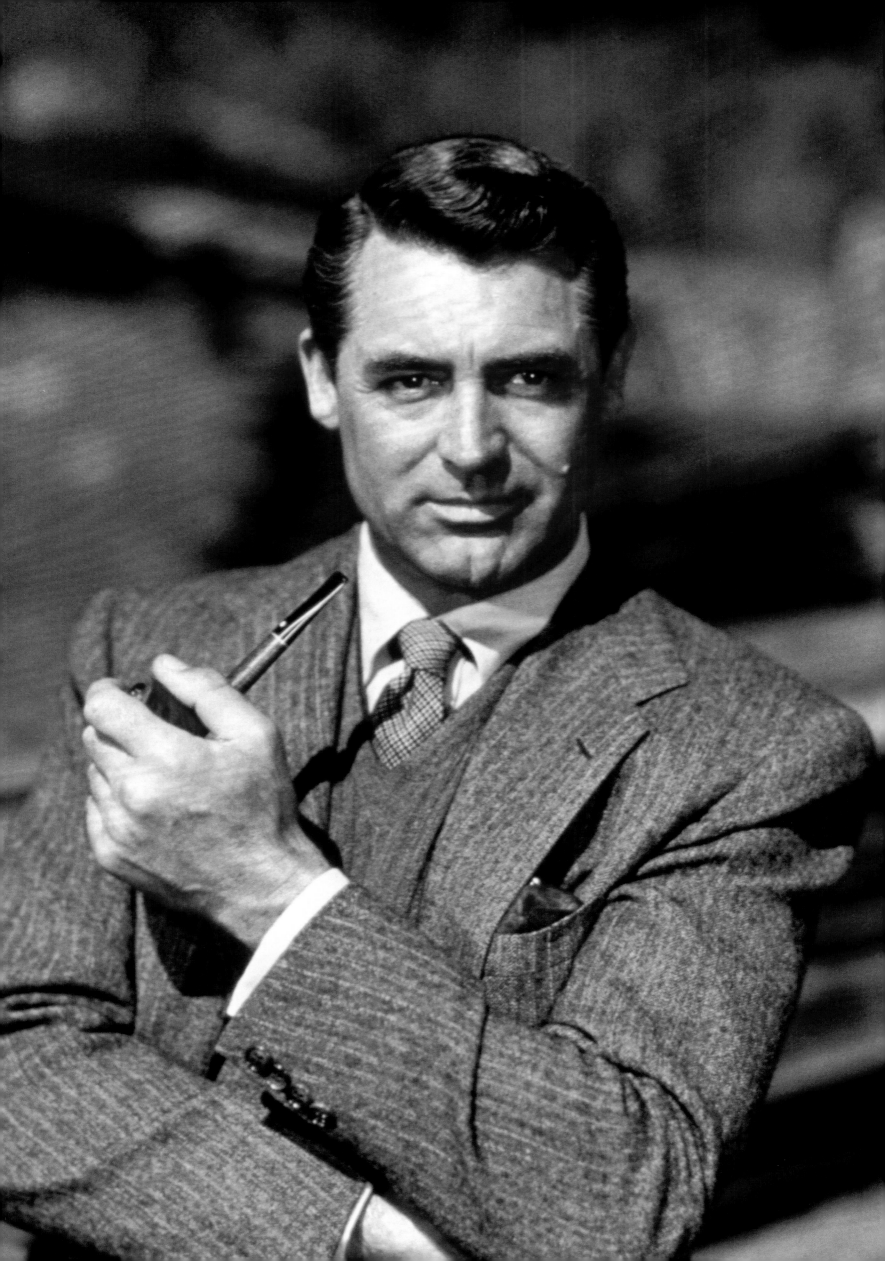

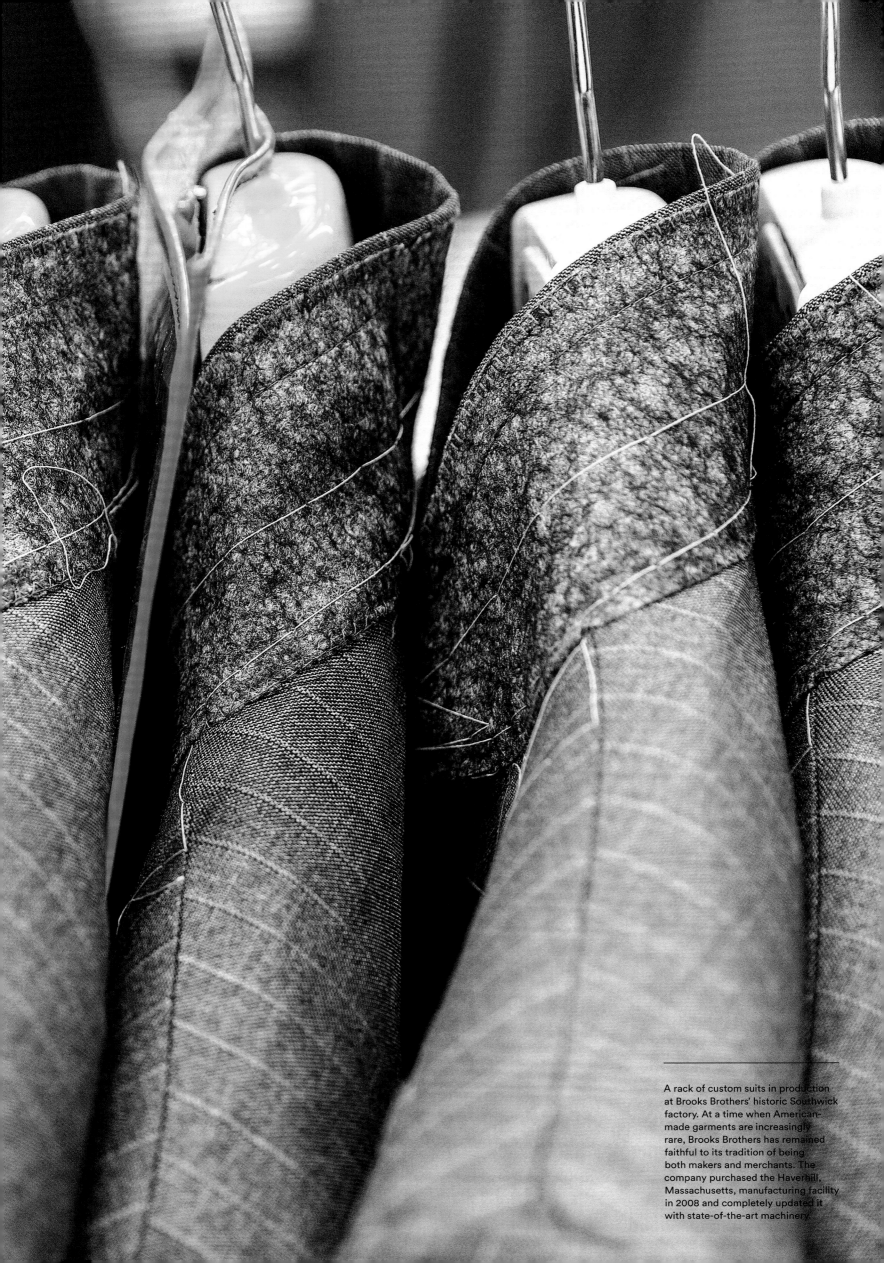

A rack of custom suits in production at Brooks Brothers' historic Southwick factory. At a time when American-made garments are increasingly rare, Brooks Brothers has remained faithful to its tradition of being both makers and merchants. The company purchased the Haverhill, Massachusetts, manufacturing facility in 2008 and completely updated it with state-of-the-art machinery.

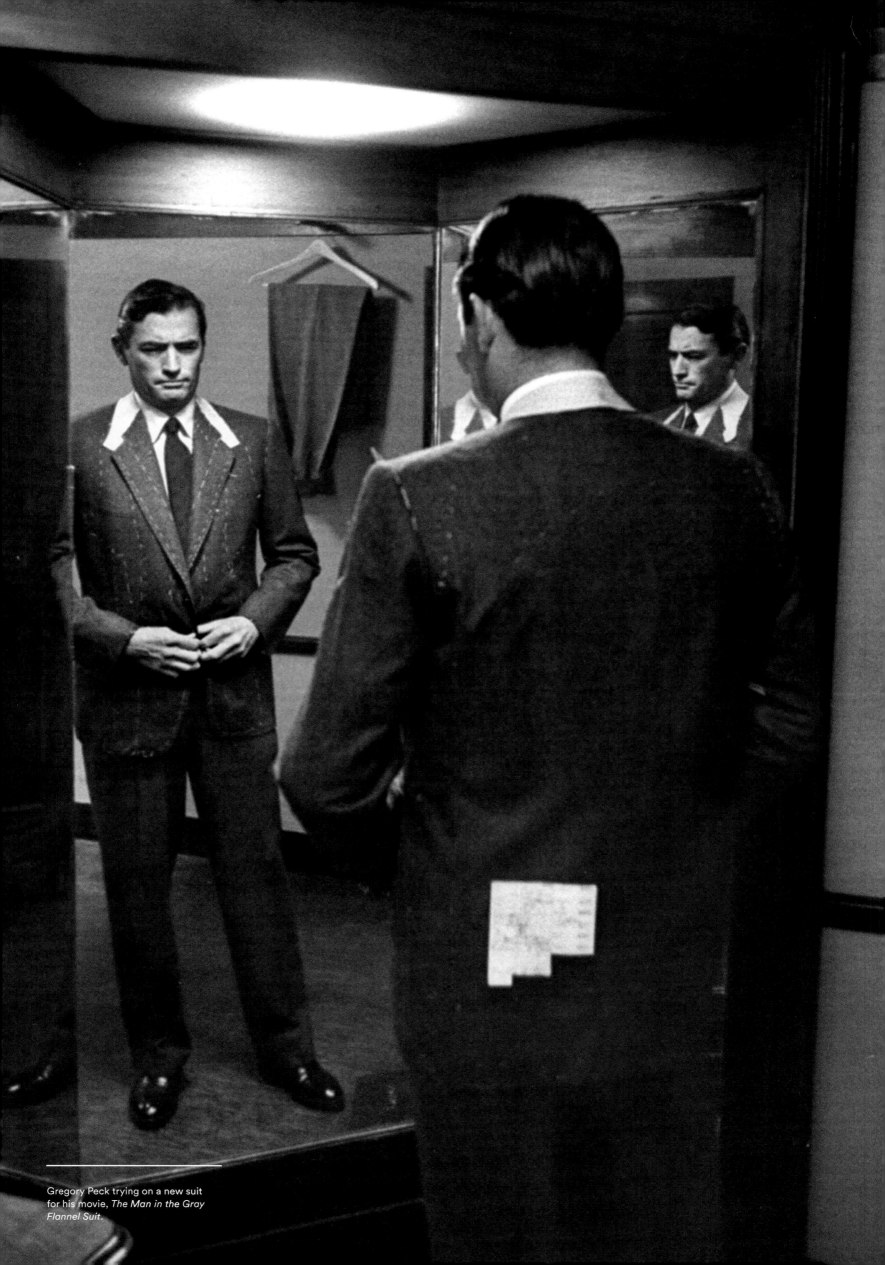

Gregory Peck trying on a new suit for his movie, *The Man in the Gray Flannel Suit*.

"Before there were designers, there was Brooks Brothers. In the days when men liked wearing uniforms they bought them at Brooks Brothers. If they liked the shirt they bought it ten times over and that's why they loved Brooks Brothers—for the perfect roll on the collar and the beautiful buttons on the oxford cloth shirt. You couldn't go wrong. Brooks Brothers is true American taste."

—GENE PRESSMAN, former co-chairman of Barneys New York

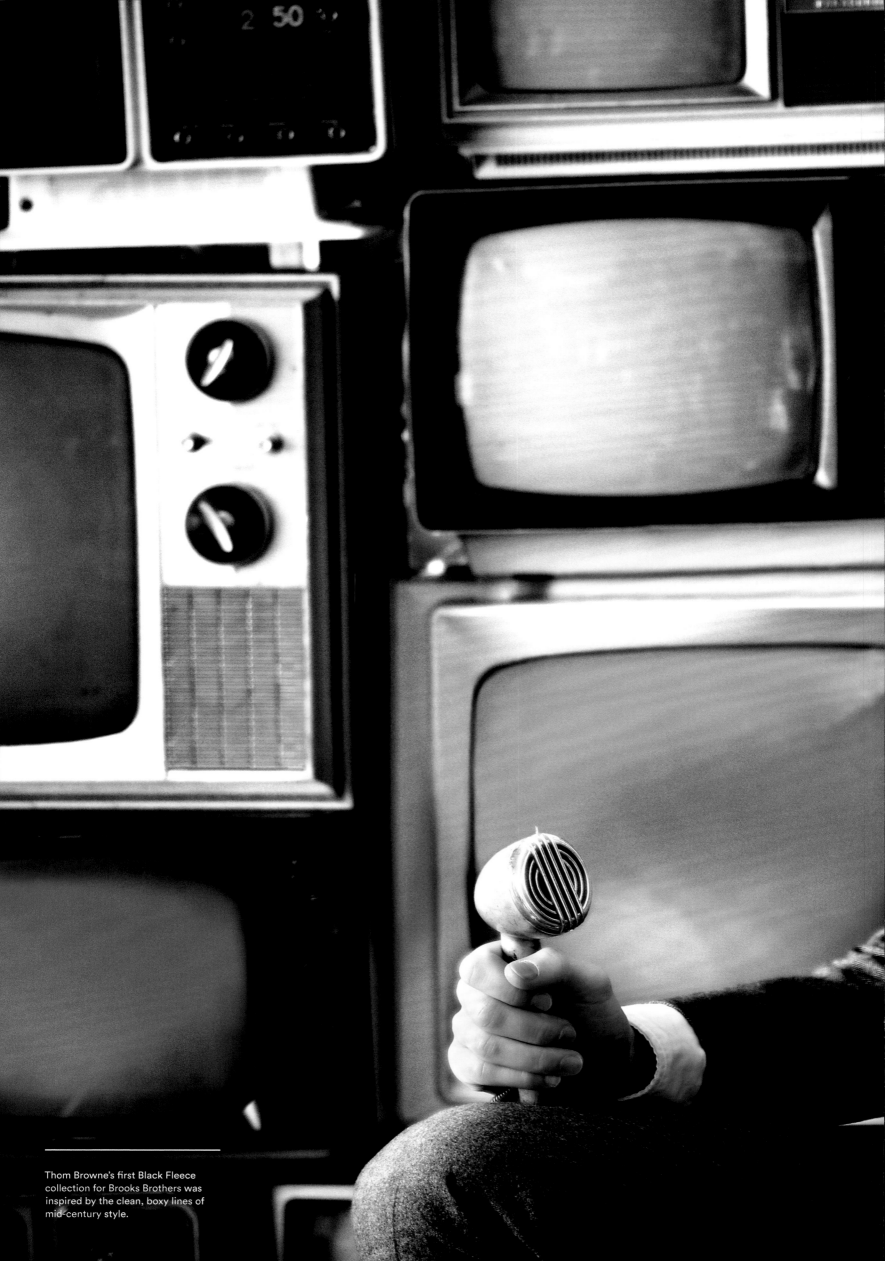

Thom Browne's first Black Fleece collection for Brooks Brothers was inspired by the clean, boxy lines of mid-century style.

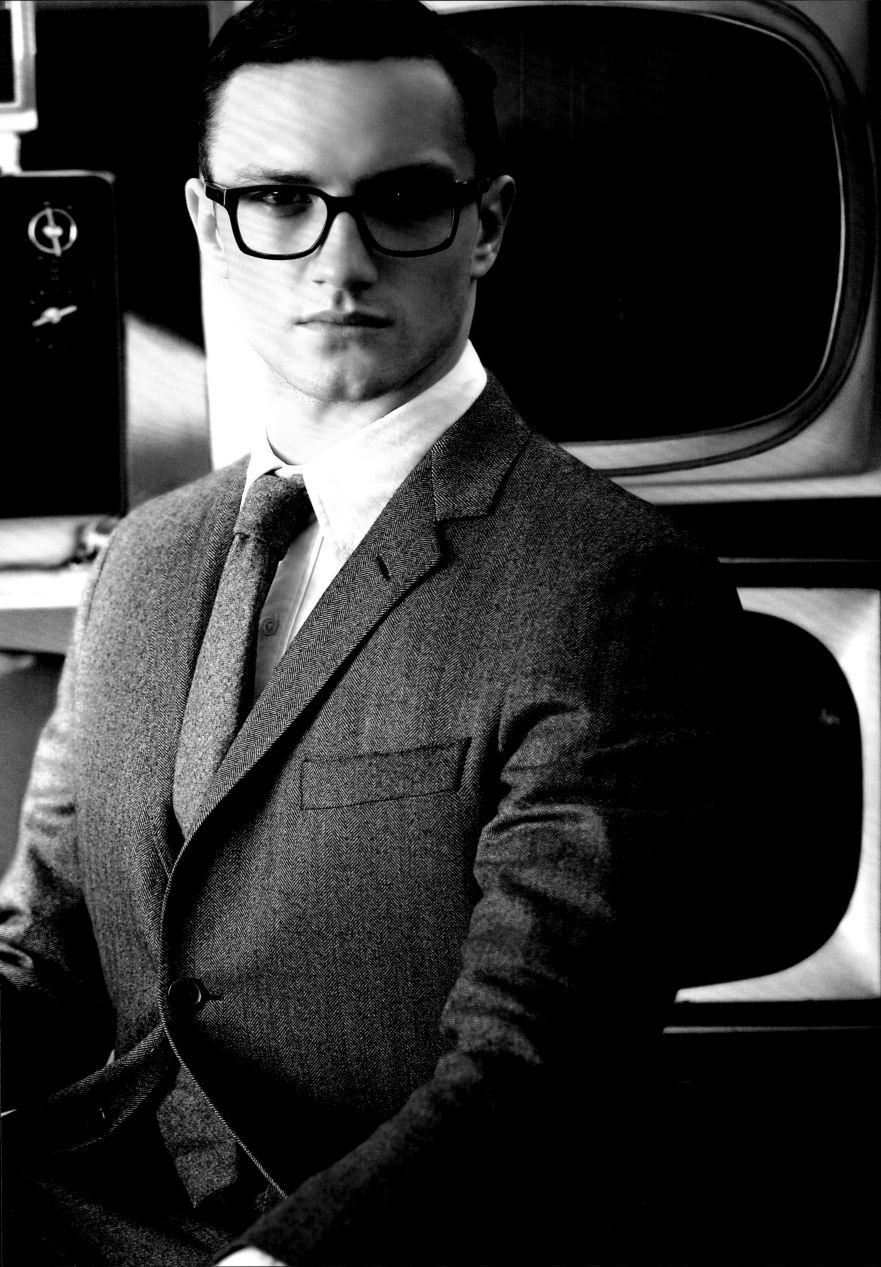

outstanding quality and workmanship
BROOKS BROTHERS CLOTHING
our own styling, materials and tailoring

We control every step in the making of our distinctive own make suits, sportwear, topcoats, overcoats and evening wear...from the careful selection of woollens woven in the finest English and Scottish mills (many in our own exclusive designs and colorings)...to the final hand-detailing. The natural shoulder, roll of the lapel and soft front construction of our jackets are details that are unmistakably Brooks Brothers...fine points that—along with our unerring quality and workmanship—have made the name Brooks Brothers synonymous with correct attire.

Our Own Make 3-Piece Suits, from $105

Topcoats, from $115 · Sport Jackets, $75 to $90

ESTABLISHED 1818

Brooks Brothers,
CLOTHING
Men's Furnishings, Hats & Shoes

346 MADISON AVENUE, COR. 44TH ST., NEW YORK 17, N. Y.
111 BROADWAY, NEW YORK 6, N. Y.
BOSTON · CHICAGO · LOS ANGELES · SAN FRANCISCO

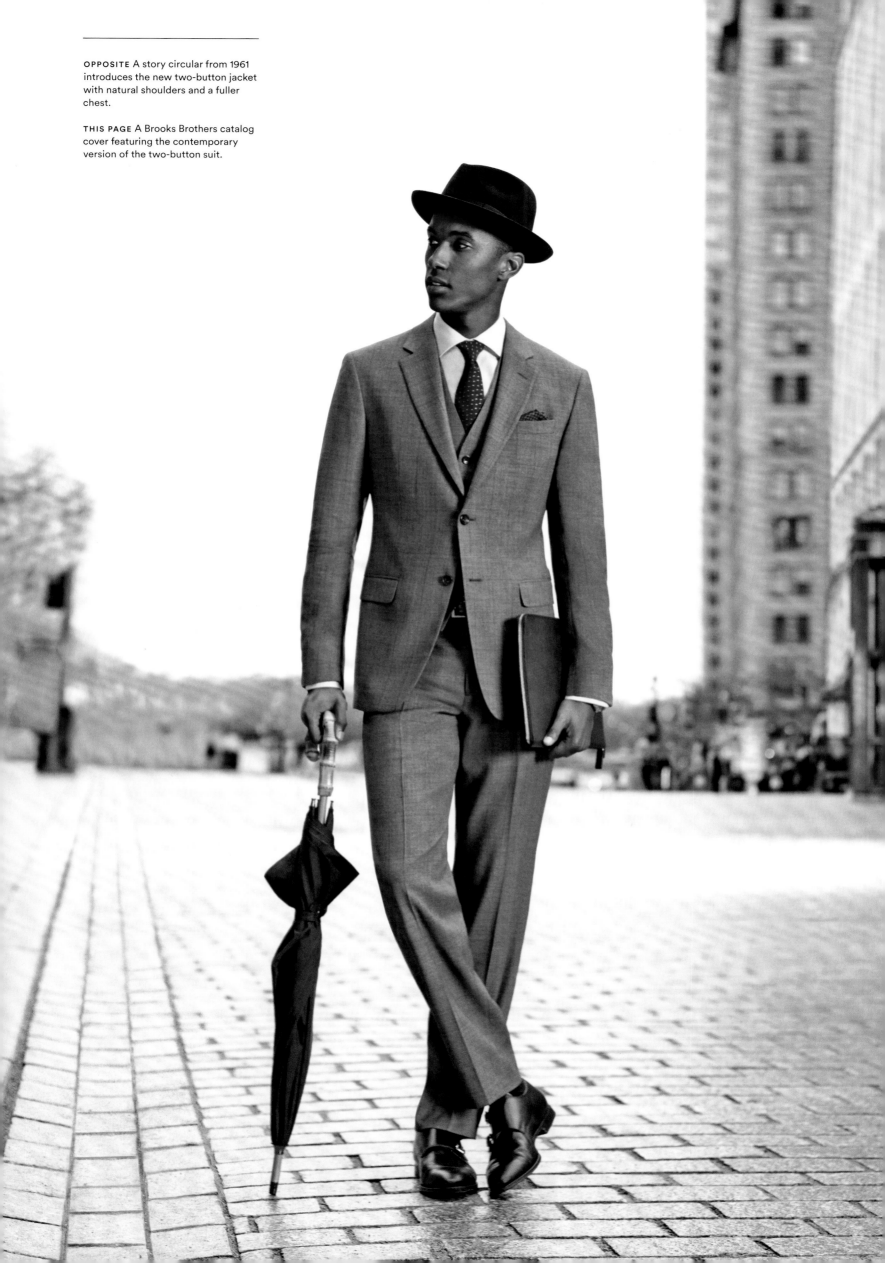

OPPOSITE A story circular from 1961 introduces the new two-button jacket with natural shoulders and a fuller chest.

THIS PAGE A Brooks Brothers catalog cover featuring the contemporary version of the two-button suit.

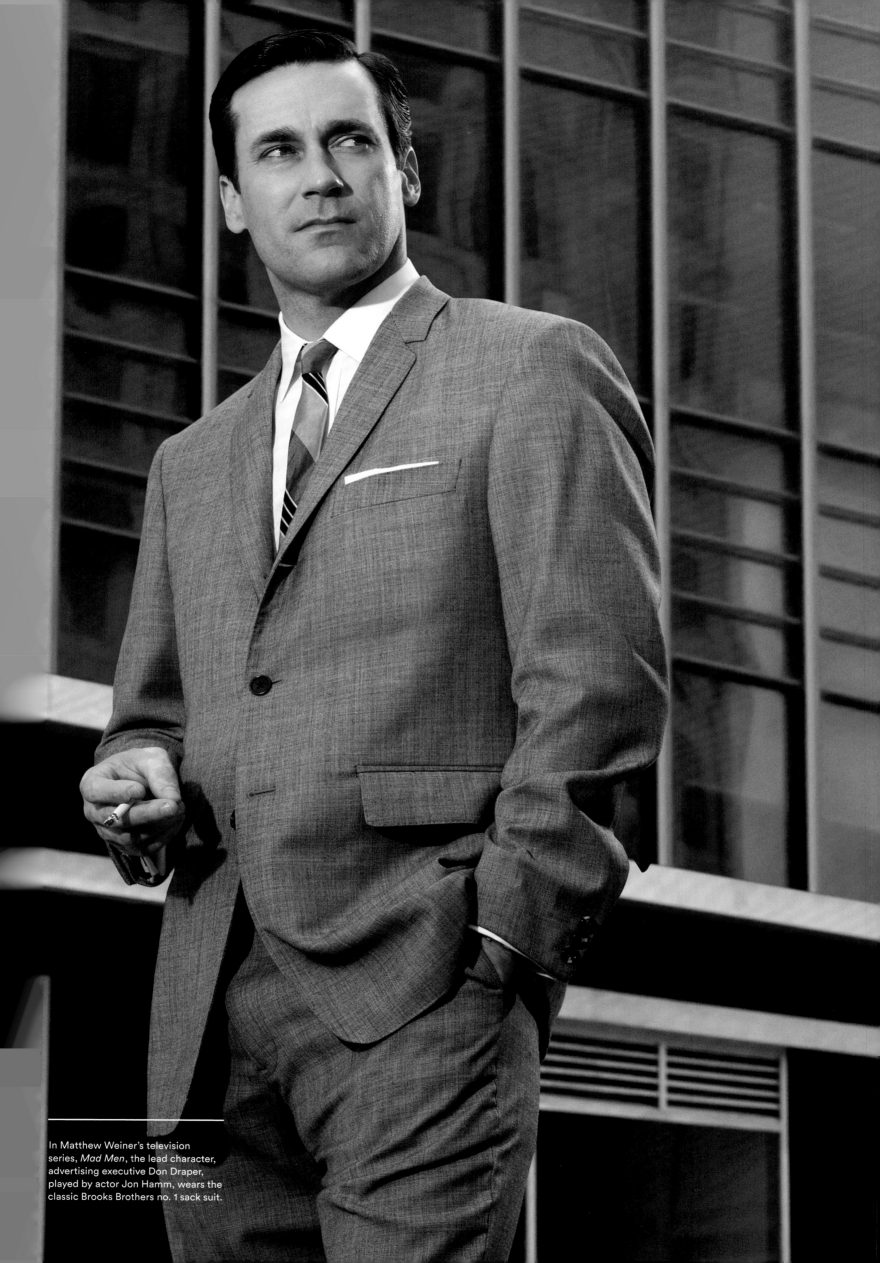

In Matthew Weiner's television series, *Mad Men*, the lead character, advertising executive Don Draper, played by actor Jon Hamm, wears the classic Brooks Brothers no. 1 sack suit.

MAD MEN BEHIND THE SEAMS

A Conversation With

MATTHEW WEINER

My father and mother got married in 1959. They were about the age of Pete and Trudy and, although they are first-generation Americans, my father is a very preppy person. I grew up sitting in Brooks Brothers waiting for him to get his clothing. In the late 1970s and especially in the early 1980s, when button-down shirts and button-down collars went out of style and pleated pants came in, my father would still go to Brooks Brothers to get what he wanted. From that childhood memory, Brooks Brothers became completely symbolic of a kind of classic style to me. It was definitely from a different era.

The clothing and style of the late '50s was such a big part of *Mad Men*—not as a symbol of conformity, because we now know that 99 percent of the show was about the desire for conformity, or this idea that conformity is an illusion, but as a story point for us driven by the costume designer, Janie Bryant. For example, it was very important to show the difference between characters: between Pete's youthful, three-button, European, Carnaby Street–influenced look and Don's classic Brooks Brothers look and then Roger, who has a slightly earlier look with the vests and the double-breasted coats, and Cooper, who was basically dressed in the 1920s.

All of the clothing was available in the classic patterns that Brooks Brothers had established since the beginning of the twentieth century. When *Mad Men* was filming, they were still making these patterns. At one point they had stopped making them, and with casual Fridays there had been a downturn, but as it happened, the relaunch of many of these classics coincided with the start of the show; it was a total coincidence. We didn't drive that. And of course, Janie was in love with the idea of Brooks Brothers and was already work-

MATTHEW WEINER is the creator of the AMC television drama series *Mad Men*, which premiered in 2007 and ended in 2015.

ing with vintage pieces from them, and then we started working with them directly.

I have a philosophy of period detail that was slightly different from the way it had been done previously in movies and on television. With a period that is as design-specific as the 1960s, which is where we started the show, we made a conscious decision that everything from the show was not going to be from that day. My theory is that everything exists at once and that people's taste may stop—as it does with music—in the period where they looked the best. So someone would have a requirement for a business look, but there was also a personal style. Peggy is dressed from the 1940s because she doesn't have a budget and she lives in Brooklyn, which at the time was considered slightly less stylish and rural compared to Manhattan. And then you have Joan, who is dressed pretty much in the 1950s.

For the men it could be boring and uniform, but Janie found a way to use the palette and the style of the time for as much personal expression as was allowed. You wouldn't notice it if you looked at a home movie from the time, but when you see the men standing next to each other you see the specific gradations of a lapel, a fabric, the pant length, or the jacket. All of these things become personal expressions, and Brooks Brothers had that entire variety for us.

We used costumes to help create the characters—the character being a personal life for a fictitious person. That was new in terms of depicting a period. Instead of looking at things you would have seen in magazines at the time, we made a concerted effort to use home movies and pictures to capture what life was really like. We wanted to do what was actually going on then. The costumes were also reflective of the financial reality of the characters and their aspirations. You have someone distinguishing himself, like Harry Crane, who's always wearing a bow tie. He may be imitating Burt Cooper because Burt has the job Harry wants.

For me it was important, and was also part of what Brooks Brothers provided, to not have the most extreme high-end item, but to have the thing that people really used and wore. Take the Chesterfield coat, which is a men's overcoat with a fur collar from the 1890s. It comes in and out of style, and the lapels get smaller and larger and sometimes they are velvet, but it's an overcoat that goes over a suit, so it has to be big. We waited for them to come back into style in the story of the show and we gave them to people who would have had them. Harry Crane wears one in the finale. Roger always had one because he was supposed to be of different means. I'm sure Cooper wore one at some point. Don not so much. He was an everyman whose style was set the way it was. He always wore the same suit. He didn't change it that much—and they didn't back then.

Another thing we got from Brooks Brothers was the classic striped pajama. This was not just from the movies—in that time the idea of sleeping in anything but pajamas was uncomfortable. I didn't understand Don wearing a full suit of clothing to bed every night, but Janie insisted that this is the way people went to sleep. And so all of a sudden the men's pajama and the light robe that went with it and the light shoes became part of the show.

With a character like Betty Draper—played by January Jones, who has a history of being a model—it would have been really easy to just put Betty in whatever was on the magazine covers at the time. Instead, Janie gave her a dress that she wears in more than one episode because of course Betty has a closet; she's a character in real life. She is upwardly mobile and she's a beautiful woman, but she went to high school in the 1940s and she's a mom and has to keep all of that in mind.

By the end of the show Betty is going to a Republican fundraiser with her second husband in a Jackie Kennedy–style inauguration party dress. It's ten years later, but that's what women of her means were wearing. Ten years is a long time, but when you think that you graduate from high school at eighteen, have you really changed your look so radically by thirty? Or are you just trying to look good and keep up with trends? That's what Janie is so great at—not just making it stand out for the moment, but having a complete education about what would have been available, what that person would be wearing for the event, what they struggle with personally.

Probably the biggest taboo that was broken by the way we chose costumes on the show, especially for men, was the idea that there would be any expression of vanity. It was unmanly to care about your hair or your nails or your clothes. We tried to express the fact that that was a lie. Men care about these things. Even smaller details tell this story, like what kind of T-shirt you wear. Don wears a classic crewneck. Some people wear a V-neck. Roger wears a tank T-shirt. What is the purpose of that? Why is there more than one? Well, you might wear the one your father wore. You might pick it for comfort, or because it goes with the clothes you like to wear. And all of a sudden you start to see people who actually view this as an expression of who they are.

Part of that is the story of materialism, but part of it was telling the truth about men, which is a lot of what the show was saying. Yes, men control women's fashion and they're negative about them and critical, but they're also doing it to each other. That was new. I don't think you'll see any man in a dramatic interpretation of anything outside of the theater or a politician behind the scenes who cares about what they're wearing.

You see it in *American Gigolo* in the 1980s, which to me, in my high school years, had the most obvious impact on the way people dressed. All of a sudden there's this super handsome movie star, Richard Gere, wearing all these expensive clothes and all of a sudden everyone in my high school is going out in a knit tie. Just the idea of men caring about that in a dramatic situation was new. Of course men have always cared about it, otherwise Brooks Brothers would be out of business.

It's also about the service element of being evaluated—are you improving yourself? The idea of men standing there in the fitting room with mirrors everywhere is a fantasy of success. It's aspirational. Whether it's real or not, it's a chance to improve your self-esteem. And part of that is getting service. Which was always a part of the Brooks Brothers experience.

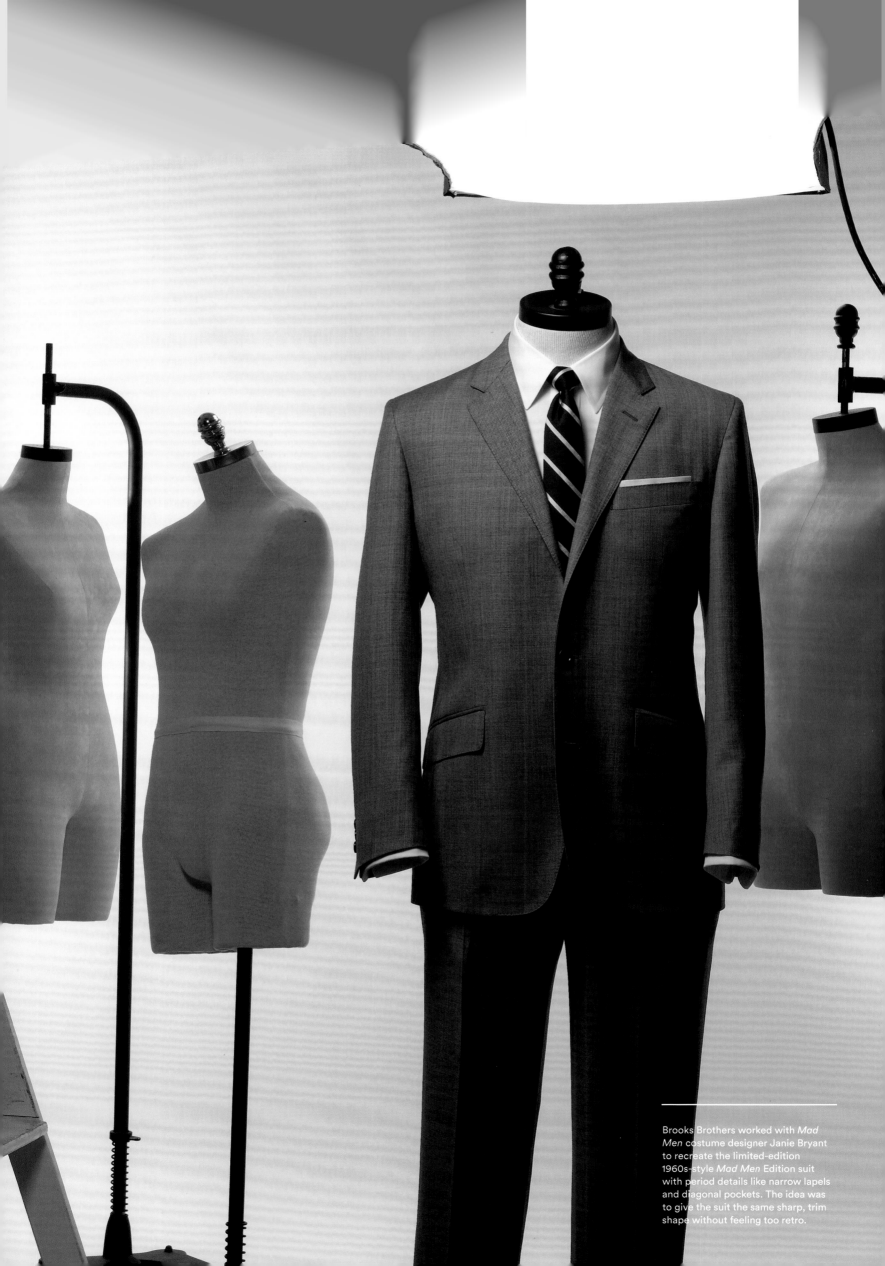

Brooks Brothers worked with *Mad Men* costume designer Janie Bryant to recreate the limited-edition 1960s-style *Mad Men* Edition suit with period details like narrow lapels and diagonal pockets. The idea was to give the suit the same sharp, trim shape without feeling too retro.

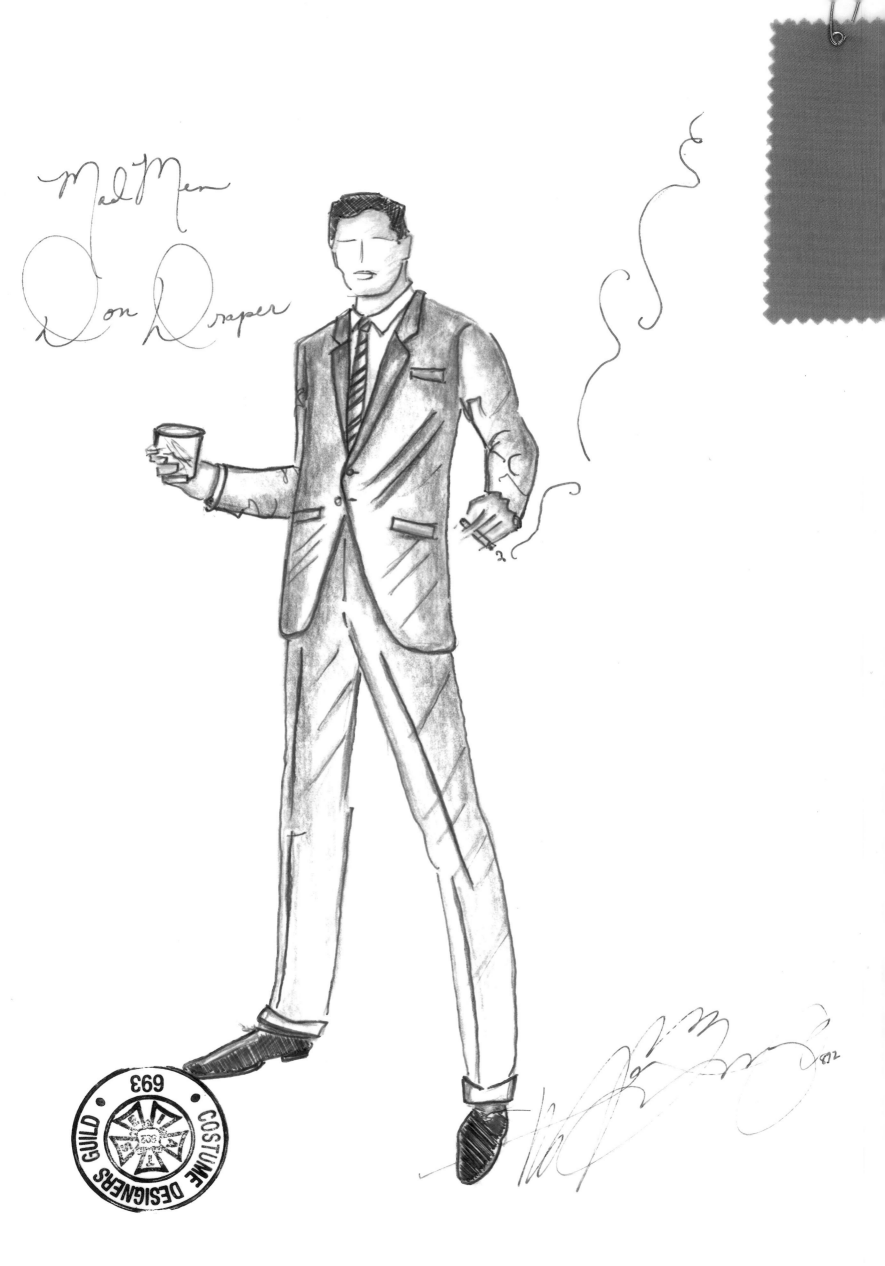

"In order to create the costumes for *Mad Men*
I began by visually dissecting the period
of the 1960s. I imagined those characters and
what they looked like, where they shopped.
Don Draper, Roger Sterling, Pete Campbell,
even Harry Crane—all those advertising
men of Madison Avenue shopped at Brooks
Brothers. They wore the iconic Brooks
Brothers slim cut suits with the narrow lapels
and the flat front trousers because they
were ambitious, they aspired to a certain taste
level and that's what Brooks Brothers
stood for. That iconic, beautiful grey shark-
skin suit Don Draper wears was a visual
symbol of his success."

—JANIE BRYANT, costume designer for *Mad Men*

OPPOSITE Costume designer Janie
Bryant's sketch for Don Draper, the
lead character in *Mad Men*.

"Glory, glory, leg-o-mutton
Glory, glory blazer button
Glory, glory poly-cotton
As its truth goes marching on"

—BROOKS BROTHERS COMPANY SONG

Three great names combine to produce a completely revolutionary and amazing new shirting fabric that we call

BROOKSWEAVE*

BROOKSWEAVE*

in the first Dacron and cotton blend oxford shirt for men . . . it is porous, fast drying and requires no pressing

From DuPont came Dacron†. . . and invaluable technical assistance. From Cone Mills, one of the largest and most modern in the country, came the spinning and weaving skill and know-how to produce this fine cloth. And from our own workrooms came the shirts themselves, made on our button-down collar style.

Made of a blend of Dacron and fine long staple cotton, Brooksweave shirting combines the soft, natural feel of our world-famous cotton oxfords, with all the magic qualities of Dacron. Months in the making, in the experimenting, and in the test-

ing, it is, we believe, the finest and most practical shirt of its type ever produced. The Brooksweave shirt can be washed at night, hung on a hanger soaking wet and be dry, fresh looking and ready to wear the next morning. Here is the answer to laundering problems, both at home and while traveling.

Brooksweave is a world wide exclusive and is sold only at Brooks Brothers' stores or by our Traveling Representatives.

In White, on Our Famous Button-Down Collar Style. In all sizes from 14-32 to 17½-36 **$12.50**

*The term Brooksweave is a trade mark of Brooks Brothers, Inc.
†DuPont's polyester fiber

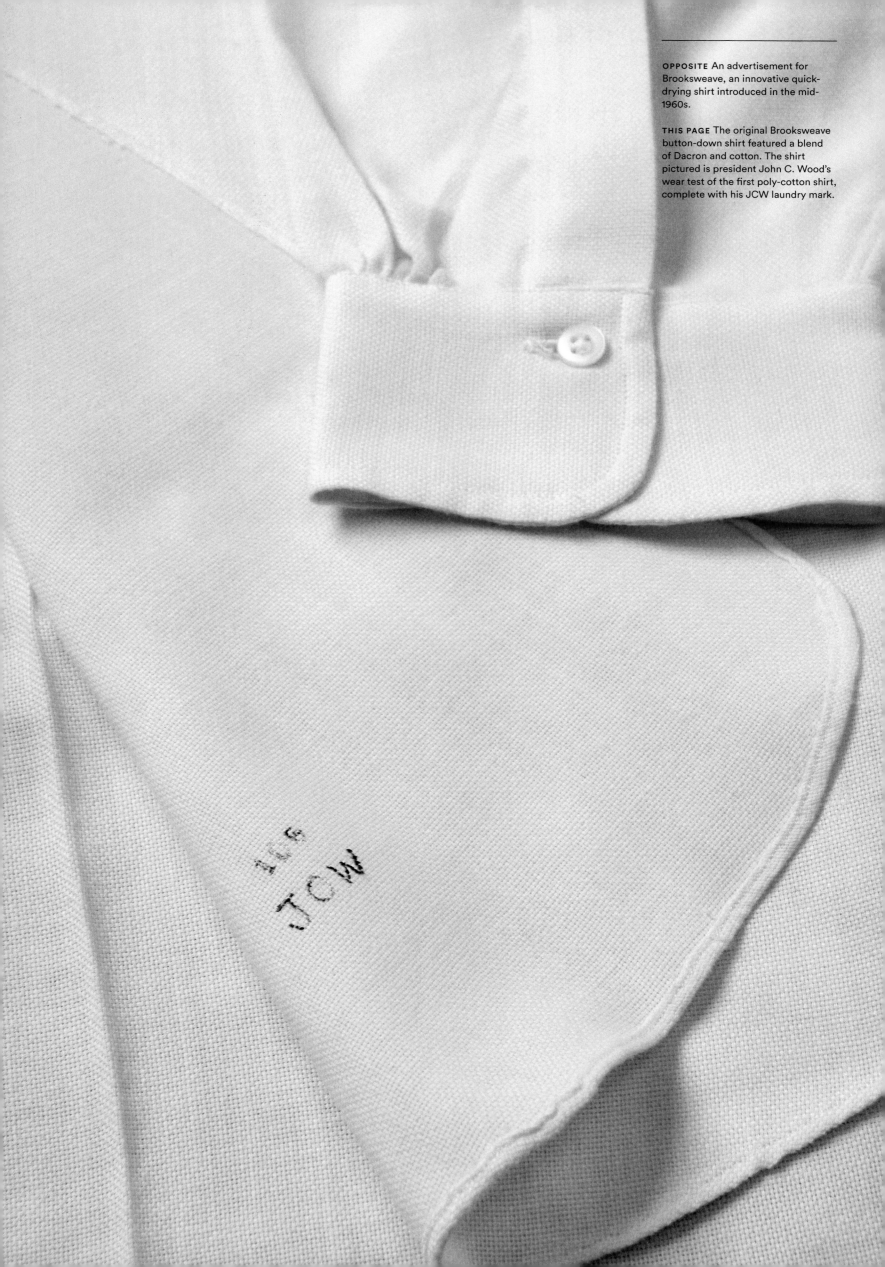

OPPOSITE An advertisement for Brooksweave, an innovative quick-drying shirt introduced in the mid-1960s.

THIS PAGE The original Brooksweave button-down shirt featured a blend of Dacron and cotton. The shirt pictured is president John C. Wood's wear test of the first poly-cotton shirt, complete with his JCW laundry mark.

THAT'S ENTERTAIN= MENT

RK GABLE-Metro Goldwyn-Mayer

ouglas Fairbanks Jr. was so crazy about Brooks Brothers that he spent years trying to convince Winthrop Holley Brooks, chairman of the board and great-grandson of the founder, to open an outpost in Hollywood. By 1939, Fairbanks had succeeded and Brooks opened small showrooms in both Beverly Hills and San Francisco. The company was careful about expanding and didn't open a full-sized San Francisco flagship until 1959. Hollywood got its flagship in 1964.

Soon, every silver-screen star and then some were shopping for suits, coats, and furnishings. Fred Astaire would buy fifty foulard ties at a time and paisley scarves to wear as belts. Gary Cooper bought dozens of pairs of chamois gloves—to wear in winter and summer. Maurice Chevalier bought only hats. And Clark Gable had his suits custom-made at Brooks Brothers because no ready-made suits could fit his broad-shouldered physique. Katharine Hepburn bought seersucker slacks and Marlene Dietrich stocked up on silk dressing gowns. Errol Flynn, Rudy Vallée, Roland Young, and John Boles were also Brooks Brothers regulars.

As much as they loved the clothing and accessories, the stars loved the anonymity they experienced at Brooks Brothers. Despite the fact that he was a regular customer, the legendary actor John Barrymore would introduce himself every time he approached a salesperson at the counter. Burt Lancaster, Robert Montgomery, Chester Morris, and Cary Grant would wander in and examine clothing samples, but the Brooks Brothers clerks were told to pay no more attention to the stars than they would to unknown customers. And the credit department was so strict they wouldn't even allow Rudolph Valentino to open an account.

Hollywood stars have worn Brooks Brothers almost as much on screen as they have off. As Atticus Finch in Robert Mulligan's 1962 film version of *To Kill a Mockingbird*, Gregory Peck famously wore a Brooks Brothers suit. And in 1945, when Tyrone Power was prepping for his part playing a disillusioned World War I pilot in *The Razor's Edge*, he asked Brooks Brothers' president Winthrop Holley Brooks for advice on how a wealthy young man would have dressed in the 1920s. Brooks offered to take him down to the second floor and outfit him right then and there. Not much had changed.

Costume designer Catherine Martin explored the roaring 1920s sartorial definition of a wealthy man when she was preparing the wardrobes for Baz Luhrmann's 2013 movie version of *The Great Gatsby*. Martin relied on Brooks Brothers' archives when researching the film's costumes and was challenged to justify the pink suit Gatsby wears in the denouement of the story when Tom Buchanan tries to discredit him. "We found several references to Brooks Brothers making livery uniforms for wealthy clients in the '20s," she explains. So when Leonardo DiCaprio appears as Gatsby in a pink linen suit, the look is pure Brooks Brothers—not only in the making of the costume, but also the reference to pink, which was a popular color at the store in those days. In all, Martin worked with Brooks Brothers to create 1,500 costumes for the film. The signature button-down shirt gets more than just an "extra" scene in

OPPOSITE Clark Gable wore Brooks Brothers custom suits exclusively because ready-made suits did not fit his broad-shouldered physique.

movies and television shows. Gregory Peck wears one in the opening scene of the 1956 movie *The Man in the Gray Flannel Suit*, and Fred Astaire wore one in *Royal Wedding*, as did Denzel Washington in *The Great Debaters*. In *Argo*, Ben Affleck's disheveled rep tie and oxford cloth button-down express just a little bit of the trauma his character endures, while Matt Damon's white button-down in *The Adjustment Bureau* reads clean-cut. Even Kermit the Frog has his own custom-made version, created especially for the first *Muppets* movie in 2011.

On television, *Gossip Girl* stars from Blake Lively to Penn Badgley wear a variety of classic Brooks Brothers looks, while Ed Westwick opts for the Black Fleece hunting jacket designed by Thom Browne after a 1930s version. The cast of *Glee* burnished their clean-cut personalities with help from Brooks Brothers' argyle vests, striped oxford shirts, and bowties galore. *Scandal*'s Fitz would not be so presidential without his pristine Brooks Brothers suit and furnishings.

Brooks Brothers' famous tie table even gets a cameo in Jason Reitman's 2009 film *Up In The Air*, when George Clooney's character, corporate hatchet man Ryan Bingham, ducks into a Cincinnati airport store to make a phone call and lingers over a display of rep ties. Dressed in a custom-made Regent suit, no less.

THIS PAGE Douglas Fairbanks Sr., considered one of the best-dressed men of his time, was also a big Brooks Brothers fan.

OPPOSITE Fred Astaire famously wore Brooks Brothers' foulard ties as belts.

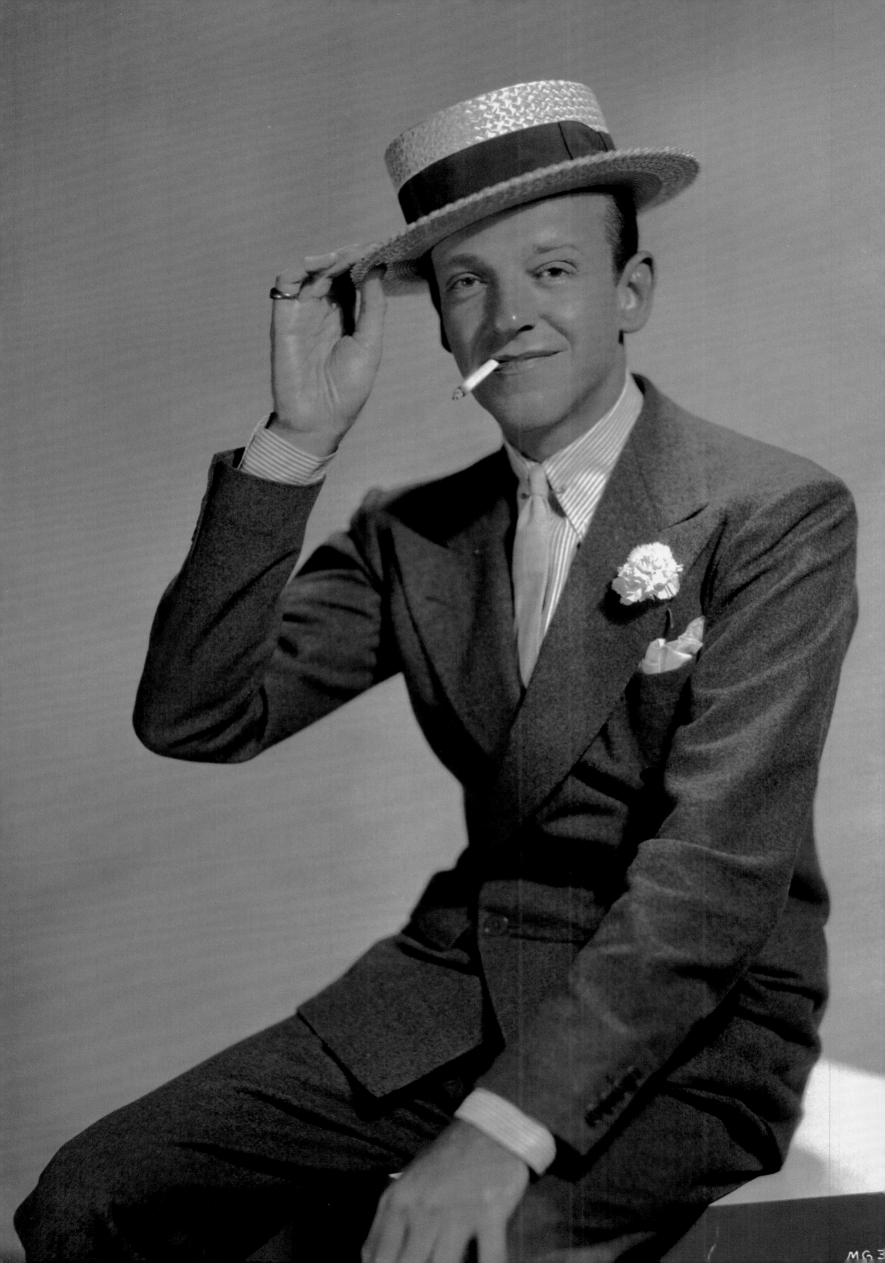

Members of the cast of *Gossip Girl* pose in Brooks Brothers staples like the oxford cloth button-down and the rep tie.

"I was just ten years old when my father
came back from a trip to America with
two Brooks Brothers shirts each for both my
brother and me. Even then, I knew that this
was a special gift. Today I have a collection
of these shirts—and I'm not the only Italian
with a story like that!
In the 1970's I came to New York
and discovered an icon. Since then, no trip
to New York was ever complete without
a visit to 346 Madison Avenue. Brooks
Brothers is the symbol of tradition for the
modern lifestyle and nobody can deny its
success. We have been honored to be a
participant in its development, particularly
over the last 15 years."—

—PIER LUIGI LORO PIANA, Deputy Chairman, Loro Piana

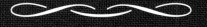

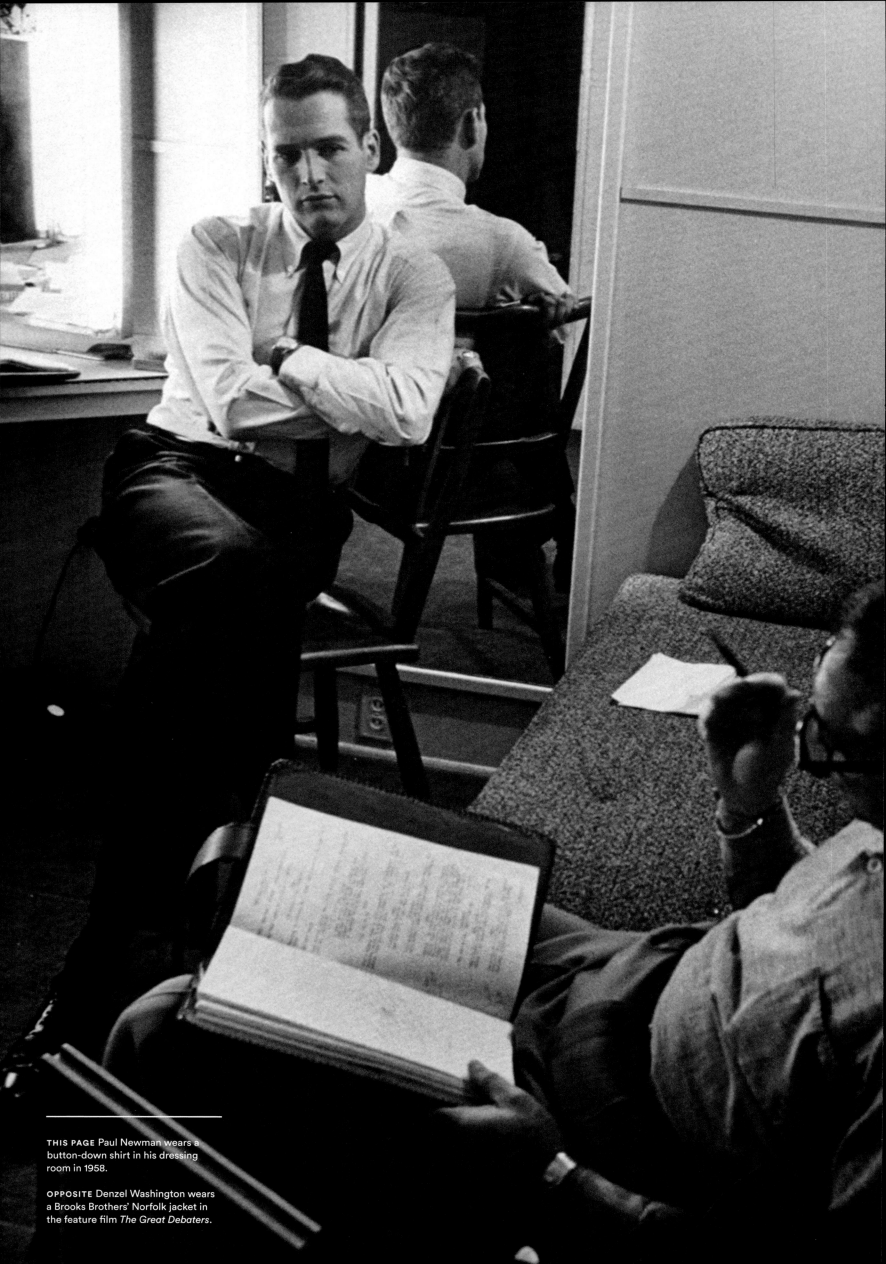

THIS PAGE Paul Newman wears a
button-down shirt in his dressing
room in 1958.

OPPOSITE Denzel Washington wears
a Brooks Brothers' Norfolk jacket in
the feature film *The Great Debaters*.

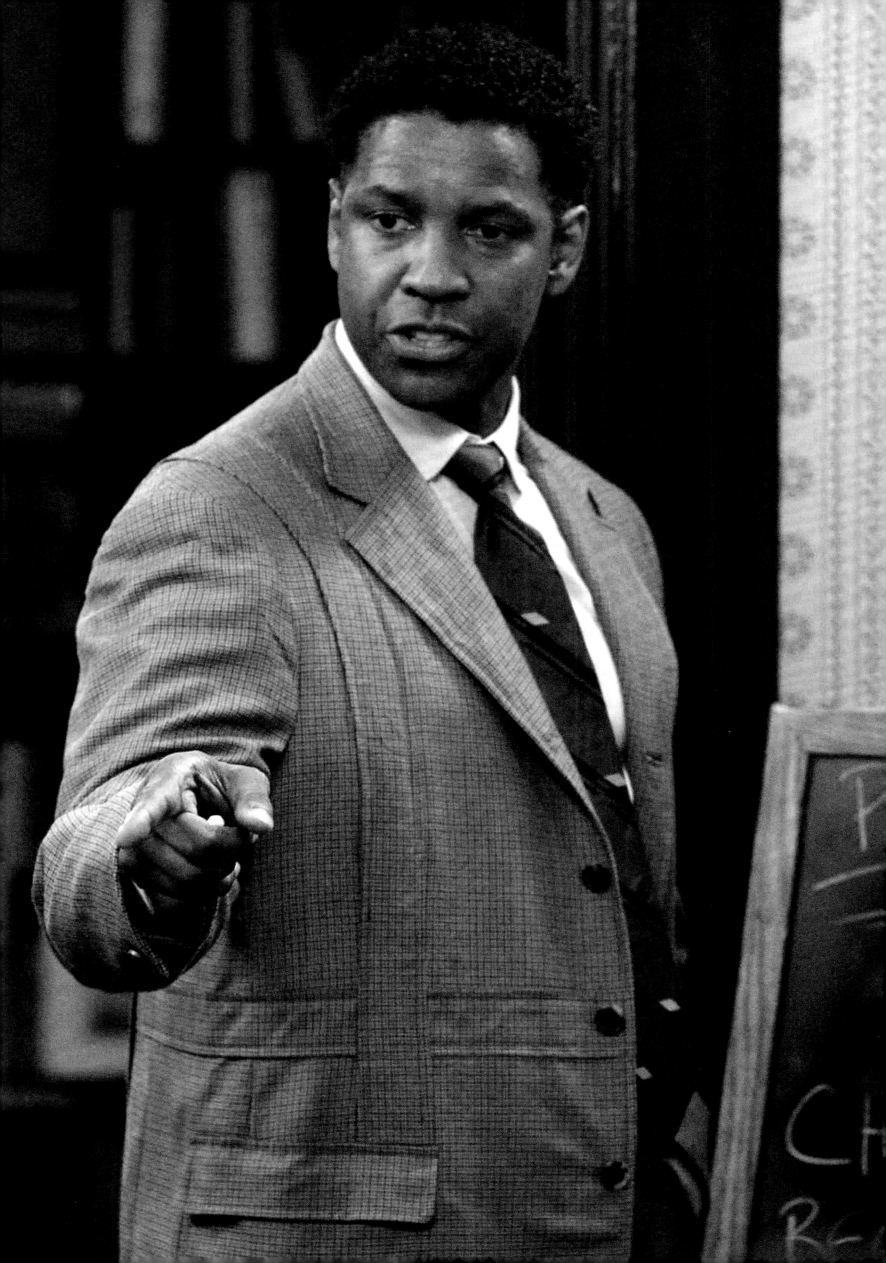

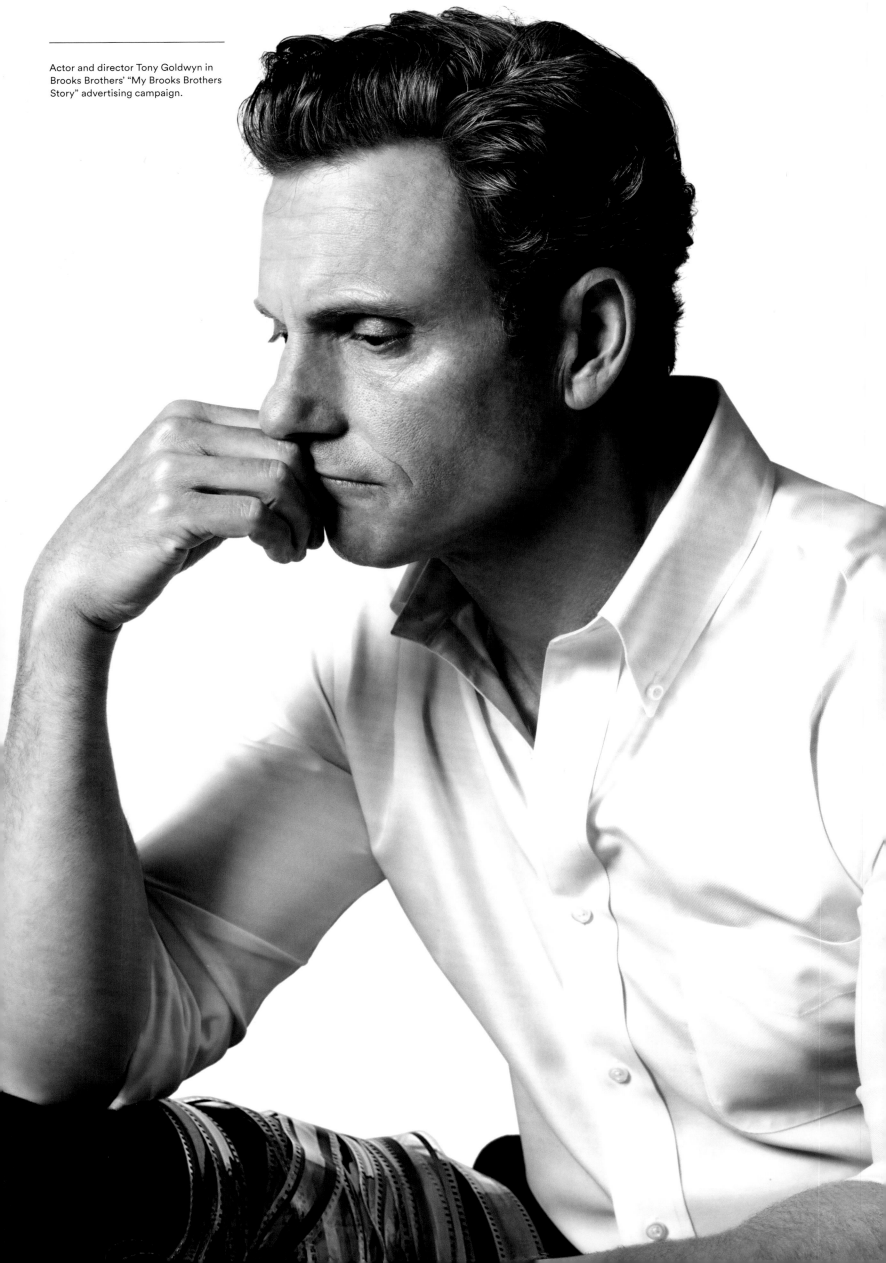

Actor and director Tony Goldwyn in Brooks Brothers' "My Brooks Brothers Story" advertising campaign.

"For me Brooks Brothers epitomizes
style and elegance. My love of
the brand only deepened during my
seven seasons of *The West Wing*,
as many of our characters were dressed
in their amazing suiting and shirting.
Now I have come full circle and back
to Brooks Brothers again in creating
the male characters on *Scandal*.
Fitz would not be Fitz without his
Brooks Brothers suiting."

—LYN ELIZABETH PAOLO, costume designer

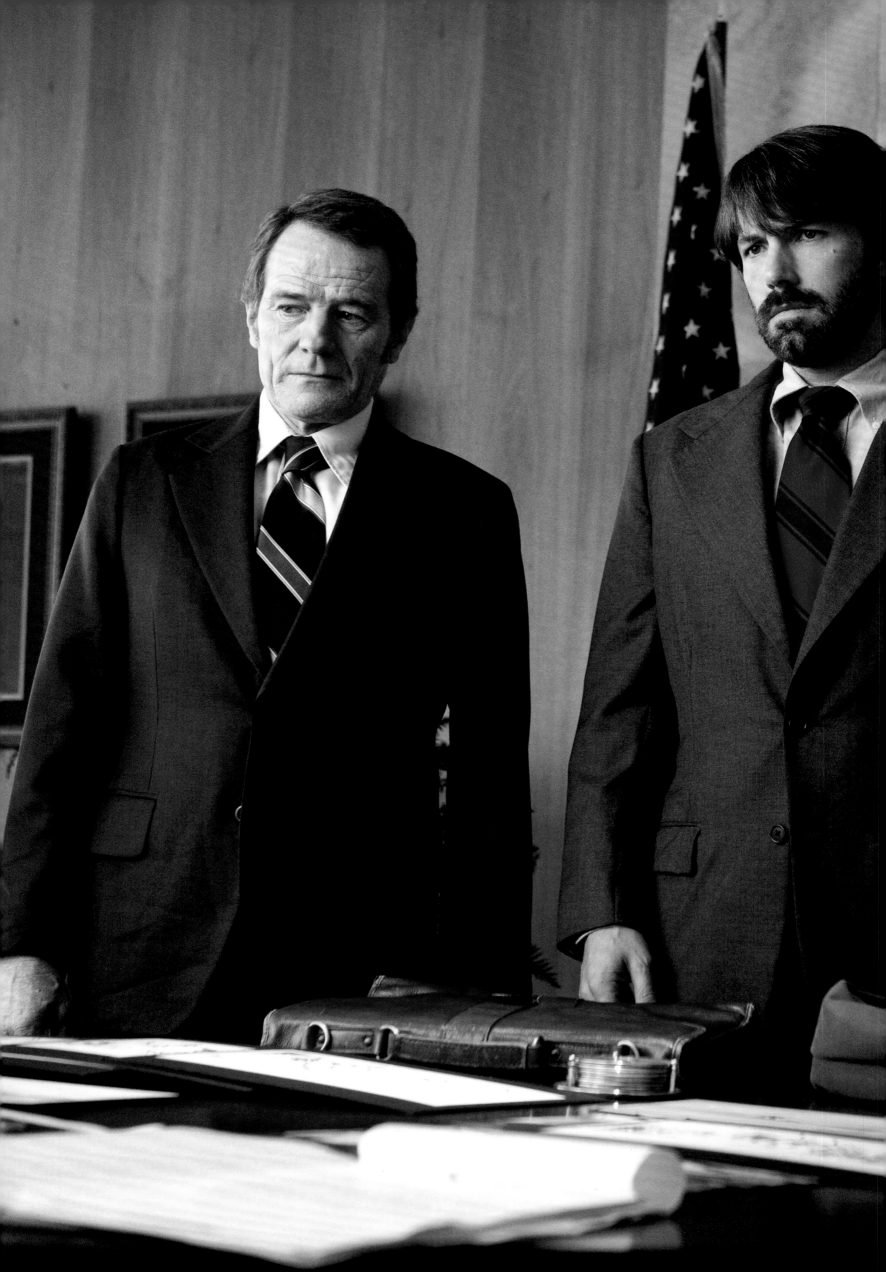

In the 2016 feature film *Argo*, Ben Affleck's rumpled sack suit and 1970s-style wide tie perfectly portray his character's stressed-out situation.

"There's something almost punk rock about Brooks Brothers and its conservative image. It's the oldest American menswear brand, but it has stayed relevant and retained the cachet of the Golden Age of Hollywood because it's still the place you go when you want to look appropriate. There's an elegance that is not anachronistic, you're not shopping there for costume."

—CAMERON SILVER, author, designer, and vintage clothing expert

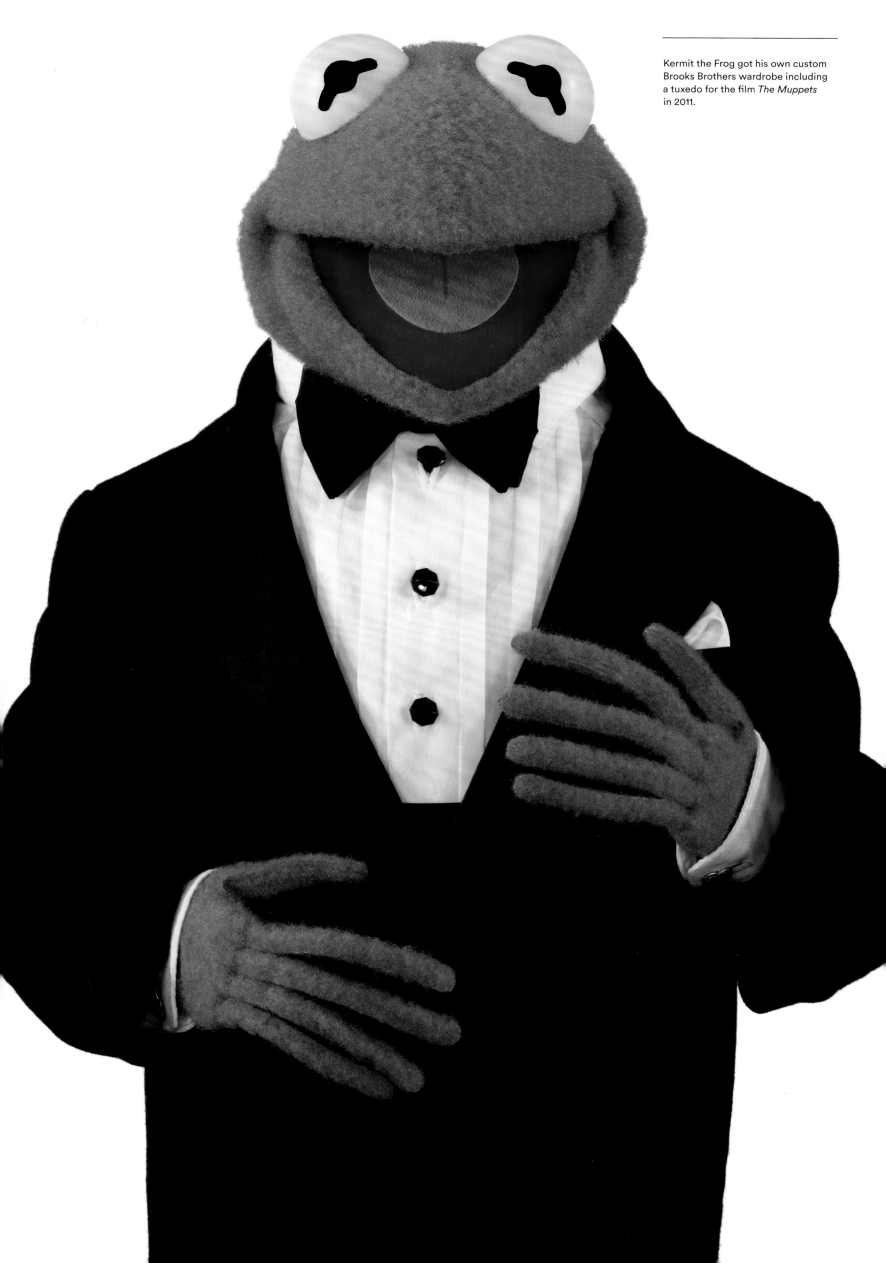

Kermit the Frog got his own custom Brooks Brothers wardrobe including a tuxedo for the film *The Muppets* in 2011.

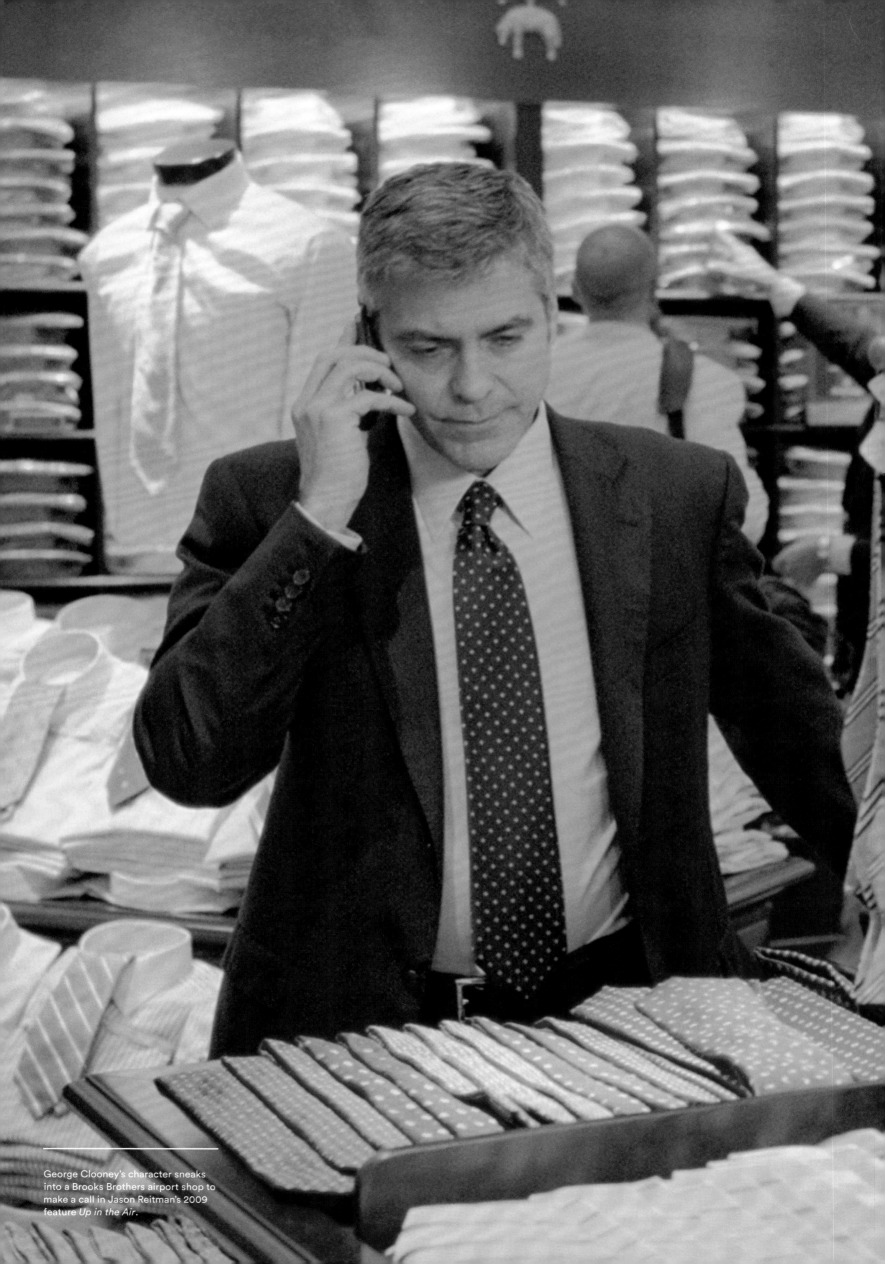

George Clooney's character sneaks into a Brooks Brothers airport shop to make a call in Jason Reitman's 2009 feature *Up in the Air*.

Neckwear
Buy 1 get the second
30% off
orig. '39.50 – '165 each

Brooks Brothers

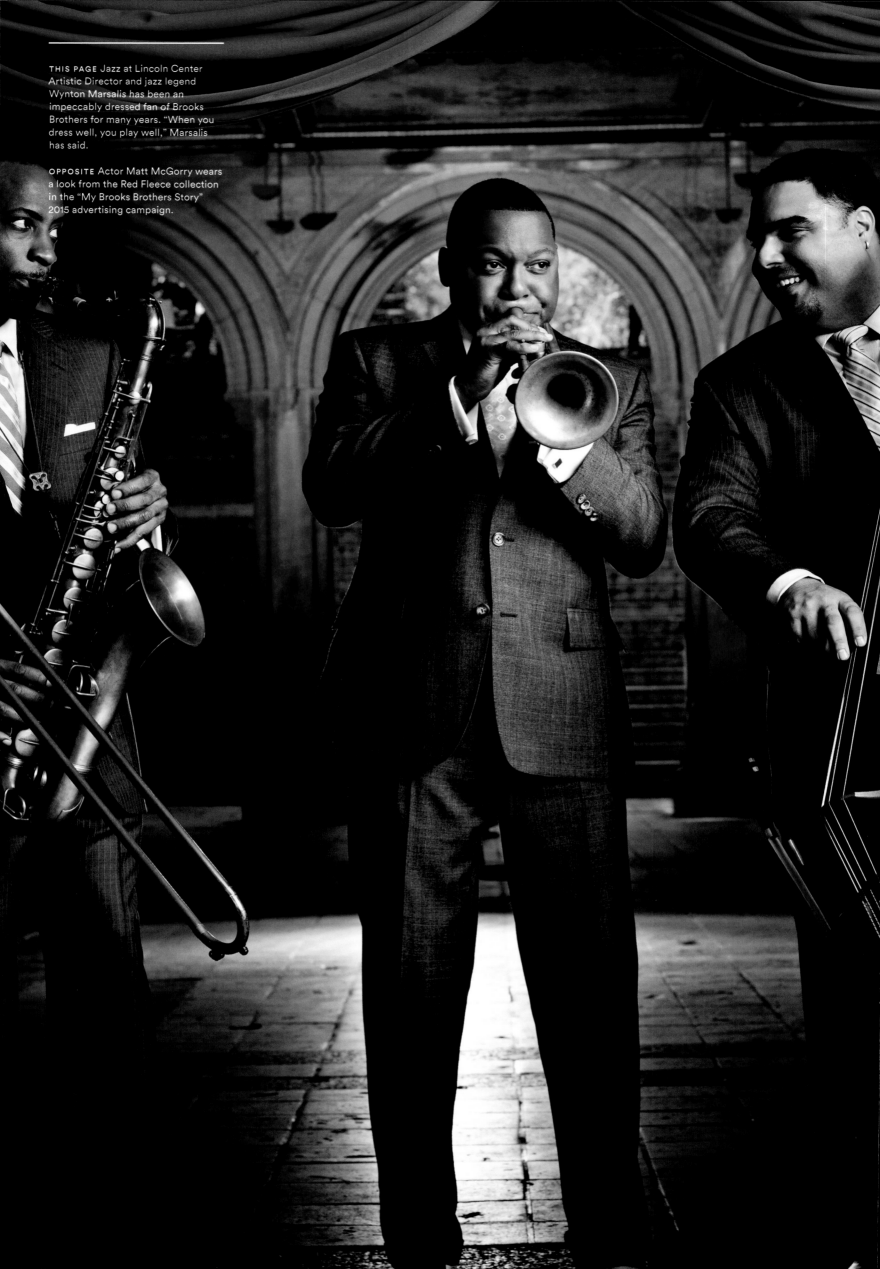

THIS PAGE Jazz at Lincoln Center Artistic Director and jazz legend Wynton Marsalis has been an impeccably dressed fan of Brooks Brothers for many years. "When you dress well, you play well," Marsalis has said.

OPPOSITE Actor Matt McGorry wears a look from the Red Fleece collection in the "My Brooks Brothers Story" 2015 advertising campaign.

Actor Darren Criss, far left, and the cast of *Glee* often stepped out in Brooks Brother's attire.

"When I came to New York in the 70s,
Brooks Brothers was really the only men's store
I knew about. I was working at *Time* and the
style of dress for men, was, to put it mildly,
conservative. So I bought shirts and ties to sort of fit
in. After a few purchases, one of the sales clerks—
who lives in my neighborhood and who I still
see from time to time—suggested I get a store charge
account. I applied for it and about a month later
it arrived. I was living down in the village and we
had a radiator with a wooden cover in the front hall
where the mailman dropped everyone's mail.
I remember coming home and seeing the Brooks
Brothers envelope. I opened it and there was my
Brooks Brothers charge card. With my name on it.
I promise you, it was then that I first felt like
a real New Yorker. And I've been a faithful
customer ever since."

—GRAYDON CARTER, Editor in Chief, *Vanity Fair*

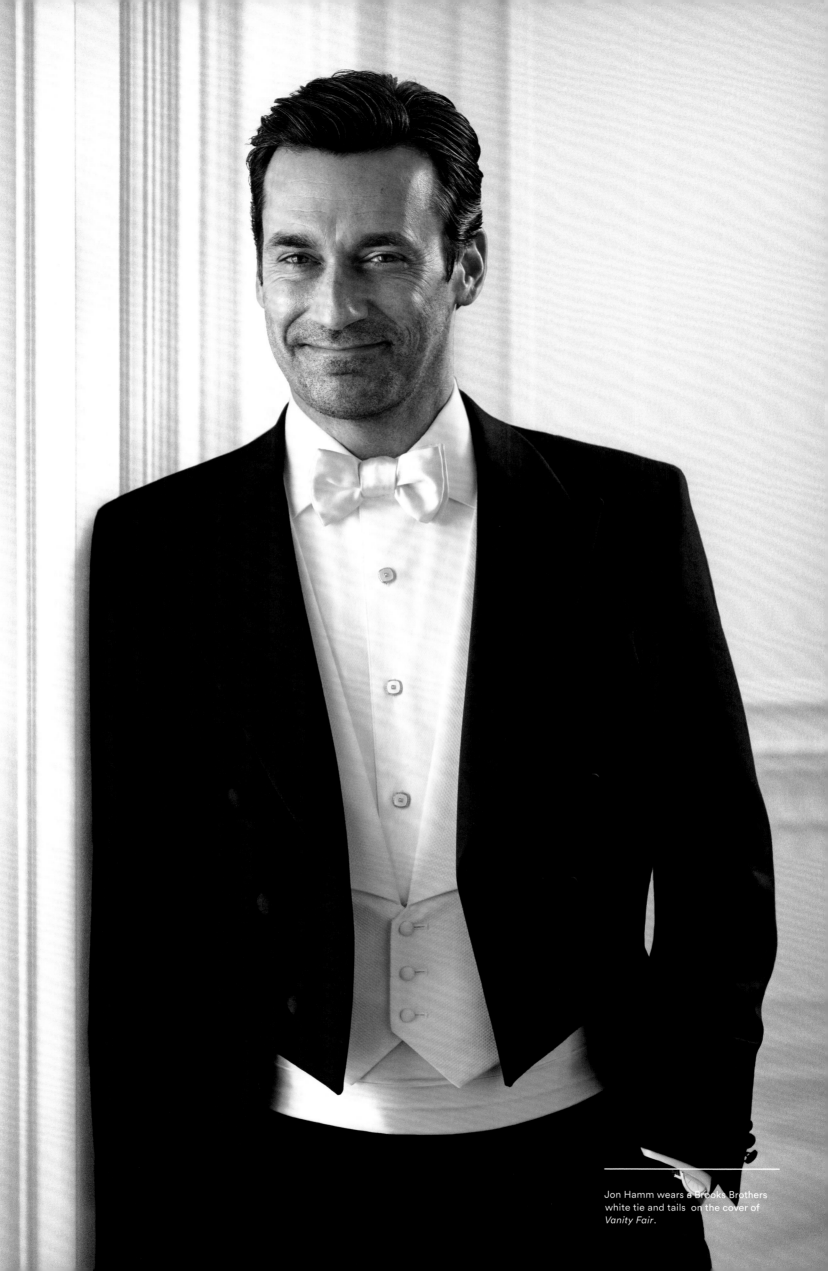

Jon Hamm wears a Brooks Brothers
white tie and tails on the cover of
Vanity Fair.

"Brooks Brothers is
as American as Apple pie!
For me it's about the
perfect striped shirts,
the perfect men's underwear,
it IS about being proper
in the most elegant way."

—DIANE VON FURSTENBERG, designer

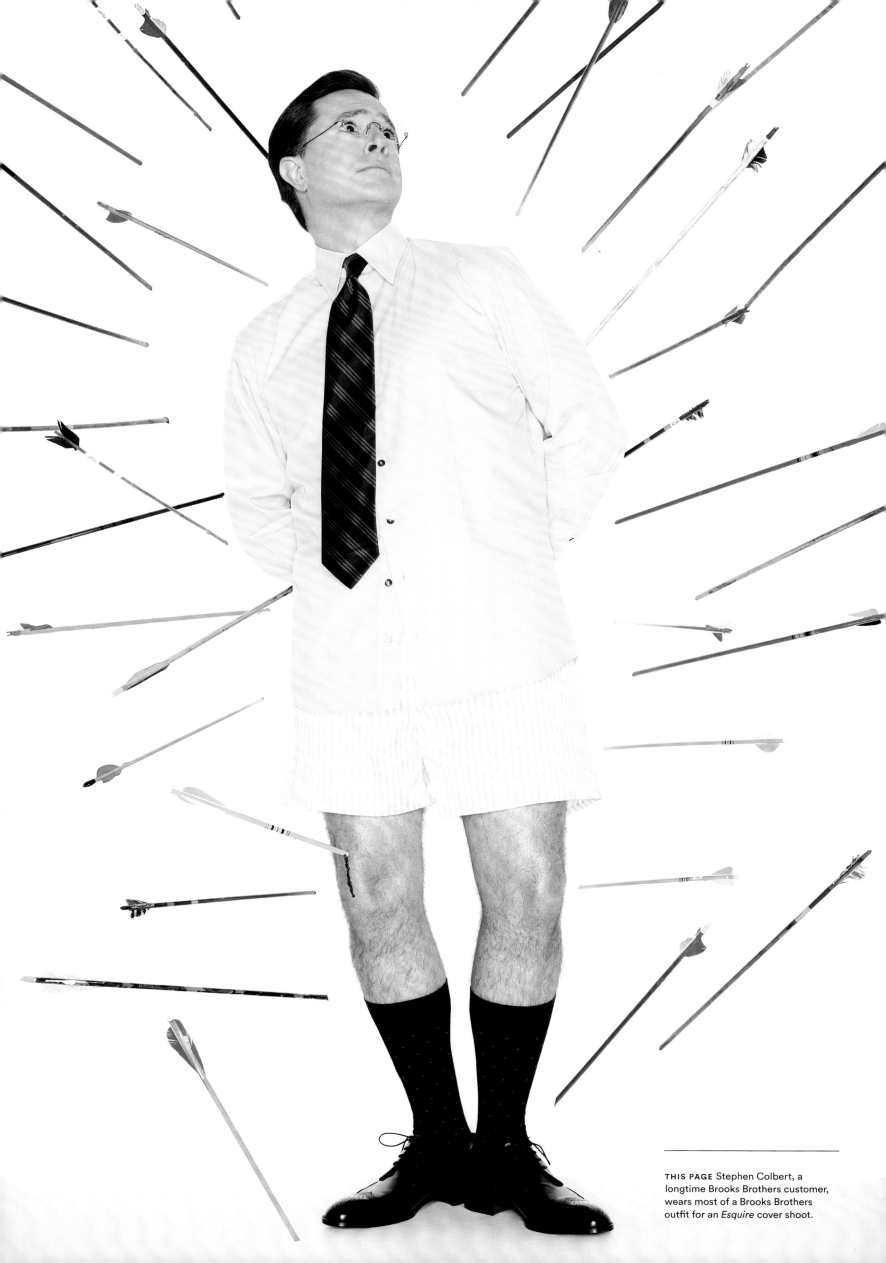

THIS PAGE Stephen Colbert, a longtime Brooks Brothers customer, wears most of a Brooks Brothers outfit for an *Esquire* cover shoot.

OPPOSITE Steve McQueen was a loyal Brooks Brothers customer.

THIS PAGE Steve McQueen's Brooks Brothers credit card.

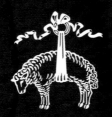

CHAPTER TEN

INDELIBLE STYLE

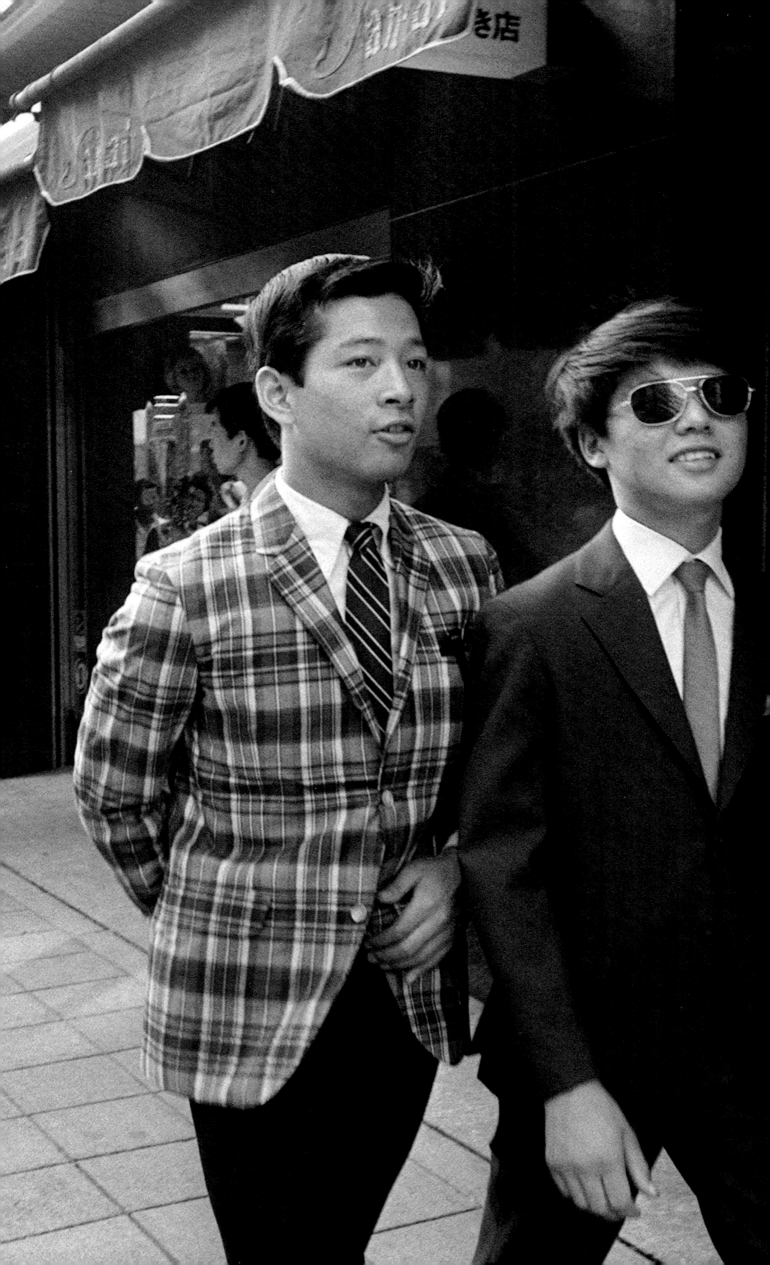

I n the spring of 1964 the Japanese designer Kenzo Takada arrived in Paris wearing a madras jacket and khakis. All around him street fashion was exploding—from London's Carnaby Street to Paris's Boul'miche, where ready-to-wear designers were breaking rank with the formal dress codes of haute couture. Kenzo would eventually become one of the fashion world's leading designers, but at that moment he was under the influence of a trend that had taken Tokyo by storm—Ivy League—and Brooks Brothers owned it.

The Ivy League look had followed a circuitous route, from the pages of the Brooks Brothers catalog to the bucolic Princeton campus, where in 1959 an ambitious ready-to-wear entrepreneur named Kensuke Ishizu had traveled by train from New York City to study the preppy look favored by the university's students. Ishizu had first spotted an oxford cloth button-down shirt on an American officer in Japan after the occupation and he had an idea to copy it and create what he hoped would be the first trendy clothing line for Japanese men. VAN Jacket became the counterculture hit of 1960s Japan and reconfirmed Brooks Brothers' far-reaching influence for a new generation.

After Kensuke and Takada came a whole slew of what is now known as "avant-trad"—or avant-traditionalist—designers and stylists steeped in the classical vocabulary of Brooks Brothers. Magazines, documentaries, and—much later—blogs were devoted to capturing, promoting, and reproducing an aesthetic now commonly known as "Take Ivy," after a campaign Ishizu had created in 1965 and eventually turned into a book and film about the American Ivy paradigm. In Japan the look endured for several decades, inspiring designers and manufacturers to recreate exact facsimiles of the Brooks Brothers look. And on runways in Paris, designers like Junya Watanabe, a protégé of Rei Kawakubo of Comme des Garçons, began collaborating with the brand, exploring and reinterpreting wardrobe basics like the trench coat and the oxford cloth button-down.

OPPOSITE In the 1960s, Japanese style setters picked up on Brooks Brothers' "avant-trad" look and made it a cutting-edge fashion statement of Tokyo—one that endures to this day.

While the Japanese were very literally influenced by Brooks Brothers' classic style, many American designers closer to home borrowed more liberally from the brand. One young designer in particular had gotten his start at Brooks Brothers, working in the late 1960s as a salesman at the tie counter. Educated in the ways of Brooks Brothers, Ralph Lauren would famously go on to create his own collection of wider ties in keeping with 1970s fashions. From one tie, he built a multi-billion-dollar business inspired in many ways

by the Brooks Brothers' sensibility, including the early-twentieth-century Ivy League look. Even Ralph Lauren's polo insignia owed something to Paul Brown's polo pony sketch.

From there the field was wide open, and legions of creative minds galloped in, reinterpreting the wardrobe staples of the same polo players, Princeton grads, and Madison Avenue men that Brooks Brothers had defined. From Tommy Hilfiger to Vineyard Vines and from J. Crew to J. Press (now ironically owned by the Japanese), the idea of an American code of "appropriate" dress has blossomed and morphed into a multitude of expressions.

"All of those iconic American lifestyle brands tap into what Brooks Brothers meant in history as the original understated, put-together look," says Zac Posen, who now designs the brand's women's collection. "And those different elements that encompass the classics have reentered high fashion and high street style, from top to bottom, from the white shirt to the blue blazer, the polo shirt, khakis, and the camel overcoat. Brooks was the originator of all of these items."

And yet American style doesn't belong solely to Brooks Brothers. One brand alone cannot claim the ever-changing, complicated history of menswear. But much of the early foundation of a certain American menswear ethos originated with the vision of Henry Sands Brooks. And the host of "true American" brands that has sprung up around the world in the last five decades proves that Brooks Brothers is more than a menswear brand; it is a sensibility. Today the influence can be felt from university stores to department stores and from international fashion runways to Instagram accounts.

Perhaps in response to the indelible stamp Brooks Brothers has put on American menswear, the company in recent years has reached out to more fashion-forward designers to revisit the classic products that have inspired so many. In early 2007 the avant-garde menswear designer Thom Browne signed on to create Black Fleece, a renaissance of many of Henry Sands Brooks's original ideas, including the red wool fox-hunting jacket and the early-twentieth-century tweed suit. Later, Zac Posen was hired to add his glamorous vision to the women's line, a mission he said would continue the tradition of the highest quality fabrication of items that are timeless but can be put into fashion. A mission that will surely take up where Henry Sands Brooks left off: "To make and deal only in merchandise of the best quality, to sell it at a fair profit only, and to deal only with people who seek and are capable of appreciating such merchandise."

OPPOSITE Models at designer Zac Posen's fall 2017 Brooks Brothers presentation in New York City. Posen has given a modern twist to traditional fabrics and items, like windowpane plaid, the polo coat, and the oxford-cloth button-down.

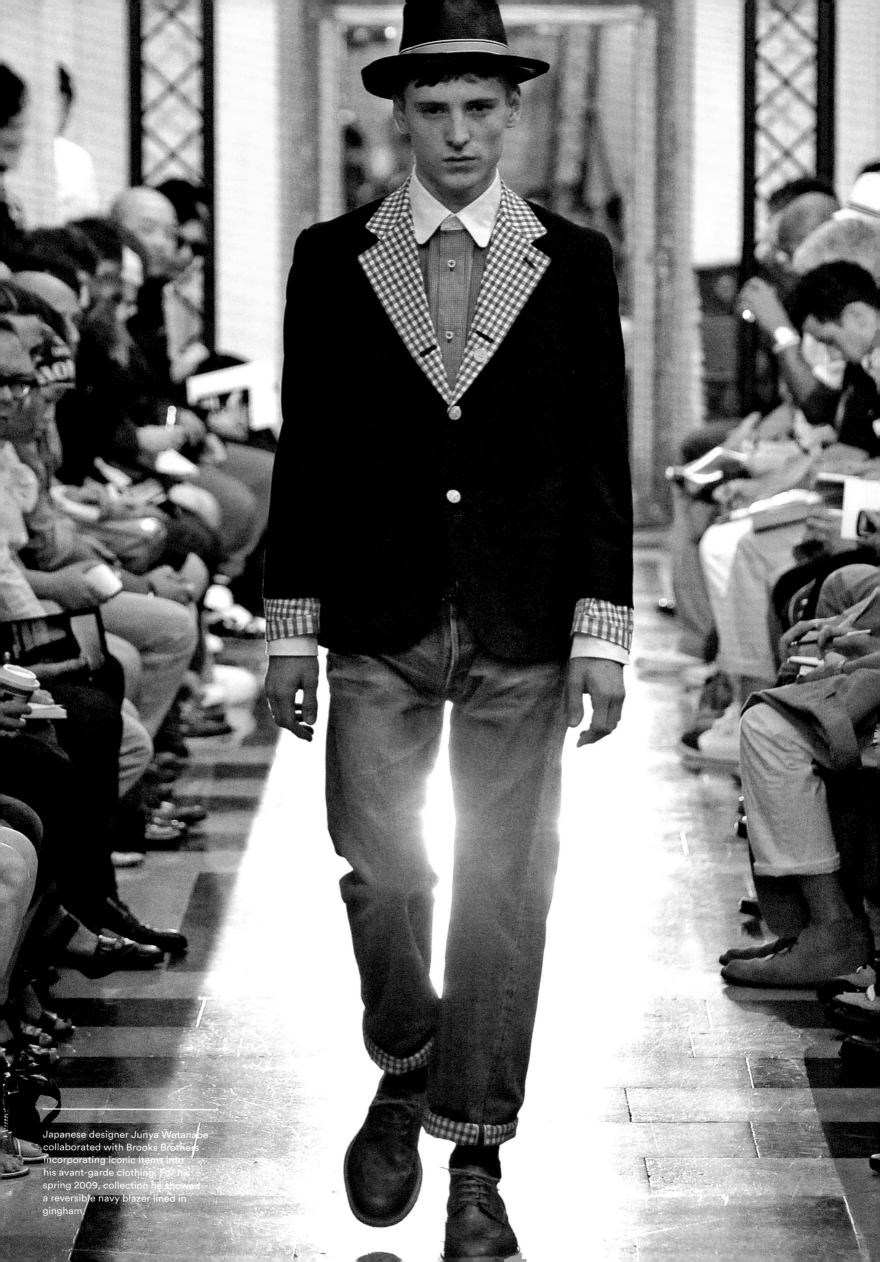

Japanese designer Junya Watanabe collaborated with Brooks Brothers, incorporating iconic items into his avant-garde clothing. For his spring 2009 collection he showed a reversible navy blazer lined in gingham.

"I've always been an admirer
of Brooks Brothers' history,
authenticity and uniqueness. In
seeking collaborators for my MAN
collection, this is the first and only
requirement. In the field of shirts
there is no shirt more famous
and steeped in tradition than the
button-down shirt of Brooks Brothers.
To ask them to collaborate with me
has always been a major objective
and to receive their agreement was a
fulfillment of a dream."

—JUNYA WATANABE, designer

"When I think of Brooks Brothers, I immediately think about tasseled loafers, Fred Astaire, and seersucker suits. It is the first American brand I have wanted to wear and I'm not the only French guy who feels that way!"

—CHRISTIAN LOUBOUTIN, designer

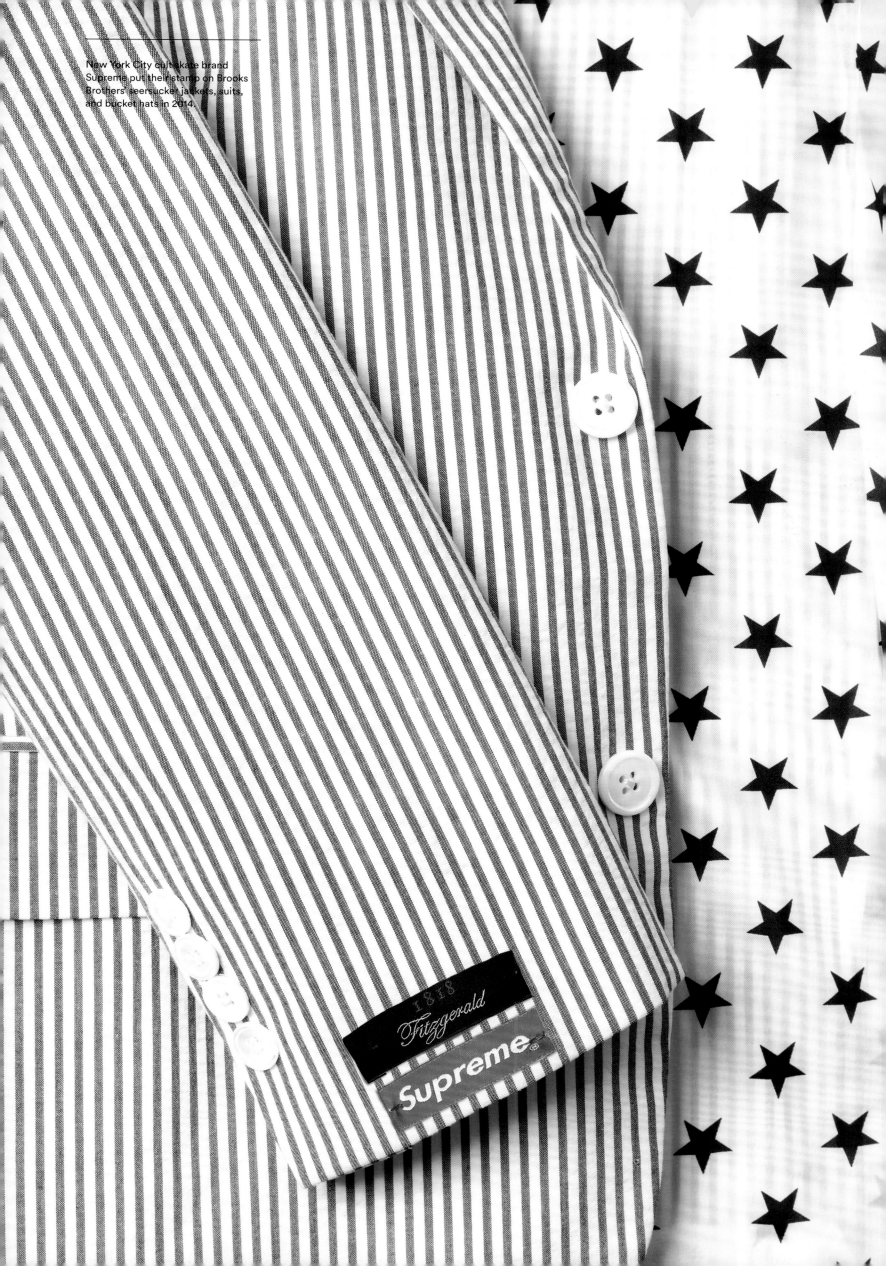

New York City cult skate brand
Supreme put their stamp on Brooks
Brothers seersucker jackets, suits,
and bucket hats in 2014.

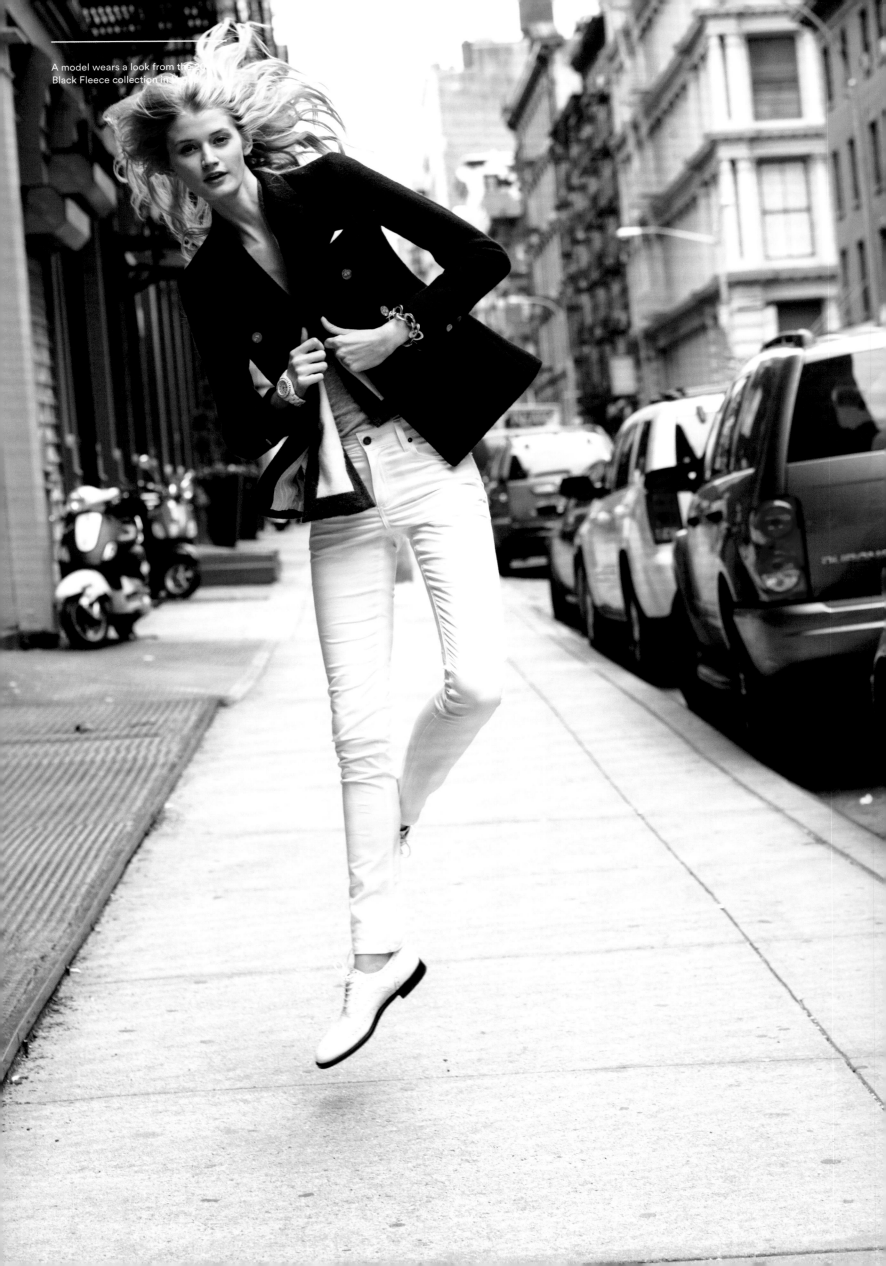

"I've always been drawn to the American style of the late 1950s and 1960s. It's more about the spirit of this time that I am drawn to, as this was the time when there was a distinct American sensibility."

—THOM BROWNE, designer of Black Fleece, in *The New York Times*

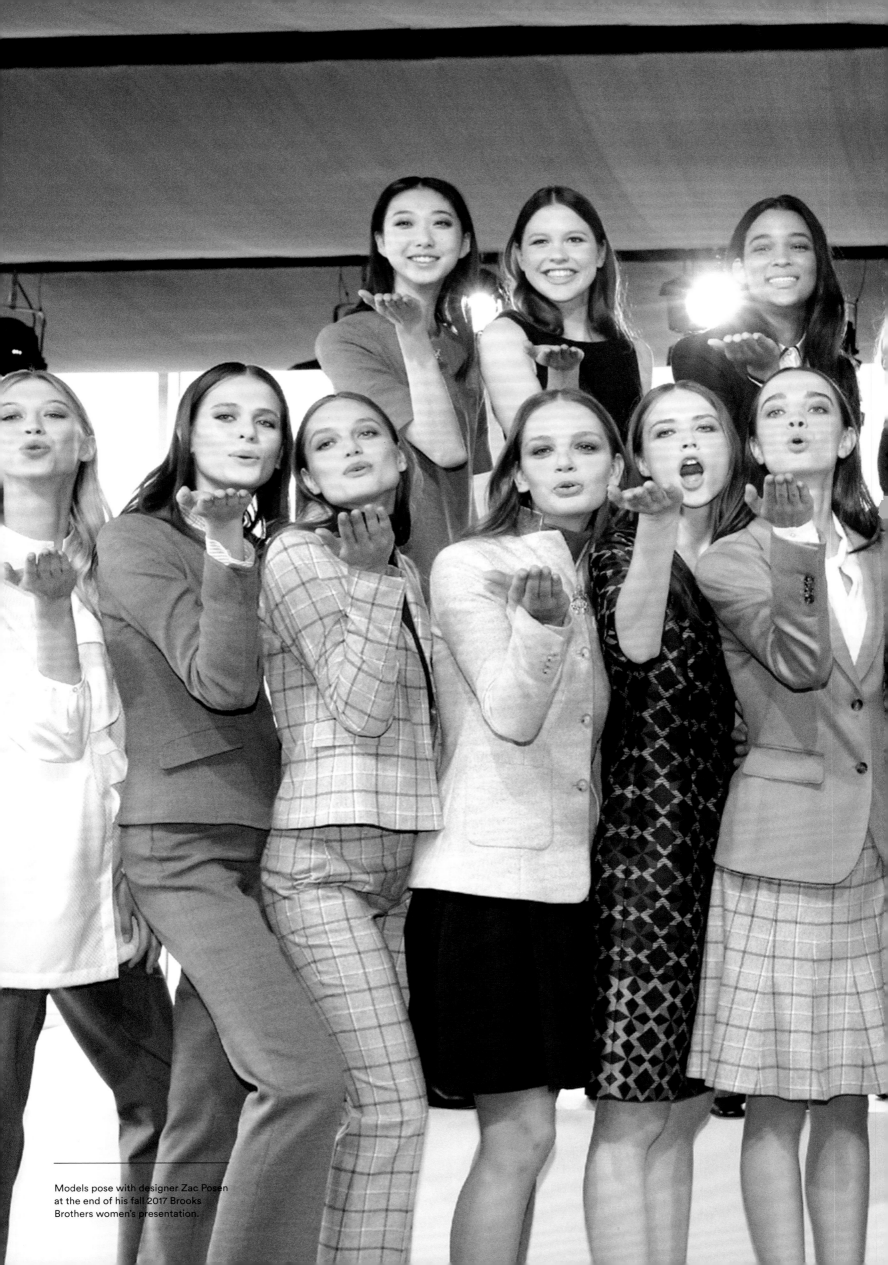

Models pose with designer Zac Posen at the end of his fall 2017 Brooks Brothers women's presentation.

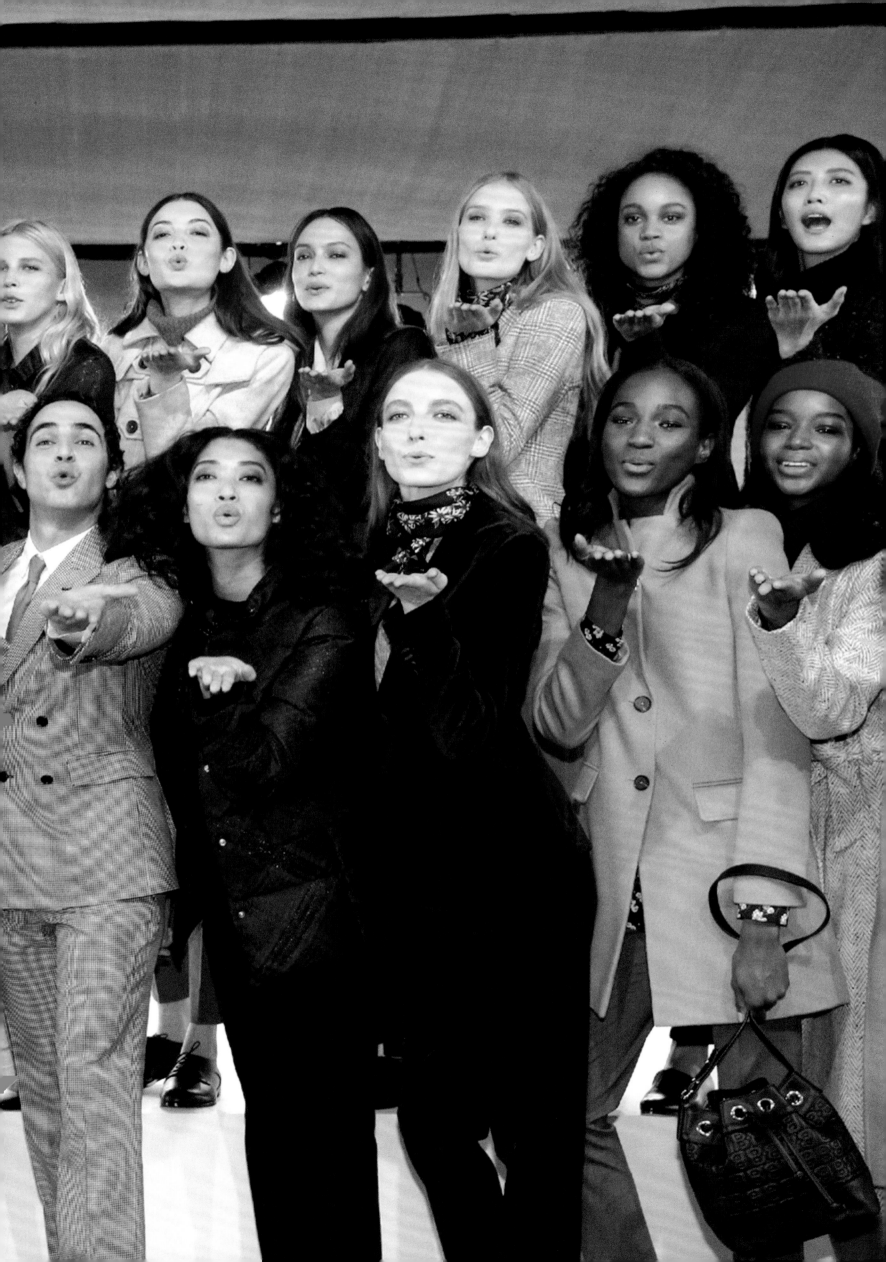

"Growing up on Spring Street with artist parents,
Brooks Brothers and that whole aesthetic was
as far away from my world as it could be. But in life,
as in design, the opposite of reality is always
romanticized. I was born and bred downtown and I
definitely romanticized the other world, this world
of timeless classicism. My great uncle had a collection
of Brooks Brothers pajamas from the 1960s and
as a teenager I began wearing them as an evening look.
What I discovered is that there's something
way more punk about being put together than
being disheveled."

—ZAC POSEN, designer and Creative Director of the Brooks Brothers Women's collection

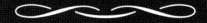

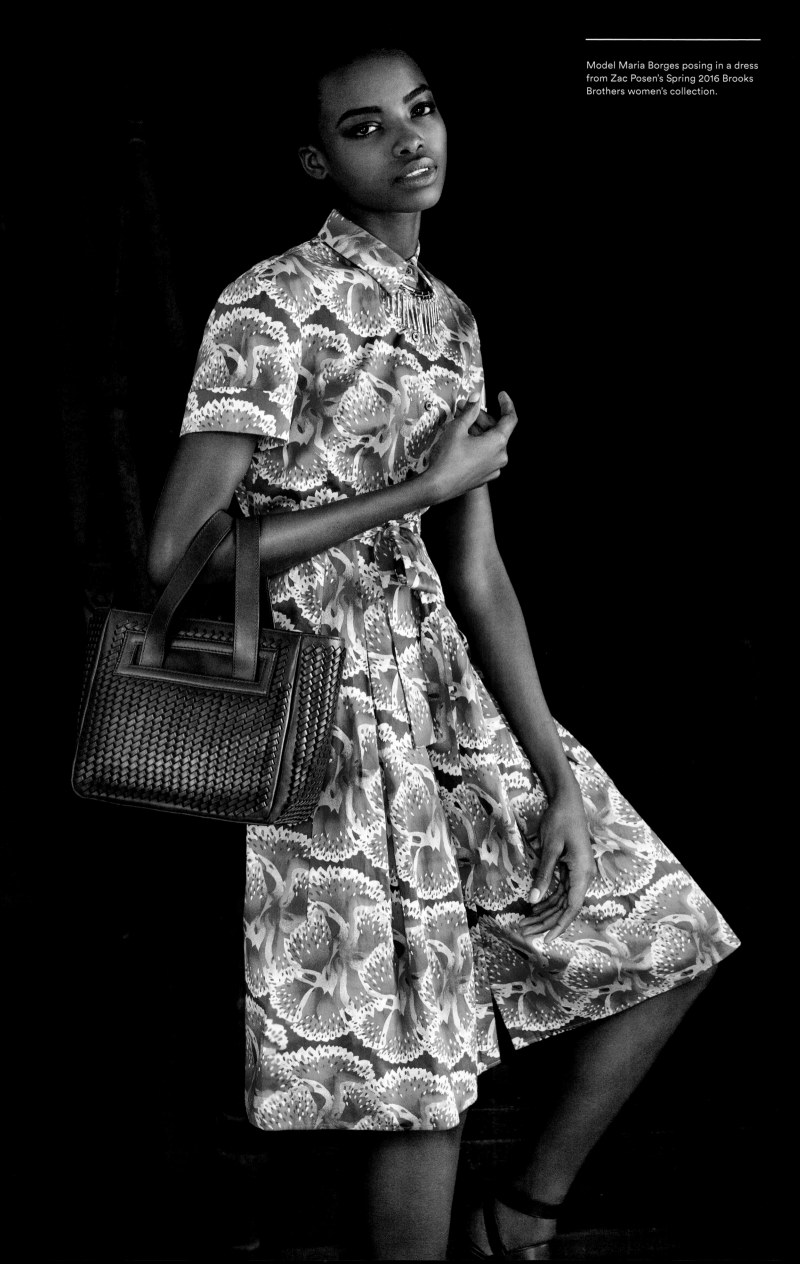

Model Maria Borges posing in a dress from Zac Posen's Spring 2016 Brooks Brothers women's collection.

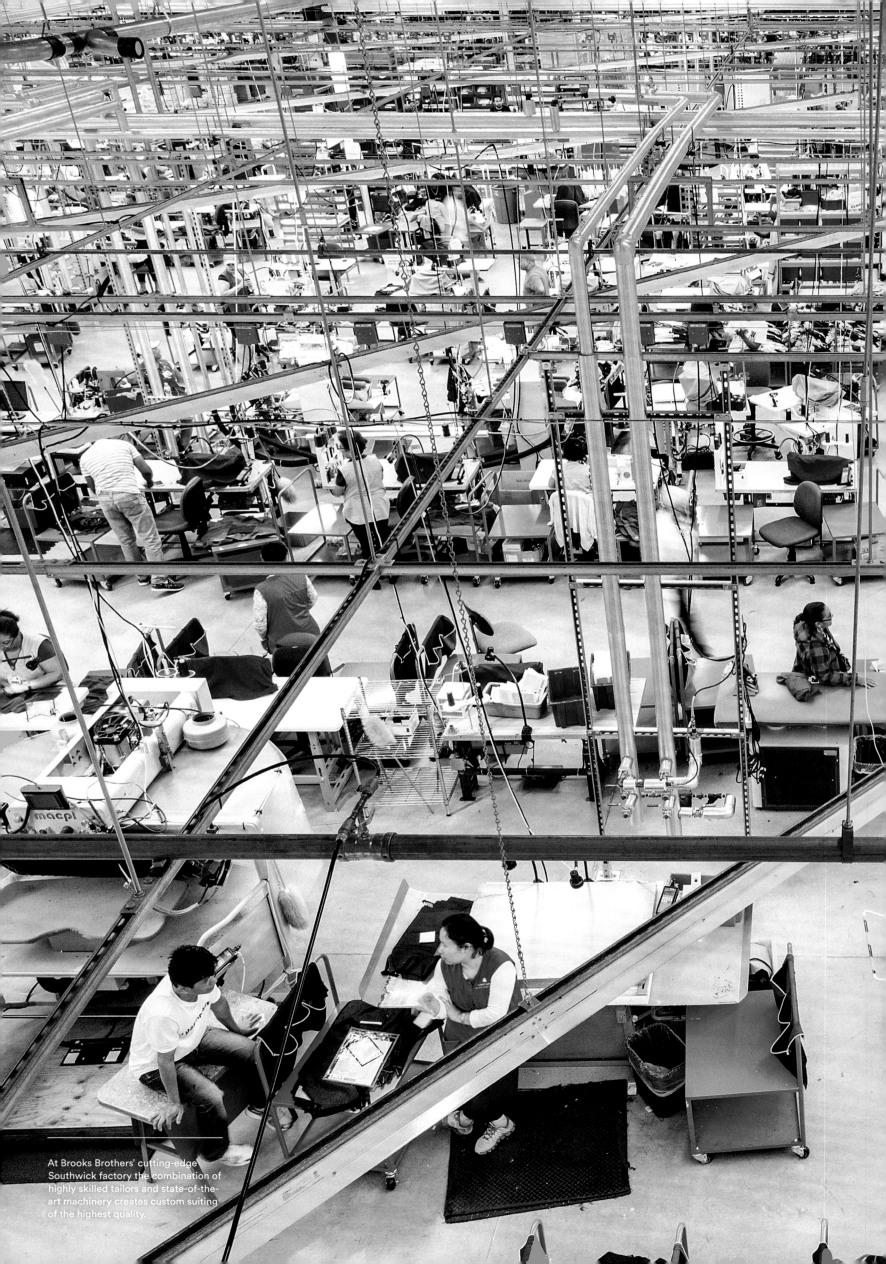

At Brooks Brothers' cutting-edge Southwick factory the combination of highly skilled tailors and state-of-the-art machinery creates custom suiting of the highest quality.

"To be perfectly frank, whenever
we contemplate changing anything
around here, a perceptible shudder
goes through the store."

MR. WOOD told *THE NEW YORK TIMES* in 1956

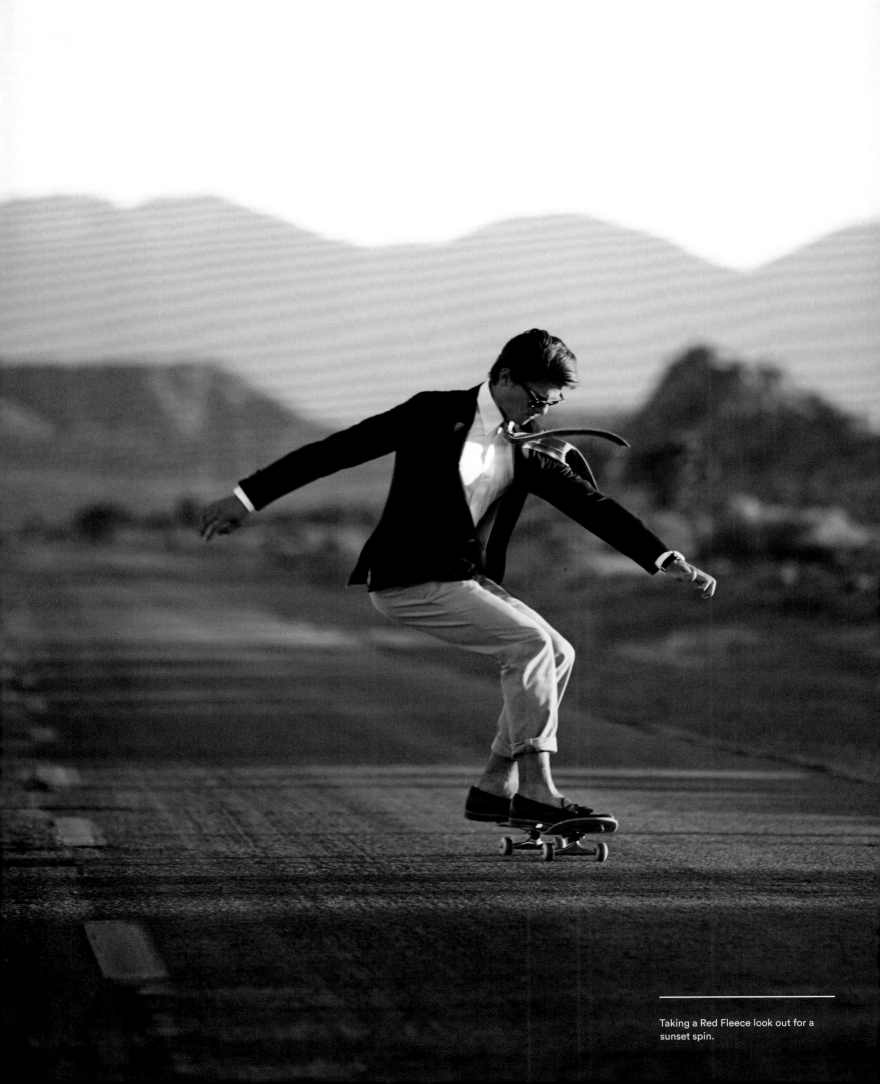

Taking a Red Fleece look out for a
sunset spin.

ACKNOWLEDGMENTS

On behalf of Brooks Brothers, Arthur Wayne and Kelly Stuart would like to extend a special thank you to Kate Betts, Carlo Miari Fulcis, Doug Shriver, Raymond T. H. Jones, The History Factory: Jennifer Andreola, and Chris Juhasz, the design team at NR2154: Jacob Wildschiødtz, Elina Asanti, Nicole Irizarry, Stefanie Brueckler, Madelin Fuller and Rafaella Castagnola, especially to our publisher at Rizzoli: Charles Miers, Anthony Petrillose, and Gisela Aguilar.

We would like to extend a very big thanks to Lisa Birnbach, Teri Agins, Tommy Hilfiger, Patricia Mears, Jim Moore, Carl Sferrazza Anthony, Catherine Martin, Eleanor Lanahan, Paul Cavaco, Candace Bushnell, Jay Fielden, Marina Rust, Elizabeth Saltzman Walker, Kelly Stuart-Johnson, Carlyne Cerf de Dudzeele, Jill Kargman, Gene Pressman, Matthew Weiner, Janie Bryant, Lyn Elizabeth Paolo, Cameron Silver, Graydon Carter, Diane von Furstenberg, Junya Watanabe, Christian Louboutin, Thom Browne, and Zac Posen for their contributions.

We would like to thank all of the photographers, photo agencies, talent, publicists, film studios, publications, and organizations for the rights to reproduce their work.

Thanks also to Claudio del Vecchio, Lou Amendola, Dana Schiller, Marcus Sberna, Morgan Powell, Matt Conte, Joe Trimble, Luca Gastaldi, John Erickson, and the many other Brooks Brothers associates who helped make *200 Years of American Style* possible.

FIRST PUBLISHED IN THE UNITED STATES OF AMERICA IN 2017 BY

Rizzoli International Publications Inc.

300 Park Avenue South

New York, NY 10010

www.rizzoliusa.com

© 2017 Brooks Brothers

BROOKS BROTHERS

Arthur Wayne, *Vice President, Global Public Relations*

Kelly Stuart-Johnson, *Director of Learning / Brand Historian*

Kate Betts, *Editor*

RIZZOLI INTERNATIONAL PUBLICATIONS

Charles Miers, *Publisher*

Anthony Petrillose, *Associate Publisher*

Gisela Aguilar, *Project Editor*

Victorine Lamothe, *Proofreader*

Kaija Markoe, *Production Manager*

Kayleigh Jankowski, *Design Coordinator*

ART DIRECTION AND DESIGN BY NR2154

Jacob Wildschiødtz, Elina Asanti, Madelin Fuller, Nicole Irizarry

Distributed in the U.S. trade by Random House, New York.

Printed in Italy.

ISBN: 978-0-8478-5992-4

Library of Congress Control Number: 2017942613

2017 2018 2019 2020 / 10 9 8 7 6 5 4 3 2 1